WI

D1645080

To be returne

Authoring
Performance

WHAT IS THEATRE?

Edited by Ann C. Hall

Given the changing nature of audiences, entertainment, and media, the role of theatre in twenty-first-century culture is changing. The **WHAT IS THEATRE?** series brings new and innovative work in literary, cultural, and dramatic criticism into conversation with established theatre texts and trends, in order to offer fresh interpretation and highlight new or undervalued artists, works, and trends.

ANN C. HALL has published widely in the area of theatre and film studies, is president of the Harold Pinter Society, and is an active member in the Modern Language Association. In addition to her book *A Kind of Alaska: Women in the Plays of O'Neill, Pinter, and Shepard*, she has edited the collection of essays *Making the Stage: Essays on Theatre, Drama, and Performance*. Hall is also the author of a book on the various stage, film, print, and television versions of Gaston Leroux's *Phantom of the Opera*, *Phantom Variations: The Adaptations of Gaston Leroux's Phantom of the Opera, 1925 to the Present*.

Published by Palgrave Macmillan:

Theatre, Communication, Critical Realism
 By Tobin Nellhaus

Staging Modern American Life: Popular Culture in the Experimental Theatre of Millay, Cummings, and Dos Passos
 By Thomas Fahy

Authoring Performance: The Director in Contemporary Theatre
 By Avra Sidiropoulou

AUTHORING PERFORMANCE

THE DIRECTOR IN CONTEMPORARY THEATRE

AVRA SIDIROPOULOU

AUTHORING PERFORMANCE

First published in 2011 by
PALGRAVE MACMILLAN®
in the United States—a division of St. Martin's Press LLC,
175 Fifth Avenue, New York, NY 10010.

Where this book is distributed in the UK, Europe and the rest of the world,
this is by Palgrave Macmillan, a division of Macmillan Publishers Limited,
registered in England, company number 785998, of Houndmills,
Basingstoke, Hampshire RG21 6XS.

Palgrave Macmillan is the global academic imprint of the above companies
and has companies and representatives throughout the world.

Palgrave® and Macmillan® are registered trademarks in the United States,
the United Kingdom, Europe and other countries.

ISBN: 978–0–230–12018–1

Library of Congress Cataloging-in-Publication Data

Sidiropoulou, Avra, 1972–
 Authoring performance : the director in contemporary
theatre / Avra Sidiropoulou.
 p. cm.—(What is theatre?)
 Includes bibliographical references.
 ISBN 978–0–230–12018–1 (hardback)
 1. Theater—Production and direction. I. Title.

PN2053.S45 2011
792.02'33—dc23 2011020683

A catalogue record of the book is available from the British Library.

Design by Newgen Imaging Systems (P) Ltd., Chennai, India.

First edition: December 2011

10 9 8 7 6 5 4 3 2 1

Printed in the United States of America.

To you, Nikiforos, my first

CONTENTS

Acknowledgments ix

Introduction Auteurism: New Theatre for Brave New Worlds 1

1 The Rise of the Modern Auteur 11

2 Enter Artaud 33

3 Beckett's Turbulence 51

4 Auteur on the Road 75

5 The Means as an End 107

6 Conquering Texts 135

Afterword 159

Appendix: *Six Case Studies* 161

Notes 179

Bibliography 193

Index 205

ACKNOWLEDGMENTS

AUTHORING PERFORMANCE: THE DIRECTOR IN CONTEMPORARY THEATRE would not have been made possible without the help of a number of people. One of these friends, my Romanist mentor S. D., has been instrumental in getting the book on its way. His trust, unrelenting guidance, writer's acumen, and academic's informed feedback throughout this demanding process have been more than invaluable. I thank him to eternity. I am also indebted to my Palgrave editor, Samantha Hasey, for all her assistance and support through every phase of the book's making.

Professor Elizabeth Sakellaridou at the Aristotle University of Thessaloniki, more than anyone else, is behind the initial conception of the book. I wish to thank her for all her encouragement and constructive comments; her comprehensive expertise, together with our heartfelt exchange of theatergoing experiences and the constant inter-circulation of ideas and creative input have been a major fuel in my work. Professor Giorgos Pefanis at the University of Athens has also been a priceless interlocutor in matters of theatre criticism and theory.

Some of the book's research involved a great deal of work in the United States. I have been very privileged to recurrently hold long conversations on the nature of auteurism and the future of the theatre with director Robert Woodruff and playwright Charles Mee, both of whom have been a great source of inspiration not only in the writing of this book but also in the shaping of a personal aesthetic in my directing work. Tom Dale Keever, a theatre scholar and practitioner himself has been a sound source for production history with an insider's knowledge of the contemporary Broadway and off-Broadway scenes. I am also forever grateful to my good friend Alisa Regas for supporting me in every way possible during my time in New York and sharing with me several meaningful evenings in the theatre.

In the course of writing, I have been in constant touch with theatre artists from many parts of the world: from Greece, Cyprus, Germany, and Turkey to the U.K. and United States to Japan, and Iran. Some of these people I have been fortunate to consider personal friends: they have been

part of my reality as a theatre scholar and a director, and knowing them has helped me in many ways get through difficult spans in my own career. Even though their names may not all appear in this book, their sheer presence in the arts has assured me that the commitment to a surprising, sincere, as well as profound theatre will always keep this art form alive.

Finally, this book would not have been realized without the continuing, tireless support and patience of my family. I can only thank each and every one of them, for their unwavering belief in me at times when I felt my courage failing. In particular, I wish to express my gratitude to my husband, who has at critical moments given me faith in myself as a writer, director, and individual and assure him that writing about directing has been well worth my endless introspection as an artist: putting my thoughts and observations on paper has made me all the more eager to go "out" and further explore the endless possibilities of making theatre.

AUTEURISM: NEW THEATRE FOR BRAVE NEW WORLDS

IN 1960, EUGENE IONESCO LIKENED THE AVANT-GARDE ARTIST TO "an enemy inside a city which he is bent on destroying, against which he rebels." Ionesco argued that, like any system of government, "an established form of expression is also a form of oppression. The avant-garde man is the opponent of an existing system. He is a critic of, and not an apologist for, what exists now" (45). Since the latter part of the twentieth century, the role of the director as maker, creator, ultimately "author" of the theatre event has been firmly rooted in the practices of the avant-garde stage. In fact, among the most common titles that came to be identified with innovative theatre makers, such as "conceptualist," "formalist," "experimental artist," and "scenic writer," that of "director-auteur"[1] has been the most apt. Borrowed from French film criticism, the descriptive term *auteurism* can be applied to the creative process of those directors who adapt/interfere with/ deconstruct the playwright's original script or construct their own, having developed a unique style, a trademark that characterizes their work. The concept actually emerged in 1948 with French New Wave director and film theorist Alexandre Astruc's essay "Naissance d'une nouvelle avant-garde: la caméra-stylo" ("Birth of a new avant-garde: the camera-pen") in *L'Écran Français*. The camera, according to Astruc, was the director's pen, and by controlling it imaginatively, cinema could become a commanding medium of expression, equivalent to literature or painting. Astruc's notions were taken on by a number of critics such as André Bazin and filmmakers such as François Truffaut, who used the French cinema journal *Cahiers du cinéma* as a forum to voice their iconoclastic ideas. Truffaut's revolutionary article in 1954 "Une certaine tendance du cinéma français" ("A certain tendency

in French cinema") first introduced the term *auteur* to the world of the arts through the coined phrase "la politique des auteurs" ("the policy of auteurs"), which celebrated directors' total control over the artistic product and delegated to them authority as well as responsibility for all aesthetic choices. In 1962, American critic and writer Andrew Sarris, in his treatise "Notes on the Auteur Theory," formulated the notion of auteurism more systematically, privileging with the honorary title "writer-creator" only those directors whose productions regularly exhibited a singular technique and style. Not surprisingly, *American Cinema: Directors and Directions, 1929–1968* quickly became the unofficial "bible" of auteurism in the cinema.

As in film, the practice of auteurism in the theatre espouses that directors are the "authors" of the theatre event when they leave upon it a distinctive imprint, which expresses a sense of visual panache and a choice of subject matter that are constant across a body of work. Fundamentally, it was the *film* auteur theory of the 1950s that gave the extra (necessary) push from the 1960s on to awakened critical interest in the concept of performance as autonomous text: an interweaving of layered mediums, references and discourses, quite separate from the dramatic play which originates in the playwright's mind and is exhausted on the printed page. From its inception, the work of theatre auteurs has saluted directors' thematic, stylistic, and methodological consistency, basing it on an uncompromising personal vision and aesthetic: the director controls the artistic statement, takes credit for the end result, and is responsible for attracting an audience. Whether they stage an existing play; rework, deconstruct, and put together an updated version of a classic; or devise a new piece from scratch, auteurs will always ensure that the final product will bear their own signature, as indelible, if not more so, as that of the original playwright, when there is one. On this account, the art of the "director-auteur" is almost instantly identifiable with experimental, image-oriented, nonlinear work, often associated, in "distinction to normative directing practice in the theatre...more with the symbolic than the naturalistic" (Schneider and Cody 2002, 125). Responding to the new challenges of these directional changes, Robert Wilson, perhaps the most celebrated among auteur directors in the twentieth and, so far, twenty-first centuries, reveals that his responsibility as an artist "is to create, not to interpret." He insists that directors create a work for spectators and therefore should allow them "the freedom to make their own interpretations and draw their own conclusions" (Wilson and Eco 1993, 89–90). He thus sets out an understanding of the operation of "reading" and staging texts as an act of authorship rather than of reflection, illustration, and clarification. From this perspective, directing is not just another *lecture* but essentially, a new *écriture* of the labyrinthine issues and tissues of intentions, perceptions, and compositions.

Historically, the twentieth century enthusiastically celebrated the arrival of the empowered director, who came to give expression to an overall feeling of restlessness and a craving for earth-shattering shifts in society, culture, and the arts, and to simultaneously reconcile a choice of existing "isms." The reconsideration of the role of the director, the broadening of the notion of text, and the revised practice of the mise-en-scène as an independent, self-ruling art—dating back to the first historical avant-garde, with artists such as Edward Gordon Craig, Adolphe Appia, Max Reinhardt, Vsevolod Meyerhold, Bertolt Brecht, and Antonin Artaud and culminating in the establishment of "directors' theatre" in the 1980s—have bequeathed theatre its present all-embracing, defiantly pluri-vocal form, purging it to a significant degree of sentimentality and high-ringing drama. Auteur performances that rethink the text in less language dependent, decidedly more metaphoric and imagistic ways, have become standard production fare in international arts festivals, stimulating debates frequently verging on animosity. Anxious to shed the skin of verisimilitude, which defines the structural logic of realistic theatre, these productions lend themselves to continual transformation, "making text" of anything that can be theatrically *capitalized*. In fact, what used to be the canon of "good theatre"—lucid, audible, and relatively unequivocal narratives transported equally articulately onto the stage—has been replaced by self-reflexive, impressionist motifs and allegories that heavily rely on signs and ciphers. Further, fragmentation and indeterminacy in structure and theme have well discarded Aristotelian teleology and declared character redundant or *dead,* while the structural comforts of linearity, which mostly refer back to purely logocentric plays and mask subjective reality by rounding up its sharper edges, are now exposed and seen for what they are: a largely spurious rendering of a world that refuses to be contained and explained merely in words.

Invariably attached to the postmodern aesthetic, some of auteurism's key elements include the celebration of deconstruction, anti-textuality, hybridization, and heterogeneity. Anti-mimetic, ritualistic, and physical performances draw on the principles of cubism to construct jarringly dissimilar events, which the spectator is invited to view from multiple angles. Visual actions stand in oblique relationship to the dialogue, while stories can be told simultaneously, borrowing from film's techniques of dissolves, cuts, and framing. Since language can be non-semantic, imagery, carrying the force and impact of archetypes and symbols, replaces verbal expression. At the same time, structural design and technological expertise typically undergird the action, while the manipulation of rhythm and bodily expression are given priority over dialogue, which is often looked down on as merely explicating it. In this sense, space, lighting, and costume become *stories* in themselves, which can generate multilayered narratives, randomly splintering

and fusing. Given that the concepts of transformation, repetition, and free association are also prominent, associative memory is valorised over linear storytelling to the effect that ellipsis becomes a major punctuation mark in the syntax of the performance. Further attributes, as Hans-Thies Lehmann demonstrates in *Postdramatic Theatre,* also include "ambiguity; celebrating art as fiction; celebrating theatre as process; discontinuity; heterogeneity; non-textuality; pluralism; multiple codes;...subversion; all sites; performer as theme and protagonist; deformation" (2006, 25).

If we reflect back on the early experiments in theatrical form, we will certainly trace a continuum: following Alfred Jarry's groundbreaking innovations, Craig's writings on the possibilities of an abstract theatre, where setting, mood, and atmosphere, together with the actors' expressive physicality, would be the principal elements, duly anticipated the authoritative existence of the modern director who would supervise and unify all such aspects of performance and devise a tight and coherent form to welcome a solid artistic vision. Expounding his radical, if ultimately inapplicable, views in his series of essays *On the Art of the Theatre* (1911), Craig first used the term "stage director" to refer to the person who masters all practices pertaining to the conception and realization of a theatre production. Notably, seeking to deconstruct the long-lasting hierarchy of playwright, director, and actor perpetuated in "literary" theatre, Craig repudiated the former role of the director as mere interpreter of the dramatic text, fully convinced that:

> When he [the stage director] interprets the plays of the dramatist by means of his actors, his scene-painters, and his other craftsmen, then he is a craftsman—a master craftsman; when he will have mastered the use of actions, words, line, colour, and rhythm, then he may become an artist. Then we shall no longer need the assistance of the playwright -for our art will then be self-reliant. (77)

Craig's visionary speculation on a "director-author" laid the foundations for future ventures in performance form, which would develop at the interstices among distinct practices. Suspicious of realistic theatre's blind insistence on intelligibility in a world which actually makes little sense, auteurs have labored to envision and realize forms of theatre that capture the ideological and aesthetic turmoil of modern drama since the beginnings of the twentieth century, toying with the ingrained potential of realism, surrealism, symbolism, expressionism, and even Wilson's Theatre of Images. Among other things, their ambition is to dramatize "the obsessional dimensions of historicized memory to create images that verbal language cannot reach, or amplify sounds which return words to an inexorable materiality" (Schneider and Cody 2002, 126). Artaud, working in the 1930s, was

rightly credited as the first official exponent of the new function of theatre, underlining the necessity for groundbreaking innovations in the mise-en-scène. Significantly, Artaud's theories were instrumental in establishing a long line of directors-auteurs, such as Peter Brook, Jerzy Grotowski, and Eugenio Barba, who made it their goal to reconstitute Western theatre's lost spirituality, understood to manifest itself in the kind of metaphysical energy permeating Greek tragedy. Anchored on Artaud's theory, directors' interest in the "bodiness" of performance as an alternative yet indispensable language for the stage, reverberates his own conviction that for the theatre to affect people, the intellectual appeal of a literary text is never enough, and the construction of corporeal meaning would be a priceless corrective to the degradation of the theatre experience. Some years later, when defining the theatre of the absurd in his essay "The Avant-Garde Theatre" (1960), Ionesco would also speak of "the denunciation of the ridiculous nature of a language which is empty of substance, sterile, made up of clichés and slogans; of theatre-that-is-known-in-advance" (48–9). The idea that language is transparent and therefore unreliable received further theoretical backing from the post-structuralists' conviction that it is impossible for any work of literature to attach itself to a fixed meaning.[2] In this respect, Roland Barthes', Umberto Eco's, and Jacques Derrida's theories on the "death of the author," "the open work," and the concept of *différance,* respectively, would eventually embolden auteurs to view their own work as a field of *play* and dynamic interaction between writer, director, and audience.[3] Inevitably, the reinvention of theatrical language and the critiquing of canonical dramatic works, which Artaud had notoriously defamed as "masterpieces," presupposed an investment in a *performance text* emerging out of the collaborative intuitions of all the artists involved in its making but ultimately bearing the signature of a director, who would no longer act *simply* as a privileged stage manager of slightly increased artistic responsibilities. Notwithstanding the enthusiastic, for the most part, acknowledgment of the director's new function, no one can deny that the pyramid of interpretation in the theatre has undergone a dramatic reversal, replacing the author, hitherto posing at the highest tip of the pyramid, as the exclusive interpreter of the world, with the director-auteur as the new author[ity].

Trying to come up with a consistent methodological and conceptual scheme to identify and analyze current trends, the more recent scholarship on experimental theatre has often addressed contemporary performance mostly, if not exclusively, from the perspective of a postmodern, media-soaked culture. There has been a keen interest in the new functions of the mise-en-scène (see Patrice Pavis' *La Mise en Scène Contemporaine* [2007] and *Languages of the Stage* [1993]) and in the revised position of the performer (see Phillip Zarrilli's *Acting (Re)Considered* [1995] and Philip Auslander's *From Acting*

to Performance [1997]) as well as in the changed, now creative and involved, role of the spectator (see Susan Bennett's *Theatre Audiences: A Theory of Production and Reception* [1990] and Bert O. States' *Great Reckonings in Little Rooms* [1985]). One should also take into account the gradual reevaluation of the dramatic text and of text-based theatre as a whole. One of the studies that documents and investigates the recalibration of the dramatic text in avant-garde, media-tized performance is *The Transparency of the Text: Contemporary Writing for the Stage,* edited by Donia Mounsef and Josette Féral (2007). To some extent, up until recently, most analyses of contemporary innovative work have contrasted "properly" dramatic theatre with post-modern performance, often innocuously leveling the notion of "dramatic text," by identifying it exclusively with *well-made* plays of realism abiding by the conventions of verisimilitude and psychological development of character. Lately, however, theatre scholarship has started to address the need to explore the text's performative potential, with the awareness that it can both shelter and expose the ideological, emotional, and cultural perturbations of twenty-first-century audiences. Among the more active of theatre scholars, Patrice Pavis, Lehmann, Marvin Carlson, Elinor Fuchs, Rebecca Schneider, and Philip Auslander, to name but a few, have written on the changing landscape of the modern stage. *Re: Direction: A Theoretical and Practical Guide,* edited by Schneider and Gabrielle Cody (2002), is in fact one of the very few analyses that touch (if briefly) upon the phenomenon of auteurism as such. Another seminal study is surely Lehmann's *Postdramatic Theatre* (originally published in German in 1999), inspired by the work of experimental theatre directors and playwrights from the 1980s and 1990s on. Of course, Pavis' thorough examination of the semiotics of stage direction has taken existing scholarship many steps further; surveys on directors' aspirations and methods, such as *Fifty Key Theatre Directors*, edited by Shomit Mitter and Maria Shevtsova in 2005, also constitute valuable sources of production history within the broader context of the avant-garde theatre.[4]

All this said, despite the number of studies dedicated to the avant-garde movement in the West, auteur theory is firmly locked within the jurisdiction of film studies. What is more, the dialectics of directorial interpretation and the ethics of auteurism still remain relatively unexplored, attached to a more general criticism on the limits and limitations of "directors' theatre." This is where this book comes in, recognizing the need to place the work of auteur stage directors within a more specific and systematic analytical framework. In this respect, *Authoring Performance* aspires not only to add to the existing scholarship but also to create a theoretical yet also practice-related context in which to examine and evaluate auteur contribution to the modern stage. It should also be read as a reaction against the pessimism that overrides contemporary criticism, which has been, for the longest time, prophesying the

death of theatre; as this book argues, the art of the auteur is still very much alive in our times, facing the same types of challenges that had informed the work of early-twentieth-century experimentalists. Implicit in this conviction is the assumption that the most radical directors have always fought against a closure of form, successfully competing against those cultural circumstances that perpetuate via theatre a soporific, complacent, and noncommittal stance vis-à-vis society. Surely, Tom Bishop's semi-rhetorical question in "Whatever Happened to the Avant-Garde?"—"After all, after nudity, after incest, after murder, rape, or cannibalism, how can you still shock a public that is force-fed the worst horrors daily on the evening news?" (quoted in Mounsef and Feral 2007, 11) is valid; yet, it is exactly this flatness of experience, largely deliberated by the media culture, that theatre still tries and always *will* try to overcome, sometimes by fighting the system—the media world, for that matter from within. For one thing, challenging the speed and the literal representability of film and television, meaningful theatre must struggle to retain its unique position among the arts by reinventing itself in multiple forms and reexamining its prevailing discourses. In this respect, demystifying the omnipotence of the text, cross-disciplinary exchange, characteristic of auteur practice, has introduced the up-to-date digital aesthetic and the reality of virtual experience into the more literary structures of the theatre; this is no surprise really, since the most significant artistic experiments throughout the twentieth century have been based on collaboration across mediums and fields of study, favoring different versions of the Wagnerian concept of *Gesamtkunstwerk* (a total work of art), which to some extent has the ability to reconcile most formal dualisms. Mapping the different faces of "technologization," the paradigm generated by some of the auteur productions we will be looking at, by artists as different and distinct as Wilson, Peter Sellars, Ivo van Hove, Simon McBurney, Christoph Marthaler, Robert Lepage, and Elizabeth ("Liz") LeCompte, is that even though technology functions principally as a structural tool, it often exposes its own transparency and underlines the fluctuating identities of men and women in a brutally insentient world. Alongside that awareness and with the view to developing further some of the points raised by theoreticians such as Pavis or Lehmann, with regard to the future of avant-garde performance, I am bringing into sharp focus auteur strategies for marrying form with content, calling attention, all the same, to some of the dangers involved in ambitious, yet mercilessly frozen formalism.

Besides the future viability, or not, of valid forms of theatre, another question that has repeatedly resurfaced in theatre-studies scholarship, and which this book takes up, is, what it is exactly that the twenty-first-century theatre is reacting against. As I have just now suggested, the Cassandras of critical theory have been presaging the death of theatre, claiming that the institutionalization of auteur directors has manufactured an overly comfortable

context for them to create in; in other words, it has made them part of the social, ideological, and cultural system they had originally struggled against. My own view of auteur theatre does not necessarily locate its perils within the bosoms of a festival-[s]ized, high-budget, and "high-production-values" context. Whether grassroots experimental or opera-scale, auteur performances will always be facing the issue of *meaningfulness,* of how to stimulate thought, memory, and the senses, by reinventing (their) form.

It is the above dialectic which has led me to put the following hypothesis to test: namely, whether the "secret" of accomplishment and the lasting effect of certain productions may indeed lie in the ways directors accept and manipulate to their advantage the tension between the semiology of the mise-en-scène and the phenomenology of performance. In resonant auteur work, the ambiguous relationship between these ever-troubled enemy-companions—still being viewed mostly in antithetical terms—has functioned less as a polarity and more as a necessary, taxing, yet also rewarding, cohabitation. The conviction that the functions of director and actor are actually complementary also proposes that auteurs who attempt to unite theatre's inherent duality as a semiological/mimetic field and a phenomenological performing space have a lot more space to move in and many more weapons at their disposal. In fact, only if we take this duality seriously, by beginning to recognize and enjoy the fact that its two poles are mutually connected, rather than downright opposing, can we actually begin to grasp the range of creative possibilities available to directors.

One last thing: writing primarily—but not exclusively—on auteur theatre in the West, I am bringing into focus examples of established European and American directors; this choice is not accidental, since most of these artists—Tadeusz Kantor, Brook, McBurney, Sellars, LeCompte, Wilson, Ariane Mnouchkine, van Hove, Marthaler, and Lepage among them—have been critically acknowledged for several years and thus their work serves the purpose of exploring to what degree they have resisted retraction to easy pattern, as opposed to a recognizable style, which is one of the most common dangers associated with the decay of avant-garde art. Having said this, I remain fully conscious that the list of auteurs is extensive and ever-growing, including Krzysztof Warlikowski, Romeo Castellucci, Valery Fokin, Jan Fabre, Silviu Purcărete, Declan Donovan, Olivier Py, Kristian Lupa, Thomas Ostermeier, Yuri Lubimov, Oskaras Koršunovas, Heiner Goebbels, Anatoli Vassiliev, Eimuntas Nekrošius, Frank Castorf, Christoph Nel, Katie Mitchell, Grzegorz Jarzyna, and many talented others. That in itself is a positive sign, a good omen. In so far as imagination and inspiration exist, new forms of art will always emerge. Indeed, as long as there are battles to be fought for in society and within oneself, there will also be a desire to transform or transgress. Theatre has no choice but to live up to the challenges of its time.

CHAPTER BREAKDOWN

CHAPTER 1

Chapter 1 documents the origins and social context of auteur theatre and its development to the present. It briefly discusses the theories of Craig in relation to the director as creator, and brings into sharp focus some of the early-twentieth-century innovations as first introduced in the work of Jarry, Constantin Stanislavski, André Antoine, Jacques Copeau, Meyerhold, and Reinhardt. At the same time, it touches on the foundations of the social function of theatre and the gradual shattering of illusionism, championed by artists such as Copeau, Erwin Piscator, and Brecht and helps draw parallels with the work of numerous auteurs in more recent years, who celebrate the communal nature of theatre. Finally, this chapter paves the way to a more in-depth analysis of the reconsidered notions of mimesis and representation in auteur performance.

CHAPTER 2

Mainly a discussion of Artaud's influence on auteur theatre and specifically on the revised role of the director as author of the theatre event, Chapter 2 explores the ways in which Artaud's theory in *The Theatre and its Double* (1936) anticipates the work of directors who have based their theatre on signs shared by all human beings, thus ensuring universal impact. The chapter also marks Artaud's revolt against Western theatre's aesthetics, and his rejection of Aristotelian mimesis. By bringing in Derrida's analysis of Artaud's work, particularly in relation to the notion of the "theological stage" and the banishment of the author-God from the stage (Freud's "parricide"), the chapter illustrates the ways in which Artaud identifies the ultimate "triumph of the pure mise-en-scène" (i.e., its disentanglement from literature and the tyranny of the word), the salient feature of all auteur directing.

CHAPTER 3

Chapter 3 is an analysis of Samuel Beckett's later drama and its legacy on auteur directing: it establishes the connection between his performance texts and the revised notion of the dramatic (literary) text as a dynamic space of confrontation between the word and the image. Examples from Beckett's later plays illustrate how the integration ("writing in") of the performance-bent elements of image, sound, and technology helps subvert conventional forms of representation. Examining Beckett's process of "self-collaboration" as author and director of his texts and discussing the writer's tight control over the text's staging possibilities, the chapter also brings to attention issues of interpretation and authorship, which are fundamental in auteur practice.

CHAPTER 4

Chapter 4 scrutinizes the actual directing work of established auteurs, primarily in Europe and the United States, and describes their method of work, their sources of inspiration, together with the challenges involved in their directing. It focuses on auteur directors' creative strategies of self-collaboration, recycling, collage, Gesamtkunstwerk, and ensemble work as well as their means of manipulating the audience's emotional involvement.

CHAPTER 5

Inspired by Artaud and Beckett, contemporary auteurs have both manufactured and manipulated an array of stage languages to create "sensorial" texts in performance. Based on numerous examples from recent acclaimed productions by Brook, Wilson, LeCompte, Martha Clarke, Sellars, Marthaler, Anne Bogart, and Lepage, among others, the chapter explores image structuration and framing, technology and mediation, the body and sound as text and language. It also deploys a critique of auteur practice, pointing out the challenges involved in the directors' attempt to communicate meaning while remaining true to their desire for formal innovation. In exposing some of the dangers inherent in empty formalism and the postmodern proclivity to "groundlessness," this critique foregrounds the ongoing dialectic between content and form that still continues to provoke controversy in current theatre criticism.

CHAPTER 6

Reexamining the performance text by first outlining the semiotics of the creative collision between the mise-en-scène and the performance, Chapter 6 revisits the post-structuralists' views on the open text and the authorial contribution of the spectator; it also examines the emergence of a performance-informed new dramaturgy (what this study has termed "neo-dramatic" writing), identifying some of its predominant structural, linguistic, and stylistic foundations in the work of Caryl Churchill, Charles Mee, Martin Crimp, Adrienne Kennedy, Susan-Lori Parks, Mark Ravenhill, Valère Novarina, and others. The chapter addresses the issue of authorship by discussing the battle of supremacy and ownership of the text, which regularly defines the relationship between playwright and director. As the question of the viability of a text-less stage is raised, the reader is invited to consider the position of the verbal text as a valuable partner in auteur performance.

THE RISE OF THE MODERN AUTEUR

I. BEGINNINGS

The term "director" is only a little more than a century old. Theatre artists working as producers and stage managers first made their appearance at the end of the nineteenth century. Self-proclaimed "actors-managers," they were actually the forerunners of the modern director. Before that, in the eighteenth century, companies were supported by royalty, and competition among different groups was banned. Gradually, however, these old monopolies were dismantled and theatre assumed another role, occasioning the emergence of various individual companies, which brought about more diverse as well as sophisticated audiences that demanded novelty; as a result, "spectacle" was introduced into professional practice, thanks in particular to some accomplished managers who secured improved stage equipment for their theatres. Because of rapid developments in stage machinery and lighting (one of the major changes being the replacement of old gas lamps with electric lighting), an emphasis on design became apparent: artists grew more and more involved in matters of staging, competing against each other in originality of costume and sets. This intensified the need for one single person, an industrious and resourceful stage manager (a *régisseur* in French), who could coordinate the numerous dynamics involved in making a production.

While the role of the so-called producer became more acknowledged around the end of the nineteenth century, the term "metteur en scène" captures the hybrid function of a modern-day director, stage manager, and producer, closer to what we now know as "artistic director." British actor, director, and scenic designer Edward Gordon Craig (1872–1966) was the first to embrace the term "stage director," applying it to the person who

mastered all practices pertaining to the stage. For Craig, the director was a supreme artist, the orchestrator and arbiter of events, the one to monitor the creative process and unify a multitude of theatre discourses. Influenced by Richard Wagner's principles of *Gesamtkunstwerk* (a total work of art), in 1905, Craig proclaimed that the art of the theatre was "neither acting, nor the play," not scene, nor dance, but consisted of "all the elements of which these things are composed...action, words, line, color, rhythm" (quoted in Walton 1991, 52).[1]

It was only in the 1950s that the word "director" was more consciously taken up and more freely applied, as a result of the broad usage of the term in the film industry. However, in our attempt to trace the beginnings of directing in the Western world, we should, in all fairness, credit the Duke Georg of Saxe-Meiningen (1826–1914) as the first "official" director. His company, formed in 1866, toured Europe extensively, putting a lot of emphasis on visuals and serving his comprehensive artistic vision, especially vis-à-vis the "faithful" restoration of historical drama. On the whole, the nineteenth century revealed a strong interest in historical reconstruction. Duke Georg's restoration of Shakespeare's *Julius Caesar* (1867) in its exact reproduction of historical detail stimulated animated discussion regarding the ways for directors to treat classic works of literature. In this respect, it highlighted the complexity of an issue which, in the years to come, was to become key in directing practice. The longing for a more realistic portrayal of life to oust the hyperbolic emphases of romanticism signaled theatre's turning inward, simultaneously breeding manifold administrative demands, which rendered the role of director-producer necessary. Undertaking these responsibilities, Duke Georg diligently laid out the foundations of a viable modern theatre practice. Having put together a robust ensemble, he insisted on long periods of rehearsals and demanded that the actors work with sets, costumes, and properties from the very beginning of the rehearsals. To some extent, he explored the ideal circumstance for the production proces, which today seem possible only in financially healthy, state-subsidized theatres and opera houses, where set designers are asked to deliver a complete model of the set long before rehearsals with actors actually begin.

All in all, the time seemed ripe for several divergent artistic movements and trends to flourish in the theatres of Europe. The fin-de-siècle genesis of the new stagecraft came as a reaction against the scenic practices of traditional European theatre, such as naturalistic scenery, which was frequently manifested in the excessive clutter of archaeologically "authentic" detail. Many late-nineteenth-/early-twentieth-century pioneers, such as Craig, Constantin Stanislavski, André Antoine, Jacques Copeau, Vsevolod Meyerhold, and Max Reinhardt proposed a new staging style of austerity and suggestion (which would also extend to the acting), thus putting their

stamp on the freshly established practice of mise-en-scène and contributing valuable insight vis-à-vis the inspired exploitation of its compositional languages. Eventually, new techniques were developed and groundbreaking theatrical devices invented to serve the appetite of an increasingly cultivated audience.

In 1896, Alfred Jarry (1873–1907) mounted *Ubu Roi* at the Théâtre de l'Oeuvre in Paris in what was to become a landmark production. Jarry dared to put on stage the "full implications of an irrational and destructive existence" (Braun 1982, 57), setting the model of a liberated theatre celebrating aesthetic autonomy. He attacked the complacent bourgeois audience of his time and used every means available to shatter all sense of scenic illusion, bringing anarchic and clownish elements into performance and striving to restore to the theatre a "license to confront the world with its own brutishness" (52). Specifically, Jarry and his actors deployed lines, characters, settings, and music to build within the performance a truly authentic event. The purpose was to bring stage and audience together in direct confrontation, rather than to reenact, as the theatre of illusion repeatedly did, a situation presumed to have occurred in some other place or some other time (56). Ecstatic at the shocking effect of *Ubu*, Jarry, after the opening performance, enthusiastically took credit for the tremendous controversy that the production had stimulated:

> It was intended that when the curtain went up the scene should confront the public like the exaggerating mirror in the stories of Madame Leprince de Beaumont, in which the depraved saw themselves with dragons' bodies, or bulls' horns, or whatever corresponded to their particular vice. It is not surprising that the public should have been aghast at the sight of its ignoble other self, which it has never before been shown completely. (Quoted in Braun 1982, 52)

Jarry's influence on the next generations of avant-garde artists was colossal: not only would *Ubu* provide the groundwork for Brecht's theory of alienation but some of the techniques widely employed in the play—the distorted and staccato delivery of lines, the exaggerated use of masks, the ultra-grotesque characterization, and stylized movement—also pointed to a future style of acting and directing unfettered by the constraints of realism. Breaking most rules of theatrical representation, Jarry became the official father of the fin-de-siècle avant-garde movement as well as the adopted father of the surrealists, symbolists, Dadaists, and absurdists; his influence extends well into to the more recent generations of auteurs.

Within this vortex of changes in theatrical form, French poet, painter, and director Antonin Artaud (1896–1948) duly followed course, examining the function of theatre and underlining the necessity for profound changes

in the mise-en-scène. His theory of a revised stage, the "Theatre of Cruelty," and of the director's reconsidered role were expounded in his collection of manifesto essays, *The Theatre and its Double* [*TD*], published in 1938. Writing in a time of doubt and despair, Artaud stressed the importance of a priestly figure, of a director-*creator* who was prepared to assume the role of a shaman in order to reconstitute theatre's lost spirituality in the people's minds and everyday lives. Comparable in scope to Jarry's heretical rethinking of the stage, Artaud's theories were monumental in establishing a long line of directors-gurus such as Peter Brook, Jerzy Grotowski, and Eugenio Barba, among others, who, in the 1960s and 1970s, made it their mission to reattain theatre's (misplaced or relinquished) "holiness." In point of fact, Artaud's assumptions regarding the mise-en-scène were largely indebted to Craig, who had already introduced the radical notion of the stage director as creator. Determined to deconstruct the long-lasting hierarchy of playwright, director, and performer perpetuated in literary theatre, both Craig and Artaud conscientiously dismantled the role of the director as mere *explicator* of the dramatic text.

Already at the end of the nineteenth century, Europe had welcomed a new sensibility signaling the break with existing representational and narrational determinants—romanticism and melodrama in particular—in favor of a realistic or naturalistic rendition of reality. The sweeping changes in the social climate of that era, affected by the coming of the Industrial Revolution, were followed by a demand for realistic form and subject matter in the arts, facilitating the birth of new plays and an abundance of innovations in staging. Along these lines, the ostentatious acting style that had been dominating European stages in the eighteenth century was also severely questioned. The new directions in the arts were ardently supported by major writers of that period. As early as 1827, Victor Hugo (1802–1885) condemned the artifice of classicism, publishing a manifesto on realism in the preface of his play *Cromwell*, in which he advocated the imperative that art deal with the full picture of truth: "...that the ugly exists there beside the beautiful, the deformed next to the graceful, the grotesque on the reverse of the sublime, evil with good, darkness with light."[2] Significantly, Emile Zola's (1840–1902) writing anticipated the advent of naturalism, a movement that sought to portray the nitty-gritty details of life, dismissing surface depictions of reality.[3] Zola's partiality to naturalism, along with his denunciation of the inflated and empty acting of his contemporaries, facilitated the rise of the New Naturalists movement; its first exponent in the theatre was director André Antoine (1858–1943) with Théâtre Libre (formed in 1887). A true champion of naturalism, Antoine was preoccupied with the notion of the "fourth wall": plays should be rehearsed in a real room with four walls, without spectators worrying about the fourth wall, which will "later disappear

so as to enable the audience to see what is going on" (quoted in Roose-Evans 1991, 17). Antoine's fourth wall, the existence of which came to be forever identified with a predominantly realistic directing and acting style, would reinforce the empathetic bond between actor and spectator. Enveloping the auditorium in a world of utter illusion, the fourth wall was critiqued ferociously in the years to come by political activists such as Brecht, whose aspiration was to intellectually stimulate the audiences, rather than shower them with chimerical comforts.

The transition away from the grandiose and largely superficial productions of the past toward realism inevitably bore with it a desire for more authentic detail in staging. Both Antoine in Europe and David Belasco in America instantly adapted to the new demands, constructing striking naturalistic sets and cogently communicating the idea that "it is the environment that determines the movements of the characters, not the movements of the characters that determine the environment" (Antoine quoted in Innes 2000, 52). Under the direction of Constantin Stanislavski (1863–1938), Moscow Art Theatre (founded in 1898) was also concerned with how to apply the rules of New Realism on stage and the means to get actors to digest and work within those rules. The longing for a truthful portrayal of character, upheld by Zola, became for Stanislavski an everlasting obsession. His directing work at the Moscow Art Theatre was pioneering in giving prominence to the role and preparation of the actor, instead of merely administering the technical issues that a director-producer also faced. Admittedly, Stanislavski considered performance much more than a social event: it was an artistic experience and a journey into the human psyche. Ambitious to make his audiences' involvement more entrancing, Stanislavski built atmosphere in detail, paying special attention to the design of both sets and costumes. Contrary to what is broadly believed, Moscow Art Theatre's experiments in style were not exclusively realism-based. To some degree, despite his reputation of being a staunch advocate of the movement, Stanislavski also attempted to invoke mood and symbolist nuance (principles instigated by Craig) in his stagings. For instance, in the production of Knut Hamsun's *The Drama of Life* (1905), Stanislavski exploited the effect of shadow play, making use of backlighting to foreground the silhouettes of the spectators. Similarly, in Leonid Andreyev's *The Life of Man* (1907), the sensational black-velvet design was used to cover the whole stage, against which a set made of rope was built in a way that the outlines of doors and windows were suggested (Roose-Evans 1991, 19).

While realism continued to flourish, at the other end of the ideological and aesthetic spectrum, the proponents of symbolism would speculate on different functions of art, envisioning a quite distinct role for the theatre artist. Craig's theories were particularly popular; in truth, his prodigiously

symbolist vision rendered him the founder of non-illusionistic theatre, together with the Swiss lighting designer Adolphe Appia (1862–1928). Honoring their symbolist roots, and in defiance of the New Naturalists, the two aimed to rediscover the lyrical and (mostly) obscure aspects of life that lay hidden beneath pictorial realism. Like true symbolists, they were convinced that the pursuit of spirituality and the inner workings of the soul are sources of a profound truth much more superior to the truth derived from objective observation. Because truth is subjective, and therefore impossible to grasp with the five senses, it can never be expressed directly via tangible means, but can only be hinted at through a system of symbols that evoke feelings and states of mind. In this light, art can only be real if it has the potential to become transcendental. This notion prefigures Artaud's adulation of the "metaphysical mise-en-scène," which he considered the only viable alternative to "stale" representational theatre, because only if the theatre is reunited with the potentiality of different forms, sounds, gestures, and colors can it regain its "religious and metaphysical aspect" and be "reconciled" with the universe (Artaud, *TD*, 70). It is no accident that under the influence of both symbolism and naturalism, several diverging theories on the nature of art and the concepts of reality and truth came into view. For one thing, symbolism, pleading for trust in the subjective experience, instigated a reconsideration of the relationship between individual perception and the representation of outside life. The premise that this kind of liaison was no longer indispensable or a given in artistic creation progressively carved the way to the modernist movement, which endorsed a distinct emphasis on form over content. Pictorial exactitude in the depiction of recognizable subjects yielded power to innovation, imagination, and style, qualities that continue to define the work of the most innovative auteurs to date.

Stanislavski's experiments with mood and atmosphere at the Moscow Art Theatre reveal a fresh tendency to view design as one of the rudiments of the stage. As a matter of course, the extensive dialogues on the potential stage renditions of a text between Stanislavski and his designer, scenic artist Viktor Simov, established a trend of life-long consummate collaborations between directors and their design team, in which "technicalities" are overshadowed by visionary discussions on textual, acting, and mise-en-scène considerations. At the same time, perhaps more than any other theatre artist of his time, Craig exerted a profound impact on future stage designers. His contribution is inseparable from the introduction and adulation of abstract design and the idea of blending disparate scenic elements, such as set, costume, movement, and lighting, in ways that can produce a unified concept, whose function is to *transcend,* rather than represent reality. In effect, his assertion that "realism is only exposure whereas art is revelation" (quoted in Roose-Evans 1991, 45) was grounded on the understanding that theatre

was not an intellectual or literary event, but a primarily visual experience, appealing to the audience's senses. "I let my scenes grow out of not merely the play, but broad sweeps of thought which the play has conjured in me" (quoted in Innes 1983, 240), Craig insisted, leaving out of the performance equation the conventional elements of dramatic art, such as plot and character, as rather inconsequential. And while design increasingly became basic food for theatre, and the stage event opened up to the fusion of movement, rhythm, lighting, and music, the verbal text surrendered its long-revered position as the cardinal element of performance.[4]

Around the same time, Appia, in his 1895 study *Die Musik und die Inscenierung* (*Music and Stage Setting*), proposed his own reforms for the revival of scenic art. Earlier on, both Duke Georg and Antoine had experimented with the possibilities of lighting and shadow to generate mood and atmosphere, but Appia took lighting design several steps further. Musically trained, he was impressed by the compositions of Wagner and sought to evoke in his own work the subtle fluidity of music. First and foremost, rhythm, tone, and melody were to determine the production's setting and lighting as well as the actors' movement in and out of them:

> Light has an almost miraculous flexibility...it can create shadows, make them living, and spread the harmony of their vibrations in space just as music does. In light we possess a most powerful means of expression through space, if this space is placed in the service of the actor. (Appia, quoted in Huxley and Witts 2002, 29)

Like Craig, Appia valued a theatre of atmosphere, rather than of appearance, and conceived of stage environments featuring visual scores, which would be fully realized only in the minds of the spectator. Abstract simplicity was crucial: quite in line with Craig's set designs, notorious for their rostra, columns, steps, and ramps, Appia's lighting was also environmental and architectural, embracing and structuring the three-dimensionality of space. Quite justifiably, his ideas on lighting design have been known to help formulate an awareness that lighting defines, reveals, and highlights the emotional mood of a scene from moment to moment. In such manner, his, as well as Craig's, influence on contemporary theatre artists is prodigious. Some of today's most acknowledged designers and auteurs work mostly on mood and suggestion, rather than on description and illustration. Similarly, lighting in contemporary auteur performance serves as a constitutional tool, and instead of *presenting*, it often *embodies* characters in a play. As a result, quite a few of the most visionary directors to date have depended upon the ever-increasing technical possibilities of lighting to model visually ravishing landscapes; in doing so, they value design as a stage language

that often carries the same weight as verbal text. Over the years, the relationships that develop between directors and designers have been indicative of the emphasis placed on design. Brook's view of the director-designer relationship in *The Empty Space* (1968) is telling: "The earliest relationship is director/subject/designer.... The best designer evolves step by step with the director, going back, changing, scrapping, as a conception of the whole gradually takes form" (113–4).

The innovations in stage machinery at the beginning of the twentieth century helped directors shape impressive spectacles and satisfy their audiences with startling stage effects. In Germany, the Austrian Max Reinhardt (1873–1943), artistic director of the Deutsches Theatre, certainly took note of the aesthetic of both Craig and Appia, introducing three-dimensional sets in his work. Particularly attentive to elaborate design principles, his productions were celebrated for their epic-scale, sensational sets, advanced stage machinery, lighting, and colors. Working in detail, Reinhardt transformed stage technology and developed an impressive eclectic style by borrowing from several other traditions. His proclivity for incomplete plays allowed him to treat the text as a pretext for his imposing events, which he would ordinarily infuse with effects of his own devising.

In current auteur work, "spectacle," translated as visual perfection, plays a more prominent role than ever. However, criticism is ruthless in those cases where directors try to make up for dramaturgical and directorial inadequacies by resorting to sensational effect. Most of the times, heavily image-saturated performances are criticized for treating the verbal text merely as an excuse, a convenient cover-up of gratuitous forms and visual ploys. We will discuss in detail the dangers of formalism. For now, it may be interesting to view this tendency in contradistinction with the prevailing notions locked within the origins of Western drama and especially in reference to Aristotle's utter rejection of spectacle, which he considered to be the least important among the elements of tragedy, treasuring plot (action) as the most essential of theatre, instead. Yet, in defiance to Aristotle's categorical attitude "against performance," audiences have always appreciated the generous provision of visual entertainment, especially when it hinges on fresh theatrical conventions. One valuable outcome of the innovations in stage design and technology in the early twentieth century was the reconsideration of theatrical spaces. Appia would urge his contemporaries to leave their theatres to their "dying past" (quoted in Roose-Evans 1991, 51) and construct buildings designed to cover the space in which they work:

> We shall arrive, eventually, at what will simply be called the *House*: a sort of cathedral of the future, which in a vast, open and changeable space will welcome the most varied expressions of our social and artistic life, and will be

the ideal place for dramatic art to flourish, *with or without spectators.* (Appia 1993, 115)

Reinhardt was especially drawn to unusual spaces wherein to host his epic-scale events. Quite regularly, he chose to stage them in unorthodox, non-theatrical places such as cathedrals, squares, streets, and even entire villages, as was the case with his production of *Faust,* set on a mountainside in Salzburg and, more remarkably, with Hofmannsthal's *Everyman* (1927), in which he managed to involve the population of a whole town, setting the action in the cathedral square of Salzburg and placing actors on the towers of churches throughout the town, having them calling the name of Everyman (Roose-Evans 1991, 65). Still, the need to reconsider theatre spaces was more "officially" articulated by Artaud, who argued in 1921 that dramatic art was the art of life that could be expressed without major theatre machinery, sets, and buildings, since time and space were enough.[5] Other directors in the early twentieth century also experimented with unusual spaces and stage configurations, reflecting the increased level of intimacy in the audience-stage relationship. One of them, Nikolay Okhlopkov (1900–1967), a disciple of Meyerhold, would strip the stage and all seating from the theatre, placing spectators right in the middle of the action. Okhlopkov's radical gesture was, in the 1970s, taken up by Brook, who conducted similar experiments with space in his Théâtre des Bouffes du Nord in Paris. In the same decade, Ariane Mnouchkine's production of *1789* displayed a circle of stages surrounding the audience, which sat in the middle. A few years prior to Mnouchkine's production, in 1966, Luca Ronconi—whose work has been clearly indebted to Reinhardt—tackled space issues spectacularly in Ariosto's *Orlando Furioso*: during performance, the audience was made to follow the actors and be exposed to selected fragmentary scenes from the play, unable to see the whole picture. Ronconi has been concerned with manipulating theatre space ever since, consciously breaking away from realistic representation by effectively handling multiple stages and depicting with directorial coherence scenes that feature no clear logical progression.

In the fiery 1960s and 1970s, Richard Schechner of the Performance Group articulated the need for what he called "environmental theatre," the basic principle of which was to create and use "whole" spaces as well as to involve the "outside" (namely, the city) in the action, through the modalities of time and space. In making the nebulous frame of the "environment" a home for their productions, directors were attacking linear representation radically, for each spectator would have to be subjected to a different version of reality. Quite similar was the concept of *found space,*[6] which has been a recurrent feature in auteur work. British director Deborah Warner's site-specific productions, for example, fully exploit the dynamics of pre-

existing and mostly familiar spaces, to inculcate in her events additional shots of cultural reference. Notable works include the 1995 *St. Pancras Project,* a "haunting installation/walk through the Midland Grand Hotel" in London (Raymond 2003), *The Angel Project* (2003), a select guided tour of New York City and her memorable staging of T. S. Eliot's emblematic poem *The Wasteland* in various locations around the world, such as an armory in Dublin, an abandoned brewery in Toronto, and an underused cinema in Montreal.[7] Directors such as Warner are always on the lookout for intriguing—frequently off the map—spaces to house and nurture their experiential adventures, resisting the conveniences of the proscenium arch, which continues for the most part to be associated with realism-based performance. Nonetheless, in our days, the term "sight-specific" seems to have stretched a little too far, to include any theatre that stands in opposition to the "main-stream," by virtue of the fact that it refuses to be staged in an actual theatre.[8]

Back in the early twentieth century's mélange of artistic and socio-ideological directions, two very distinct tendencies prevailed: on the one hand, there was Antoine's and Stanislavski's devotion to realism, also fortified by the social circumstances of the era; at the antipodes, one sensed a growing attachment to a precocious type of formalism, as expressed by Meyerhold, Craig, and Appia. An unapologetic apostle of form, anxious to create a kinetic experience for the audiences and fully contesting the emotional character of acting, Craig had anticipated Russian director Vsevolod Meyerhold's (1874–1940) conviction that theatre could appeal to feelings only through movement. Craig's view of performance was closer to what we currently term "dance theatre"; in fact, he should also be credited for his immense influence on modern dance, which is still largely fashioned after what he had originally envisaged as "correlated movements of sounds, light and moving masses" (quoted in Roose-Evans 1991, 41). Craig's collaboration with dancer Isadora Duncan was only a token of his fascination with the new varieties of expressive physicality that were rapidly taking over the stage. In this respect, his rebellion against realistic representation was by no means limited to scenic design: for him the performers' structured and controlled movement was fundamental, while the portentous artificiality that characterized the prevailing acting styles of the past was ultimately a source of a more general mistrust for the actor:

> Do away with the real tree, do away with the reality of delivery, do away with the reality of action and you tend towards the doing away with the actor. Do away with the actor and you do away with the means by which a debased stage realism is produced and flourishes; no longer would there be a living figure to confuse us into connecting actuality and art. (Craig quoted in Huxley and Witts 2002, 159)

Craig's defiance of the rhetorical acting popular at the Comédie Française paved the way to both Copeau's and Artaud's kindred polemic a few years later. Beyond any doubt, pompous acting had been a trademark of the eighteenth century European tradition, outshined by words and a blind reverence to the playwright. Scandalously against actors, Craig maintained in his seminal essay "The actor and the Über-marionette" (1907) that the most beautiful form of acting can only be achieved through the controlled movement of a marionette:

> May we not look forward with hope to that day which shall bring back to us once more the figure, or symbolic creature, made also by the cunning of the artist, so that we can gain once more the 'noble artificiality' which the old writer speaks of?... To that end we must study to remake these images no longer content with a puppet, we must create an über-marionette. The über-marionette will not compete with life—rather it will go beyond it. Its ideal will not be the flesh and blood but rather the body in trance—it will aim to clothe itself with a death-like beauty while exhaling a living spirit. (40)

It is questionable how successful Craig's theories on acting would have been, had they ever been put into practice, betraying as they did, a guileless conceptualism mostly inapplicable on the stage. Ironically, although Craig shared Reinhardt's emphasis on "mechanics" and the catholic use of the actor's body, the latter's experiments in controlled acting were much more effective. Reinhardt's company was perhaps the only troupe in Europe that proved itself able to realize most of those pioneers' theatrical vision. In reality, his actors shared some of the qualities embodied in Craig's ideal über-marionette, having been trained to take direction "almost as if they were puppets, controlling every movement and gesture, the slightest change in intonation" (Innes 1983, 110) and subordinating their personalities to the director's rudimentary precepts.

Inevitably, the plethora of styles in the emerging theatre of the twentieth century, together with the constant demand for formal innovation, stimulated discussion on whether form actually precedes content or vice versa, a question which to date remains very much part of the agenda in auteur practice. In many ways, the yearning to shatter the artifice of the existing stiflingly verisimilar performances united artists of very diverse backgrounds and aesthetics, such as Meyerhold, Alexander Tairov, Okhlopkov, and Yevgeny Vakhtangov. Meyerhold's rejection of realism led to experiments in grotesque representation, which in themselves required more stylized techniques. In actuality, he perfected a kind of stage idiom that meshed his own recognizable amply-practiced forms and foresaw the performances of several late-twentieth-century auteurs; particularly, of those, whose work

pivoted around a heightened language and in which realism, whether in act-
ing, design, or storytelling, was systematically shied away from. Meyerhold's
conviction that "when in the art of the grotesque form triumphs over con-
tent, then the soul of the grotesque and the soul of the theatre will be one,"
went alongside the celebration of the "fantastic," which could then "exist
in its own right on the stage," together with the "'joie de vivre'"... "redis-
covered in the tragic as well as in the comic" (quoted in Braun 1982, 142).
Meyerhold's declarations on the supremacy of form and physicality over plot
and characterization eliminated psychology-informed concerns and posi-
tioned him against Stanislavski and the life-long search for inner truth in
acting.[9] Meyerhold was adamant about those two things that were "essential
for a play's production," namely, discovering "the thought of the author"
and subsequently revealing that thought in a "theatrical form." He aptly
named his aesthetic a "jeu de théâtre" (a "game of theatre") and proposed to
structure performance around it (Roose-Evans 1991, 21). Further novel con-
tributions to the stage included the broad use of circus, mime, and music-
hall techniques. In fact, in considering mime as superior to words and in
trusting that theatre had to disentangle itself from literature, Meyerhold also
foreshadowed Artaud's condemnation of the written text as exclusive carrier
of meaning.[10] In his 1912 groundbreaking essay "The Fairground Booth,"
Meyerhold underlined the primacy of pantomime over words and articu-
lated the importance of reviving primordial elements of the theatre, such
as mask, gesture, and movement. In this, too, he was not alone. Craig had
already theorized the need for the theatre to reattain the formalist stylization
of the classical Greek stage, where the choreographed presence of actors was
especially pronounced. Despite the fact that Meyerhold was one of the keen-
est supporters of symbolism, his search for new theatre forms took him back
to the acting tradition of Commedia dell'arte, prompting him to rework its
principles in a modern context. More importantly, wishing to develop an
ensemble company whose members would be proficient as athletes/acrobats
and even animated machines, he formulated *Biomechanics* in the 1920s, a
system of rigorous training designed to prepare actors to operate efficiently
within his multifunctional constructivist sets.

Meyerhold's goal was to help the actor acquire emotional discipline and
muscular response in order to be able to convey a sense of "truth" to the audi-
ences. Whereas Stanislavski's system of "method acting" involved strategies
of stimulating the actors' memory and inner emotional process, Meyerhold
worked reversely, "from outside in": rehearsals would start with the group's
exploration of formal patterns and the setting up of a preliminary physi-
cal score, which actors would then improvise and expand on. In essence,
those procedures suggested that psychology was directly related to physical
response as well as systematized movements and gestures and, therefore,

emotive states could be portrayed corporeally. Meyerhold's technique, based on the idea that the essence of human relationships was not limited to verbal manifestations, to some degree safeguarded theatre against the dangers of "emotionalizing." Similarly, his conviction, that because movement precedes emotion, actors, through practice, can assume gestures that can allow feelings to emerge automatically, helped him form an inventory of gestures and movements for each emotion that the actor could assume according to the needs of specific scenes: physical patterns were to be precisely calculated to admit "no accidents" and ensure the actors' ability to command themselves on stage. The plea for consistency in acting went even further back to the eighteenth century, with French philosopher Denis Diderot's (1713–1784) famous treatise "Paradoxe sur le comédien" ("Paradox of Acting"), published in 1830. Diderot religiously defended actors' controlled, as opposed to emotional (and therefore unreliable), performance:

> In my view he [the actor] must have penetration and no sensibility; the art of mimicking everything, or, which comes to the same thing, the same aptitude for every sort of character and part.... The extravagant creature who loses his self-control has no hold on us; this is gained by the man who is self-controlled. The great poets, especially the great dramatic poets, keep a keen watch on what is going on, both in the physical and the moral world.[11]

Developed with the view to getting actors ready to meet the formal requirements of his elaborate blocking, the system of *Biomechanics* had a remarkable influence on modern dance and physical theatre in the years following Meyerhold's directing practice. The assiduous, almost spiritual cultivation of the body, adopted by Artaud in "An Affective Athleticism" (1935), found a different expression in Samuel Beckett's treatment of the actors' bodies as fragmentable and machine-controllable. For many directors particularly in the latter part of the twentieth century, choreography—the sophisticated handling of the company's physical life—became a primary element of form. The understanding that in shaping or exposing the characters' inner life, movement is often a more appropriate and immediate medium than verbal language, has been shared by formalist auteurs, like Robert Wilson, Elizabeth LeCompte, and Anne Bogart.[12]

All that said, despite the emergence and appeal of increasingly "aestheticized" performances propounded by Craig, Appia, and Meyerhold, the times following World War I started to require of the theatre quite a different function: art's calling became the undertaking of a more social role in order to reflect the sweeping changes in the ideological and economic circumstances of the troubled era that had just dawned. In 1913 Paris, Jacques Copeau (1879–1949), a former drama critic, founded the Théâtre du Vieux

Colombier, initiating his audiences into a repertory based on the classics, which nonetheless served to provide a commentary on contemporary life. Copeau pursued a simplicity and selective elegance that he applied to both directing and acting, congruous to his desire to eliminate "theatrical elements" from his work. His zealous championing of "a bare stage for a new play,"[13] was subsequently taken up and shaped into an aesthetic credo in *The Empty Space* (1968), Brook's theory of the stage. At the same time, even though Copeau believed in the text, its rhythms and sounds, he favored theatre's communal function: the stage was a medium which could by definition bring people together, but to do so it had to rely on the guidance of an enlightened director-guru acting as a spiritual guide. Intent on putting his theories to actual practice, he formed a school of actor training largely based on physical theatre, with the view to developing the same principles of an organic as well as holistic theatre, which were to influence the work of Grotowski, Brook, and Barba from the 1960s onward.[14]

Serving the same purpose of restoring for the people theatre's lost sense of community, Erwin Piscator (1893–1966), an advocate of art's social function, advanced in the 1920s what he called *epic theatre*. Anxious to awaken society to face the social and ideological clamor of the time, he devised a method of episodic representation (at once embraced and perfected by Brecht), which thoroughly undermined the residue of illusions in the spectator, trying to register reality as convincingly as possible. Being a precocious multimedia artist, Piscator was the first director to introduce film into live performance. In point of fact, he became the founder of documentary theatre, seeking to effectuate the stage's social purpose by giving the work authenticity and remaining concentrated on the audience's critical processing of factual information. In mounting mostly expressionist productions at the Volksbühne in Berlin, he used technology and improved production techniques that included scene titles, photo-montage, photo projections, and split-level stage on revolve,[15] insisting that because the main function of his "theatre of search" was to instruct, social messages would be better communicated through a form implementing as much of an accurate depiction of reality as would ever be possible. Rooted in Piscator's theatre, auteur work today addresses current social affairs by means of advanced theatre technology, including sophisticated multimedia equipment. For instance, the revisionist and hugely political interpretations of Greek tragedies by American director Peter Sellars are by and large filtered and effected through state-of-the art monitors and digital applications.

Significantly, in the 1930s, Brecht established his own version of epic theatre—modeled after Piscator's theories—which was to radically change the face of directing and acting as well as the notions of presentation and representation thereafter. His drama was a form of sociology in practice, the

purpose of which was to teach us how to resist and to survive. Because the truth was "concrete" and as such not subjected to psychological implications, it was necessary that the audience's reaction to the spectacle be *critical* rather than empathetic. In the more recent theatre scholarship, Brecht's objectivist view of art has been questioned; in fact, as a playwright, he has also been broadly appropriated by postmodernism, partially because of his nonconformist formal innovations as well as his aversion to conventional narrative flow.[16] As Elizabeth Wright argues in her analysis of the postmodern elements in early Brecht' plays such as *Baal* (1922) and *The Jungle of the Cities* (1923):

> In this other Brecht of the early plays... the performative mode appears instead of the denotive mode of the later plays, with the result that accidental meaning subverts any didactic intention....In these plays there is no appeal to the audience to solve the contradictions outside the deliberately unfinished work. The work of the plays is on language, with the effect that the characters are not self-present but continually constitute themselves via an other. (1988, 97)

While new perspectives are being called for in evaluation of Brecht's alleged assimilation into postmodernism and despite the fact that we can neither fully ignore nor whole-heartedly accept the validity of his limitless faith in objective truth—any more than we can painlessly sum-up or resolve notions of "survival" in today's art-satiated world—the axiomatic split between the social and the aesthetic function of art remains. Brecht's industrious dedication to *Verfremdung* (*Alienation Effect*) in his productions invariably intended to eliminate spectators' soporific repose vis-à-vis spectacles customarily steeped in make-believe. On that account, he also revolted against the conventions of realistic theatre, and in particular, the legendary "fourth wall," which was conceived as a shelter to the actors, protecting them within an area largely off-limits to the audience. Through and through, Brecht abolished the formerly revered barrier, transgressing all boundaries between reality and fiction, presence and mimesis, and in doing so, rendered the identification between audience and stage action and character virtually impossible. Clearly, illusionistic drama had been for centuries tied to an exigently teleological narrative, dramaturgically manifest in the Aristotelian faith in a universe ruled by divine justice. The symbolic death of *telos* both as redemptive *end* and as *purpose* in the post–World War I era signals the sudden departure away from the mimetic space of recycled fantasies, associated with realism, toward less linear narrative forms in the theatre and in the arts, in general.

As directing and acting styles were relentlessly put into trial, so was the audience-stage relationship constantly re-examined and redefined. The desire

was common in many directors to bring audiences closer to the event of their plays. Breaking down the barrier between the stage and the auditorium, Meyerhold, for one thing, had infinite trust in the spectator's use of imagination, claiming that "the audience is made to see what we want them to see" (Roose-Evans 1991, 25), while Reinhardt struggled to recapture the fusion of actor-spectator and resurrect the ancient Greek ideal of theatre containing modern life. Ultimately, although most of the ambitions to achieve such sublime union failed, the artists' search had been in earnest. The inflammatory conviction that the theatre is an intrinsic human need reached its peak with Nikolai Evreinov, who had succeeded Meyerhold as director of the Vera Komisarjevskaya Theatre in Moscow. Already in 1908, Evreinov insisted that "theatre is a basic organic urge like hunger or sex" (quoted in Roose-Evans 1991, 26), a thought also fostered by Brook, especially in the 1970s.

For the theatre to reach out to a broad audience and leave a meaningful and lasting mark, early experimentalists looked for ways to restore it to its primordial festive roots. The aspiration to emancipate art by bringing it "down" to the people was quite visible in Copeau, who often urged his contemporaries to "leave literature and create a fraternity of players... living, working, playing together,... creating together, inventing together their games, drawing them from themselves and from others" (87). On a similar track, during his time at the Berliner Ensemble, Brecht often rewrote his plays in rehearsal, together with his long-term collaborators.[17] Significantly, in the course of the play's [re]composition, no final version of one script existed: it was free-standing and provisional, an "encounter" as well as an experiment. The preliminary and un-fixed quality of the text, frequently arranged from anecdotes taken out of the company's personal experiences, made it easier for the members of the group to bond creatively, sharing personal history and ideas and working together toward common pursuits, as was in effect the "writing" of the production script. Instigated by Brecht, ensemble acting became extremely popular especially in the 1960s, with The Living Theatre, The Open Theatre, The Bread and Puppet Theatre, and The Performance Group, to name but some of the most established theatre groups, blossoming in the United States. Almost two decades later, in the 1980s, ensemble companies started to provide a welcoming environment to the practitioners of devised theatre, procuring the means for extensive discussions among the company's members, judicious fieldwork, improvisations, and interviews with people from specific target groups. Facets of such practice can surely be traced in the work methods of Bogart's SITI Company, LeCompte's Wooster Group, and Simon McBurney's Complicité. Along with that, it may be worth noting that as a result of such circumstances conducive to ensemble work, the relative novel trend of "playwrights in residence" has become increasingly popular, with many production companies investing in new writing, especially

in the United Kingdom, Central Europe, or North America. Established as well as younger generation playwrights are commissioned to develop new scripts in collaboration with the director and the actors of the group, often with spectacular results. Among such viable examples, we should definitely include the explosive encounters of postmodern playwright Charles Mee with choreographer-director Martha Clarke, and cutting-edge New York–based auteurs Bogart, Robert Woodruff, and Tina Lindau.[18]

Theatre's communal spirit, tracked down to Brecht's Berliner Ensemble, manifests the perpetual need for performance to reattain its origins of festival, divested, however, of all religious nuances and enriched by an awareness of art's social function. In the New York based Living Theatre (founded in 1947 by Julian Beck and Judith Malina), artists all worked and lived under the same roof; similarly, in the outskirts of Paris, Mnouchkine's Théâtre du Soleil (formed in 1964) has since the 1970s operated as a creative commune, reshaping and presenting myths and stories through the filter of a contemporary eye and with a view to demystifying their traditional significance as imposed by canonical literature. No doubt, the work of the Théâtre du Soleil can be viewed in terms of a "kind of political theatre which seeks to advance the role of theatre through awakening the audience to the conditions of their existence and the possibilities of change" (Roose-Evans 1991, 88). Through research, improvisation, and experimentation with a range of theatrical idioms, the company's pursuit is to "take some trivial happening and make it concrete, bring it to life, not merely do a play about the opinion we hold on some political problem," as Mnouchkine once claimed in an interview (quoted in Roose-Evans, 88). For example, in the renowned production of *1789*, the reinterpretation of the French Revolution was done from the point-of-view of the common French people, adding a fascinating twist to the received interpretation of history.

Correspondingly, in his theoretical and methodological analysis *The Theatre of the Oppressed* (put together in the early 1970s), the late Brazilian director, activist, and innovator of post-Brechtian political theatre, Augusto Boal, undertook the task of undoing the audience-actor split by proposing the dynamic interaction of actors and spectators. The concept of the *spect-actor* became a dominant force within Boal's later Forum Theatre work, in which the empowered audience was encouraged to not only imagine change but also to gradually, upon communal reflection, generate social action.[19] In the line of political thinkers such as Brecht, Mnouchkine, and Boal, other theatre directors have tried to "institutionalize" the explosive coexistence of artists and the circulation of thoughts that can develop into ideas and gradually, under ripe conditions, into coherent and resonant works. In more recent years, theatre companies regularly organize creative retreats of hard work and introspection in the hopes that during a certain period of

gestation, brainstormed abstractions will eventually be shaped into narratives and finally into performable scripts.

More than anything else, the split between the perception of theatre as a decidedly intellectual affair and the celebration of its intuitive nature was ingrained in the reconsidered role of verbal language within the dramatic text. Craig and, more conspicuously so, Artaud some years later, disputed the supremacy of the word, locating the true origins of the theatre in dance and mime. Even though Craig did not utterly eliminate text, his sympathies lay with unfinished plays that left directors room for guilt-free visionary encounters:

> When no further addition can be made so as to better a work of art, it can be spoken of as "finished", it is complete. Hamlet was finished -was complete- when Shakespeare wrote the last word of his blank verse and for us to add to it by gesture, scene, costume, or dance, is to hint that it is incomplete and needs these additions. (Craig quoted in Walton 1991, 55)

Similarly, in *The Empty Space* Brook referred to the three main elements of theatre, space, actor, and audience, omitting the need for a text: "A man walks across this empty space whilst someone else is watching him, and this is all that is needed for an act of theatre to be engaged" (20). In an attempt to sum up the nature of the debate between the literary (dramatic) and the "physical" (performative) nature of theatre, Roose-Evans highlights the point of contention, discussing the "undeclared war between the intellectual and the intuitive," both of which fear each other. He argues that "the intellectual clings to the concept of a literary theatre because he regards words as man's highest achievement" and wonders if there is any space for music, painting, dance, and sculpture within this approach. Probing into this debate further, Roose-Evans quotes Swiss psychoanalyst and philosopher Carl Jung's theory of the unconscious:

> Without our knowledge, the life of the unconscious is also going on within us. The more the critical reason dominates, the more impoverished life becomes; but the more of the unconscious, and the more of myths we are capable of making conscious, the more of life we integrate. (Jung quoted in Roose-Evans 1991, 87)

Jung's observations draw on Friedrich Nietzsche's emblematic distinction between the instinctual and the rational components of the self, according to which, in the domain of art the Dionysian spirit, almost uncontrollable in urges, is pitted against the cerebral, sensible Apollo:

> Dionysiac art, too, wishes to convince us of the eternal delight of existence. It makes us realize that everything that is generated must be prepared to face

its painful dissolution. It forces us to gaze into the horror of individual exis-
tence, yet without being turned to stone by the vision: a metaphysical solace
momentarily lifts us above the whirl of shifting phenomena... now we see the
struggle, the pain, the destruction of appearances as necessary, because of the
constant proliferation of forms pushing into life, because of the extravagant
fecundity of the world will. (Nietzsche 1990, 102)

Almost certainly, the ideological foundations of the battle against theatre's
literaturalization were first laid out by Artaud, who insisted on the preva-
lence of the "poetry of senses" over the "poetry of language," identifying its
concrete physical power in its ability to express thoughts that were beyond
the reach of the spoken language (*TD*, 37) and trusting that metaphor, imag-
ery and allegory contained the kernels of "true expression," much more than
lucid speech, since "all true feeling is in reality untranslatable. To express it
is to betray it" (71). Ironically, long after Artaud's time, the conflict between
intellect and instinct, which Artaud lavishly theorized, still continues to
invariably haunt directing practice.

II. Bequests

Pondering on the playwright-director relationship through the ages, we
ought to recognize that its codes had remained more or less undisturbed
from the classical times up until the Elizabethan Age. The writer ordinar-
ily being the director of the play, production was congenially regulated by
the same person, whether that was Aeschylus or Shakespeare; no doubt,
an ideal state of self-collaboration, which was also distinctly celebrated
by Artaud. In the post-Elizabethan era, however, adaptations of existing
plays became standard practice. Directors-producers often tampered with
"unacceptable" scripts, modifying the scenery and altering the flow of the
plot in order to produce more digestible spectacles. Gradually, in the late
nineteenth century, directors triumphed in their role as authors of the
theatre text, exploring the possibilities of an ever-growing array of sce-
nic languages available to them. As Pavis illustrates, the recognition and
appreciation of the director's function toward the end of the nineteenth
century altogether transformed the landscape of modern theatre. For one
thing, it was acknowledged that a director was "capable (or culpable) of
marking a text produced on stage with the stamp of a personal vision."
This is why, Pavis believes, "for the theatre of mise-en-scène it is quite
logical to focus analysis on the performance as a whole, rather than consid-
ering the latter to be something derived exclusively from the text"; in this
respect, he diagnoses the changes that have been taking place within fifty
years as "a shift from one extreme to the other: from philology to scenol-
ogy" (Pavis 2003, 198).

Once again, Meyerhold was among the first directors to dismiss the role of the playwright in the making of performance, boasting of having removed the author as far as possible from the theatre, declaring, as *New York Times* columnist Frank Rich—who quotes him—reminds us, that: "the playwright always interferes with the true director-artist" (1985). Ironically, some time later, when referring to his collaboration with Stanislavski, Meyerhold modified his original condemnation of the author, speaking rather of two systems that complete each other. In any case, his precocious observations regarding the tension involved in the collaboration between directors and playwrights resurface in the work of twenty-first-century directors-auteurs. Surely, playwright and director roles competed for authorial control of text and meaning from as early as the 1900s, with Copeau on the one hand insisting that directors were but translators, who must render the playwright's intention precisely, and on the other, "raving" against directors who felt tempted to "conceal the playwright's lack of skill" using their own "technical resources." In the process of staging "certain masterpieces," which are "said to be unplayable," directors, according to Copeau, may lose patience and start entertaining ideas of "revising them or removing the difficulties in them." His caution makes him issue a warning against those who dare proceed "boldly up to the very source of creation" and convince themselves that they can "shape the entire process" (quoted in Huxley and Witts 2002, 155). Copeau's declaration of war on directors, which three decades later would be totally dismantled by Artaud and thereafter by his followers, was only a small sample of the (latent) animosity that has forever disturbed the rapport between directors and playwrights. Copeau actually went as far as to wish "for a dramatist who replaces or eliminates the director, and personally takes over the directing" by substituting "professional directors who *pretend* to be dramatists":

> ...But since we lack great dramatists who stage their own plays personally and with authority, the great director shows his mettle only when he confronts a written master-piece, particularly when that masterpiece is considered unplayable. Because he believes in it, he understands it; and because he has insight and respects it, he wrests its secret from it. (155)

And yet, induced by Artaud's theories on the new mise-en-scène, the sweeping changes in the perception of art as a whole in the 1960s and 1970s resulted in a profound reconsideration of the role of the dramatic text in the theatre and, subsequently, that of the director as creator of the theatre text and author of performance. In 1964, French actor and director Roger Planchon would speak of an "écriture scénique" ("scenic writing"), manifest in a wide range of spectacles with a strong visual and physical emphasis. At the same time, the 1970s marked the declaration of the "death of

the author," encouraging the mise-en-scène to exist as an open, text-free property, entirely determined by the director. In this perspective, the intricate task of engineering the theatre event was thought to be more viably served by the director-*auteur,* who had somehow secured the right to treat the playwright's text merely as a scenario fleshing itself out only in performance. The tendency to view the playwright as redundant became particularly dominant in the 1980s, a decade during which the institutional glorification of the auteur also coincided with the emergence of the theatre of images; developed by visually-minded artists such as Wilson, LeCompte, Clarke, and Sellars in the United States, or Tadeusz Kantor, Mnouchkine, and McBurney in Europe, visual formalism, substituting images for words in the syntax of performance, has been a rudimentary aesthetic and narrative frame to date.

It comes as no surprise that in the latter part of the twentieth century the literary text occupied a secondary position in theatre practice, considered just one among the many materials of the stage, rather than the primary locus of performance. With the performance script being built synthetically out of pieces of literature, history, bits and pieces of dialogue, improvisations, or media reports, the idea of *fragment* as a structural device for theatre also became very pronounced. Notwithstanding Pavis' axiomatic proclamation: "tout texte est théâtralisable, dès lors qu'on utilise sur scène" ("all text can be theatricalized as soon as it is used on the stage") (Pavis 1996, 353; my translation), the new directions in performance practice inevitably affected the kind of dramatic writing that would ensue in the late 1980s and the 1990s: dramatic texts became more theatricalized, incorporating the increasing demands of performance within the literary form. In this respect, one can never stress enough the massive influence of the early experimentalists in the repositioning of the linguistic sign within the totality of performance's signifying systems, as manifest in the revolutionary experiments in language and form of the fin-de-siècle "First Avant-Garde," Jarry's *Ubu Roi* (1896) providing a jarring alternative to the prevailing bourgeois narcissism. Following Jarry's steps in re-prioritizing the elements of theatre, Artaud provided the bedrock for the pioneering work of Schechner, Beck and Malina, Joseph Chaikin, and Robert Schumann in the "Second Avant-Garde" of the 1960s and 1970s. Around that time, Beckett's revolutionary integration of performance into the dramatic text, together with his involvement in issues of self-representation and mediation through technology, prepared the ground for further experiments in dramatic form, to the effect that the boundaries between playwriting and mise-en-scène as scenic writing became increasingly blurred.

Reception of the auteur-director's text, often the product of convergence of several art forms, such as film, the visual arts, dance, etcetera, has posed

additional challenges to spectators who had been for centuries trained in perceiving theatre as a mostly linear, logo-centric arrangement of plot incidents. Ever since the physical productions of the 1960s, the audiences of radical performance have been asked to understand and appreciate the new "frame" of the stage, which often includes new unconventional spaces as well. In many cases the spectators encounter difficulties in absorbing an image-based and multi-perspectival performance event. And yet, the stage imagism practiced by Wilson, Brook, Robert Lepage, Christoph Marthaler, or Sellars, had been long ago foreshadowed by Craig, Appia, Reinhardt and, of course, Artaud; they were the first to recognize, although not to fully put into practice, that to be trained away from literature and logos into the arts and the concept presupposes a willingness on the spectators' part to let go of their expectations of performance as mere "illustration of classic texts." Thanks to those directors' pioneering strategies in *educating* their audiences, it has become gradually less "painful" for spectators not only to "accept the "modern" set but also to refrain from subscribing to "a comprehensible fable (story), coherent meaning, cultural self-affirmation and touching theatre feelings" (Lehmann 2006, 31). This explains why, in contrast to what often appeared to be a lethargic encounter between spectators and the stage—a result of the ever-fixed relationship between signifier and signified—the most exciting and viable forms of auteur theatre occur when semiotic relationships are re-examined or disrupted. Without any doubt, the defiance of conformity should be credited to Jarry, Jean Cocteau, Meyerhold, and their followers. In the heart of auteur practice, where surprise lies, transformation replaces identification.

Inspiring the actual theatre practice of the above, Antonin Artaud's theories of the new mise-en-scène would significantly change the aesthetic of the theatre and firmly establish the stage director as "scenic writer," the *author* of the performance text. With his theory of the stage elaborated in *The Theatre and its Double,* Artaud planned the seeds for the experimental theatre movement that reached its highest peak in the 1960s and has remained active (even if transmuted or dispersed into different forms) ever since.

ENTER ARTAUD

I. BRILLIANT UTOPIAS

My aim is to liberate a certain theatrical reality which belongs exclusively to the stage, to the physical and organic domain of the stage. This reality must be liberated by means of spectacle, and therefore by *mise-en-scène* in the broadest sense of the word, that is, as the language of everything that can be put on the stage, rather than as the secondary reality of a script, the more or less active and objective means of expansion of the script. Here, therefore, the director becomes the author, that is, the creator. (Artaud *Selected Writings* [SW], 299)

In his writings, Antonin Artaud (1895–1948) vehemently dethroned those "reptiles of authors"[1] in order to establish the director as the new theatre authority. His astounding impact on later generations of auteurs has been associated with his innovative ideas in relation to the spiritual and holistic view of art, the cultural and anthropological interest in performance, the imagist and sensuous conception of the theatre event, the redefinition of the performance text, and, in the end, the emphasis on theatre as "process." Because of his influence, he has often been hailed as a shaman and a physician for culture, responsible not only for the total reinvention of the stage, but also for a radically changed conception of the arts. From the 1960s on, the avant-garde movement, fighting for the "reinvention" of theatre, eagerly took on his iconoclastic theories, making them a banner for artistic revolution, including the deconstruction of literary text and the redefinition of performance. Artaud's emphasis on the creative role of the director is inextricably linked to auteur practice. Clearly, his principles formulated a trend, an aesthetic that gave momentum and support to the work of prominent companies, especially those falling under the somewhat portentous, all-inclusive labels of "avant-garde," "underground," and "experimental."

Originally, it was the subversive ensembles of the 1960s and 1970s that rediscovered Artaud's writings, investing in his heartfelt outcry, "Theatre must be thrown back into life," and the anguished renouncement of literature in "no more masterpieces" (*The Theatre and its Double* [*TD*], 74). In the more recent times, acclaimed auteurs internationally, including Brook, Wilson, Mnouchkine, Tadashi Suzuki, and others, have invariably taken on Artaud's emphasis on the nonverbal aspects of theatre.

Artaud conceived of the world in binary oppositions. Throughout his life and in his extensive theoretical oeuvre (laid out in sixteen volumes), he struggled to reconcile the fundamental split between life and art, the body and the mind, factual reality and metaphysics. Deeply tormented, he often used his own experience of suffering as a metaphor for the malaise of art. Having experimented with hallucinatory drugs and institutionalized until his death, he worked as a writer and director with images of violence, danger, and madness, voicing the disturbing erosion that had been seeping into the theatre. In fact, he "was the catalytic agent for an entirely new drama that used the complex resources of the modern theatre to express the age-old cry of fear and protest, the most elemental human impulse from the most primitive man to the present" (Wellwarth 1964, 25–6). In addition, he tirelessly criticized the realists' and the naturalists' claim that the theatre should copy life, exposing what he considered the shallowness of psychological drama. More importantly, he dismissed the hegemony of literature over theatre as fatal and advocated the liberation of the stage from the written word, becoming one of the first writers-artists to explore the fluid boundaries between text and performance. In this light, even though his ideas were seldom tested within the four walls of a theatre (the total of his directing work was limited to the productions of a mere three full-length and four one-act plays),[2] the observations in *The Theatre and its Double* acted as a radical stimulus in the already changing climate in the arts of the 1920s and 1930s.

Expressed in elaborate, if occasionally delirious, metaphors, Artaud's theories implied that for the theatre to reattach itself to humanity and regain its lost vitality, new stage languages should be introduced or given stronger emphasis to address issues that can never really be expressed in ordinary discursive speech. Those languages needed to be physical and spatial (generated and consummated in the actor's body), as well as pre-thematic and primordial, based on signs that would be shared by all humans and guarantee universal impact. Attacking Western bourgeois culture at large, Artaud championed the necessity for an uncompromising mise-en-scène, bringing together actor and spectator in a mystical and shocking cohabitation. The perception of the world as a divided place tortured by violently contradictory forces led him to a systematic formulation of binary oppositions in the spectrum of art as well, which he ventured to bridge through a model for

theatre practice that "would continue to stir up shadows where life has never ceased to grope its way" (*TD*, 12). His writings evidence that he was always concerned with a wide array of systemic conflicts: between art and life, performance and poetry, Oriental force ("cruelty") and occidental complacency, myth and literature, sensory impact and intellectual understanding. He was also concerned with the clash between the image and the word, physical and psychological theatre, and, significantly, director and playwright. In fact, the originality of his theories lies in the pioneering reconsideration of the mise-en-scène and the revised role of the director as *author*—that is, as utmost creator of the stage event and writer of the performance text. Making strong claims, Artaud's writings were often quite extreme, to the point of instigating a cultural revolution. Among other things, they propounded that artists should find recourse in myth in order to remain in touch with divine forces. "We aim to do no less than return to the sources, human or inhuman, of the theatre, and raise it from the dead," he argued in his "Manifesto for a Theatre that Failed" (*SW*, 161). Bearing the potential to be purgative, unaffected by the corruptive filter of speech or the logically organized thought processes inflicted by Western philosophy and intellectual practice, theatre should exist on a prelogical and pre-thematic level.

Like the surrealists, Artaud trusted that a universal language articulated through the actors' bodies and communicated to the spectators' sense organs, could eventually reveal to the audience profound metaphysical truths that lay buried under several layers of academic reasoning. The theatre had to release hidden energies contained within all kinds of oppression and thus induce catharsis through delirium and emotional violence ("cruelty"). The plague metaphor was analogous: like the insidious, deadly condition, theatre should affect the spectator in an instinctual and devastating manner, carrying the potential to attack the body unexpectedly and with the same immediacy as the actual disease. Notwithstanding its fierceness, Artaud always considered theatre's nearly physical effect on spectators as truly beneficial, forcing them to practice introspection and, in this respect, causing "the mask to fall," revealing "the lie, the slackness, baseness, and hypocrisy of our world" (*TD*, 31). Manipulating the metaphor of the plague, he thoroughly undermined the idea of theatre as a meeting place for the chimerical illusions reproduced by quotidian speech. In Artaud's view, the stage should assume a metaphysical quality and "hurt" actors and spectators equally, by "touching life" and revealing to them the naked truth of existence. Once again, the main conceit he wishes to communicate, that of slaughter, is violent, as well as carnal, since the reflection of life on the stage produces an image of "carnage" and of dark forces inherent in all human beings (*TD*, 31). At the same time, the perennial themes of love, madness, and crime also require a stage that can be both broad and resilient enough to contain their magnitude; not

surprisingly, Artaud's holistic outlook sought refuge in archaic, Dionysian sources and this stress on primitivism is no accident: at the time when Artaud radically challenged what it meant to be civilized, the overriding question had been how to recalibrate the role of culture in general. People's spiritual rebirth and a sense of revised ethics in the arts were becoming the rule of the day; in that respect, the theatre was to retrace its steps back to its religious, ritualistic origins, shedding off all tangential elements obfuscating its moral, as well as aesthetic, function. Artaud put forward that myth should become the main ingredient of the new stage, untouched as it was by literature and containing truths that had remained pure, uncontaminated by the mediating hand of the author. It was essential for artists to transubstantiate myth into modern-day, yet entirely universal fables, using the power of images, whose comfort people have always resorted to. The urge toward a theatre of myth was fully endorsed by Brook, Mnouchkine and Theodoros Terzopoulos, who, for several decades have been delving into the vast resources of mythology in both Western and Eastern cultures, as notably in their productions of *Mahabharata* (1985), *Ik* (1975), and *Orghast* (1971); *Les Atrides* (1992) and *The terrible but unfinished story of Norodom Sihanouk, King of Cambodia* (1995); and *Bacchae* (1986), respectively. Significantly, Artaud's adulation of universal myth helped launch the major trend of interculturalism in modern theatre practice, which was more or less officially institutionalized in the 1970s by avant-garde directors-theorists Richard Schechner in New York and Eugenio Barba with the Odin Teatret in Denmark.[3]

Considering the plethora of experiments of established auteurs who manipulate the infinite possibilities of ancient (oral or written) traditions as a basis for their performance texts, we can only begin to grasp the iconoclastic implications of Artaud's theatre of myth, especially at the time he was writing. Aside from the changes brought forward by the "First Avant-Garde" in Europe, theatre was still being principally regarded as a more or less *eccentric* branch of literature, its textual core subjugated to the interpretative hand of playwrights, who, in their treatment of mythology, made sure to confine its chaotic intimations to small-scale stories conveniently contained within words; those words were, for Artaud, unable to trigger the rebirth of the "total man," or exude the taste of true madness and magic, which were the rudiments of the stage. Artaud's understanding of "cruelty" refers to theatre's vulnerability, its pursuit of inner truth, its exposure to madness and despair, and, in the end, the quality of creating discomfort and even pain. Because the primordial savagery of myth has perhaps always been a most compelling stimulus for spectators, theatre needs to re-approach the elemental, if terrifying, "truthful precipitates of dreams" (*TD*, 92), so as to satisfy the audience's instincts, illusions, and obsessions for violence, lust, and transgression. Behind the need for catharsis, however, a rigorous moral

stance is suggested: the way Artaud perceives cruelty relates more to an earnest passion for the purity of the mind (and by extension, that of the stage) than anything else. Defiant and potentially destructive, his understanding of cruelty, at least in theory, remains perhaps a valid means of safeguarding theatre's vitality within any aesthetically and ideologically jaded context.

Thus guided by his devotion to cruelty, in his quest for the origins of theatre, Artaud turns to archetypes and symbols, which substitute for the narrative's psychologically defined characters and misleading signifiers, affecting audiences in a chthonic, yet also cathartic way. He understands stage poetry to be both the result and the generator of such symbols, embodying latent forces and tensions that exist within people. The re-attainment of a primal appetite for life and the recovery of the intuitive wisdom obscured by putrid intellectuality are congruous to the conviction that theatre should not simply reflect life but also create the circumstances for its regeneration:

> Artaud believes that our dreams disclose the terror and cruelty which govern our fundamental instincts. And it is the task of the theatre to present these dreams in all their nightmarish reality. [He] justifies his conception of the theatre with the argument of theatrical catharsis: man can rid himself of undesirable desires and drives by presenting them on stage. (Greene 1970, 115–7)

In the wake of the twentieth century, Appia and Craig had predicated that "the theatre of the future" would be "a theatre of visions, not a theatre of sermons nor a theatre of epigrams" (Roose-Evans 1991, 76). Central to those visions, dreams would not make for "a servile copy of reality," but would allow the public "to liberate within itself their magical liberty" (*TD*, 86) and be only recognizable when "imprinted with terror and cruelty" (*Oeuvres Complètes* [*OC*], IV, 103). In the end, to transform dreams into stage action, theatre must discover and cultivate a more resonant form and language, an everlasting pursuit among directors, who, since Artaud's time, have invariably sought to resuscitate the mise-en-scène from the grips of self-satisfied, risk-averse, and therefore ineffectual stage conventions.

II. PERILOUS PASSAGES

Clearly for Artaud, the equation between life and art had been resolved early on, with life being the favored part, since "we need to live first of all" (*TD*, 7). Because life is a "fragile, fluctuating centre which forms never reach" (*TD*, 13), theatre's mission was to reveal the elusive core of humanity that words never penetrated. Accordingly, he vehemently asserted his commitment to a theatre of also an actor-*creator*, simultaneously fathering

the concept of a "theatre of blood": the actor, along with the director, is certainly an original generator of text, since, in a theatre submerged in the reality of life, the actor does not "perform" but creates. In a letter to Paule Thévenin on February 24, 1948, Artaud's vision of the stage was put in poetic form:

> ...a theatre which at each performance will stir
> something
> in the body
> of the performer as well as the spectator of the play,
> but actually,
> the actor does not perform,
> he creates.
> Theatre is in reality the genesis of creation:
> It will come about. (Quoted in Schumacher 2001, 200)

In a theatre that *creates* instead of imitating life, the performance duly resists the impulse to operate as a spectacle of situations framed outside life; rather, it produces "temptations" and "vacuums" around things, setting the body of the actor against those dynamic sources of vitality that affect the spectator. Mistrust for repetition is central and the construction of an unmediated, finite reality, the "unprecedented eruption of a world" (*SW*, 155) is indeed "the crux of the matter." Viewed in this light, repetition is a poisonous slave to representation, a strategy that kills. In his elaborate analysis of Artaud's theory, "The Theatre of Cruelty and the Closure of Representation" (1978), Jacques Derrida quotes Artaud's "I have therefore said 'cruelty' as I might have said 'life'" (*TD*, 114) to make a stronger case for the non-representability of theatre, arguing that "theatrical art should be the primordial and privileged site of this destruction of imitation: more than any other art, it has been marked by the labor of total representation in which the affirmation of life lets itself be doubled and emptied by negation" (Derrida 1978, 234). As Derrida illustrates, Artaud disengages the mise-en-scène from any responsibility to represent, blaming the fraudulent longing for representation on the appropriation of the stage by literature and speech and insisting that if the mise-en-scène continues to serve solely as a means for illustrating the text, as a simple accessory in performance, "a sort of spectacular intermediary with no significance of its own" (*TD*, 105), then its function will be justified to the degree that it withdraws itself behind the words of the playwright and remains tied to the mechanisms of presentation. Naturally, Artaud rejects Aristotelian mimesis as obsolete and potentially dangerous, professing that "art is not the imitation of life," but "life is the imitation of a transcendental principle which art puts into communication with once again" (*OC*, IV, 310).

In Derrida's analysis, representation (mimesis) guarantees the perpetration and perpetuation of the Christian God's design for the universe. A nonbeliever, almost a pagan, Artaud turned against the teleological structure of Aristotelian drama and sought inspiration in a text-less (therefore, "God-less") theatre. Not surprisingly, in the dichotomy between occidental and Oriental thought, which could in certain respect be read as the cultural side of the argument *for* or *against* the existence of the Christian God, Artaud decidedly opted for the latter, wishing to infuse the Western stage with archetypal patterns and hieroglyphs, to carry through to the audience what he believed would be a more authentic life experience. Implicit in his choice was the conviction that, if indeed the theatre created life, the experience of reality should remain uncontaminated for the spectator. The ever-disquieting notion of representation is intertwined with mediation. In literature-based drama—governed by the premise that the playwright is the primary "reader" of the world—the director, a "servant" to the playwright's text, is at best a secondhand intermediary between the world and the actors (who actually, in turn, become interpreters of the director's interpretation of the playwright's text). At the bottom of this pyramid of involved perception, the spectator poses as the end receiver of the initial conception of the world.[4] Yet Artaud unsettled this paradigm and proposed a different model of "reading" the text: renouncing the mediation of the author, he bestowed all interpretative power to the director-creator. In that respect, the ideal artist was embodied in the composite artist-creator (or director-writer), a role in which artists such as Beckett, in the second half of the twentieth century, and British dramatist Howard Barker or American director Richard Foreman in more recent decades, among others, have triumphed. The overarching imperative of Artaud's era—the fight for the appropriation of the stage—continues to our day to upset the relationship between playwrights and directors: instigated by Artaud, the theory of a text-redeemed mise-en-scène stipulates that either the author must assume the role of the director, or, alternatively, directors must reinforce their function as creators and promote themselves to omni-powerful decoders of universal meaning.

In this perspective, Artaud also prescribes a new function for playwrights, asking them to assume full responsibility for the scenic potential of their material. Authors should be trained not only to retain control of their own prerogatives in the process, but also to incorporate the dynamics of the stage into their work, having first acquired hands-on stage experience. Implicit in this is the awareness that an active involvement of the playwright in the specifics of theatre practice will first and foremost end "the absurd duality existing between director and author" (*TD*, 112) and facilitate theatre's mission, understood to be the creation of a complete, lifelike experience for the audience. Interestingly enough, Artaud's theories thrive in axioms,

admonitions and reprobations: he chastises the idea of any author, "that is to say creator" (117) who does not have direct control of the performance. Similarly, if a director believes in "consummation" and "purity," he has a calling to discover, through experimentation with movement and gesture, the equivalent physical metaphors that correspond "psychologically" to "the most absolute and complete moral discipline" and "cosmically" to the releasing of powerful energies that can both stimulate and annihilate whatever stands in their way (114–5). More than anything, what appears to infiltrate his conception of the director as *auteur* is an acknowledgment of responsibility and honorable purpose; in a letter to French actor and director Louis Jouvet in 1913, Artaud "casually" suggests that the duty of a good director is "to betray the author, if necessary, in order to give his play a production that holds together and makes an impression" (*TD*, 11).

Ironically, the challenging notion of interpretation as *betrayal* has been at the root of almost every single facet of the longstanding debate on the limits of directorial freedom. Examples of contemporary auteurs who would not hesitate to interpolate scenes, dialogue, or characters in their revisions of an existing play abound, while the great classics continue to be the most vulnerable of all sacrificial victims as far as directors' creative experiments (or abuse) go. For example, in Germany, the labels "irreverent" and "disrespectful" or at the antipodes "ingenious" and "fearless" are variously applied to the productions of Thomas Ostermeier with the Berlin Schaubühne (among them, *Othello* [2010], *Hamlet* [2008], *Cat on a Hot Tin Roof* [2007], and *Hedda Gabler* [2005]). In Ostermeier's work, visual and audio quotes from the cinema, TV soap operas, comics, and pop culture underscore the action, frequently disorienting, or entirely enraging, a part of the spectators. His 2004 *Nora*, an iconoclastic deconstruction of Henrik Ibsen's *A Doll's House*, caused a sensation as well as an uproar to international audiences, when Nora, rather than simply walking out on her husband, took out a gun and fired against him.

Quite radically, one of Artaud's most remarkable influences on contemporary auteur practice concerns his condemnation of traditional narrative forms. Ferociously urging audiences to reject purely literary artifacts in his legendary essay "No More Masterpieces" (*TD*, 74), he identified the reasons why the public felt no affinity to the existing literary works, precisely in their being "literary, that is to say, fixed; and fixed in forms that no longer respond to the needs of the time" (75):

> [In Artaud's view], from the moment of "transport," immediate reality, every-day experience, became insufficient, inoperable.... It was necessary to introduce a super-reality...which would embrace tangible daily experiences, *plus* spiritual leverage, *plus* an immanent metaphysical and meta-psychological

power for which daily experiences would be a most incomplete medium.
(Arnold 1963, 18)

In prioritizing the power of "spectacle" over speech, Artaud was once
again profoundly anti-Aristotelian, "spectacle" being for Aristotle the
least respected among the six elements of tragedy.[5] His implied metaphor
of Western theatre is quite archetypical: the "author-God" bestows on the
audience a definitive and omniscient text messengered by his slavish rep-
resentative, the director. While the author-God is confident that this gift
will virtually guarantee the longevity of his own sovereignty, in Artaud's
retelling, the structure and moral of the Christian tale are subverted; in his
preferred version of the world, the slave will duly rise to question his ruler
by exposing the gift's decaying contents. The loathing of the "theological
stage," to borrow Derrida's term, culminates in the expulsion of the author-
God from the stage, in a violent act that the French philosopher—borrowing
Freud's term—calls *parricide,* a "murder at the origin of cruelty." Restoring
the order of cruelty, the origin of theatre is "the hand lifted against the
abusive wielder of the logos, against the father, against the God of a stage
subjugated to the power of speech and text" (Derrida 1978, 238–9).

According to Derrida, Artaud, like Nietzsche, has banished God from
the theatre as an "interloper," a "transgressor" who attempts to impose the
"logos" upon the pure, primordial sensibility of the "action." In fact, "God's
text" is "underlying the operation of the classical theatre" and allows no
escape from the "perpetual representation of the original creation."[6]
Therefore, the expulsion of the author-God from the stage is instrumen-
tal to the redefined role of the spectator. In Derrida's view, if and when
the stage is finally released from the tyranny of the author, the freedom
of the mise-en-scène would be reconstituted and the participants in the
performance—no longer holding defined roles as actors or spectators—
would cease to be "the instruments and organs of representation" (237).
Once again, the notion of representation, evidently an anathema in the
avant-garde practice in general, is critical: Artaud declares that, in the new
mise-en-scène, the stage would cease to represent (i.e., simply repeat) a real-
ity conceived and experienced outside of the theatre, nor would it be "an
addition," an illustration of the dramatic text. Specifically, in the theatre,
representation denotes the repetition of a present existing elsewhere. As
Derrida argues, because Artaud understands representation to be the "sur-
face of a spectacle displayed for the spectators," he renounces all but the
original representation, which, according to the principles of cruelty, is in
fact a "nonrepresentation," "if representation signifies, also, the unfolding
of a volume, a multidimensional milieu, an experience which produces its
own space" (237).

In effect, theatre is a *no thing* making use of everything—gestures, sounds, words, screams, light, darkness—and rediscovering itself "at precisely the point where the mind requires a language to express its manifestations" (*TD*, 12). Artaud's ambition to replace "dialogue theatre" with mostly physical art-forms that borrow from several sources across disciplines (the visual arts, dance, cinema, circus and mime, among them), has, in many ways, inspired Beckett's hybrid performance texts from the 1960s onward and also created the circumstances for the writing of plays that would be open to an interaction with the audience. The "triumph of the pure mise-en-scène" (*OC*, IV, 305) offered those spectators greedy for mystery and with a mind "poisoned by matter" an outlet for their repression, which had been accumulated within art-forms that had, for the longest time, inadvertently deceived them. Theatre's break from "this mythical and moving immediacy" (*TD*, 116) was to be redeemed by the new mise-en-scène.

Following up on Artaud's dismissal of the "theological" stage, where, in Derrida's apt description, the spectator is a mere "enjoyer," a voyeur, a "passive, seated public, a public of spectators, of consumers,"[7] nonconformist directors have been looking into ways to annul the distance between spectator and spectacle, already prompted by Appia, Meyerhold, and especially Reinhardt. Along with placing the spectator in the center of the action, not infrequently, auteurs formulate play-texts using people's responses to questionnaires, short interviews, or critical opinions. Many times, the exact words of the latter become the basis of the script, a practice that characterizes what is currently known as *verbatim theatre*,[8] some of the structural principles of which are, for example, present in Eve Ensler's celebrated play *The Vagina Monologues* (1996); similarly, Jessica Blank and Erik Jensen's *The Exonerated* (2002), which dramatizes the cases of people sentenced to death for crimes they did not commit, is in fact based on material from interviews that the authors held with sixty former death-row prisoners who had been exonerated.

Other times, directors shape their performances around direct audience participation—a method intrinsic in *interactive theatre*—or involve the spectator in the action in somewhat less dramatic, yet equally deliberate, ways, including feeding them, inviting them on stage for a dance, or making them active listeners in a speech; such strategies are much valued by the likes of Mnouchkine and McBurney. Nevertheless, the breaking down of barriers between audience and actors has never been a bloodless affair; Artaud's criterion for good art is not standard entertainment fare, but rather, as Susan Sontag points out, a "sensory violence" (*SW*, xxxii), an attack on the spectator's senses and sensibilities. Because any live and shared event is fundamentally a perilous affair, the audience can only leave the theatre touched, shaken, and altered. A *metaphysically* conceived stage carries a brutal, almost *physical*

determination to demolish falsity, while the idea of cruelty is grounded on "a mode in which one is shocked bodily into an awareness of the undomesticated or the uncanny" (Artaud in Tharu 1984, 75). An "emotional and moral surgery upon consciousness" (Tharu, xxxvi), theatre actually *has* to be cruel. The "theatre of cruelty" means a "theatre difficult and cruel for myself first of all" (*TD,* 79), because "we are not free. And the theatre has been created to teach us that first of all" (79). The only thing that can guarantee the spectator's involvement in the spectacle, in fact, the prerequisite for the viability of the stage, is an all-consuming emotional response and the experience of "human anguish." A detached observer no longer, the spectator is aware of the "dangers" involved in going to the theatre, which might be likened to the agonies one has to endure before undergoing a medical operation. Therefore, in the theatre of cruelty, what is afflicted is not only the spectators' mind, but also their sensory organs. Within a spectacle that confronts audiences directly, Artaud's cruelty is tantamount to "necessity" and "rigor," upsetting cultural preconceptions and reversing common aesthetic expectations. Prescribing the ideal connection between spectator and spectacle, Artaud wishes the spectator to "be in center" and the spectacle to "surround him" (81) and explains how, as Derrida suggests, the theatre of cruelty "lifts all footlights and protective barriers before the 'absolute danger'" (Derrida 1978, 244). Yet, the loneliness of the spectator marking the experience of the unfailingly stimulating terror which lurks behind theatre's unpredictable nature, is actually liberating: this cruel theatre eventually replenishes us with an "appetite for life, a cosmic rigor, an implacable necessity" (*TD,* 102).

III. THE MISE-EN-SCÈNE *AN SICH*

Artaud's theories on the universal impact of physical language, taken up by experimental directors from the second half of the twentieth century onward, originated in his down-reaching mistrust of verbal language, traditionally considered the supreme as well as exclusive system of communication. Expressive of and responsible for the lifelessness of Western civilization, a culture that had been petrified under complacent and clichéd assumptions, dramatic language (speech) should, in Artaud's view, make room for alternative stage idioms that would bring to light the subtlest nuances of the human condition and reinforce the metaphysical dynamics of theatrical action.[9] The perception of the dramatic text as subordinate to theatrical performance and the updated function of directors no longer serving as "artisans" or "adaptors," but instead as creators responsible for the formation of a new world on stage, were major points of affinity to the philosophy of Craig, Appia, and Meyerhold. To revive the theatre as a "magical operation," a "total spectacle," Artaud transferred the onus to space and endorsed stage

means such as dance, sound incantation, gesture and pantomime, architectural shapes and lighting, confident that these would enrich the performance with the same sense of total freedom that exists in music, poetry, or painting.[10] His preoccupation with painterly composition and film affiliated him with a more visual language, "coinciding with being," once again foreshadowing Beckett's experiments with performative language and sensory imagery. Naturally, he also made a strong case for theatre's superior position in the arts: because of its dual nature in combining words with matter, theatre, unlike cinema, is "carnal, corporeal" and thus able to integrate unlikely forms and mediums into one whole gesture and verbal language—static objects and movement in three-dimensional space (SW, xxxi).

A major pivot in Artaud's aesthetic was an envisioned language that would exist "halfway-between thought and gesture" (TD, 89), regaining its original mythical stature and form, and linking the theatre to "the expressive possibilities of forms, to everything in the domain of gestures, noises, colors, movements, etc." A corrective to the decadence and excess of speech-dominated performance, this would be a language that would restore theatre "to its original direction...reinstate it in its religious and metaphysical aspect,...reconcile it with the universe" (70). Artaud is in effect conceiving of a language that can be embodied. In point of fact, what had clearly marked his divorce from verbal language was the 1931 Colonial Exhibition in Paris. In the ceremonial performance of the Balinese dancers, he first glimpsed at the possibilities of a multidimensional stage idiom based on incantation and highly codified physicality and was shocked profoundly. He was particularly impressed by the dancers' impressive array of gestures, which instantly struck him as a potential rudiment in his own sought-after arsenal of scenic tools. Fascinated with how "the theatre also takes gestures and pushes them as far as they will go" (27), he noticed that in the Balinese theatre "there is no transition from a gesture to a cry or a sound: all the senses interpenetrate, as if through strange channels hollowed out in the mind itself" (57). Hence gesture and bodily expression, so wisely manipulated in Oriental art to impart a sense of the intangible, proved a fascinating alternative to the occidental stage's shallow externalization of psychology. The elaborate, though elemental physical language defining Asian performance rituals "necessarily induces thought to adopt profound attitudes which could be called metaphysics-in-action" (44).

Enraptured with the idea of discovering primitive sources of inspiration and exploring their application on existent forms of theatre, Artaud held on to the symbolism (what he called "hieroglyphs") of Eastern performance to fortify his attack on worn-out forms, which had not only ceased to express a modern problematic but also inherently sheltered the decaying morality of prevailing artistic functions and forms. On the one hand, speech could

extend beyond and outside words, its "dissociatory" and "vibratory" action "developed in space" (*TD*, 68); on the other hand, the visual features of things such as movement and gesture were paramount in re-conceiving the language of the stage as truly spatial. Physical signs had to be understood and made into some sort of an alphabet for the new language, in the same way that shouts, sounds, and lights ought to be organized to make "true hieroglyphs" out of characters and objects (68). In line with the observation that the Balinese theatre is based on a physical and nonverbal understanding of the theatre form, quite separate from any written text, Artaud equated Oriental culture with a more spiritual attitude to life and art. By and by, speech should engineer a metaphysics of language, while language must be reconceived "as a form of incantation" (46).

On all accounts, the wordless stage that Artaud contemplated was meant to be realized within the actor. After all, the central dichotomy tormenting him had always been that between body and mind: corporeal presence, uncensored by cerebral processes and therefore universal, has been paramount to the expression of transcendental states. Because the body is the fundamental generator of praxis, it alone is capable of reconciling the formative dualisms that jeopardize the unity of the theatre event and act inside the silences of a new physical language. In his essay "La parole soufflée" ("The Stolen Word" [1965], in *Writing and Difference* [1978]), Derrida fitly elaborates on Artaud's pledge vis-à-vis "the existence of a speech that is a body, of a body that is a theatre, of a theatre that is a text" (174–5). The impulse to redefine and empower the actor's body lay the circumstances for the establishment of physical theatre, allowing Brook, Kantor, Wilson, Suzuki, Bogart, and others to espouse performance inconsistencies, gaps, and contradictions and to trust that the actor can materially translate them into compelling narrative forms. Suzie J. Tharu illustrates how Artaud "takes the 'obedient, conformist' text (that which is and can be spoken) and juxtaposes it with a bodily statement that contradicts, questions and undermines it, but also makes for an engendering of the new," also pointing out that what results is "not so much a meaning, as an *event*" (1984, 64).[11] Yet, despite the proclivity for physicality, Artaud never quite banished the word from performance, but rather modified and reversed its function: he cleansed it of psychology and re-accessed its musical, incantatory sense, the actual flesh of it, convinced that the way language is physically delivered (for example, through the emphasis on pitch or the repetition of certain syllables), can actually affect our nervous system and therefore influence us emotionally. This line of argument is certainly in the right track: "If sounds, noises and cries are chosen first for their vibratory quality and only secondly for their meaning, language will communicate physically—not intellectually, and therefore superficially"

(Greene 1970, 149). At the same time, while Artaud conceded that his language's "grammar" was "still to be found," he already foresaw gesture as "its material and its wits" (*TD*, 110),[12] potentially, as the foundation for unusual forms of a stage écriture consisting not in the transcription of speech and phonetic writing, but in "hieroglyphic" writing wherein "phonetic elements are coordinated to visual, pictorial, and plastic elements" (Derrida 1978, 240). As a result, he never tired of declaring that his ideal repertoire would be based on performances that displayed a strong physical articulation, either by disengaging themselves from conventional verbal texts, or by modifying and re-writing them, using language in new and surprising ways.[13]

The big Artaud "comeback" occurred in the 1980s. Since then, his impulses have circulated among a substantial number of artists and writers who were ambitious to restore in their work the immediate, experiential effect of physical language. Wilson's work, for one thing, is hugely indebted to Artaud's "dream of a theatre occupying the space of plasticity and 'physicality,' rather than psychology":

> Wilson's work on language, the way he displaced visual and auditive dimensions of discourse, dissociating sign and meaning, may be paralleled with Artaud's effort to expand articulated language beyond the metaphysics of words. (Bel 1997)

Even though Artaud's vague reference to writing's "new sense" leaves plenty of room to speculation and even more space to criticism, evidently his vision of truly spatial idioms extends beyond the employment as well as deployment of language merely for the purposes of communicating, but predominantly engages it as a building constituent in the text of the performance. Committed to his subversive approach to the specifics of textuality, Artaud encourages experiments at "direct staging around themes, facts or known works" (*TD*, 98), "encountering the obstacles of both production and performance" (41). His model clearly suggests that the stage realization of a concept can best be negotiated and finalized during performance; on that account alone, he can be said to have fathered the ideas later on developed by devised theatre companies, such as British groups Peepolykus, Kneehigh, Improbable, and, of course, Complicité.

Above all, to formulate and apply an agile performance language, validating itself as the only possible alternative to an obsolete stage and a "sacred and definitive text" (*TD*, 89), the challenge lies in the mise-en-scène's bridging the gap between body and mind and gracefully uniting sense and sensibility, the Apollonian and the Dionysian nature of both performer and spectator. Since the organic basis of emotion is located inside

the performer and words are no longer the unique carriers of meaning, language can be transmuted into action when embodied in the actor. In the same way, unplanned performances substitute for the impervious fixity of the literary text. Again, the binary line of mediation versus interpretation is critical: rather than relinquishing their talent to the playwright's words, actors collaborate with directors in interpreting the original *über-text*, namely the world itself, expelling the author from the stage. The figure-product of this mutual exchange is what Artaud calls "creator," the ultimate agent of demiurgic impulses, who, adopting the vocabulary of physical language, manages to reconcile text and performance and put the final signature on the theatre event. The dual function of the artist as director *and* author is the basis of *auteur theatre*.

Freeing the performance text from the restrictions of predetermined dialogue, since text "will not be written out and fixed a priori, but will be put on the stage, created on the stage, in correlation with the requirements of attitudes, signs, movements and objects" (*TD*, 111), Artaud is also celebrating the art of improvisation, one of the most effective mechanisms of furnishing details of thought, action, and blocking to the main structure of the production. Renouncing "the theatrical superstition of the text and the dictatorship of the writer" (124), he is fearless vis-à-vis the challenges involved in composing an entirely new text "ex nihilo" and opts for veracity, vulnerability, and exposure. His fiery instigations for artists to surrender to "chance" (158) convey a very earnest desire to divest the process of creation from the exhausting pursuit of success and the burden of constantly having to "please" an audience. In all respects, given that the verbal text vandalizes the stage ("toute l'écriture est de la cochonérie," or "all writing is garbage" [quoted in *SW*, xxii]), the critical rejection of literary masterpieces and authorial authority is imperative for the vindication of theatre. The loathing of words admits a broader rejection of literature as a fixed, claustrophobic, and elitist genre, continually undermining the desired bond between creator and receiver.[14] On that account, it is impossible for literature to coincide with life, having been predetermined, preselected, and pre-performed by the author and therefore abrogating any dynamic interaction with the audience it is supposed to serve.[15]

This said, we should by no means overlook Jean-François Lyotard's wariness in relation to the Artaud-prescribed efficacy of a predominantly visual language for the stage. Pavis discusses Lyotard's analysis—according to which, Artaud, "wanting to destroy not the theatrical system termed Italian, that is European, but at least the predominance of articulate language and the effacement of the body, stopped halfway" (Pavis 1981, 80)—and turned toward "the construction of a tool, which was to be yet another language, a system of signs, a grammar of gestures, hieroglyphs" (Lyotard quoted in

Pavis 1981, 80). Lyotard contends that although "silencing the body through the theatre of the playwright is nihilistic, making it speak in a vocabulary and a syntax of mime, songs, dances, as does the Noh, is another way of annihilating it: a body 'entirely' transparent, skin and flesh of the bone that is the spirit, intact from any pulsional movement, event, opacity" (80). In the end, as Pavis acknowledges:

> Artaud's failure was his wanting to counter the fossilization of the theatre by putting in its place a vision of the theatre that was too spatial and not sufficiently inner and pulsional, his searching for an impossible scenic and gestural language, his forming an ideal likewise too specific, in this case too spatial and visual, of the theatrical event. (80)

IV. THE BATTLE CRY

Since the time of *The Theatre and its Double,* avant-garde practice both in directing and playwriting has sought ways to make Artaud's visual theatre exist in the context of performances or plays, which, without regressing to the traditional hierarchies of psychological characterization or linear structure, can still express through language and sound poetry the "unseen" and the "unsaid" of life's complexities. How can everyday language go beyond the quotidian experience? What possible form could encompass the ruptures of modern consciousness? What is the role of art and of the artist today? Artaud struggled to address some of these questions in his feverish writings. His lofty theories and ideas had little opportunity to be tested against the harsh logistics of stage practice; nevertheless, profuse as well as vehement, they constitute inexhaustible sources of inspiration. Affiliated with the movement of the surrealists and founder of the Théâtre Alfred Jarry, Artaud was looking for a forum through which to instigate his ideas on cruelty and metaphysics, contemporary culture, and the reformation of life. Simultaneously provocative and affirmative, the notions expounded in *The Theatre and its Double,* together with his extensive correspondence with actors, directors, and other artists of his time, have prepared the ground for various idiosyncratic theatrical undertakings, updated according to the ever-revised terms of contemporary performance. Sontag powerfully impresses in her introduction to *Selected Writings* that "what [Artaud] bequeathed was not achieved works of art but a singular presence, a poetics, an aesthetics of thought, a theory of culture, and a phenomenology of suffering" (xx). While the necessity for change and revolution against established norms exists in every culture and at all times, Artaud had the vision to conceive of and the courage to articulate a changed world, a new theatre, a reformed language, and a deconstructed form.

From the second half of the twentieth century on, the broad gamut of staging forms and combinations available to theatre-makers has originated stage texts consisting of anything that can be made into usable material. Notwithstanding the utopia of Craig's and Artaud's passionate celebration of a theatre, which not only "eliminates words" but also expresses "a state prior to language" in presenting "a secret psychic impulse which is Speech before words" (*TD*, 53–4), it is no surprise that the avant-garde movement, which has always displayed strong antitextual sentiments, was greatly encouraged by Artaud's writings. After Artaud, the logo-centric approach to the theatre was replaced by the viewing of performance as an art-form in its own right, and from the outset, the dominance of the word, of "theatre as text," was the locus of fierce avant-garde opposition. Whether open or latent, antagonism between text and performance never fails to trigger animosity, posing serious axiomatic questions as to who the author of the "theatre text" is and whether it is possible to legitimize and give credit to the originator of the performance adventure. All these issues continue to reverberate in current auteur practice, but the interest now lies both in the directors' attempt to approach nonverbal methods of communication and perception, and in their stimulating mechanisms of nonlinear association.

It is no surprise that Artaud lent himself to appropriation: not only did he mirror a general discontent with mainstream forms of art and the on-growing need for an overwhelming reform of the stage; he also expressed the "profound and more general disillusionment with conventional forms of society and religion" (Innes 1993, 60). Artists are always eager to dash toward anyone and anything that can potentially contain their dissent and help voice their claims; Artaud was an excellent vehicle for that because his theories remained unscathed by practice, pure and resilient through the years. Positively ahead of his time, he provided a viable context for speculation on the role of the arts and the nature of representation. His texts, teeming with abrasive ideas, introduce, as Donald Gardner acknowledges, "certain new criteria, not so much for aesthetic form, but, more disturbingly, for what a work of art is."[16] In seeking to go beyond the limits of speech, in fact, beyond all limits imposed by literature and received intellectual processes, Artaud was instrumental to the development of physical theatre, and of course, to the establishment of performance as an equal, if not superior, partner to the dramatic text within the general context of the theatre praxis. Among his consistent followers, Brook and Charles Marowitz set up The Theatre of Cruelty Workshop in 1964 as a training arena for actors who wished to experiment with forms of exceptional physicality promulgated by Artaud.[17] Also, Brook's and Jerzy Grotowski's (1933–1999) "holy" theatre has also been greatly indebted to the viewing of performance as a vessel for mystical trips undertaken by both actors and spectators. In fact,

Grotowski's Polish Laboratory Theatre was created so that the entire process of rehearsing and putting on a play could serve the spiritual reeducation of the actor, furthering and completing Artaud's concept of ritualization and the application of the primeval, almost religious forces innate in Eastern art and philosophy. Undoubtedly, Artaud's emphasis on modes of unconventional staging also influenced the non-text based work of Barba, the unusual audience-participatory spaces of Schechner's Performance Group, and Julian Beck's and Judith Malina's physical productions with the Living Theatre. Furthermore, the eclectic borrowing from Oriental art-forms has been central to the work of Mnouchkine as well as Brook, while Wilson found in Artaud the validation he sought to invest in a theatre of emotive images, in which gesture replaced words, and speech surrendered to sound and incantation.[18]

Sadly, some of Artaud's followers have taken on his postulations undigested, anxious to hold onto the labels of the "intellectual"/"revolutionary"/ "innovator" that tag along his legacy. The banner of "metaphysical" or "profound," which has commonly attached itself to Artaud's theories, is still repeatedly raised in productions whose heralded revolutionary spirit is predictably limited to facile formalism[s]. At the same time, the question still remains whether Artaud's propositions can actually be implemented to artistic practice today or if they should be handled or looked upon as mere sources of inspiration. After all, "Artaud's genius...consists in the courage with which he returned again and again to the thematic of the transformation of life" (Gardner 2009). Perhaps the ideological courage and theoretical depth of Artaud's writings will remain unchallenged for many more years to come. For one thing, the era that gave birth to his philosophy was a turbulent one: the sociopolitical instability of the 1930s was certainly reflected in the orgasmic eruption of pioneering movements in art and literature, some of which, like modernism, thoroughly renounced realistic (representational) art. Artaud's disciples in the 1960s had different social and political battles to fight. Nevertheless, despite the fact that the institutionalization of the avant-garde in the late twentieth century brought with it a degree of reluctance for extremist or even mildly confrontational attitudes vis-à-vis the world we live in and the conditions that render art meaningful, it might be worth asking oneself if a cultural revolution can occur in our days. And if yes, what kind of artistic conditions can such revolution occur in, since already, the demand for ideological as well as meaningful theatre is high.

CHAPTER 3

BECKETT'S TURBULENCE

I. TORTURED HYBRIDS

There will be a new form, and this form will be of such a type that it admits the chaos and does not try to say that the chaos is really something else. The form and the chaos remain separate. The latter is not reduced to the former. That is why the form itself becomes a preoccupation, because it exists as a problem separate from the material it accommodates. To find a form that accommodates the mess, that is the task of the artist now. (Beckett, quoted in McMillan and Fehsenfeld 1988, 14)

Samuel Beckett's (1906–1989) influence on auteur directors is revolutionary and manifold: from the standpoint of a playwright transferring performance parameters to the dramatic text, he put the notion of the mise-en-scène's centrality into actual practice, proposing a creative junction of director and writer within the same text. He has been rightly credited also as the father of avant-garde dramaturgy, his tremendous impact stretching to the plays of many European and American dramatists, including Caryl Churchill, Valère Novarina, Michel Vinaver, Jon Fosse, and Richard Foreman, to name but a few. Having come to writing in the 1950s, all through his long and prolific career as a novelist and playwright, he has been alternately labelled a modernist, an absurdist, an existentialist, and even a postmodernist, each title attesting to his multifaceted as well as precocious genius. Introducing staging concerns into writing, his drama evolved from mainstream classic to minimalist avant-garde—a process that commenced with *Happy Days* in 1961 and came full circle in most of his later plays and, more shockingly so, in *Not I* (written in 1972)—and pushed theatrical form to its limits. Beckett's ambition was to explore the potential of as much artistic material as possible by joining different media together in order to manufacture a regenerated form that would be based on drama and yet include

paralinguistic and para-literary elements. For that reason, he experimented with plays for radio (*All That Fall* [1956], *Embers* [1959], *Rough for Radio I&II* [1960/1], *Words and Music* [1961], *Cascando* [1962]); film (*Film* [1963]); television (*Eh Joe* [1965], *Ghost Trio* [1975],...*but the clouds*... [1976]); and mimes (*Act Without Words I&II* [1956]), all the while continuing to produce pieces for the stage. Eventually, however, the borders between his "regular" stage plays and the plays written for other media became blurred. In particular, the generic distinctions between radio dramas and stage dramas started to break down, as Beckett made sound and voice constitutional elements of his later plays.

Raising the issue of representation in the arts, Beckett's short plays reveal his solid conviction that, in the appreciation of the theatre, the literary text is only one part of the overall experience, in itself inadequate to express or foresee the intricacies involved in the hydraulics of performance. This explains the fascination with more "flexible" texts, in which the playwright's innate (and to a degree, inevitable) directorial vision formally becomes part of the written script. Setting specific performance criteria for the dramatic text, Beckett uses the stage elements of lighting, set/props, sound/silence, and movement as structural determinants, often filling in for "gaps" in plot and characterization. Even more notably, he organizes his stage directions into definitive sets of rules for prospective directors, demanding that these be observed as instructed and treated as text rather than as mere suggestions for blocking. What emerges is a hybrid score of no specific hierarchies, which mixes verbal language with performance idioms and essentially constitutes the writer "director" of his play.

Repudiating both psychological and Aristotelian validation of drama, Beckett dives into the subtlest inmost mechanisms of "making theatre," which inevitably call for different kinds of authorial attention. In doing so, he disrupts the stability of the relationship between signifier and signified, never to question in more realistic forms of dramatic writing, opting instead for patterns of fragmentation, repetition, and silence and opening up the plays to a much broader range of signs to augment the sensory experience of the audience. Working along the lines of Artaud's rejection of literary expression in favor of more compound discourses for the stage, he similarly jettisons the logo-centric order of drama, which had dominated theatrical representation up until his time. At the bottom of his eagerness to "crack" theatrical experience lies an investment in alternative mediums of representation, as in the case of the play *Breath* (written in 1969), perhaps the most minimalist play conceived within the Western dramatic canon. Ironically, the play features neither dialogue, nor actors, but just a concept of a set (a stage filled with refuse), on which a cry, a respiration, and an expiration take place consecutively. Lighting is an essential component of the piece, as

is manifest in its dramaturgically fraught scaling. In fact, *Breath* evolves into a precisely calculated, yet dynamic coexistence and coordination of lighting, set, and sound; the concept, plot, scenic, and aural details of the play are conceived as a whole, and the dual metaphor of life and death embodied in the complementary actions of inspiration and exhalation is much more eloquently served by the implied newborn baby's cry and the "amplified recording" of a breath (*Collected Shorter Plays* [*CSP*], 211) than it would potentially be through a more conventionally "dramatic" unfolding of character and situation. The use of silence and the control of these principles are also pivotal. In a text of *no text,* even the most immaterial qualities assume the function of language.

In itself, *Breath* is startling proof that theatre can emerge out of the most basic elements of existence, as its actual length on the page and duration in performance imply. In similar manner, in *Nacht und Träume* (1982), "elements" in the introductory page of the play replace what are conventionally known as "dramatis personae." Beckett's originality is not limited to his reversing the formal order of dramatic writing; in fact, what can be loosely termed "dramatic characters" (for example, Dreamer A and his dreamed self, B) are boldly mixed with principles of performance (such as the last seven bars of Schubert's *Lied, Nacht und Träume*), images taken from nature, and even dreams (evening light, dreamed hands) (*CSP*, 305). The protagonists are no longer recognizably human: in their sheer decomposition and lack of materiality, they mirror Beckett's overall disillusionment with the world's brutal mechanization, especially after World War II. In fact, in one of his rare statements on art, Beckett had declared that "there is nothing to express, nothing with which to express, together with the obligation to express."[1] Reflecting a deeply wounded vision of the humankind at large, this aphorism also suggests that the magnitude of people's existential void can only be sheltered within less limiting forms of writing, those which defy the concept of teleology celebrated in Aristotle's propitious triad of "a beginning, a middle, and an end." Through and through, Beckett's writing registers how our everyday experiences emphatically dispel all belief in either safe beginnings or redemptive ends, but are instead marked by discontinuity and flashes of chaos, no matter how masterly organized into some semblance of normality these appear to be. Beckett thus becomes a pioneer in formalizing the need for a new dramaturgy and vouching for the fact that neither structure nor language "as we know it" are in any way capable of arresting the fluidity of the modern condition. Not only does he capture the fragmentation of consciousness in the highly patterned speech of his equivocal bodies, but digs even further into the duality of the human self, the clash between the "I" and its other half, whether it is a voice, a tape recorder, or an image. The torturous excess of subjectivity, which still

haunts the work of some of the most prominent auteurs to date, is tryingly
present in the battle between the dramatic (psychological, recognizable,
and human) character and its performative counterpart (imagistic, elusive,
and unreal), revealing Beckett's profound understanding of a spectator's
modes of reception: "When I write a play I put myself inside the characters,
I am also the author supplying the words, and I put myself in the audi-
ence visualizing what goes on onstage" (Beckett quoted in McMillan and
Fehsenfeld 1988, 14).

As in the theatre of the auteur, in Beckett's short plays, the relationship
between "textual language" (where text equals literature) and "perfor-
mance language" (composed by the elements of mise-en-scène) is con-
stantly put into trial. Although he consciously chooses not to jeopardize
either one of the two ends of the spectrum in favor of the other, there is
always a sense that we are experiencing a fragile tension between the word
and its scenic counterpart. As drama merges with performance, the spec-
tator may lose track of the story, characters, or text itself, and instead strive
to locate and sustain the play's central image, which is frequently blurred
or simply surreal. Verbal language, at times spoken by one sole actor and
becoming increasingly elliptical as the playwright moves further inside
his exploration of the theatre medium, blends with choreography, sound,
echo and silence, lighting, abstract costume and set design. Complying
with the way verbal images alternate with visual ones, the reader mentally
connects the two and is transformed into a by-proxy spectator. In fact, the
merging of drama with performance is everywhere, as "one genre breaks
into another" (Brater 1990, 17). As readers or spectators of Beckett's late
plays, we can never be absolutely certain if we are dealing with works of
dramatic literature or written "spectacles" for the stage. By demanding
that our attention be equally distributed among our visual, aural, and
intellectual channels, these texts stimulate our thinking and thoroughly
assail our senses:

> [In Beckett's theatre] genre is under stress. The theatre event is reduced to a
> piece of monologue and the play is on the verge of becoming something else,
> something that looks suspiciously like a performance poem. All the while a
> story is being told, a fiction closely approximating the dramatic situation the
> audience encounters in the theatre. (3)

II. QUESTIONS OF "AUTHORSHIP"

I am naturally disturbed...at the menace hinted at in one of your letters, of
unauthorized deviations from the script. This we cannot have at any price and
I am asking [London producer Donald] Albery to write [American producer

Michael] Myerberg to that effect. I am not intransigent, as the [bowdlerized] Criterion production [in London] shows, about minor changes, if I feel they are necessary, but I refuse to be improved by a professional rewriter.[2]

Beckett issued this warning message to his friend and American publisher of Grove Press, Barney Rosset, in February 1956, rushing to prevent what he called "unauthorized deviations" in the forthcoming Broadway production of *Waiting for Godot,* after a failure in the Miami première. Since the Broadway production was to have a new director and cast, Beckett wanted to ensure that his text would be "respected" literally to the letter. Having discovered theatre late and engaging fully in the dialectic between the page and the stage, Beckett not only immersed deeply in the world of plays to create works that carried performance inside them, but he also became professionally involved in their staging, wishing to explore the possibilities of performance "hands on," as well as to apply his own observations to already existing (published) play-scripts in order to turn them into theatrically more viable pieces for the stage.

After he became established, following the success of *Waiting for Godot* (1948–1949) and *Endgame* (1955–1957) in English and French, Beckett first began to closely observe the productions of his plays, establishing strong ties of friendship and collaboration with the artists involved in each project. Above all, what really added to his resolution to keep an eye on what directors brought to the table was the eagerness to set what he called a "standard of fidelity" (Gontarski 1998), which later assumed greater dimensions and earned him the reputation of an author exceedingly possessive of his texts and therefore tremendously difficult to work with. Becoming gradually inseparable from his own productions, after fifteen years of writing plays, Beckett turned to the actual *practice* of theatre and this direction signaled an enormous change in the shape of dramatic writing worldwide. From the early 1960s up until his death in 1989, Beckett continued to redefine the shape of drama, trying out all potential forms and combinations of reconciling literature with the performing arts. In the course of casting off his purely book-bound persona in favor of a multifarious theatre personality, he would go back to his earlier plays to fix what he thought was wrong, superfluous, or not theatrical enough. This concern started a whole practice of revisions in works that had already been published but on which Beckett was, at the time, working as a director. Surely, his insistence to correct texts that were already out in the market often caused havoc to publishers, who would have to wait for him to complete a number of rehearsals before going back to the text to apply what he thought were necessary revisions. Sensing how crucial it was for writers to endorse performance in their work, Beckett would only complete his plays "on stage."

To illustrate the point, as S. E. Gontarski relates, on November 24, 1963, Beckett made reference to his wife's disappointment with the German production of *Spiel* (*Play*) in a correspondence to Barney Rosset: "Suzanne went to Berlin for the opening of *Play*. She did not like the performance, but the director, Deryk Mendel, is very pleased. Well received."[3] Beckett had already pointed out the necessity for even more rehearsals before authorizing the play's publication when he first informed Charles Monteith of Faber and Faber on November 15, 1963, that he would have to make some "rather important changes in the stage directions of *Play*," adding a few days later that:

> I suddenly see this evening, with panic, that no final text of *Play* is possible till I have had a certain number of rehearsals. These will begin here, I hope, next month, and your publication should not be delayed [that is, publication should follow soon after production]. But please regard my corrected proofs as not final. (Quoted in Gontarski 1998)

Not surprisingly, multiple versions of the plays began to circulate among producers and playwrights. As he continued to direct, Beckett continued to revise, a cycle of self-collaboration that naturally produced a proliferation of variants of the same text (Gontarski 1998). Beckett's close friend and long-time cultural reporter and critic for the *New York Times* Mel Gussow remarks how "each time [Beckett] staged a play, the play changed. While directing he found 'superfluities': words as well as actions" (Gussow 1996, 37).

Both Gontarski's articles "Revising Himself: Performance as Text in Samuel Beckett's Theatre" (1998) and "Reinventing Beckett" (2006) are solid studies of Beckett's evolution from playwright to director of his plays. In "Revising Himself," Gontarski tracks Beckett's development particularly in reference to his self-reinvention and self-discovery during his nineteen-year directing career, from 1967 to 1986, when he had staged more than twenty productions of his plays in English, French, and German. He researches Beckett's work on texts of his that had already been published but to which Beckett kept returning as a director with fresh sensibilities that he wished to apply on them. In many respects, Beckett "staging himself even well after initial publication would mean revising himself and would allow him to move forward by returning to the past, to implement, refine, and extend his creative vision to work published before he became his own best director" (Gontarski 1998). Gontarski also ponders on the inevitability of Beckett's "self-collaboration," given the tension that often characterized his relationship as a playwright with most of his plays' directors.

Devoted to modernism, Beckett was adamant about the aesthetic value of the work, as becomes particularly clear in the corresponding mandates of his stage directions. Beyond formal sensibilities as such, his commitment

to the idea of performance reinforced the conviction that no play can claim finality unless it is tested against the actuality of the stage. Yet, the question that comes to mind when we consider the challenges in store for a director working on a Beckett play bears upon whether Beckett's texts can really ever be *owned* by another artist. The definitive imprint of the playwright on the overall dramatic image together with the restrictive specificity of the stage directions undermine the promise of further readings. To put it more plainly, what exactly is the director's job in a Beckett production and how does one stage Beckett's already "directed" plays? In other words, how much room for individual interpretation and imaginative thinking does Beckett—or after his death, the notorious Beckett Estate, which handles the rights of Beckett's plays—allow those directors who ultimately dare "take on" his plays? Speaking from the perspective of an actor, Beckett's close collaborator, Billy Whitelaw, who performed in several of his short plays and most notably in *Not I,* tried to dispel the theory that Beckett was in any way a tyrannical auteur: "A lot of people think he's a dictator, who insists, 'You must say it this way.' He's not. He has a very definite idea of how he wants it to go, but within that, I can emotionally take off on my own" (quoted in Gussow 1996, 85). And yet, in the same interview with Gussow, Whitelaw contradicted herself when conceding that Beckett "drives actors nuts. He keeps saying he's been thrown out of most theatres. It can be very trying sometimes" (90). Indeed, Beckett's own self-sarcasm concerning the taxing "affair" between director and actor is humorously reflected in his play *Catastrophe* (1982). Yet, without a doubt, working on a Beckett text is perhaps even more trying for directors than it is for actors, given that his stage directions, exacting, as well as definitive, allow for little variation in staging. Because his plays convey a strong sense of performance, it is almost prohibiting even for the most adventurous director to tamper with them in any way. Taking the point a little further and addressing the issue of what is legitimate or, in fact, legal in a theatre performance, Gontarski raises a question that continues to ring bells in directing circles and also among Beckett critics and theorists:

> Is there a future for Beckettian performance? Can it be reinvented again? And if so, what might such reinvention look like, given the restrictions on performance imposed by the legal heirs to the work, heirs who function with all the *droits d'auteur*, but none of his flexibility? (Gontarski 2006, 436)[4]

On that account alone, it is no surprise that many directors finally resist the courtship of Beckett's formidable texts, intimidated by the limitations they would inevitably face in the process of staging, most of their fears essentially encapsulated in the risk of having to surrender their artistic

identity. In that respect, the "double" of Beckett *the playwright*, that is Beckett *the director*, adds an extra layer of complication to the already charged relationship between writers and theatre practitioners. Hence the joke in the theatre market, that the best, in fact the *only* possible way for someone to direct is to resort to the obvious convenience of dead authors. All pleasantries aside, that choice appears really popular with auteur directors, who prefer to shy away from dealing with a (vocal) living playwright in the rehearsal room. In relation to the particular terrors possessing Beckett-engrossed directors, Jonathan Kalb in *Beckett in Performance* (1989) brings up an unusual metaphor, which "from the standpoint of contemporary performance theory" renders Beckett "the embodiment of the director's nightmare, the Ghost of Banquo in the person of the Author, who was supposed to have been mortally wounded at the end of last century and dead since Artaud" (150).

The extents to which playwrights and scripts can determine performance is an issue that arose painfully in JoAnne Akalaitis' 1984 production of *Endgame* at the American Repertory Theatre (A.R.T.) in Boston. Beckett denounced the project altogether, discrediting the director's choices as reflecting a vision of the play very far removed from his own. In the A.R.T. program notes, his discontent was made quite clamorous: "Any production of *Endgame* which ignores my stage directions is completely unacceptable to me" (quoted in Brustein 1999). Given Beckett's proprietorial zeal and daunting passion for control, one can only wonder what the appeal of directing his plays actually is. According to Alan Schneider, apparently Beckett's favorite American director, working on a Beckett text is simply a matter of making sure that "the nonessentials don't creep back in" (Brater 1990, 4). Once again, it is the unsettled definition of "nonessentials" that harbors misunderstanding and even ferocious dissent.

Naturally, these concerns remain unresolved. For one thing, directors committed to Beckett have no choice but to follow the thread carefully laid out by the playwright and remain aware that no matter how innovational it aspires to be, set as it is within text-fixed yet performance-related boundaries, the production can never really look *much* different from any other director's version of the same play. No matter how ingenious the director, how distinct of a persona the actors bear, how original their physicality and levels of emotional content, and how minutely conceived the details of design are, there is in fact very little an artist can do to break free from the formal requirements of Beckett's performance scripts. Stepping outside the prescriptive diagrams that Beckett repeatedly inserts in his plays would never simply be a mere aesthetic choice: these blueprints are part of the script, and, specifically in the case of Beckett, for a director to ignore or deviate from the "text" would be an open declaration of his or

her opposition to the right and the potential of drama to be anything more than simply "literature."

III. THE TEXT ON AND OF[F] THE STAGE

The infamous rejection of Akalaitis' staging of *Endgame* in 1984 was, legally speaking, ascribed to the production's refusal to conform to the play's laid out specifications of set. Notwithstanding the extremity of Beckett's attitude, irritating though this reminder might be to some, we can never emphasize enough that stage directions for him constitute a vital part of the text and are not to be taken lightly; not only do they serve as the latent voice of the director-author, but also provide a structure that accommodates dramatic action. This fact alone connotes their authorial and authoritative function, which duly begets remarkably similar-looking productions, rendering the possibility for stylistic variation sadly implausible.[5]

Quite radically in his later plays, Beckett increasingly lists production parameters in a body of detailed stage directions at the beginning of the text, where ordinarily dramatis personae would be introduced. This strategy signals his moving further and further inside the practice of directing. In *Rockaby* (1979), for instance, the opening indication of "light/eyes/costume/attitude/chair/rock/voice" (*CSP*, 273–4) immediately captures our attention. Sometimes the stage directions, which can also appear at the end of the play, are as great in volume as the text itself. In *Come and Go* (1965) for example, they actually include a diagram of each of the three characters' position in performance (196); even more scrupulous is the insertion of a diagram of the rings meaningfully referred to by the protagonists, together with another one describing the way their hands should be formed at the end of the play. This kind of meticulousness, however, cannot be justified purely on the grounds of the given choreographic complexity throughout the piece: in addition to dictating the successive positions that the three females take up on stage, the notes at the end of the play have a prescriptive function, containing detailed information on the lighting, costume, set pieces (seats), and actors' exits. Even vocal intonation, such as expressive "*Ohs*" that punctuate the play's action, is fully accounted for. The unique, if peremptory, function of Beckett's notes transforms readers into audience members, invited to envision the performed version of what they have just read. In a most satisfying act of imagination, the reader is subconsciously involved in the mechanics of directing, creatively applying Beckett's instructions to the text.

In *Not I*, because the stage directions command a performative reading (that is, a reading in which stage considerations are fully accounted for), rather than a literary one, we are coerced into conceiving the text in visual

terms. Actually, this formal strategy, first conceived in *Happy Days,* presupposes and relies upon a sensual, rather than an intellectual processing of all information. In the opening note of *Not I,* movement is defined to be an act of raising and falling of arms sideways *"in a gesture of helpless compassion,"* which progressively diminishes to the point of becoming barely noticeable in the third recurrence. The duration of the pause is also specified to be just about enough to hold the motion (*CSP,* 215). Following the initial note, Beckett promptly introduces us to his bizarre universe by designating the very presence of the protagonist Mouth, standing upstage audience right in a dark stage, *"about 8' above stage level, faintly lit from close-up and below, rest of face in shadow"* (216). The "antagonist" Auditor's position on stage, physical posture, and costuming are also described in detail: standing downstage audience left, he is a "tall standing figure" of undeterminable sex, covered *"from head to foot in loose black djellaba, with hood."* He is also fully lit, but only *"faintly,"* and placed on *"invisible podium about 4' high,"* he is *"shown by attitude alone to be facing diagonally across stage intent on MOUTH, dead still throughout but for four brief movements where indicated"* (216).

Herbert Blau argues that "Beckett taught us before theory that paratextuality is built into the language" (2000, 67). Carefully outlined in the opening directions, staging elements function both as dramatic principles and as a way to organize performance texts. Accordingly, the section at the end of each play, which Beckett dedicates to matters of staging, ought not to be seen as an addendum for production, but as an integral part of the text itself. Within the composite stage picture, the framing principles of set, props, choreography, silence, lighting, and repetition are prevailing idioms that run parallel to the words of the text. As such, they not only provide clues for the text's physical realization on stage but also reveal a form of writing that is as malleable and open as performance itself. The story told depends for its stage articulation—whether actual or virtual—on the playwright's intuition of an embodied world that can breathe life to it. As the existentialist meets the postmodernist, a variety of things may happen on the way: barriers between drama and performance collapse for the empowered text to reverberate the fissures and perturbations of contemporary experience.

Clearly, the incorporation of notes in Beckett's plays further testifies to his writing's precocious postmodernism, vindicating as it does, the possibility of *anything* becoming text. Several years after Beckett's iconoclasm, imaginative experiments with the form of dramatic writing itself have yielded multidimensional texts that make no attempt to separate the conventional *dramatic* parts (for example, dialogue) from their performance context.[6] In this book's last chapter, we will analyze in some detail the ways in which Beckett's formal innovations have significantly been passed onto

neo-dramatic writing. It may be helpful to mark anyway how the interaction of the performing arts with literature—which was essentially heralded by Beckett's radio plays as well as by texts such as *Ghost Trio, Quad,... but the clouds..., Nacht und Träume*, all written for television—has further anticipated the future genesis of enthralling mixed-media plays, as is, for example, British playwright Caryl Churchill's *Hotel* (1997), a choreographed opera or sung ballet set in a hotel room.

Lighting: Perfectly subsumed into the notes are specifications of lighting. Beckett uses an imaginative range of possibilities to create liminal spaces that place particular emphasis on the precariousness of the characters' lives. Clearly defined in the stage directions, the interplay between light and darkness and the contrast of the lit and dark areas of the stage varies in form, duration, and intensity from play to play. For instance, in *Rockaby*, Beckett manipulates lighting combinations to create revolving perspectives on the central visual image of the isolated female figure (the woman, W) who sits on the rocking chair. Different gradations of lighting appear throughout the play, patterning not only the actor but also the space, sculpting it with shades of dark and grey: while the rest of the stage remains obscure, the light on the rocking chair accentuates the character's minimal action. The faint spotlight on the face remains constant throughout the play. As is suggested in the stage directions, sometimes, its rim may include "*narrow limits of rock*," but will remain focused on the face "*when still or at mid-rock.*" During W's speech, her face moves gently in and out of light, layering the visual impression of the scene (*CSP*, 273).

Lighting is a powerful index of possibilities, providing, defining, or refining identity and, on many occasions, acting as the "third character" in the play, which either grants favors or altogether sabotages action. For example, in *Play* (1962–1963), the spotlight, one of Beckett's most cherished recurrent devices, is converted into a supreme weapon against the three characters that try to tell a story, serving as a convincing symbol of the writer's authority over his own narrative. According to the stage directions, the spotlight focusing on the actors' faces activates their speech, while lighting swifts from one character to another without delay, dictating, rather than following, the rhythm of delivery, since "*the response to light is immediate*" (*CSP*, 147). In addition, in the notes placed at the end of the play, Beckett clarifies that "the source of light is single and must not be situated outside the ideal space (stage) occupied by its victims." Quite adept at the varieties and possibilities of lighting design, Beckett prescribes the positioning of the spot to be at the "*centre of the footlights*," which will allow the faces to be lit "*at close quarters and from below*" (158). The notes are particularly emphatic, predicting each potential staging choice; for example, the likely occasion when three spots would be "*required to light the three faces simultaneously*," in which case "*they*

should be as single spot branching into three" (158). Beckett even feels obliged to provide full justification for his directives, explaining how the "*method consisting in assigning to each face a separate fixed spot is unsatisfactory in that it is less expressive of a unique inquisitor than the single mobile spot*" (158). Pondering upon the sadistic role of the spotlight on Beckett's stage, Anna McMullan argues that much of his theatre:

> Focuses on strategies of surveillance and spectacle—most of the bodies which appear in his plays are subject to discipline and cannot escape either the confines of the stage or the relentless glare of the spotlight.... Beckett plays on relations and levels of authority within the theatrical apparatus: the authority of the text, the author, the director or the audience. The body of the actor is frequently foregrounded as the material on which this authority is inscribed and displayed. (1993, 16)

Hence, in *Play*, the writer assumes the joined role of stage manager and light board operator, in control of the blackout sequence. The use of spots that get transferred from one character to another supports the authority of the writer as a director-God bestowing the power of speech on his subjects. As a consequence, lighting becomes the main protagonist in the play, given that the omni-powerful spotlight enables as well as monitors the characters' speech. The three obscure personae are obliged to patiently wait for the spotlight's arrival, so that they can get on with their story, welcoming the right to recite their lines, which can only be granted by the spotlight on each of them alternately. The writer's preoccupation with darkness and light is even haunting the play's very words:

> W1: Yes, strange, darkness best, and the darker the worse, till all dark, then all well, for the time, but it will come, the thing is there, you'll see it, get off me, keep off me, all dark, all still, all over, wiped out. (*CSP*, 147)

The constitutional function of lighting is also prominent in *Footfalls* (1975), adding to the intriguing aural atmosphere of the play and reinforcing imagistically the recurrent structural motif of footsteps. Ironically, the lighting scheme set up in the play's stage directions consciously conceals, rather than revealing details of set and costumes: "*Lighting: dim, strongest at floor level, less on body, least on head*" (*CSP*, 239). May is clad in a "*worn grey wrap hiding feet, trailing*," and the patterned dimming of light on the strip focuses our attention on the auditory, rather than visual details of the play. Inevitably, the insidious presence of lighting isolates the acting area and directs our concentration to the "*clearly audible rhythmic pad*" of nine steps on a strip downstage, parallel with front, "*width one meter, a little off centre audience right*" (239).

Set: Writing to Jean Reavey in 1962, Beckett underlined the use of stage space as "primary in dramatic construction" (quoted in McMillan and Fehsenfeld 1988, 15). Along with the conceptualized function of lighting, Beckett's bare stages intentionally contain no specific representational value, a fact that permits him to open up the microcosm of his characters to even greater abstraction. In *Play*, the curtain rises on two women and a man (referred to only as W1, W2, and M) situated in a row along the front of the stage with their heads sticking out of the tops of large urns and the rest of their bodies unexposed. In the course of their [in]action, there is no change in either landscape or the positions of the actors. Rather, drawn into this barren space, the spectator experiences isolation in its extreme form, rendered a slave to the discretion of the spotlight. A cardinal theme in Beckett's writing, existential solitude is ubiquitous in his encapsulated landscapes, which are permeated with reflections of alienation and impotence. The scenery is minimal and symbolic, mirroring the irremediable condition of a world devoid of substance, in which the subject remains suspended, disoriented, and abandoned. Dean Wilcox explores how Beckett's later plays "allow the space of the stage to resonate a presence with its presumed absence":

> Beckett created a dramaturgical structure in which the space of the theatre is addressed as space and not as an illusionary place. It is with this understanding that Beckett was able to side step the notion of dramatic place to allow the theatrical space to take precedence and ... illuminate the power and presence of that which is presumed empty. (2000, 550)

In reality, none of *Play, Not I,* or *That Time* (1975) exudes any visible signs of human presence or even traces of a life that had existed in some remote past. The bare stage typically confines the voice to a space "emptied of all but the word" (Tharu 1984, 92). The overall conceit is that of sterility, as if the earth has sucked up the lifeblood of humankind, depleting the surrounding space of all oxygen. Unlike the representational sets encountered in realistic theatre, in Beckett's world, the barren stage cannot hold memory or echoes of anything that stretches beyond the unbearable "now" of the protagonists' narrative. Steeped in nondescript stillness, it craves for a vibrant image, whether visual or aural, that will animate it.

Movement: Regarding it an intrinsic part of the mise-en-scène, Beckett is also extremely punctilious about the actors' movement. Quite predictably, blocking no longer communicates a plausible or predictable sequence of the positions that human beings normally assume on different occasions; rather, the physical life of the "characters" is activated within a tight choreographic pattern, joining together several ingredients of staging to convey the playwright's point of view more forcefully. In *Quad* (1982), subtitled *"A piece for*

four players, light and percussion," four figures appear in succession, scurrying along to a rapid, polyrhythmic percussion beat to form a quadrangle, and then depart in sequence (*CSP*, 291). The play contains no dialogue, only the four Players who traverse the perimeter and the diagonal of a square. Beckett defines the paths of each Player with absolute precision, analogous to that of a computer program and, as in a game, fully determines in advance both the proposed course to be followed and the demarcation of the rules. This fact alone magnifies the impression of inexorability embedded in the formalized movement: the Players rush toward what initially appears to be a collision point, but instead of achieving a climactic encounter, are "obliged" to start all over again, and the pattern keeps repeating itself. What first comes across as a comedic routine is gradually transformed into an ordained march, poignantly echoing Winnie's lamentation in *Happy Days:* "What a curse, mobility" (46).

By and of itself, movement is rarely separated from the text: certain words and speech patterns can only be uttered in distinct body postures and some lines are only produced from a specific physicality. For example, text and choreography interface in *Rockaby,* with the rhythm of textual delivery not simply adjusted to the movement of the rocking figure, but purposely written into it. Once more, Beckett pieces together seemingly contrasting performance elements, pursuing a total work of art. Quite predictably, lighting is instrumental: when there is speech, the face is *"slightly swaying in and out of light"* (*CSP*, 273); similarly, when Voice (V) gives way to an echo and the rocking comes to rest, there is a *"faint fade of light"* (273). In truth, sound, movement, and lighting work together in admirable synchronicity and the joined impact is enhanced by occasional touches of color and shades in the playwright's black-and-white canvas: W, sitting on a chair that is *"pale wood highly polished to gleam when rocking"* (273) wears a black evening gown, while her unkempt hair is grey and her face and hands are white. The correspondence of the visual to the audible image is so solid that each seems unable to stand on its own without the other; in this vein, the language we hear not only offers us background exposition for the image we see but also describes it neatly and systematically. In the end, the poetic anatomy of the text fosters the rocking movement of the protagonist in such powerful way that it becomes almost impossible to determine if it is the rhythm of the text that generates the rocking, or if, instead, the structure of the rocking gives the text its distinct musical shape, akin to a lullaby:

> ... Till in the end
> Close of a long day
> To herself

Whom else
Time she stopped
Going to and fro
Time she stopped (*CSP*, 276)

According to the embedded directions, there is a simultaneous "*coming to rest of rock*" and "*faint fade of light*," immediately after the echo of the voice's "*time she stopped,*" which, in turn, is succeeded by a long pause. When the rocking momentarily stops, V stops, too; it is only W's plaintive interjections of "more" that urge both rocking and the voice to keep going (276).

Costume: Not surprisingly, the description of costume in Beckett's stage directions is also remarkably precise. The playwright's fascination with the equivocal and the grotesque pervades his "de-characterized" protagonists, ordinarily dreary and devoid of individual attributes, with their facial features mostly concealed. Their nondescript-ness becomes a visual statement of their trifling position in a meaningless universe; in a world that cannot nurture grace or benevolence, the function of the costumes serves to underline human beings' uniformity and drabness and, on certain occasions, even their singular aberrancy. While in *Not I* the description of costuming, especially in relation to the Auditor, sets the tone and the atmosphere of the play, even more conspicuously, in *Come and Go* the costume design provides a particularly emphatic mechanism of characterization: Ru, Vi, and Flo are clad in identically shaped coats, "full-length" and "buttoned high." All three of them wear "*drab nondescript hats with enough brim to shade faces*" and "*light shoes with rubber soles,*" while their hands are "*made up to be as visible as possible.*" As far as we can tell, none of them wear rings. What is important for Beckett, however, is that the three "figures" appear to be "*as alike as possible,*" the only differentiation being the color of their overcoats, "*dull violet,*" "*dull red,*" and "*dull yellow*" for Ru, Vi, and Flo, respectively (*CSP*, 196). Sometimes, the characters' costumes tie in with both lighting and movement in operative ways, as in *Rockaby*, in which W's jet sequins on her stunning robe of black lace are made to "*glitter when rocking.*" In similar fashion, the "*incongruous flimsy head-dress*" is "*set askew with extravagant trimming to catch light when rocking*" (273). Sometimes, as in *Quad*, where "*each player has his particular color corresponding to his light: 1 white, 2 yellow, 3 blue, 4 red. All possible costume combinations given*" (292), costume administers additional structural backing to the play. To bring up some more examples: in *A Piece of Monologue*, the Speaker in "*white hair, white nightgown, white socks*" (265) is more of an apparition than a fully fleshed individual, while *Catastrophe* offers another aspect of the organic function of costume: the autocratic Director exercises his power over Protagonist by constantly dressing and undressing him (coat, hat, gloves), wishing to achieve a specific

visual effect and force his own personal fantasies on the actor and on the performance. At the same time, the masterful use of makeup, adding significantly to the overall alienating effect in Beckett's work, delivers white, ghostly, sexless faces of no particular character or identity, *"so lost to age and aspect,"* as in *Play,* as to seem *"almost part of urns"* (147).

Fundamentally, Beckett's revised form fills in for plot and exposition. The comprehensive stage directions substitute for background information and the Aristotelian rules describing and prescribing dialogue-bound elements of structure such as rising action, reversals, recognition, climax, and denouement, could not be further removed from the application of a modernist aesthetic. In contrast, readers are invited to "unearth" whatever referential clue exists mostly through the notes, which in themselves greatly define the progression of dramatic action, hijacking a role traditionally held by dialogue. Almost certainly, if we had to compare the entire set of dramaturgical principles expressed by Aristotle in *The Poetics* on the one hand and by Beckett on the other, we would be unable to leave the matter of characterization aside, particularly vis-à-vis Beckett's "insolent" obliteration of psychology. As we move further inside Beckett's non-eschatological writing, we begin to accept that the presence of psychologically defined characters becomes less apparent or relevant. Arguably:

> In the later plays the strategies that Beckett employs to diminish the presence of his character become more schematic—to the point when the words that form the text are removed from the actor and presented independently as a recitation to which he or she listens... Beckett's characters seem trapped both within some defined space and within these verbal structures that possess their minds. (Lyons 1982–1983, 300)

And while in more traditional forms of drama, elements of structure, such as exposition, are principally divulged in the dialogue, its underlying subtext, or both, Beckett leans on the juxtaposition or the conflict between the main dramatic characters and their abstracted double in order to expose stories well hidden in memory and in constant battle with the character's *present.* Sometimes, *para-dramatic* counterparts are embodied in the dissociated half of one's self or in a complementary "other," cast as a Voice, a tape recorder, or a Mouth. In *Footfalls,* the reader- spectator witnesses a dialogue between a May (M) and her mother's voice (V). All through the play it remains unclear whether what we see and what we hear actually refer to the characters' own past or to sheer bits and pieces taken from other people's personal histories; Beckett establishes a central plot structure based on the encounter of M with V, refraining from specifying whether that confrontation is experienced, remembered, or manufactured. In respect to this, Brater talks about

a "compensatory formal coherence," which replaces the easy apprehension of plot summary (1990, 53). Note, for example, the following excerpt from the play, where the staccato delivery and the repetition motif both give texture to M's dialogue with her (imaginary) mother:

> M. What age am I now?
> V. And I? [*Pause. No louder*]. And I?
> M. Ninety.
> V. So much?
> M. Eighty-nine, ninety.
> V. I had you late. [*Pause*]. In life. [*Pause*]. Forgive me again. [*Pause. No louder*]. Forgive me again. (*CSP*, 240)

In exploring issues of subjectivity and embodied-ness in Beckett's work, Stanton Garner comments on the profound dislocation of the self:

> By the time of such late works as *Not I* (1972), *Footfalls* (1976) and *What Where* (1983), the body is almost a ghost of itself, reduced and decentered in the minimal space it has left, doubled by words that both address and disown it. Invaded on all sides by an irremediable absence, its very presence to itself is no longer secure (1994, 29)...From the physical harshness of *Godot*... to the simultaneously bodied and disembodied spaces of the late plays, Beckett's drama explores the instability between a profound material inherence in the physical body and a corresponding alienation, and it dramatizes the subject's futile pursuit of any means for overcoming its own non-coincidence. (31)

The sense of alienation that Garner impresses is intensified further by Beckett's adept control of time as a rudiment of exposition, also informing the aesthetic choices of many contemporary auteurs who distort, accelerate, or annihilate its frame to undermine smooth representation. Robert Wilson, Christoph Marthaler, Krzysztof Warlikowski, Simon McBurney, and Elizabeth LeCompte are especially skilled at bending dramatic time to navigate their audiences through the fluctuating, yet highly captivating actuality of an ever fluid *now*. It is important to trace some of their strategies back to Beckett: rather than exposing issues of historical time—that is, of time that has been known to have existed and can therefore be accounted for—in the characters' lives, Beckett's dramas oscillate between a timeless past and a flexible present, stretching beyond conventional measures of temporality, continuity, or duration, while the stage abstractions that dramatic characters compete against also carry a story within them. In such light, the convergence of literature with performance originates a remarkable type of structure, with exposition lying at the mercy of the spectator's bridging the two competing ends of the spectrum. To illustrate the point, in *Rockaby*, the

rocking figure in the chair urges her own recorded voice to tell her story, always interjecting with the imperative "*more*" at critically timed moments.

Repetition, too, becomes one of the most striking mechanisms to further exposition within the characters' hallucinatory fictions. By intermittently referring back to specific parts of a story and reiterating key words and phrases, Beckett hierarchizes one theme over another, directing our attention accordingly. In *Not I*, underneath the main narrative of Mouth reporting a nameless woman's inability for speech is the theme of an infant's abandonment, which keeps coming back as a repeated motif in Mouth's story, not only to open the play but also featured throughout it: from Mouth's delirious speech, it is only scattered fragments that we can use to piece together the story about the little girl who is apparently prematurely born to no family:

> MOUTH:...out...into this world...this world...tiny little thing...before its time...in a godfor—...what?...girl?...yes...tiny little girl...godforsaken hole called...called...no matter...parents unknown...unheard of...(*CSP*, 216)

The merciless repetition of phrases such as "tiny little thing," "godforsaken," and "speechless all her days," which flesh out the moments after "*pause and movement 3*" (221) as well as "*pause and movement 4*" (222), gives added emphasis to the overwhelming feeling of desolation that the play betrays. Similar patterns of repetition exist in *Rockaby, A Piece of Monologue*, and *Ohio Impromptu* and help establish the impression of a unified story that spectators are encouraged to trail, restoring in them the energy to mentally conjure up the strand of some plot rather than systematically follow an actual line of action.

When directing his plays, Beckett also required of his actors to visualize every action of their characters. "Know precisely in what direction they are speaking," he urged them. "Know the pauses" (quoted in McMillan and Fehsenfeld 1988, 15). In his view, the sensory image lay at the center of theatre praxis, affecting sight, hearing, and intellect in the same way that visual representation was just as important as, if not more powerful than, verbal communication, the one sometimes supporting and complementing, or reversely, contrasting and antagonizing, the other. In the later plays, the verbal text exists in fragments, pitted against the stark visuals of barren landscapes (as in the mime *Act Without Words I* [1956]), geometric configurations (as in *Quad* [1981]), or singular forms (as in *Not I*). Those multilayered texts, products of the jarring junction of logos and image, challenge our faculties of perception and, at the same time, reflect the writer's profound understanding of the audience's processes of reception. The emergence of a sustained conceit through "words in motion" confirms Beckett's supreme

visual sensibilities. The dramaturgical potential of the image reverberates in his emblematic landscapes, bare, suggestive, and strikingly parabolic, an endless horizon of kinesthetic possibilities allowing the text to come to life. Often injected with technological potential, they betray an intense fascination with pictorial composition, whether symbolist (*Come and Go* and *What Where* [1983]) or utterly surreal (*Not I*). However Beckett constructs his imagery, the result is always, at the very least, dramatic. Like a visual artist, he is meticulous with the materials and techniques he applies on his canvas, as in *Play*, where the dominant frame of the three heads emerging out of the three large urns—the rest of the bodies concealed and immobile throughout—makes up, beyond any doubt, for an original comment on stagnation and entrapment. Perhaps less alarming, but equally sensational, is the single "shot" of the rocking figure in *Rockaby*. Dressed in formal costume and alternately lit from different angles, W recalls Baroque portraits steeped in chiaroscuro cadence. To that effect, the text is choreographed in detail, for the dramatic conceit of rocking to embrace a broader sensatory image. Sometimes, the designed imprint eclipses the mere painterly. *Not I* is set in a pitch-black space lit by a single beam of light illuminating just the actress's mouth. Standing on its own to unleash a torrent of rambling sentences, Mouth becomes a terrifying symbol of disarticulation and dismemberment. The very fact that the protagonist is a purely visual element is telling: accepting a mouth as the unorthodox focus of the play predisposes us to think of the text in staging terms. Because it is impossible to attribute psychological intentions to a compositional element, the mere suggestion of motivation and character would appear ludicrous.

Significantly, visual metaphors are predominantly indices of the subjects' fractured or displaced identities. Beckett's ravishing icons of dissociation never fall short of underlining his special interest in the experiential reading of his plays, as opposed to a cerebral processing and appreciation of plot and subject matter: "I am not un-duly-concerned with intelligibility," the playwright told actress Jessica Tandy, who played Mouth in the Alan Schneider New York premiere of *Not I* in 1972. Adding, characteristically: "I hope this piece may work on the nerves of the audience, not its intellect" (quoted in McMillan and Fehsenfeld 1988, 15). Living up to his promises, Beckett sadistically tests his spectators' tenacity, balancing out sound and visual stimulation so that their ears and eyes are never given a rest. In *Not I*, he manipulates *both* sight and hearing: while Mouth speaks, Auditor hears, and audience sees, we are obliged to never lose track of the point where sound and image converge. This "anguish of perceivedness," to use Beckett's term in *Film* (*CSP*, 163) is instantly experienced by the audience. "As Mouth talks about fixing something with her eye, 'lest it elude her,' this is precisely the audience's visual limitation in focusing the lenses of its own eyes on the minimal image of

Mouth" (Brater 1990, 20). Since spectators have trouble locating the physical presence of Mouth, they are partly deprived of the image. It is also taxing to follow Mouth's teeming monologue; fully aware that certain words will escape us, we members of the audience still obsess about how the dialogue is carried on. "Auditor is 'practically speechless,' and Mouth is only lips, teeth, and tongue, not, as far as we can see, eye or ear" (21).

The image-metaphor in *Not I* is particularly complex, implicating all three of the speaker's sensory organs (eyes, ears, and mouth), which naturally trigger different types of stimuli in the spectator. As a consequence, the convergence of "textual" and "performance" languages not only brings a tension in the dramatic action of the play, but also forces readers-spectators to cultivate their own interpretation, to be witness to all aspects of the play's making. Ironically, in the same way that textual language is bolstered up by evocative stage images, visual iconography is contingent on the words that generate and sustain its formation. In *A Piece of Monologue* (1979), while Speaker describes the images we see, we actually expect them to gradually materialize in front of our eyes through his words, transformed from static descriptions into dynamic properties of action: "Where is he now? Back at window staring out. Eyes glued to pane. As if looking his last. Turns away at last and gropes through faint unaccountable light to unseen lamp. White gown moving through that gloom" (*CSP*, 268). In like manner, visual considerations are not addressed merely in the stage images, but also unfold subtly in the text, facilitating exposition. In fact, while Speaker tells his story in visual terms, language forms pictures as *word-scapes*, steadily fixed in the present tense, the inexorable and irredeemable "now" of performance. Similarly generated and executed through language are also the props that flow over Speaker's monologue:

> In the light of spill faintly the hand and milkwhite globe. Then second hand. In light of spill. Takes off globe and disappears. Reappears empty. Takes off chimney. Two hands and chimney in light of spill. Spill to wick. Chimney back on. Hand with spill disappears. Second hand disappears. Chimney alone in gloom. Hand appears with globe. Globe back on. (*CSP*, 267)

Other times, sensory images are forged by combining or contrasting visuals with sound, as in *Footfalls,* in which a musical circular structure is tied to the movement and where, reversely, movement determines the overall visual effect of the stage picture, in a fashion reminiscent of *Rockaby.* The play's physical life and sound-score are closely interconnected, bound by a tight rhythmic pattern prescribing which words and sounds should accompany the footsteps. Yet, although the play's choreographic pattern is compelling in itself, Beckett also wants to satisfy our sense of hearing: not only

is V hauntingly reciting its story but the sound-scape of steps, chimes, and echoes also reinforces the general dramatic effect. In the opening directions the steps are described as a *"clearly audible rhythmic tread"* (239). Reference is also made to the voices *"both low and slow throughout"* (239), while a *"faint single chime"* and a pause *"as echoes die"* are also integrated in the text (239). M's pacing, while she carries on a dreamlike conversation with her mother, makes for a resonant visual, particularly in relation to the actual sound of the steps, the compulsive speech of V, and the chiming accompanying the action. Once again, the audience's attention is shifted from one sensory source to another. Nevertheless, the leading concept remains aural. Sound is framed, rather than antagonized by the visual impact of M's pacing. The effect of bell chimes, the intervening silences, and the shuffling of M's feet are all augmented by Beckett's poetic use of lighting and taut choreography. As a result, the echo of the uncanny footsteps, as imagined by the reader and perceived by the audience, breaks into an infinite time, a metaphysical locus of endless vagrancy.

At the same time, the interest in combining diverse art forms to formulate a new language for his plays also led Beckett to a sophisticated involvement with stage machinery. On the simplest level, technology was disguised as a spotlight regulating the action and speech of the three characters in *Play*; it also supported the simple mechanical equipment for the bringing in and out of the props in *Act Without Words I*, together with the perfunctory movement of the rocker in *Rockaby*. Technology was also present in the small megaphone in *What Where* (1983), functioning purely as an expository device. Implementing a subtler metaphor, it became embodied in the tape recorder which controls memory and time in *Krapp's Last Tape* (1958), perhaps the most celebrated example of Beckett's manipulation of technology's dramaturgical potential. Alongside, in the radio play *Cascando* (1961), an Opener "opens" and "closes" two characters: Voice desperately promises "this time" to tell a story he or she can finish, while Music also struggles to create a finished composition. In some ways, the play dramatizes an existential quest for closure and resolution. The interplay of the three "characters," whereby when instructed by Opener, Voice begins mid-sentence, is reminiscent of Krapp's taped diary entries:

> OPENER: [*With* VOICE.] And I close.
> [*Silence.*]
> I open the other.
> MUSIC:...............................
> OPENER: [With MUSIC.] And I close. (*CSP*, 137)

Manipulated at will by the playwright-director, technology dispenses the means to control the logistics of time and memory. At the same time,

mechanical devices frame the action, signaling the shift from present to past time. In *Krapp's Last Tape,* Krapp listens disdainfully to his earlier self recorded in several tapes, choosing to intervene by either rewinding the tape at specific moments, or suspending the recorded narrative altogether:

> TAPE: back on the year that is gone, with what I hope is perhaps a glint of the old eye to come, there is of course the house on the canal where mother lay a-dying, in the late autumn, after her long viduity [KRAPP *gives a start*] and the—[KRAPP *switches off, winds back tape a little, bends his ear closer to machine, switches on*]—a-dying, after her long viduity, and the—[KRAPP *switches off, raises his head, stares blankly before him. His lips move in the syllables of "viduity." No sound…*] (*CSP,* 59)

Yet, temporality and remembrance, formerly handled through recording devices, were progressively controlled by less realistic means, and heavy, material apparatus, such as the dramatically and dramaturgically awkward recording machines, were replaced by more abstract forms of memory signifiers. Cumbersome realistic devices eventually disappeared from Beckett's writing in favor of the disembodied voice, which was granted character and stage presence. Freestanding in its separation from the material self, the voice became a "voluminous" expression of the subject's immersion into the paths of consciousness. As theatrical form looks increasingly inward, Beckett explores the physicality of the inner voice, against which the conventional "dramatic" persona is pitted. We have but barely touched upon the issue of the dismembered body in *Not I,* where the Auditor remains silent, confronted by the terrifying presence of Mouth. In similar ways, the central metaphor of the divided subject in *Rockaby* is graphically conveyed in the split between the voice (V) and the body (W) in one single person; yet, the most dramatic effect is achieved thanks to the interplay of recorded and live voice. In *That Time,* Beckett introduces us to Listener's face and to "Voices A B C" that are "*his own coming to him from both sides and above*" (*CSP,* 228), making the disconnection transparent in the triple split defining the Listener's consciousness. Along these lines, the ongoing fascination with synthesizing filmmaking, television, and dramatic strategies also engendered plays such as *A Piece of Monologue* and *Ohio Impromptu;* in the latter, the implacable repetition of sounds and images shapes the language of Speaker and Reader, respectively. Despite the lack of a recorded voice, both actors' voices set a religiously deliberate rhythmical pattern.

By its own nature technology adds another dimension to Beckett's dramatic form, capable as it is of introducing nonhuman elements into live action and therefore amplifying his plays' pervading sense of desolation. Linda Ben-Zvi argues that "what technology can do is to provide one more way of calling attention to 'the mess' by allowing chaos into art and not

trying to quell or explain it—Beckett's way of 'failing better' in the con-
temporary world" (2006, 486). Beckett employed technology to pronounce
more emphatically the limitations of word-based theatre and, reversely, the
multiple possibilities of compound genres. In doing so, he stretched the
boundaries of drama to thus far unimaginable extremes: the inspirational
use of mixed media in his late plays has influenced the productions of estab-
lished auteurs such as LeCompte, Sellars, and McBurney, as well as the aes-
thetic choices of smaller but equally imaginative theatre companies, such as
the New York–based Ridge Theatre.[7] Inviting performance into his drama,
Beckett achieves a kind of stage poetry that would be hard to create or be
sustained through verbal language and literary form alone. As the sensory
image establishes its concreteness, a new dramatic form beyond the abstract
signification of the word begins to emerge. Defying all genre classifications,
Beckett's texts may partly justify actress Jessica Tandy's semi-comedic view
of his art: "You may find nothing in it, but I suspect you will never forget it"
(Brater 1990, 21). As the plays become shorter and shorter, the sensory image
conquests the terra firma of the page, ousting the word to a less domineering
position and yielding original formations that feature conventions of their
own. Beckett's acquired, as well as *essentialist*, understanding of minimalism
guarantees that nothing more than absolutely necessary will ever enter his
theatre. Embodying Artaud's ideal of the archetypical auteur, and more sig-
nificantly, confirming it as a viable possibility, he provides a perfect writer/
director composite.

AUTEUR ON THE ROAD

I. DIRECTORS AS SELVES

Strongly influenced by the aesthetic and philosophy both of Artaud's "Theatre of Cruelty" and of Beckett's minimalist writing and following course on the early-twentieth-century experiments in technique as well as form, directors from the 1960s onward responded to what Hungarian literary critic Péter Szondi described as "the crisis of drama," which manifested itself in an "increasing tension between the formal requirements of Aristotelian drama and the demands of modern 'epic' social themes which could no longer be contained by this form" (quoted in Lehmann 2006, 2). It is worth examining the different ways in which auteurs, especially from the mid-1980s on, furthered and perfected the methods and discoveries of pioneers such as Jarry, Craig, Meyerhold, Appia, Stanislavski, Piscator, and Brecht, conscious that a more abstract type of theatre, in relation to the performance's conception, design, and acting style, was gradually becoming a valid reality, almost a necessity in itself. Having acquired confidence in this shifting of emphasis from mimetic, plot-driven drama to an ever-fluid image-based performance where various media, textualities, cultures, and styles combine and collide, avant-garde directors in the West have been developing their own singular methods and stage idioms, contributing to the resolute establishment of auteur theatre, which is more than ever present in the wake of the twenty-first century.

As we schematically explore some of these directors' techniques, pursuits, and strategies in both rehearsal and performance, it would be helpful to point out that these artists share a common impulse, namely, to reconsider the notion of text as a dynamic field of interaction for playwrights, directors, actors, designers, and spectators, who come together in order to coauthor the event of performance. In this synergetic process, creative "loans" are a given, with auteurs partaking of similar directorial strategies and theatre languages

to engineer inspirational stage microcosms. As *New York Times* critic Frank Rich argues in "Auteur Directors Bring New Life to Theatre" (1985), even though these "directors' devices sometimes overlap...the visions they offer, however elaborate, are not decorative or illustrative—they transport the audience into states of mind rather than real places."

For one thing, the fascination with process and form renders directors' work susceptible to highly solipsistic creations. What better medium for an auteur than self-referential theatre, drawing attention to the act of self-genesis? A sense of solipsism inevitably informs the course of self-collaboration— Beckett models the self-collaborating artist from the beginning—a frequent trademark of auteur work. In current practice, examples of directors writing their own texts, as is, for instance, Richard Foreman, artistic director of the Ontological-Hysterical Theatre in New York, or younger generation Richard Maxwell with The New York City Players, abound. While Foreman's works are mostly self-referential comments on the process of writing and often "wittily deconstruct themselves in the very process of their enunciation" (Vanden Heuvel 1994, 50), Maxwell's productions tightly place his writer's textual ellipsis within an urban space, constructed through his director's eye and ear for the contemporary; a similar need to sculpt and own the overall artistic outcome is responsible for the desire of self-termed dramatists as is the British writer Howard Barker to also direct their own stage-minded, conspicuously stylized pieces. Together with his company, The Wrestling School, Barker, also a visual artist and theorist, has written, broadcasted, and produced over a hundred plays, uncompromisingly mixing images of explosive violence, passion, history, and current politics in his performances and viewing each one of them as a forum for public debate, where audiences are challenged to keep up with the frenetic pace of his writing and the complexity of his allegorical imagery.

Whilst the variations of self-collaboration range from short performance acts to self-directed solos, the sheer force of creation sometimes underpins the actuality of the play, disrupting the flow of the narrative and deconstructing the illusion of its totality. In this self-reflexive operation, Brechtian principles of distancing prevail, and "there is always a moment at which the performance indicates how it is constructed (and therefore deconstructed), an element which at the same time discourages any referential allusion to the outside world" (Pavis 2003, 317). However, the addictive deliberateness of what often becomes an attack on logic and meaning is also a symptom of directorial insecurity: occasionally, the random selection and mixture of diverse as well as distracting elements, rather than provide the desired critical distance between the spectator and the spectacle, altogether disengages the audience from the experience of genuinely processing and appreciating the performance. In this respect, the desire to break free from established

performance conventions through the construction on stage of an autono-mous universe adhering to its self-determined rules can achieve clarity and significance only if it is founded on directors' vision of *some* world, whether plausible or fantastical.

Foreman to some extent epitomizes the archetypical *auteur* in that his work manifestly redefines the relationship between playwright and director. In the earlier plays "Foreman the director" consciously served "Foreman the playwright": "The sets were extremely minimal...I built everything. But I added no decoration," Forman explains (1992, 71). Later on, however, in *Paradise (Hotel Fuck)* (1998), *Permanent Brain Damage* (1996), and *Pearls for Pigs* (1997), Foreman resolutely altered his former minimal style, actuat-ing ebullient environments that allowed his creative resourcefulness to soar up high, letting the director-designer take over. Nevertheless, the relation-ship between writing and directing in his work remained ultimately one of mutual "respect," with writing informing his stage choices and directing often being an extension of his writing. In fact, Foreman postulated that his staging functioned "not as an attempt to CONVINCE the audience of the play's reality or verisimilitude...but rather [as] an effort to rewrite the text back into manuscript. It is a CONTINUATION of my writing process" (Foreman 1977, 21; emphasis original).

Albeit stylistically distinct from Foreman's work, Wilson's production of *Hamlet* (1995) is also the product of a perfectly balanced control of drama-turgy, movement, design, and acting. Wilson worked with the text adapted by Wolfgang Weins and performed *Hamlet* as a monologue in fifteen scenes. The ingenious conception of the play as a solo not only attests to Wilson's well-served function as the *über*-writer and performer of the piece, who additionally stages and designs it; adding an extra layer of complexity to the idea and practice of self-collaboration, the production introduces the character of Hamlet as an omnipotent auteur, incorporating all aspects of performance into his role, speaking all other characters' lines, and assuming Claudius', Polonius' and Ophelia's personas. In discussing the conceptual basis of his one-man show adaptation in the hour-long documentary *The Making of a Monologue: Robert Wilson's Hamlet* (1995), Wilson reveals that in his preparation of *Hamlet* as a monologue, he was anxious to discover a mechanism that would allow the protagonist to impersonate other charac-ters in the play. Coming up with the strategy of flashbacks, he set the play a few seconds before Hamlet dies and ended it with his last speech, a choice that was justified by the fact that the action was mostly internal, taking place in the character's mind. Hamlet thus looks back on his past life in that "split second before he dies" and sees the whole play in front of his eyes, as much as we can also see him "in many different ways, as a child, or a boy; reflecting on an older person and thus being an older person; reflecting

on a woman and being a woman; being a man."[1] Reinforcing his authorial function by graphically jotting down his thoughts and plans in a notebook as the Danish Prince, Wilson corroborates his status as supreme author of his show, responsible for reorganizing scenes, selecting costumes and props, devising and supervising the solo—essentially, operating as the orchestrator of a large symphonic piece. This approach to directing does full honor to the tenets of auteurism, in which authorship of the performance text is vital: even when auteurs stage a preexisting play, the final performance cannot but carry within it their own mark, and to some degree the production will always retain its stature as the director's work.[2]

In his theory of "Czysta Forma" ("Pure Form") in 1923, Polish painter, playwright, novelist, photographer, and theorist Stanislaw Ignacy Witkiewicz (1885–1939) professed the autonomy of the stage world, a world functioning merely according to its own laws of internal composition.[3] Casting aside all aspects of mimesis in art, the theatre of Pure Form should only be regarded, and thus decoded, as a fiction manufactured exclusively out if its formal elements. In point of fact, the construction of a self-governing world on stage, redeemed both from the binding hold of an intimidating and arbitrarily prescriptive "outside reality" and the "only acceptable reality" of the literary text, has been a uniform pursuit in auteur work. Ingrained into the foundations of Pure Form is the understanding that each theatre event has its own logic and that part of the director's job is to organize and communicate to the spectator the rules that govern it. At the same time, "reality" in art, as Polish auteur Tadeusz Kantor (1915–1990) testifies, "can only be 'used'":

> Making use of reality
> In art
> Signifies
> An annexation of reality....
> During this process,
> Reality transgresses
> Its own boundary
> And moves in the direction of the
> "impossible." (Kantor 1993, 96–7)

Rather than "annexing reality," auteurs choose to focus on the materiality of the present moment, on the "presence" of the performance's *now*, which inadvertently enters the dramatic form causing a series of collisions. A revised sense of the "real" becomes a seminal metaphor, particularly in projects of self-collaboration: for example, Foreman steps into the territory so well laid out by Beckett in his late works, by writing into his own texts his director's vision and amply integrating scenic elements. Often, the very making of a work of art decidedly becomes the subject of his work. At times

self-conscious and self-indulgent, the writing produces "pre-staged performances" rather than dramatic plays, which make subtle allusions to what the playwright has created. As Nick Kaye illustrates:

> Foreman's method involves a continual attempt to observe and defeat his writing's coming into "play" and so to escape the formal and thematic implications of whatever elements he introduces... Signs of plot or narrative are evident, yet no plot emerges. In his stagings, too, Foreman extends precisely this same mode of self-consciousness, looking back towards the fragmentation of his writing rather than forward towards any kind of final coherence. (1994, 52)

In some respects, Foreman's act of writing deliberately undermines itself, sabotaging the possibility of meaning; despite or because of the fact that the text resists the lure of conventional structure, initially seizing the audience's instinctual attention almost by force, one may find it difficult to remain engaged for too long, for the additional reason that Foreman frequently "disrupts any sense of center by the presentation of simultaneous and irreconcilable focuses" (54). The violation of sense and continuity, the dispersal and fragmentation of dialogue, and the performers' consistent concentration on the audience rather than on each other are strategies that reinforce the self-reflexive, fragile nature of his performance texts.

Self-collaboration and the pursuit of artistic autonomy are regularly accompanied by an incestuous reevaluation of themes and techniques, where artistic methods and materials are processed into original configurations. In discussing people's need to remain updated, French philosopher Jean Baudrillard had first formulated the notion of "recycling" as a constitutive aspect of contemporary culture. The strategy of collage, which defines the work of directors as distinct as Foreman, LeCompte, Wilson, Suzuki, and Terzopoulos, rubs together texts, media, traditions, and genres in several compelling (or occasionally demoralizing) fusions. Besides the reticulation of compositional materials such as images, sounds, portions of text, and music, the recycling metaphor in the theatre is further stretched to the broader notion of postmodern *pastiche* of attitudes and methods. Ironically, incongruity becomes a matter and element of style.

Manipulating the relationship of object to its scenic environment, Kantor challenged conventional representation already in the 1960s: in his mise-en-scène, stage articles circulate freely, stripped of their representational potential and rearticulating "their functions in relationships which were accidentally formed and which could not be anticipated according to any pre-given norms" (Kobialka quoted in Mitter and Shevtsova 2005, 70). Ready-made elements as abstract as environments or props are "incorporated into artistic

activity" (70), juxtaposed in dynamic relationships, putting together ravish-
ing collages that carry history and memory within them. *Today is my Birthday*
(1990), bombarded with basic as well as marginal objects and people from the
director's reservoir of imagination and memory, is a characteristic example:
three empty picture frames function as a background to the essentially chime-
rical action, whereby characters from past productions parade on stage freely,
thus effecting a world that blurs all designations between the self-imposed and
tyrannical *real* and the vindicated fantasies of the artist's mind. Not unlike
Kantor, Foreman uses recycling and collage in an attempt to illuminate the
fraught relationship between reality and illusion. Yet he takes the technique a
step further, reclaiming not only images or framing devices such as assorted
strings and distinct sounds, but philosophical considerations and directorial
strategies, as is presentational acting, constant interruption, Brechtian dis-
tancing through blinding lights, buzzers, and musical fragmentation.

Both recycling and collage have ceded a permanent structural axis to
Anne Bogart's SITI Company, cofounded with Tadashi Suzuki in 1992
in Saratoga Springs, New York. Dance-theatre and opera pieces (see *Seven
Deadly Sins* and *Lilith* at the New York City Opera, in 1997 and 2001,
respectively) feature together with new works composed in collaboration
with contemporary playwrights, as are for example, Bogart's and Charles
Mee's unapologetic "remaking" projects. Bogart also favors devised works
(see the film-industry-inspired *American Silents* in 1997), adaptations of
classical texts, and originally synthesized pieces, which are inspired by texts
by a single playwright and which SITI consequently reshapes into organic
performance scripts. Biography also becomes a valid framework for the com-
pany's work, as is manifest in the staging of pieces revolving around major
American cultural icons, such as Andy Warhol (*Culture of Desire* [1998]) and
Robert Wilson (*Bob* [1998]), as well as lofty figures such as Virginia Woolf
(*Room* [2002]), Gertrude Stein (*Gertrude and Alice: A Likeness to Loving*
[1999]), and Orson Welles (*War of the Worlds* [2000]).

Collage-based work is also quintessential for the Wooster Group, which
habitually incorporates principles of film editing into its performances.
Having accumulated and reused a substantial volume of material, including
inside stories, jokes, dance movements, and amusing mistakes, the company
browses through it and adjusts it to the needs of each show. Yet, Wooster
Group's director, Elizabeth LeCompte, refuses to exploit this diverse "mat-
ter" in ways that will facilitate the building of unified mimetic narratives;
rather, the precise use of contrast constantly underpins the assimilation of
collage pieces into potentially seamless compositions. For instance, in the
group's production of *Hamlet* (2007), a filmed version of Richard Burton's
interpretation of the title-protagonist (1964) becomes an instrumental back-
drop to the live action. In this case, the *juxtaposition* rather than *integration*

of "found" elements works counter to the functional principles of collage. In fact, the term is invested with novel significance, divorced from the philosophy of its assumed function of reflecting some idea of totality, however provisional. Furthermore, the Group's mixture of global acting idioms and performance genres is all-embracing, ranging from vaudeville and black minstrelsy in *The Emperor Jones* (1998) and *The Hairy Ape* (1997) to digital technology and Japanese costume and movement in almost every other production. Aesthetically sanctified, the comprehensive eclecticism that inevitably marks the outcome of collage structures comes as no surprise; in fact, audiences have become increasingly familiar with the Group's noncommittal reflections on contemporary hybridized culture, which are inbred in the process. To bring another example: like LeCompte, Mnouchkine—whose narratives are mostly derived from the Western literary canon and history—borrows from the Orient the presentational and distancing elements in movement, costume, mask, and makeup to add a more global sensibility to her stage. In her probing into remote cultures, Mnouchkine is actually in league with Artaud's appreciation of non-Western modes of representation as the sole alternative to word-dominated forms. Mnouchkine's productions remain commanding imagistic fusions that mix East and West, languages and textures, contexts and cultures. Because her imagination has been inoculated with the theatricality of Asian performance since the 1960s, she has no difficulty infusing classical Western texts with acting techniques from India (Kathakali), as is notable in *Les Atrides* (1991), her adaptation of Aeschylus' *Oresteia* trilogy. However, it is really Wilson who epitomizes the eclectic artist *par excellence*. The common observation that in his theatre "anything goes" is no exaggeration: uncannily, minimalist design blends with expressionistic detail, while superbly conceived symbolism alternates with surrealist sequences; in similar fashion, postmodern choreography, together with acting techniques such as Kabuki and Butoh, is set against a vibrant pop-culture frame. Wilson's celebrated collaboration with composer Philip Glass *Einstein on the Beach* (1976) is a marked case of how the amalgamation of disparate styles constitutes a new style in itself.

As opposed to the waking reality, which can be employed as an element of stage composition, the territory of dreams is equally fertile ground for auteur experimentation with form and subject matter. Pursuing a structural flexibility independent of dramatic causal logic, directors have delved deep into the world of the unconscious for inspiration, adopting some of the techniques of expressionism and surrealism. Given that our subconscious works alongside, counter to, or beneath our conscious mind, many auteurs, in Artaud's, Jarry's, and Guillaume Apollinaire's steps, try to enter and lead their audiences to the landscape of dreams and the unconscious "through the back door." It is in this spirit that LeCompte describes her

directing as a means of framing "people's dreams about themselves," in order to connect with them (quoted in Kramer 2007, 52). Impressionistic fictions recurrently determine performance structure, as in Wilson's work, which de-hierarchizes both images and verbal text according to the nondiscursive logic of dreams. Directors often make use of the ever-shifting angles of the subconscious to alter our perception of events, while the application of symbols establishes an environment of shared understanding. Symbols are invaluable elements in the semiology of the mise-en-scène, because, being the property of "all," a common language, they procure direct access into the intuitive understanding of the stage material. To an extent, they represent the hidden or repressed instincts which are stored in the unconscious mind, where they reside until some stimulus brings them to consciousness. The observation that archetypes and primordial images are specific forms and pictorial relationships that consistently appear in all ages and latitudes and haunt people's dreams and fantasies universally had already driven Carl Jung, in the wake of the twentieth century, to theorize on the existence of a collective unconsciousness—the sum of all experiences and attitudes that humankind acquired during its racial and genetic development. In effect, Jung insisted that it was in the collective unconscious where the meaning of symbols had been inscribed.[4] Implementing his postulations on stage practice, auteurs negotiate the emotional impact of archetypes, in order to forge access-ways into states of being that remain intellectually impervious. In this context, the spectator's journey is primarily experiential. Yet, the process of stirring up associations through less recognizable routes than immediate recourse to archetypes, makes for much subtler, yet more complex and ultimately rewarding, perceptual strategies relying on the gradual, as opposed to instant, gratification of the spectators' senses; the immediate objective being to trigger inside the spectator a personal connectedness to images, thoughts, or phrases that may or may not have been also personal to the auteur upon their inception. Thus, in practice, auteurism introduces a new model of shaping artists' imagination and simultaneously redirecting the perceiving powers of the audience. The disengagement of art from its former socially and ideologically mandated reliance on factual detail ordinarily generates performances that feature separate nuclei of meaning and intensity, rendering spectators open to multiple perceptions. In this train of thought, Russian formalist critic Victor Shklovsky, instigator of the concept of *defamiliarization* in literature, already in 1917 shared his conception of art in his landmark essay "Art as Technique":

> The purpose of art is to impart the sensation of things as they are perceived and not as they are known. The technique of art is to make objects "unfamiliar," to make forms difficult, to increase the difficulty and the length of

perception because the process of perception is aesthetic and in itself must be prolonged. Art is a way of experiencing the artfulness of an object; the object is not important. (Quoted in Wilcox 2000, 80)

For one thing, the uses of collage, montage, recycling, and the manipulation of technology in exchange for virtual constructions of reality, together with attempts to access the unconscious—as first manifest in the structures of expressionism, Dadaism, and surrealism—prevent our instinctual awareness from comfortably resting on familiar or predictable patterns. On the other hand, the democratic employment in performance of different genres of literature and art has effected a changed notion of perception on the whole. In many instances the experience of the theatre event is deliberately "cracked open," allowing directors to creep inside the crevices and to either prolong the spectators' absorption of images or, reversely, subject them to the vertiginous speed of technology. Given that it is nearly impossible to take in at once the multiple signs of performance (which as a rule are organized in extremely complex ways), spectators are further discouraged from processing them instantaneously, prompted instead to "postpone the production of meaning (semiosis) and to store the sensory impressions with 'evenly hovering attention'" (Lehmann 2006, 87).

Within the reconsidered frame of subjective and relativized time, synthesizing the particular moment is therefore only possible through the imagined entirety of the envisioned event, since the constituent parts of a performance move parallel to each other rather than centripetally toward the event. Auteur predilection for simultaneous and multidimensional action further challenges the audience's ability to *instantly* acquire a sense of totality in its understanding of the theatrical event. Sometimes, the effect is the prolongation of audience reception, as in the Wooster Group's rapid succession of contrasting images or the bewildering yet carefully mapped out bombardment of narratives in the productions of Complicité; in both cases, the spectators' constellations of impressions are first stored in their depository of mental associations, to be later processed in detail and registered in some kind of imagined whole.

Wilson, for that matter, likes to train his spectators' perceptual channels toward greater diversity, pursuing a different focus, which could potentially grant them freedom from limiting social and artistic structures. For one thing, his systematic observations on physiological perception eventually prepared him for the formation of a distinct directorial and performance idiom abiding by new rules of coherence and cohesion, albeit strictly nonrealistic. To an extent, Wilson's encounter with "maladjusted" children, and, in particular, his experience with deaf-mute Raymond Andrews, culminated in his experimentation with alternative modes of awareness in *Deafman*

Glance (1971). In rehearsal, Wilson discovered that those children's own sense of seizing and understanding the world contained a logic that para-doxically became increasingly coherent, after one had spent some time to take it in. Since then, he has exploited that piece of wisdom to redeem his audiences from societal impositions. His actors are trained accordingly: their special physical attitudes, together with the varied sounds they are made to produce, are further scrutinized and developed during rehearsals and workshops to serve Wilson's remarkably personal, nonnaturalistic style of directing. This acquired taste of artistic freedom is also applied on the director's compositions of "total works of art":

> For me it's all opera in the Latin sense of the word, in that it means work: and this means something I hear, it's something I see, it's something I smell. It includes architecture, painting, sculpture, lights... We are developing a theatrical language with the body that can parallel the language of literature. (Wilson quoted in Delgado and Heritage 1996, 303–4)

Clearly, Wilson's major works, from *Deafman Glance* to the *CIVIL warS* in 1984 realize a modern-day version of Wagner's concept of *Gesamtkunstwerk,* a synthesis of separate forms—dance and movement, light, design, and music into a unified work of art. Blending elements of theatre, opera, dance, and performance art in his productions, Wilson is not a stage-director in the typical sense, but more of a "sculptor of space and time" (Delgado and Heritage 1997, 304). This is, again, congruous to the philosophy of auteur-ism: the very fact that directors can organize their text visually and under-stand the story *scenically* allows them to jump from one aesthetic to another, maneuvering their audience's angle of vision at will. In other cases of auteur theatre, both the viewing of performance as a musical score and the con-viction that directing can work almost exclusively on musical terms, with every element of the mise-en-scène constituting a part in a musical compo-sition, are also cardinal aesthetic principles, with Beckett's rhythm-based pieces fully validating these notions. Aside from the structural similarity, powerful performances achieve the same immediacy of experience that is singular in music. In some respect, just like in music, wherein the abstract and open quality of the text bestows upon the listener the opportunity to creatively "fill" in for the missing parts, in auteur conceptual or conceptu-alized performance, no path of interpretation has been set out in advance. This "generosity" is certainly obvious in Simon McBurney's work, in which the development of storytelling has more to do with the insights of a con-ductor of music than of a mere blocker of action. In fact, McBurney's style is synthetic yet coherent, poetic but never portentous. The form is subjected to constant reassessment and reinvention and, as a consequence, never feels

trite, tired, or irrelevant. Complicité's intoxicating amalgams of narrative, choreography, and technology are always based on some nearly altruistic desire to shed light on things that constantly elude us, conducting an articulate humanist enquiry into a "politics of the imagination" (Mitter and Shevtsova 2005, 249). As such, they do great justice to the Wagnerian ideal of artistic synthesis.

II. Creative Impulse and Ensemble Work

When discussing auteur practice, the need to examine rehearsal techniques is always present as well as pressing. Because rehearsal is mostly a private affair, ordinarily held sacred by both directors and actors, most directors' methods of developing a script for performance will remain forever concealed from the public eye. Having said this, from what the information that has been gathered through interviews and production books suggests, there are many auteurs whose primary concern lies in the resourceful work with *actors* rather than the dramaturgical frame of the performance. Over the years, these directors have cultivated their own set of comprehensive rehearsal techniques, designed to free the body from physical, mental, and emotional constraint and subsequently channel the actors' imagistic talent. Surely, the pioneers of the early twentieth century had first exploited the semiotics of the stage, treating the actor's body as a *sign* that spoke the story, conditions, and perturbations of the impersonated part. Reference has already been made to how Meyerhold's *Biomechanics* celebrated the actor as the principal force in the theatre, able to communicate the concept of "character" physically and replace conventional setting and props through sheer bodily expression; similar are the ways in which Artaud located all expressive feeling in the performer's body, envisioning a system of training that would be akin to that of athletes and dancers. It is in this vein that Mnouchkine considers actors *authors* who use their bodies; during rehearsals, what starts off as research on a theme jointly selected by the company is subsequently improvised by the group, regularly delivering striking forms and formations. Other examples of directors who have immersed in concentrated physical work include former Mabou Mines' artistic director JoAnne Akalaitis and her methods of encouraging the actors' body to eventually yield physical images, Brook's understanding and manipulation of energy release, as well as Suzuki's training system of exacting physical discipline.

In mapping the varieties of auteur mechanisms for physically mobilizing an ensemble, Canadian theatre and film director, actor, and musician Robert Lepage's mere "tossing" of a theme in rehearsal to unlock his actors' imagination is especially worth noting: regarding his process fundamentally as a work-in-progress, Lepage identifies performance with "more or

less a public rehearsal" (quoted in Delgado and Heritage 1997, 141). Quite detached from the limiting presence of established playwrights, Lepage's performances and rehearsals are set in motion by the actors' physical and mental agility, rather by a text per se:

> Our creative work begins with a huge brainstorming and a collective drawing session where ideas are grouped together. Then, we discuss ideas that have been singled out, which leads to improvisation. Then there's the phase of structuring the improvisations, which we rehearse, and eventually perform publicly. These performances, rather than being the culmination of the process, are really further rehearsals for us, since the show is not written down or fixed. (Lepage 1995, 177)

Markedly, the 1994 *Seven Streams of the River Ota,* the first project that Lepage developed with his multidisciplinary production company Ex Machina,[5] was made into a performance after the director's desire to work on "something about Hiroshima." Deployed in seven visual tableaux of interweaving stories, the seven-hour-long saga of what seems to be the entire twentieth century history, fuses languages, time periods, and cultures as distinct as Japanese, French, English, and Czech to tell the story of human tragedy throughout ages. The horror of the atomic bomb coalesces with references to the Holocaust and the AIDS epidemic. Lepage constantly reminds us that the backbone of the devising process is predominantly visual, animating ravishing landscapes of post-apocalypse across time and space.

Similar aesthetic principles permeate the modus operandi of Complicité: with no fixed script in hand, the company focuses on establishing the right conditions for collective experimentation on the outset of rehearsal. Espousing Lecoq's physical training, which considers collaborative work central, Complicité's "magician" Simon McBurney prepares his company's bodies and voices by toning the "muscle of the imagination" in search of a "moment of collective imagining" (Giannachi and Luckhurst 1999, 71). "I prepare [actors] so that they are ready: ready to change, ready to be surprised, ready to seize any opportunity that comes their way" (71). McBurney recognizes the significance of his own Lecoq training in so far as it has helped him replicate in his work the same unharnessed energy that can enable actors to fabricate images simply by using their bodies, and also to produce spectacular forms as one living organism, virtually defying the laws of gravity. In the production of *Out of a House Walked a Man* (1994), described by Complicité as a "musical response" to the work of Russian surrealist and children's writer Daniil Kharms, several spectators reported experiencing a hallucinatory feeling that McBurney's actors had actually grown imaginary wings and appeared to be flying around the space unhindered.[6]

No doubt, the practice of ensemble work has been supported by Artaud's viewing of the theatre art as a communal event, while in some cases the collective spirit extends beyond the space of performance. For example, besides keeping its members together to share living space and housework and operate on an equal-salary basis, Mnouchkine's Théâtre du Soleil has always relied on the practical function of a *commune,* doing credit to the title Création Collective (Collective Creation) which comes attached to the company. Working together, Mnouchkine's actors help to make costumes, sets, and props, taking turns in cleaning and cooking. On performance nights, they also prepare meals for the audience members, whom they serve at a counter in costume and in front of which they do not hesitate to apply their makeup during intermission. This is consistent with Mnouchkine's belief in the theatre as a *total* event and her radical commitment to its public nature: a convivial atmosphere and a sense of occasion are fundamental to her understanding of theatricality as the bringing together of environment, actors, and spectators. However, above all, Création Collective intrinsically relates to the ensemble's collective writing on stage, which helped shape the Soleil's early productions *Les Clowns* (1969), *1789, 1793,* and *L'Age d'or* (*The Golden Age*) (1975). Company members were then asked to research their material, and, in the end, scripts were written based on improvised exercises, stories, scenes, and characters. Mnouchkine values this method of work because she sees actors as "authors more with their sensibilities and their bodies than they would be with a blank sheet of paper" (quoted in Williams 1999, 57). Gradually, however, the role of the director in her company was reconsidered; having formerly surrendered to a more collective process, Mnouchkine reclaimed her position as the person fully in charge for centralizing all artistic activity, retaining, however, what she called a sense of "democratic centralism" (57). In some other directors' process, the ensemble's involvement in the making of a piece is even more unconventional. In a typical day of rehearsal for the Wooster Group, as Jane Kramer illustrates, everybody, from actors to designers to technicians, is called in for a brainstorming session. LeCompte asks them to contribute with ideas, thoughts, or, sometimes, tangible things such as something they read or listened to. She will then "take in their reactions and sometimes laugh or, more often, groan while they stumble around inside their own heads in what could be called a first rehearsal" (2007, 53).

Even though techniques may vary, in most of these directors' rehearsal practice, the physical and improvisational work with actors is instrumental to generating and developing not only strong stage images but also parts of the performance text. On the other hand, when we consider the actual mechanisms involved in the perception of a piece of theatre, we become conscious of the fact that as soon as a performance is put out in front of an

audience, spectators instantly participate in a dual, if paradoxical, action of involvement and distance: to follow the story and store up their impressions of character and situation, they engage with the spectacle through readily activated sensory channels yet they are also asked to mentally decipher the numerous signs employed on stage and to untangle the thread of the mise-en-scène. Directors' twofold approach to stimulating theatergoers could be conjured up in terms of "alienation and festivity" or how to manipulate emotional involvement. Bert O. States' *Great Reckonings in Little Rooms* (1985) offers a detailed analysis of the spectator's binocular (phenomenological Vs semiotic) perception of the theatre event:

> It has become evident to me, in arriving at my own form of narrowness, that semiotics and phenomenology are best seen as complementary perspectives on the world and on art.... If we think of semiotics and phenomenology as modes of seeing, we might say that they constitute a kind of binocular vision: one eye enables us to see the world phenomenally; the other eye enables us to see it significantly. These are the abnormal extremes of our normal vision. Lose the sight of your phenomenal eye and you become a Don Quixote (everything is something else); lose the sight of your significative eye and you become Sartre's Roquentin (everything is nothing but itself). (8)

It is theatre's "double affiliation" to the mimetic and performing arts to which the tension between the director's control of stage semiology and the actor's inevitable phenomenology of presence is moored. Indeed this tension breeds inside the spectator, on the one hand, a feeling of distance during the cognitive understanding of semiosis and, on the other, one of empathy, given the visceral confrontation with the performer's live presence.[7] In the space of absorbing the semiology of the mise-en-scène, detecting the director behind the work and purely enjoying the actor's presence, the audience ultimately will or will not identify with the spectacle. Forged under the tremendous influence of Brecht's celebration of alienation and veritably associated with more experimental forms of drama, distancing techniques have been increasingly infiltrated into contemporary performance, manifest in the strategies of casting against type or in cross-gender and cross-racial casting. In the Wooster Group's performances, the latter two are recurrent directorial tactics: for instance, the company's leading actress, Kate Valk, became notorious in the title part in *The Emperor Jones* (1998), where, thanks to LeCompte's fascinating twist on the play, a white woman in blackface was cast in the role of a black man. Cross-racial casting was also pivotal in Brook's acclaimed *Hamlet* (2001), which starred a black actor, Adrian Lester, in the title role. It also keeps coming back as a motif in Sellars' work: in the production of *The Merchant of Venice* (1994), the Jewish character Shylock was performed by Paul Butler, a black actor, while Portia (Elaine Tse) and

her "entourage" were Asian-Americans. From the "Spanish-speaking sector" come Antonio (Geno Silva) and Bassanio (John Ortiz). "Although the words remain Shakespeare's, Mr. Sellars puts such an idiosyncratic spin on scenes that he might as well be rewriting the script" (Richards 1994).

Besides those stratagems, individual techniques for distorting space, time, and sound, as well as for disrupting the synchronization between image and text, abound in the theatre of Foreman and Wilson. Beyond question, Foreman, more than anything else, is preoccupied with defamiliarizing the spectator's perception of the everyday: his stage operates as a canvas, a painterly composition where space is framed and time is distended, objects change in size, and sounds are out of proportion. Because his desire is to shock us into confronting our own lives and selves by seeing things in a radically new light, Foreman approaches his plays with a gnawing sense of irony: not only does the dragged-out, hyperrealistic delivery of lines render all sense of empathetic relationship with the characters impossible but the divorce between the accepted meaning of the lines and the actors' actual emotional and physical reactions to the text also maximizes the deliberate aesthetic distance between the audience and the stage:

> Foreman's Brechtian impulses, such as shining light in the spectators' eyes, the use of buzzers, thuds, tape loops, and other loud noises, continually interrupt this type of spectator association and force the audience to be aware of their own perceptions as they are simultaneously perceiving them. (Wilcox 2003, 555)

Occasionally, techniques of involvement and distancing coexist, as is the case with some of Greek director Michail Marmarinos' work.[8] In the production of *Ethnikos Hymnos* (*National Anthem*) (2004), the spectators were among the actors, a part of the scenery, which was designed so as to involve them in the action. It is the setting of the play that first creates intimacy: the dining table, building a sense of community from the onset, is actually a pretext for actors and spectators to meet and converse. In line with the director's avoidance of an empathetic relationship between spectator and space and, in the end, between spectator and character, the space keeps changing, taking on cameo dimensions and refusing to provide a fixed point of reference. Resolute role-playing further contributes to the performers' transformation: there are no fixed parts, just multiple, fluid personas. The conflict between the assumed "meaning" of the enunciated text and the visual image that attends it—often antagonizing its primacy—reveals another pattern of distancing, comparable to the discrepancy that exists between the actors' (or the "characters'") intuitive responses within a particular scene and the spectators' expectation of them. Numerous other recorded examples of auteur

work illustrate how it is an integral part of the auteur's job to challenge established narrative conventions and penetrate the instinctual reactions of the house, whether through empathy or distance. Sellars, for instance, claims that he is "very influenced by theatre that is primarily experiential; rather than being about an experience, it actually is the experience" (quoted in Delgado 2002, 234). Obviously, the mission of the theatre to "involve" had been foreshadowed by Artaud long before Sellars' time. Several experiments in the 1960s and 1970s were also carried out with the view to unify spectator and spectacle in every conceivable and tangible way. In Jerzy Grotowski's production of Christopher Marlowe's *Doctor Faustus* (1963), the audience members, sitting at long tables on stage, were featured as guests to a banquet held on the night that Mephistopheles arrived to declare his proprietorial rights on Faustus' soul; encouraged to respond to the action around them, the public functioned to some degree as confessors to the protagonist.

Beyond the logistics of mere seating configurations, the union of actors and spectators can become a structural pivot. Grappling with the spirit, circumstances, and social ramifications, together with the civic significance of the French Revolution, Théâtre du Soleil's *1789* (1974) took full advantage of the theatre's communal nature. The play, put together by all company members, was presented on *five* different stages, in a formation that paid tribute to Artaud's ideal spectacle surrounding the audience. The playing areas were linked by pathways around the spectators, who had to follow the action from one stage to the next. The sense of emotional connection reached its peak in the scene representing the taking of the Bastille, for which "each actor positioned himself at a different point in the central area, gathering a small knot of spectators around him and describing the storming of the prison as if he was telling it to a few friends" (Bradby and Williams 1988, 92–3). Eager to partake of Soleil's renowned festivities, people keep returning to the company's space in the Cartoucherie area of Paris. In the end, although Mnouchkine's eclectic style has always communicated a disconcerting sense of "otherness," which may in part be a result of the fundamental setting up of the actors' identities as those of "performers acting a part," engaging the audience intellectually and emotionally has always remained high among her priorities, despite her declared aversion to psychological realism. Other auteurs are still struggling with how to render this process authentic. It may be true that the largely utopian ambition to fully realize Artaud's sought-after communion can often generate forced as well as naïve physical patterns, imposing external structures, instead of exploring ways in which meaning can be constructed jointly; yet, Artaud's ideal of festivity and participation—which was further cultivated in the avant-garde theatre of the 1960s and 1970s—has provided a valuable alternative to realism-bound, predominantly dated notions of empathy.

III. DEVISING THEATRE

The questioning of hierarchies defining conventional productions is severally manifest in current directing practice. The vital question being whether there exist in performance any reference points other than the playwright's words; a big bulk of auteur work is associated with the exploration and handling of different sources of material besides or aside from the dramatic text. Also, auteurs are preoccupied with ways to alter, interpolate, extract, or contextualize the text of an existing play in adaptations of the classics or revisionist stagings of tragedy and myth-informed drama. The constant search and discovery of more "goods" that could be put on a stage and be fashioned into theatre has freed up directors' resourcefulness even more, simultaneously opening up critical insights to the understanding of interpretation and authorship. When it comes to the form of devised theatre, the roots of inspiration for directors run deep: literary, as well as nonfiction books, broadcast pieces of news, photographs, the Internet, interviews with spectators or random passers-by, extracts from improvisational workshops with actors, newspaper and magazine clippings, recipes and poems, overused sayings and foibles. Borrowing from life and essentially dramatizing culture, devised theatre companies never cease to amaze with most improbable stage "scores," which may literally seem to manufacture text from sounds, gestures, and images. In one of the few fully fleshed studies of the genre, Deirdre Heddon and Jane Milling investigate the identity and function of the devising method:

> Devising is variously: a social expression of non-hierarchical possibilities; a model for co-operative and non-hierarchical collaboration; an ensemble; a collective; a practical expression of political and ideological commitment; a means of taking control of work and operating autonomously; a de-commodification of art; a commitment to total community; a commitment to total art; the negating of the gap between art and life; the erasure of the gap between spectator and performer; a distrust of words; the embodiment of the death of the author; a means to reflect contemporary social reality; a means to incite social change; an escape from spectators; an expressive, creative language; innovative; risky; inventive; spontaneous; experimental; non literary. (2006, 4)

Already in 1981, Richard Schechner had traced the development of an alternative trend of writing *directly* for the stage, stretching it back to the early twentieth century with Meyerhold and later on to the 1960s with Brook, Grotowski, and other avant-garde practitioners who dared question the playwright's authority. While the director "took unto himself the means of theatrical production" (Schechner 5.2, 52), the playwright, when keeping

himself or herself aside from the development of the work by not participating in the process of "constructing the text" or "in workshops and rehearsals," was regarded as "an absentee landlord" (52). In Schechner's view, directors "wanted to shape texts—the whole collection of 'texts' theatrically speaking: words, space, audience interaction with the performance, performer training, acting" (5.3, 10):

> The writer's words were used, but his authority ceased to be regarded as absolute. Productions were no longer interpretations. They became original versions "after," "based on," "using the words/themes of." Often the productions were collages of several texts. The director became the center, the transmitter, of theatrical creativity: he was the new source. (5.2, 52)

Obviously, part of the devised form's charm is intrinsically related to the ease in which it turns even the most inconspicuous fact or notion into stage matter. Theatre artists who used to frantically scour dramatic literature in order to come up with *some* oblique, rarely produced, or altogether unperformed play, have been relieved of the task; if and when a piece of current circumstance—social, cultural, scientific, artistic, or other—stirs their imagination, they feel that they have every legitimate right to model it into a performable piece, adding the layer of staging to the writing of the script. As performance blends with literature, the audience's processing and enjoyment lies in the egalitarian absorption of the play's verbal and visual elements. Because the furtive yet also burning ambition to claim a slice of authorial privilege is inherent in most humans, conspicuously more so in artists, it should come as no surprise that devised theatre directors appreciate the uninhibited license that is inadvertently granted to all participants to use the stage as a venue for uncensored expression and playful experimentation.

Among the defining principles of devised theatre are the democratic distribution and relegation of different signifying systems, but the problem often lies in the absence of a unifying vision that could be responsible for their operational control. In some of the least successful experiments with the form, a lack of structure, together with the sour aftertaste of disconnection, is common fare, habitually trying spectators' patience. The fact that devised theatre views performance as a constant work-in-progress, highlighting *process* over *product,* suggests that the performance script (un-fixed and incomplete) can easily adapt to the specific needs of the varying audiences, given that any kind of "ready-made" can be analyzed dramaturgically as a compositional element of performance. This sort of plasticity is fully in keeping with the widespread conception of interpretation as involved coauthorship, in fact with the artist surrendering the consummation of his or her work to the public, or even to chance.[9] Over and over, the aggravating

question in theatre criticism remains whether the interpretation of the world can ever be a single writer's exclusive property or, reversely, the sum of the anarchic energies of an ensemble of artists. By nature, devised theatre accelerates some of the mental operations to which playwrights ordinarily commit, such as conceptualization, visualization, scene structuration, character buildup, and dialogue construction. In this light, directors and actors can create collectively, not having to pay dues to any playwright-God. Still, whether good theatre can ever be created without a playwright is an issue that keeps resurfacing among theatre scholars, critics and regular theatergoers. The insidious pressure to live up to outstanding dramatic "masterpieces" is familiar to many devised companies, which have in the past paid the price for lacking one individual agency to guide them through the task. British theatre critic Michael Billington at one point equated devised theatre with "total mess," as Brian Logan, another critic for the *Guardian*, reports in rage in an article of his arts blog aptly entitled "Is 'devised' theatre always a case of too many cooks?" In actual fact, Logan discusses the aversion that audiences and theatre experts display toward devised theatre in terms of a kind of presumed threat that British devised theatre companies such as Right Size, Improbable, Shunt, Complicité, Peeplykus, and Theatre Workshop pose to the theatre establishment, and adds: after all, "if you take the ensemble ideal far enough, even directors (a relatively recent innovation in theatre) can be surplus to requirements" (Logan 2007). On the other hand, even though the number of devised companies, especially in Europe, is steadily rising, it is more or less a fact that the more critically accomplished and commercially successful among them still abide by the strict hierarchy which looks upon the director as the virtual master of the piece.[10] A closer look to SITI Company's rehearsals, for example, will reveal the fact that even though the performance material is jointly collected, improvised, and generated by each and every member of the ensemble, when all is said and done, it is exclusively director Anne Bogart who channels it into a final product for the stage.

A similar chain of command applies to the usual methods of Complicité, where McBurney's authority as primary instigator and final arbiter of performance meaning has remained uncontested all through the company's rise to unanimous recognition. McBurney's recipe for devising meaningful theatre resides in procuring the right circumstances for invention to occur, since "everything begins with a text of some sort."[11] Complicité had first appeared at the Royal National Theatre of London in 1991 performing Friedrich Dürrenmatt's *The Visit*. Despite its reputation as one of the leading devised companies internationally, its productions have been critically validated as part of the current Western theatrical canon. Almost all of its work, from the adaptation of Bruno Schulz's *Street of Crocodiles* in 1992 to the award-winning *The Three Lives of Lucie Cabrol* (1994) and the multimedia

Japanese spectacle *The Elephant Vanishes,* adapted from Haruki Murakami's fiction in 2003, has been founded on the fundamentals of devised practice: extensive research of material—including interviewing people and compiling information from varied sources—elaborate physical exercises, and zealous improvisation with themes, objects, and forms. Ultimately, Complicité's visionary treatment of stimulating subject matter seems to satisfy both the ensemble and its audiences equally. Devised theatre *par excellence,* one of the company's most remarkable pieces, *The Street of Crocodiles* (1992), was designed as a mobile canvas of stories interwoven with images that came alive through the physical dexterity of the performers. The production, actually drawing on stories from two Bruno Schulz's books, *The Street of Crocodiles* and *Sanatorium under the Sign of the Hourglass,* thrives with surprising imagery: new characters introduce themselves to the audience, materializing out of the most unlikely places, such as a barrel; the action of furiously flipping through pages in a book turns actors to birds, whereas the use of a large cloth transforms ingeniously to reveal a stretch of a beach, a tablecloth, and a sanatorium bed.

Another celebrated case of a director-controlled devised piece, Mnouchkine's seven-hour-long *Le Dernier Caravansérail (Odysées)* (*The Last Caravanserai [Odysseys]*) (2005) takes up the principles of Création Collective once again to engage the audiences in a reflection of current politics and social debate. The production's narrative pivot is the hardships, as well as the dignity, of countless numbers of refugees from several parts of the globe, including Afghanistan, Iran, and Chechnya. The epic dimensions of the play—perhaps "saga" would be a more appropriate term—are quite solid thanks to the use of the extensive material that the Soleil collected and devised during weeks of interviews with refugees in the detention centers of Sangatte in France and Villawood in Australia. The result is a singular montage of moving snapshots of refugee lives, performed by approximately forty actors in several different languages. Unexpectedly, the epic form is rendered intimate. Mnouchkine is unique in arousing and activating her actors' authorial instinct and at the same time commanding the material so carefully that it never feels misshaped or random.

From a different standpoint of auteur practice, adaptation is when you "take something familiar, something you know, or think you know, subject it to every conceivable transgression of interpretation and form, and return it to you illuminated and deepened" (Kramer 2007, 49). Thus spoke LeCompte, of the Wooster Group a company notorious for its guilt-free revisionist productions. Since the 1980s, adaptation has consistently been a hot trend in avant-garde work, legitimizing directorial choices that would remain mostly unacceptable in mainstream theatre. In this respect, almost every major auteur has at different times and under different circumstances

"creatively" tackled or tampered with Shakespeare and the Greeks.[12] The idea and applications behind their process are almost always uniform: to extract the "meat" of the text and reconnect spectators to the timeless themes of the great works of literature; adaptation digs inside universal reference and personal inference, illuminating them in ways that address imperative issues of today. Bogart acknowledges plays as "little pockets of memory," such as a Greek play about hubris, that a director can take on as a "chance to bring that question into the world and see how it looks at the time you're doing it." She understands artists' fascination with revisiting old works to be part of the need to reclaim something that has been lost, "the sense that theatre has this function of bringing these universal questions through time" (quoted in Shewey 2008).

Virtually the backbone of adaptation, recontextualization is ingrained into the tissue of auteurism. In the course of contemporizing an old work, the application of current cultural references is almost a given. Basic adaptation staples often include unedited scripts set in altered environments, usually transported to the present time; occasionally, however, auteurs are more daring—or irreverent, as more traditional criticism would have it—in their treatment of the original, cutting lines, reorganizing scenes, and interpolating material. Thankfully, our days are marked by a more mature attitude toward staging the classics: rather than dressing up all male actors in military uniform and all females in vinyl outfits—to use a cliché example of a recontextualization overkill—to suggest a modern context, the most absorbing productions are more concerned to light up the play from the inside and discover ways to make the old text stimulate meaningful images and attitudes in today's audiences. As a result, a lot more thought has been given to the play's translation; fastidious about which translators to commission for the work, directors seem more prepared to engage in fecund collaborations, sharing or imparting their own intuitions about the classic text in the hopes that the updated version's language can serve or even *bend* to their directorial perception.

Ideally, when the production's point-of-view is solid, revisionist renderings of classical works veer the audience's attention away from a mere pursuit of the play's words toward an appreciation of those issues of the universal human condition, which are embedded in the text and which the mise-en-scène brings to the fore. An increasingly popular form of adaptation embraces the strategy of modernizing the visual mise-en-scène of a classic play while leaving the original text intact, an old-time favorite routine of Sellars, who rose to success at the Pepsico Summerfare in Purchase, New York, in the second half of the 1980s, when he revisited Mozart's and da Ponte's operas, setting *Don Giovanni* in the streets of Harlem, *The Marriage of Figaro* in The Trump Tower, and *Così fan Tutte* in a Cape Cod diner. Convinced that our

culture today is verbally dominated, he has always wished for the audience to take in information through other pores, "be sensitive to other indicators" (quoted in Lancaster 2000). During one of the arias in *Don Giovanni,* for example, while the title character in the text sings to his sword, Sellars' visual metaphor in performance has the actor sing to a .45-caliber pistol. As a matter of course, in Sellars' manifestly stylized performances, the original text is used as "primary material," a vehicle for exposing a variety of current social matters. This is why he actually remains unconcerned with externals and, in particular, with the historical cover of the play; rather, reading the classics with today's eyes, he tries to identify and rework the political crux of the original text, divesting it of culture-specific details, which unwittingly tend to alienate modern audiences. True to his methods, in his version of *Merchant of Venice,* for example, he distances himself from Shakespeare's time yet manages to retain the poetry and still make it sound like everyday speech. This way, the text is not only more accessible intellectually but also becomes culturally relevant. At no point does the production sag, despite its length; instead, spectators, seduced, intrigued, even if occasionally disturbed, are increasingly drawn into the director's world. Overtly political, Sellars also utilizes deconstructive "distancing" and "alienation" techniques by layering his productions with a visual mise-en-scène that does not necessarily relate to the text directly: in his 1986 production of Sophocles' *Ajax,* Sellars set the story at the aftermath of an imaginary American war in Latin America. American General Ajax was played by deaf-mute actor Howie Seago, whose lines were spoken by a five-person chorus, each one of them representing a different part of Ajax's mind. More often than not, the use of microphones undermined realistic representation, while the movements of the actors systematically reflected the gestures used by contemporary politicians, and the production also included a projection of Pentagon images in addition to the Pentagon's loading dock set.[13] Likewise, Sellars used Aeschylus' *The Persians* (1993) to launch a critique of America's role in the Gulf War. Once again, the structured argumentation of the Greek plays afforded him an effective model for addressing contemporary politics.

In discussing adaptation, it is certainly worth bringing up the example of Brook, whose work on the classics betrays a reverse logic. Instead of tweaking the original text to serve the current political climate, Brook strips the plays of their historical detail, extracting and distilling, as he describes, the essence of the dramatic situation, in what appears to be a mythifying process. No doubt, *A Midsummer Night's Dream* (1970) and later *Hamlet* (2000) expressly communicated the director's ambition to release the productions from any political or politicized content.[14] Similarly, with his company in Toga, Japan, Suzuki has developed another system of relating to classical texts (in particular Greek tragedy and Shakespeare), shaping them into

postmodern stage renditions that mix elements of old and new acting traditions. Having spent many years exploring the gap between traditional and modern, mainstream and marginal cultures, "highbrow" and "lowbrow" literature, Suzuki, like Brook, has never been overly concerned with addressing the socio-historic background of old plays and appears more focused on their emotional suspense and elemental energies. One of his habitual techniques is to report the action of the play through the distorted gaze of senile, demented, or alienated persons, underwriting a "strategy for uncovering and 'making visible' the invisible world of the human subconscious by which we are all 'possessed.'" In the end, his unequivocal integration of surrealism helps make human fantasies visible (Mitter and Shevtsova 2005, 170). This approach is clearly present in his celebrated productions of *The Trojan Women* (1982), *King Lear* (1984), and more explicitly so in *The Bacchae* (1978), in which members of a mixed cast of Japanese and American actors interact with each other in their mother tongues as well as in signs. Surely, the canon's familiar content expedites Suzuki's experimentation with relatively uncharted forms of expression.

A more "sensitive" form of adaptation is the juxtaposition of the original play with a devised or *found* text. In 1984, the Wooster Group caused Arthur Miller's rage by incorporating fragments of *The Crucible* (1953) into a new piece provocatively called *L.S.D. (...Just the High Points...)*. Miller was enraged, insisting that his work had been "mangled," and took legal action, forcing the company to substitute his text with other material. This by no means stalled LeCompte's ventures with collages of classic and modern texts: Gustave Flaubert, Anton Chekov, Thornton Wilder, and Eugene O'Neill, among others, all became on occasion source-texts for the company's electrifying performances. One of the Group's most popular accomplishments, the 1997 version of O'Neill's rarely seen expressionistic play *The Hairy Ape*, featured Willem Dafoe in blackface, while, as already mentioned, in 1998, the Group's leading actress, Valk, (a white woman) played the title role of a black male train porter in a rare revival of O'Neill's *The Emperor Jones*.

Reaction from playwrights against use of their texts simply as source material for new pieces gradually turned auteurs to the safe haven of classics, sparing them, in the very least, countless hours of *a bona fide* conversations with writers, if not more serious copyright headaches. American director Robert Woodruff's urge to fellow directors to "forget living playwrights" sounds appropriately ironic. The return to the conveniences of "dealing with the dead"[15] is certainly an indication of a directional change in the artists' choice of material. In principle, given the ongoing pressures that often mark auteur directors' practice, the crucial issue to discuss surely relates to the "dictums" and limits of adaptation or, in other words, the ability to define whose work we are dealing with after all. For one thing, deep-seated in the

mechanisms of adaptation is always a desire to discover the ways in which historic reference and out-of-date "external" elements could simply *exist* in production without distracting the audience, permitting those aspects that render the play modern to be foregrounded. Still, it may be useful to mentally register the unwritten consensus shared by most theatre artists, which holds that as long as the playwrights' words remain untouched, the production script still carries the stamp of the writer's authorship. Interestingly, this rule of thumb also seems to apply to those performances in which the setting is well overwritten and the identities of the dramatis personae lose their original fixity, flowing into cultural circumstance. One such example is Flemish auteur Ivo van Hove's treatment of the classics, in which the redefinition of language's function in the act of recontextualization is central. Van Hove has gained increasing popularity among the sophisticated audiences in Europe as well as New York with such revisionist productions as Tennessee Williams' *Streetcar Named Desire* (1999), O'Neill's *More Stately Mansions* (1997), Ibsen's *Hedda Gabler* (2004), Molière's *The Misanthrope* (2007), and Lillian Hellman's *The Little Foxes* (2010). In all these works, language is rendered crisp and natural, placed in a startlingly appropriate situational context, while the patterning of the performance and the coaching of the actors exposes the play's subtext to the effect that the innermost thoughts of the characters become fully transparent.

Underneath the mechanism of recontextualizing the text is an earnest search for and administering of contemporary metaphors in performance. The real challenge continues to be how to come up with modern-day equivalents to evoke in the modern spectator, to the degree that it is possible, the same feeling of unadulterated response that a given play had produced in its original audience. To illustrate the point: LeCompte uses a game metaphor in her mixed-media deconstruction of *Phèdre* (2002), borrowing the title *To You, the Birdie!* from badminton, which gives the production its leitmotif. In fact, the play of fortune in Jean Racine's play is in the Wooster Group's version represented by a strenuous match of badminton, which has Hippolytus compete against the referee Venus. LeCompte's insight about adaptation is focused on her bringing things together and creating new forms and meanings that are not in the original. In her view, this is a way "of passing on a tradition by reinventing a play" (quoted in Kramer 2007, 54). In terms of her directorial choices, it might be challenging as well as entertaining to try and think for ourselves what might be an apt present-day equivalent to Hippolytus' physical outlet; in fact, to determine the type of activities in which a young chaste man of today could ordinarily engage to vent off his repressed sexuality. If hunting as a daily warm up feels quite removed from our twenty-first-century sensibilities, the badminton solution is in many ways ingenious. However, even when the metaphor is procured, it

takes effort to keep it not just consistent but also dynamic. Sometimes, having settled on a fixed—and seemingly secure—relationship between the "updated" mise-en-scène and the original text, directors, actors, and designers relax in the form they have invented, unwilling to transgress its boundaries, explore and exploit its possibilities. Yet, as Bogart tells us, "What is instantly definable is often instantly forgettable" (52). Reproducing a given formula, besides being tedious, defeats the premier purpose of adaptation to stir up the "muddy waters" of centuries-old texts. As British set designer John Gunter also observes, "All-embracing metaphors can be dangerous. They can be dead ends in that they can't develop in the way that a text develops" (quoted in Mock 2000, 111). Along these lines, subtle contextualization is a much more effective strategy than facile "door-to-door" adjustments of the text that try to match modern detail to the letter; in this vein, recontextualizing the original is also an infinitely more creative, demanding, and, ultimately, rewarding process than entirely "disembodying" it, to use Mel Gussow's term.[16] To an extent, it both suggests and presupposes a level of maturity consistent with directors' relinquishing their oftentimes selfish appropriation of the text.

Essentially, recontextualization entails the manufacturing of new semiological codes, defined by a logic that is not necessarily tied to a single reading of performance. The redefinition of the semiotic relationship between object and spectator occasions an environment of shared "abandon" for both director and audience, wherein dialogue, action, and scenic spatiality are celebrated free of guilt. The ensuing feeling of distance and defamiliarization forces us to look beyond the expected for a steadfast connection between text and subtext, whereas context is reevaluated as a mighty given for clarifying "grey zones," areas of uncertainty in the text, without incapacitating or devaluing the language. In effect, "the oedipal *logos* is now understood as preexistent discourse that needs to be re-marked and contextualized so that an understanding of its affiliations to culture and to various acculturating agencies can be exposed" (Vanden Heuvel 1994, 63). All in all, if we take a somewhat reductionist view, we could perhaps epitomize contextualization as an organized form of fleshing out contemporary metaphors for classical texts. However, an informed as well as visionary interpretation of text is rarely limited to clear-cut analogies; straightforward metaphors (modern military milieux being among the most popular when it comes to Shakespeare's histories or the Greeks), no matter how apt at the beginning, soon lose their freshness if overexposed. In this light, we can never tire of stressing enough just how demanding auteur work is: directors should always labor to discover or invent, adjust, and sustain the proper context/metaphor for each play to help the audience communicate mentally and engage emotionally with the actuality and truth of the theatre praxis.

If the metaphor holds, the comfort of myth is another blessing, especially in the age of technology. Against the speed of the mediated image, the integration of themes or elements of myth in performance fortifies the mechanisms of introspection, encouraging the contemplation of our existence and position in the world and easing us into reconnecting with the vast history that precedes us. "Mythmaking," writes Elizabeth M. Baeten in *The Magic Mirror: Myth's Abiding Power* (1996), "is the backbone of culture, the fundamental means by which human beings demarcate, that is to say, create, human beings" (20). Or, to follow Claude Lévi-Strauss' lead in *Structural Anthropology* (1959), myth helps explain present, past, and future, introducing timeless patterns. At the same time, the task of an artist, in Wilson's view, is not simply to tell a story but primarily to create an event; artists take the communal ideas and associations that surround the various gods of their time and "play" with them, frequently inventing new fictions to conquer or even domesticate their magnitude. This is why part of the auteur's job is to manufacture modern myths, as Wilson suggested in an interview with Umberto Eco in 1993: "We in the theatre do not have to tell a story because the audience comes with a story already in mind. Based on this communally shared information, we can create a theatrical event. An artist recreates history, not like a historian, but as a poet" (89). As myth on stage replaces dramatic action and allegorical iconography substitutes for verbal narratives, spectators, no longer bound by dramatic logic, activate their faculties of association and become part of a totality of experience, which examines states of being both deeply personal and comfortably common. By definition dissociated from real time yet consciously setting unconventional rhythms, the use of myth in the theatre can become fertile territory for experimentation with alternate modes of perceiving global history as well as individual fact. The performance groups of the 1960s and 1970s had probed into ancient myths as pre-narrative poetry-in-space rather than relying on the extant verbal texts of the tragic poets themselves. Schechner's pioneering reworking of Euripides' *Bacchae*, *Dionysus in 69* (1968), building on the ritualized immersion of the audience into the spectacle, is only one such example. Even more conspicuously, the quest for the sacred origins of theatre, which Artaud had first detected in Balinese drama, took Brook on long, "soul-searching" journeys across the globe. While modern-day storytellers in the theatre pursue a holistic quality in their art, ambitious to return performance to its religious roots, the desire to revive the universal elements of history is rarely attached to the discourse of social and political theatre.

Preoccupation with non-Western forms of theatre foregrounds the dialectic first identified by Artaud between occidental theatre as dramatic, literary, and logocentric and Oriental expression as instinctual, physical, and sensorial. We should not pretend to ignore the exaggerated as well as naive outcry

of some of the experimental work of the 1970s in particular, which demonized Western forms as axiomatically impure—the charge being that their foundations had been contaminated and rendered meaningless through the slow yet fatal process of loss of the oral culture, a tradition that was distinctly immediate and experiential. Having said this, the interest in remote cultures has also fed auteur imagination with images that generate wonderment together with distance. For example, Théâtre du Soleil's political agenda inspired Hélène Cixous, the company's long-time collaborator, to embark on a recounting of Cambodia's history from 1955 to 1979 in *The Terrible but Incomplete Story of Norodom Sihanouk, King of Cambodia* (1986). The text, fashioned by Cixous, gave Mnouchkine the scope to develop another one of her "hybrids," interweaving elements of Kabuki, Kathakali, Peking Opera, Indonesian shadow puppetry, and Cambodian forms. In the production, various cultures converged and collided, reflecting a globalism paradoxically well contained within the solid walls of a spectacle and corroborating how plunging into the mysterious *other* can be intensely gratifying, especially to an uninitiated spectator. Bonnie Marranca discusses directors' fascination with retracing lost civilizations in their work in terms of a "cultural displacement of contemporary life," which "finds its double in the lives of texts":

> These are the dispersed, refugee texts from lost civilizations, those of unknown or forgotten authors, the texts of books languishing on library shelves, texts found in archives, texts exiled into oblivion. They find a home in today's world, preoccupied by restoration.... Dispersed texts then create a mosaic pattern in which the refracted light of ancient suns turns old books into illuminated manuscripts. (1989. 37)

As early as 1972 in *Mythologies*, Barthes theorized the ideological impact of myth inherent in popular culture. He claimed that cultural assumptions were embedded in the very form of the myth and insisted on the importance of myth analysis, especially in relation to its divorce from history, which duly privileges a natural order of understanding over a historical and socially constructed perspective. Quite often, directors navigate these assumptions in performance, withholding any historical readings. If history—and thus memory—are absent, then meaning cannot be construed but through sheer communication. This awareness also assumes that even when the play's subject matter does not draw on myth directly, mythical reference in performance is always alluring, transporting the spectator beyond the socio-historical givens of the theatre house, across time and space. In a lot of auteur work, archetypal images and universal symbols available to us unconsciously exist in abundance. To give an example: in Wilson's performances, mythical figures of all times and cultures appear on stage, carrying their own

symbolic significance and resonating universal, human reference: parading on his quasi-biblical/timeless stages are, to name but a few, Noah's ark, the book of Jonah, Leviathan, ancient and modern Indian texts, a Viking ship, the Pyramids, Mycenae, Don Quixote, Tarzan, and Mata Hari. On that account, Lehmann calls Wilson's theatre *neo-mythical* yet stresses that these myths function as "images, carrying action only as virtual fantasies" (Lehmann 2006, 80). In fact, Wilson's theatre "does not make history, only its poetic other side, memory. He lingers in myth, the space between literature and history" (Marranca 1989, 36).

Inspired by Artaud, Brook, Mnouchkine and others conceived of theatre events that would seize the spectator by sheer force of the spectacle. The fundamental assumption in these directors' work has been that a nonverbal, nearly religious ritual can induce trances which will act in the audience like Chinese acupuncture, to borrow another one of Artaud's apt analogies. This undercurrent is present in Brook's performance ceremonies in which dramatic time is utterly subordinated to a mythic dimension, while the narrative absolves itself from conventional dramatic structure, opening up to the scope of history and the attainment of a "new religion" and a lost "spirituality." Brook made the capturing of a holy mystique a life-long goal, looking for archaic, pre-narrative responses primarily in physical forms. His sacred locus, the "empty space," has often been infused with fabled imagery and memories from our collective unconscious. The best example of this, his nine-hour-long *Mahabharata* (1985), consisted of a condensation by Jean-Claude Carrière of the twelve thousand–page Hindu epic, an eighteen-volume Sanskrit poem dating back to 400 BCE. Based on Hindu history, mythology, and philosophical thought, the text tells the story of the birth of heroes and gods, following the action of blood-related yet enemy families that fight for their kingdom and eventually, through a merciless civil war, experience the end of humankind and the rule of paradise. Both writer and director toiled to cover in their adaptation as much of the whole poem as possible by compressing action, characters, and secondary plots. Notwithstanding the heavy editing of the epic, in the end, the production featured twenty-two actors and six musicians, who were also an integral part of the spectacle. Reinforcing a connection to ancient Greek festivals, the performance began at sunset and ended at dawn.

In the *Mahabharata*, Brook mixes modern elements with dazzling staged action, Balinese ritual with Kathakali movement, mime with stirring battle scenes, fires, and animal and divine masks. The huge space is made to resemble an archaeological excavation site where the element of water elegantly predominates. All our senses are aroused: the musical score is effectively enticing; the half-human, half-divine masks are sensational; the burning of incense and the rich textures of the costumes all contribute

to a consummate sensuous feast. Even though the story is condensed, the mise-en-scène is expressly polysemic: making use of elements researched in all previous stages of Brook's career, the *Mahabharata*'s visual eloquence and ritualistic choreography are instrumental in communicating the intended feeling of timelessness and shared humanity. Brook's resourcefulness is boundless: blood is represented by a piece of red cloth dipped into one of the two rivers on stage; actors unroll carpets and all of a sudden find themselves in a courtroom; by throwing powder in the air they revive scenes from the battlefield. The evocative simplicity of the staging goes hand-in-hand with symbolic undertone to carry the weight of the extremely long, complex epic of supernatural beings (such as the sun god or the demon with the vast belly), as well as of intriguing sequences containing torrents of blood, thunder and meteors, uprooting of trees and sacred weapons. Symbolism replaces naturalistic detail, impossible to achieve on such epic scale, inviting spectators to make the imaginative connections themselves as myth is "brought down to the human level" (Innes 1993, 145).

Theatre, writes Brook in *The Open Door* (1995) is a "mysterious marriage at the center of legitimate experience, where private man and mythical man can be apprehended together within the same instant of time" (56). Devoted to his aesthetic outlook, in the *Mahabharata* the director appealed to the audience's intuitive perception of myth by training his performers to move to the rhythms of dormant states of being, which he believed had always been deep-rooted in mythology. His impulse was to convey internal states by pure "thought transfer," adding vocal rhythms "to discover what was the very least he needed before understanding could be reached" and developing a corporeal language "beyond psychological implication and beyond monkey-see-monkey-do facsimiles of social behaviorism" (Brook quoted in Innes 1993, 127). In point of fact, ever since the establishment of his international company, Brook has been committed to the exploration of myth in search of the "great narratives," tirelessly encouraging audiences to "see myth and archetype as dynamic, provocative and potentially transcultural paradigms for exploring present absences and possible futures interrogatively."[17] And yet, within the framework of the debate on interculturalism, he has also been fiercely criticized for "painlessly" undertaking to condense the veritable enormity of myths into West-digestible spectacles. Especially in relation to the *Mahabharata*, a significant portion of the critique focuses on Carrière's ambitious yet in parts shallow abridgment of the original poem, which variously produces telegraphic descriptions of the action, often more *recited* than *dramatized* (Rich 1987). As a result, speech after speech of heavy-handed sermonizing fills for the gaps in the storytelling, trying to sum up as much expository information as possible concerning war battles, familial history, and genealogy together with philosophical speculation. More significantly,

criticism falls on Brook's appropriation of Eastern traditions to forge a hazy atmosphere of "universal myth." It has been argued that his extensive use of Asian puppets, Japanese drums, and Peking Opera military costume makes everything blend nicely into a manageable spectacle tailored to the palate of a Western audience and largely relying on cultural stereotype. One of the staunchest critiques of the production condemns *Mahabharata* as "one of the most blatant (and accomplished) appropriation of Indian culture in recent years...an appropriation and re-ordering of non-western material within an orientalist framework of thought and action, which has been specifically designed for the international market" (Bharucha 1990, 68).[18] Erika Fischer-Lichte puts the same point across much less vehemently:

> In an intercultural performance...the communication of the foreign does not occupy foreground interest. The goal is not that the audience be brought closer to, or made familiar with the foreign tradition, but rather that the foreign tradition is, to a greater or lesser extent, transformed according to the different conditions of specific fields of reception. (1990, 283)

Albeit derived from a desire to speak across cultures, Brook's appropriation of Indian civilization, indeed at points simplistic and conspicuously adjusted to Western cultural and literary sensibilities, frequently borders on hazardous—if well-intentioned—ahistoricity. Reviewing the New York production at the Brooklyn Academy of Music (B.A.M.), Rich contends that Brook's "smorgasbord of Oriental stagecraft" can sometimes appear "synthetic." He makes reference to some of Brook's frequently "perfunctory" mechanisms for universalizing the production, such as the use of puppetry and the "relentless" Eastern music, with sounds that seem to have been "purchased by the yard, along with the rugs"; on the whole, the criticism focuses on the incontestable fact that the performance, despite or perhaps because of its forced exoticism, in the end becomes a reflection of the director's ambition to balance Eastern and Western insights with a view to making the spectacle more appetizing to his international audiences. Rich draws attention to how, in laying out the story of the two conflicting families, the Pandavas and the Kauravas, Brook encourages us to make associations with mythical figures and canonical narratives of the West, such as Oedipus, the Old Testament, and Shakespeare, and argues that "though the similarities are there to be found, one can't help wondering if the idiosyncratically Eastern character of 'The Mahabharata' has been watered down to knock international audiences over the head with the universality of mankind's essential myths" (Rich 1987).

Although Brook's "appropriation" should reversely *also* be viewed in the light of his ambition to bridge *difference* and unite cultures and traditions,

the desire to discover a universal language for the stage, which has informed his work for years, will always inevitably be exposed to a certain degree of naïveté and, as such, be prone to criticism. In discussing the intercultural element in contemporary world theatre, Fischer-Lichte ponders on how the intercultural is geared towards the idea of a "future world culture-to-be," concluding that "in this respect, theatre functions in one sense as the aesthetic beacon of Utopia" (quoted in Pavis 1996, 38). It would be wrong to underestimate the impressive, if guileless scope of Brook's ambition to conjure up the immense historical, moral, philosophical, and aesthetic magnitude of the Indian myth within one single performance. For one thing, we ought to recognize his success in making the myth familiar and intimate without resorting to externals, but instead building up the world of the play with just his actors. Christopher Innes shares the feeling that the production is ultimately "therapeutic," suggesting that humans and gods coexist and interchange; they thus effect a kind of "spiritual change in each spectator" by revealing that "divinity is within us," as the boy-listener in the *Mahabharata* discovers: "I have the same blood. I come from the gods" (1993, 145–6). Undeniably, the quest for global significance is in itself a noble goal; in his search for that allegorical empty space of myth, Brook's mission has many a time appeared romantic or futile. Perhaps the challenges involved in staging the epic poem's apocalyptic vision defy even the genius and earnestness of a director of his caliber, one whose artistic pursuits are always profound, if grandiose. Whether utopian or ahistorical, Brook's *Mahabharata* has taken the director's preoccupation with shared (universal) communication via theatre's return to "roots" even further; at the same time, it has helped him establish and develop an acting style that is rigorously physical, at the service of a theatre of visual brilliance and constant surprise—a legacy that will no doubt be passed on to younger generations of auteurs.

THE MEANS AS AN END

I. LANGUAGES

IMAGE AS STRUCTURE AND SUBJECT MATTER

Having looked at some of the work methods and sources of inspiration of contemporary auteurs, we can now examine the principal stage languages they employ in writing the performance text. A number of these had been introduced by Jarry, Craig, Appia, and Reinhardt, theorized by Artaud, and shaped into formal innovations by Beckett. The importance of the visual image; the innovative handling of time, rhythm, and sound; the emphasis on the physical life of performance; as well as the integration of technology as a potent layer of textuality have been present in some form or other in the productions of the auteurs we have been primarily examining.

"When I make a play," declares Robert Wilson, "I start with a form, even before I know the subject matter. I start with a visual structure, and in the form I know the content. The form tells me what to do" (quoted in Holmberg 1994, 84). Contrary to verbal language, often characterized by abstractions that are hard to penetrate, an image set in space and trans-formed by stage coordinates foregrounds a concreteness that is not only attractive but also essentially carries within it interpretative significance. Still, it is not just the choice of images, but, significantly, their reordering, refining, and reframing that enable the audience to move easily from one level of perception to the next and thus become a more privileged reader of the theatre event. Increasingly, more and more directors bring a paint-erly perspective to the appreciation of performance, following course on Beckett's pioneering establishment of the stage image as an integral part of the text itself. Tracing this shift in directorial emphasis, Lehmann pur-ports that the de-dramatization of text, together with the allure of writing for the stage, have in postdramatic/postmodern productions reduced plot

to a less prominent place in the hierarchy of performance in favor of the scenic process. He claims that in the process of staging traditional dramatic texts by relying on "theatrical means," some directors leave the text to the background and instead allow the "peculiar *temporality* and *spatiality of the scenic process* itself" to become more pronounced. Because of the ensuing *de-dramatization,* the performance becomes primarily "the presentation of an *atmosphere* and *state of things.*" In the end, a "scenic *écriture*" is more alluring to the audience and, as a result, the dramatic plot "becomes secondary" (2006, 74; emphasis original).

Visual framing is instrumental to the stage *écriture.* Serving to enhance the aesthetic function of an image and often assume the role of a "third character in the play," lighting provides directors with another powerful supporting device: it can isolate, juxtapose, or superimpose actions on the stage, surround actors, sculpt bodies, demarcate space, and intensify an atmosphere of ritual. To some, lighting is just as important a scenic element as an actor, as Wilson hints: "I paint, I build, I compose with light. Light is a magic wand" (quoted in Mitter and Shevtsova 2005, 186). Sharing Appia's confident assertion that light is just as crucial in performance as music is to the score, Wilson also pays tribute to Beckett, whose incorporation of lighting-specific directions in his plays was of predominantly structural and narrative significance. Additional mechanisms of framing, objects also function as symbols that evocatively rouse emotions by inculcating mental connections[1] and, in this sense, are an integral part of directors' arsenal of scenic tools. When eloquent in stage presence and associational in function, an object helps forge a complex visual language, triggering impressions and memories unique to each spectator. Possibly, Kantor was the best known innovator of scenic objects and props: a visual artist to begin with, well versed in the languages of postmodernism, he conducted daring experiments in performance art and happenings, in which props amounted to elements of the action, in dialogue with actors. Thankfully, Kantor never resorted to representationalism: his *found objects* and ready-made spaces[2] and ceremonies were organically integrated into the compositional frame of performance, doing full honor to Witkiewicz's theory of Pure Form.[3]

The visionary use of lighting, object, and image in performance to an extent serves the human need for metamorphosis. In fact, transformation as an agent of surprise and enchantment transcends directors' dexterous stratagems to translate an idea technically; rather, it is the product of an imagination flexible enough to conceive and formulate connections among seemingly incongruous things by reaching beyond the tangible icon into the recesses of the subconscious in order to unearth what has been lying there buried. Manifesting an astonishing visual sense, in his *Andersen Project* (2006)— inspired by two stories by Hans Christian Andersen ("The Dryad" and "The

Shadow")—the one-man show he wrote, directed, and performed, Lepage fully justifies his reputation as a visual wizard. According to a review of the London production by *Guardian* critic Michael Billington, the production's success should be attributed mostly to Lepage's "visual brilliance and satiric humor." Billington describes how Lepage, impersonating Andersen, has no difficulty merging from one persona to the next, from "the tall albino Frederic to a crinolined dryad emerging from the gnarled bark of a tree." The director's flair for visual metaphors is extended to the scene where Andersen strips a dressed female dummy, mirroring Andersen's desperation owing to his unrequited love for Swedish opera singer Jenny Lind. Thanks to an equally commanding imagistic verve, Andersen's "museum-case luggage" turns into a "high-speed train rattling between Copenhagen and Cologne" (Billington 2006). Not only does Lepage, in his own words "whisk the stage from one era to the next" (quoted in Clapp 2006) but he also takes on several personas and morphs from one character into another, "from the Opera director, that Machiavellian master of arts politics into a fond father reading a sad bedtime story to a beloved daughter...along with his wife"[4]; while at the same time he infiltrates the fairy-tale element in his text, mixing it with scenes from every day life and video-projected images. The handling of transformation and contrast reveals Lepage's concern with how to activate in his audience alternative perceptual intuitions. John Cobb, a Scottish actor working with Lepage on the production of *Tectonic Plates* (1990), proudly describes the director as an artist whose "actors are his pencils.... He is an auteur and watching his work in progress is like going into Picasso's studio when he's making a sculpture."[5]

Similar accolades go to Wilson, whose pictorial sense is always teeming and agile, angling our understanding of the ordinary: no image, despite its outward stillness can remain internally static for too long, and each human figure positioned on stage contains a secret, the potential for instantaneous transformation. The very space Wilson's trained bodies inhabit is shifting, uncertain, and treacherous, while the kernel for change in size, shape, and otherwise, remains integral to each one of them. *New York Times* critic Ben Brantley, who reviewed the production of *The Days Before: Death, Destruction and Detroit III* (1999), fully acknowledges Wilson's ability to manipulate "basic human physiognomy" in order to create dazzling contrasts in the sizes and shapes of his actors and therefore, suggest a "multiplicity of forms of being and, by extension, seeing." In reality, Wilson's world is ruled by the ciphers of metamorphosis and surprise: "Headless torsos and seemingly empty suits of clothes that come to life, bring to mind the paintings of Magritte, de Chirico and Dali" (Brantley 1999). It was an innate flair for visual dramaturgy and a solid background in the fine arts that gave Wilson both the impetus and the tools to construct plays as *landscapes,* informed

by the principles of Gertrude Stein's *landscape writing.* In 1922, in discussions of how and why she writes, Stein had declared that she used words to paint pictures and that she held the notion of writing plays as analogous to the practice of landscape painting, which actually absolved her of the conventions of linear storytelling.[6] By defining plays as landscapes, Stein communicated a desire to generate visual relationships in space through a play of words. Inspired by Stein's formulas, Wilson's consummate composition and three-dimensional spatiality, together with an acute attention to detail, almost transubstantiate objects and bodies into still lives and veritable stage portraits. At the same time, conventional narrative devices are abandoned, substituted by a visual introduction of mood. Although Wilson's devotion to painterly finesse is also apparent in relatively more recent productions, such as *Alice* (1992), *Time Rocker* (1997), and *Dream Play* (2000), it is especially in such early works as *Deafman Glance* (1971), *The Life and Times of Joseph Stalin* (1973), and *Einstein on the Beach* (1976) that his landscape aesthetic works alongside a more daring treatment of the verbal text. This said, even though in later works Wilson, to some degree, returns to the dramatic canon, directing plays such as *Happy Days* (2008), *The Threepenny Opera* (2008), and *Krapp's Last Tape* (2009), his imagery continues to remain associational and abstract. In his stunning treatment of August Strindberg's *Dream Play* (2000), thirteen tableaux reveal his unbridled scenic acumen: unexpected and masterly shifts in lighting register the intrusion of dreams into the realm of reality; in one of the most "Wilsonian" scenes of the play, the yard of a remote house radiates in amber light, as an indication of summertime yielding to fall. Other elements of the mise-en-scène, including the stylized choreography and occasional mime; the languorous pacing; the solid colors of the costumes pitted against the pristine, abstracted set; the filmic devices of dissolve and blackouts; and the suggestive sound-scape further reinforce the sense-informed construction of the performance. In a similar fashion, *Alice* (1992), Wilson's collaboration with composer Tom Waits and writer Paul Schmidt, reflects an analogous preoccupation with pictorial, as well as musical, principles: symbolically conceived tableaux containing imagery drawn from the infinite domain of dreams and nightmares underlines the overall mood of the absurd. A backdrop of letters and words sets up the game in which Alice and Charles Dodgson (the writer-mathematician Lewis Carroll) engage. The animal figures are also tautly conceived: for example, the White Rabbit comes onto stage in ceremonious white coat with long tails that drag along, while the Caterpillar "inflates into a phallic balloon" (Holden 1995). Wilson's depiction of Alice can be disturbing: quite ironically, at the beginning of the play, she violently smashes through the mirror rather than stepping into it; later on, her middle-aged version is discovered leisurely lying on a bed, drinking. Throughout the performance,

the juxtaposition of immaculate imagery with moments of violence reveals the forceful function of contrast as a way to cultivate within spectators an impression of overall disorientation along with mildly hallucinatory sensations. In one of the production's most characteristic scenes:

> A duel between the Black and White Knights is prefaced by an ear-splitting thunderstorm. "Jabberwocky" is sung by a chorus of Victorian vicars to the accompaniment of furiously banging percussion. As leeringly interpreted by eight bald, chalky-faced clerics, it has the ring of an obscene marching song translated into code. (Holden 1995)

The allure of visual delight is also responsible for stage adaptations of actual paintings, in what might seem to be directors' most solipsistic act of visualization. Choreographer-director Martha Clarke, formerly a member of the Pilobolus Dance Theatre and a cofounder of Crowsnest, employs a decidedly voluptuous scenic imagism to render alive painterly compositions, or even just an atmosphere. In *The Garden of Earthly Delights* (1984), Clarke dramatized the title Hieronymus Bosch triptych, while almost twenty years later she ventured to flesh out the "character" of fin-de-siècle Vienna in Charles Mee's *Vienna: Lusthaus* (2003). Both productions introduced new sensibilities of painterly performance (or performance "as painting"), interweaving theatre, dance, music, and fine art. Specifically, in *Vienna Lusthaus,* forty-four imagistic vignettes, which either coalesced or collided against each other, gave the piece its constitutive structure. Clarke used electrifyingly hedonist choreography to supply the totality of brush strokes in the canvas of performance and treated the actors' naked bodies as material for sculpting a space of memory and illusion. Despite the absence of a tight story line, *Vienna Lusthaus* is full of dramatic resonance. Mel Gussow relates how the audience is entirely captivated by Clarke's "vision of vertiginous days in Vienna," drawn inside a picture gallery, a "madhouse" or a sensuous "pleasure pavilion." Through this hazy, hypnotic collage of living images, "behind the beauty, one feels the imminent dread, yet decadence has never seemed more beautiful" (1986).

Having established at some length the function of image and of scenography as *text,* it may be worth observing how in the most resonant auteur performances, the original formation of a visual notion coincides with an emotional connection, so that ultimately a conceptual mise-en-scène is still at least partly indebted to an instinctual feeling. If this organic relationship is abandoned or, even worse, reversed with the director's personal connectedness to the primary material surrendered or sacrificed to an idea, a concept, or a form, inevitably, the image exacted can only be doomed to meaninglessness, despite its potentially spell-bounding beauty. Having said this, most

set designers who invariably struggle to break new communication barriers with the audience remain aware of the fact that their unconventional, non-representational, often altogether abstract designs will not be automatically processed or appreciated. In the end, directors' method of visualization is almost congenital. For instance, JoAnne Akalaitis insists that she gets most of her ideas from pictures: "In fact, all images in the theatre are visual, even language—it's impossible to read without making pictures in your mind. The crucial thing for me is always to remain true to your images" (quoted in Wetzeston 1981, 30). Still, it is worth keeping in mind that images are never still or shallow properties, but rather, dynamic entities, which harbor, reflect, and shape meaning. Or, as McBurney sees it, an image is a lot more than mere "pictorial representation or *coup de théâtre*"; empowered by a different logic, that of a poetry of "forms and narratives," it becomes a way to organize and layer the combination of the constituent elements of the mise-en-scène. In a way, images connect text, movement, music, and object, operating as a "fusion of form and content in an embodied, if fleeting world" (quoted in Mitter and Shevtsova 2005, 250). At the same time, given that visual interpretation begins the moment the reading of the performance text begins, and that the language of scenography is an alternative medium to logos, it also follows that:

> Every reading of the theatre text imposes choices of spatial structuring, as soon as one has to decide *who* is speaking and according to what proxemic relationships. Space is organized as much within the scenographic framework as it is by the actors' bodies and the individual and social distances to be observed between them. (Pavis 1993, 156)

It is therefore instrumental for the uninhibited reception and absorption of scenography—essentially of the image—that the director should allow the visual materials of the stage to fall into a natural balance between clarity and suggestion.

THE "PRESENT" OF TIME

Perhaps more than any other aspect of contemporary performance, it is the sense of time that has been the most seriously "wounded." In auteur semiosis, the loss of a stable time frame can largely be attributed to the overall reconsideration of dramatic time, or as Lehmann describes it in recalling Peter Szondi, the "crisis of time" (2006, 154). Cushioned within the long-held conventions of realism, theatre audiences cozily abandoned themselves to the fictitious universe of the play, pushing back the irritating intrusions of "real-time." If anything, they kept themselves "locked" inside a zone of

quarantined time, the compressed spell in which the spectacle was to unfold. Responding to the challenges posed by the ever-revised ways of looking at art, the gradual identification of scenic time with audience time brought with it endless perceptual possibilities, which in turn informed directors' signifying choices. In principle, dramatic time, commonly expediting narrative completeness in realistic drama, has been rendered subjective, irrelevant, or invalid. Destroying the illusion of dramatic continuity, the performances of the 1970s first ventured to access a new dimension of *shared* time between audience and performer, based precisely on the exploitation of the real-time aesthetic, which virtually joins the perceptual modes of the spectator with the experiential ones of the actor. In later innovative productions, particularly those influenced by the active presence of information technologies, the performance's temporal dimension is thoroughly sabotaged and unity is cancelled: time can be fast-forwarded, distended, and reshaped at will. In most cases, the manner in which it is actually maneuvered betrays a desire to "distance," to disorient, to challenge. For instance, the strategy-effect of real-time, conspicuous in Foreman, Wilson, or downtown New York company Elevator Repair Service,[7] requires of spectators a higher level of concentration: because audiences have for the longest time been schooled in understanding and accepting compressed dramatic time as the only viable paradigm in the experience of live performance, following the (natural) rhythms of moment-to-moment action calls for a gradual shifting of focus and emotional attention.

A good example of the hyper-real use of theatrical time is the work of renowned Swiss auteur Christoph Marthaler.[8] Marthaler's double interest in directing and musical composition has made him particularly sensitive to the rhythmic patterns and the nature of time in performance. For the greatest part, the excruciatingly slow pacing of his productions, where clocks have stopped—an ordinary action such as getting up from a chair takes up to five minutes to complete, and the most banal activity seems to be repeated ad infinitum—reveals his existential concern with those "in-between moments" within which people are forever locked. Duration is a dense tissue of past memories and present obstacles, where all three dimensions of time become indistinguishable. In effect, Marthaler's theatre reflects a desire to slow down and consider the constant influx of speedy images and ephemeral sensations that capitalism imposes on people; he "slows the heartbeat and stops life's flow to observe and reflect." The manipulation of time becomes a statement, "a refusal to speed up or catch up" (Andrews 2006). These principles certainly apply to the production of *Riesenbutzbach. A Permanent Colony,*[9] created jointly with Anna Viebrock (2009). Dragged out movements, minute-long pauses, and relentless repetition throw a veil over the core of the action, shrouding the audience in a mist of time: each moment

seems to expand into an eternity, so that spectators cannot but eventually share the characters' sense of impasse and neurosis, which in themselves define consumerism-drained societies. In point of fact, Marthaler's conception of *ennui* (existential boredom) as an intrinsic component of human existence is also structurally paramount in performance, calling for infinite amounts of patience and concentration. In the 2010 Avignon Festival's *Papperlapapp,* a music theatre piece dealing with questions of Catholicism and faith set in an actual Papal palace, a group of spectators were so enraged at Marthaler's exasperating balancing of frenetic moments of burlesque and suspending fragments of silence that they walked out of the theatre loudly stamping their feet, causing a general uproar.

Equally compelling can be the mechanisms of retrospection and the function of theatre as time machine. To use a conspicuous example: Kantor's obsession with past and childhood involved him in forms that were primarily intended to communicate a sense of dramatized memory. More specifically, in *I Shall Never Return* (1988), the director developed the notion of an "inn of memory": past creations merged with present circumstances, while the "I" of the creator (self) confronted his past, embodied in objects, phrases, collaged pieces of previous productions, and other "ghosts" from his vast storage of recollections. Control over time establishes another framing device. For one thing, repetition produces emphasis, as is manifest in Mnouchkine's epic *Le Dernier Caravansérail,* the structure of which was based on the uncompromising representation of refugee plight. Deliberate emphasis on acts of brutal oppression, killings, torture, and prostitution is achieved through a relentless, heart-wrenching cycle of recurrence. As John Rockwell argues, "The repetition drives home the grinding despair of these people." Indeed, the effect of such "overkill" is tremendous: before the audience gives up under the cumulative effect of torture, as the scenes go back and forth in time, Mnouchkine changes the tempo to relieve us of the tension: in the second part of the production, the rhythm changes into a contemplative tuning of the spectator to the small yet tangible pleasures of life (the final picnic scene, a "downright peaceable kingdom," topping them), that even victimized refugees can still enjoy (Rockwell 2005).

Simultaneity also models time by means of compression: by setting one action, one body, or one space against another, directors are able to simulate the effect of speed. The use of technology can actuate the manipulation of simultaneity to extremes, radicalizing, coagulating, and elasticizing time more than any other medium. Similarly captivating can be the reverse strategies of hypnotic stasis, long pauses, silence, and slowness, ticking away the eternities settling over post-apocalyptical landscapes of ellipsis and emptiness. As a rule, when time is distorted, actions take on a new significance and human perception is radically recalibrated by means either of prolongation or

of emphatically extreme duration. In Complicité's *Mnemonic,* by definition a play about time and remembering, as the very title suggests, McBurney's astounding imagery arrests time alternately in its stillness and acceleration, conjuring up in a mere two hours the icon of memory itself. Like in most of Complicité's productions, one always has the uncanny impression that visual forms have been timed to attain and sustain a certain rhythmical quality, adding even more texture to the oblique storytelling.

Most theatre deals with speeded-up time, but "I use the kind of natural time in which it takes the sun to set, a cloud to change, a day to dawn," Wilson once suggested, justifying the hallucinatory expansion of time in his work (quoted in Mitter and Shevtsova 2005, 188). Time's stillness, suspension, or grueling elongation—in some recorded cases, the action of crossing the width of the space notoriously taking more than a half hour to complete—intensifies the conception of the theatre as a landscape of the mind, where time has frozen. The distension paradoxically generates spatial expansion; within auteur-revised spatiotemporal trajectories existing outside regular coordinates of time or place, the human figure is reduced to infinitesimal points in the universe of the stage. The elongation of time, following the cycles of nature, virtually affects the way we understand the narrative, admitting it to the expanse of myth. There is no "plot" as such; instead, people's personal stories become human history.

THE VISIBLE "ABSENCES" OF TECHNOLOGY

Contrary to a "theatre of stillness," where deceleration and immobilization are standard strategies of engineering time, many auteur productions engage in the aesthetic of the media, combining live and mediated presence, recorded voice, and TV-like segmentation of theatrical time, no less in order to compete against the speed of the moving image. At the antipodes of Artaud's adulation of a metaphysical theatre based on the immediacy of the actor's body, the inspired integration of multimedia forms has been a powerful engine in radical performance ever since the 1980s. Quite subversively, technology registers a sense of resistance to psychologically validated interpretation by collapsing common representational conventions and addressing such questions as what realism and reality ultimately do mean in (virtual) postmodern culture. McBurney, LeCompte, Sellars, and Wilson are all primary agents of this problematic. Looking back to the gradual formulation of the trend, we must once again acknowledge Beckett's pioneering introduction of technology into the text and to the dramatically crucial installation of mechanically moderated selves and controlled memory.[10] Beckett's legacy is, for example, quite present in *Mnemonic,* where technologically enabled communication drives the action on and video and cellular

phones are used profusely not as mere accessories but as structural devices. In effect, as the protagonists struggle to approximate their origins, technology replaces memory, rewinding or fast-forwarding a variety of incidents and recollections.

Brecht and Piscator were the first advocates of the use of technology in the theatre as a method of estrangement. The adopted emphasis on generating a critical distance between spectator and spectacle certainly accounts for the continual presence on stage of machinery employed in production. Today, the aesthetic, functionality, and even tangible existence of film and the media predominate in performance, having originally crept into the stage around the mid-1970s, when information technologies were first introduced in the form of microphones and television screens. Technical equipment, coexisting with actors on open display—a favorite Wooster Group strategy—still serves as a reminder of the tentative relationship between rehearsal and performance. To some degree, the "live" presence of cables, lighting instruments, sound equipment, and inactivated video projectors scattered all over the playing area, designates a self-reflexive tactic. Even though the argument holds that the *vis viva* of theatre lies precisely in its limitations, and notwithstanding film's uncontested role as a unique carrier of realistic detail among artistic mediums, many auteurs borrow regularly from cinematic techniques to manufacture narratives that transcend the inbred formal constrictions of the theatre form. The reliance on technology as an instrument of storytelling and a means to accelerate, annul, or blur time and space is conspicuous in the work of McBurney, Sellars, Lepage, Wilson, LeCompte, and Foreman, among several others.

Given that the centuries-old allure of mimesis remains for many directors a mighty barrier to overcome, the intersection of theatre and media-related disciplines marks a major point of departure in contemporary performance. Lehmann actually demarcates the beginnings of postdramatic—as opposed to *dramatic* and *mimetic*—theatre in the advent of technology. In his view, although the early experimentalists introduced new and unconventional forms of staging that embraced the aesthetic of the abstract and of estrangement, their productions were still based on the existing mimetic model that had been the rule of the day for several centuries. However, as soon as the media entered the domain of performance, it instigated a new "theatrical discourse," that of *postdramatic theatre,* which was largely welcoming of multifarious artistic expression (Lehmann 2006, 22). By extension, changed social communication, as a result of the unprecedented spread of information technologies within human communication, ushered new "technology-hyphenated" forms into the discourses of the theatre. Eminent examples include American experimental performance artist and musician Laurie Anderson and her multimedia "music-theatre"

productions: Anderson's *United States* (1983) mixes rock performance with fine art, while in her later *Songs and Stories from Moby Dick* (1999), dance, music, and text interact with video. Originally trained as a sculptor, Anderson started to work on performance art pieces in the late 1960s and since then has been consistently engaged in large-scale theatrical pieces that combine a variety of sources such as music, video, painting, storytelling, and image projection. Needless to say, her involvement with multimedia forms also displays a consummate need to investigate the impact of technology on human relationships and social interaction.

Echoing Beckett's strategies of representation, some aspiring applications of technology have rendered themselves commanding moderators of identity. In the multimedia art of the Wooster Group, plasma television screens and microphones on metal stands abound; the performers are allowed to demonstrate the work of acting amid these objects of technology and also elicit through them mediated (as well as distorted) simulacrums the self. In these productions, the actors' high-pitched, interceded voices convey a sense of distance just as the body oscillates in its dual role of living entity and machinery component. On all accounts, the Wooster Group reexamines issues of race, gender, and representation, subverting and fragmenting the actors' presence on stage and simultaneously constructing "consciously inauthentic bodies in performance" (Monks in Mitter and Shevtsova 2005, 207). Aoife Monks points out that while the company approaches theatricality as a central characteristic of identity, there is also a sense of regret in its work, that bodies are inevitably interceded through representation (210). This feeling is also manifest in the types of "bodies" the Wooster Group explores in performance: emphatically, LeCompte structures her productions to reveal "unequal hierarchies of identity," as when she highlights the connection between blackface minstrelsy and contemporary American society's racism (208). In particular, her preoccupation with black minstrelsy has been a crucial structural and visual anchor in several productions, such as *Route 1&9* (1989), *L.S.D. (...Just the High Points...)* (1984), *The Emperor Jones* (1993), and *The Hairy Ape* (1995). George Hunka describes how, in *The Emperor Jones,* the protagonist, Kate Valk, displays openly her white arms and legs, which, "underneath the heavy, overwrought, Kabuki-inspired costumes," make her much more than "the vulnerable, marginalized, tragic figure that O'Neill envisioned: as a white woman playacting as a black man, she embodied the vulnerability of all humanity" (Hunka 2009). For LeCompte and her company, considerations of gender construction are also crucial: the objectification of femininity in plays of the dramatic canon is constantly undermined and brutally exposed. Technology also functions as a means not only of mediating but also of meditating on essentialized perspectives regarding

sexuality (See *House/Lights* [1999] and *To You The Birdie* [2002]). In the course of constructing "performance texts," as Philip Auslander suggests, the Wooster Group apparently assumes a "poststructuralist idea of textuality." Auslander links this practice directly to the philosophy of Barthes, whom he quotes, recalling how in the "Death of the Author" (1977), the text is viewed as a "'a multi- dimensional space in which a variety of writings, none of them original, blend and clash. The text is a tissue of quotations drawn from the innumerable centers of culture'" (1997, 33).

Not surprisingly, technologically negotiated selves produce a "crisis" within the actors, particularly during those moments in performance when they must watch themselves perform on a video screen. This tension is carried through to the spectators, challenging them to hierarchize the projected images. LeCompte is very much aware of how the mediation of identity works on an audience and how, in principle, the performance of identity on stage can alter or even define attitudes in matters of gender, race, and sexuality. For one thing, technology sheds light on reductionist renderings of the female subject in classical texts: *To You the Birdie* revisits a classical story of unrequited love, transforming the invalid Phèdre's passion for Hippolytus into a jarringly ironic multimedia exploration of contemporary cultural assumptions that relate specifically to image and body representation. To that effect, the performance is layered with alienating voice-overs, while Phèdre's figure on the video screens is split into two. Forced to become her own viewer, as she mimics her filmed version, the actress playing Phèdre sets up a correspondence between herself as a performer and the character's "body as a spectacle of tragedy and femininity, incapable of any greater physical action than being looked upon" (Monks in Mitter and Shevtsova 2005, 210). No less striking is the ability of technology to decompose the actor's voice.[11] Some of Phèdre's soliloquies are spoken into a microphone by another actor, echoing Beckett's faceless voices in *Not I, Cascando, A Piece of Monologue*, and *Ohio Impromptu*. Phèdre's words fly away from her body, unsettling the impression of her identity as "whole." The implication becomes that theatrically filtered and videoed representations of the self (and by extension of the world) are the only valid, if counterfeit, realities in postmodern, "post-existential" culture.

The introduction of technology into the theatre, further injected with the omnipotence and ubiquity of cyber realities, has also opened a door to contemporary social reference, facilitating the projection of images in places where performance cannot enter. Because it helps "quote" visual material as a background—or even foreground—for the action, technologically processed matter is a perfectly legitimate and versatile expedient for documenting or ushering the "real" world onto the stage. Rendering the coexistence between performers and their video presence possible, technology occasions

simultaneity "bringing body time and technological time into competition with one another" (Lehmann 2006, 158) and in doing so, additionally shapes and relativizes time. The application of video to integrate absent performers into the action is particularly effective: in the Wooster Group's *Hamlet* (2007), the actor playing the title role interacts with Richard Burton's filmed version of the character, which is projected on a large movie screen upstage. Besides animating as well as broadening the scope of the stage material, the background video further nurtures the performance's sophisticated structure, as is manifest in the arrangement and succession of the images, the framing of the event as a talk show, and the consistent patterns of popular TV culture. Fundamentally, technology contemporizes performance; bearing the prerogative of relating everything to the present, it effortlessly facilitates shared cultural understanding, functioning as an interlocutor between the contingencies of live action and our Facebook-ed and Twitter-ed intuitions. It is no surprise that the use of television, video, or the Internet within theatre practice ultimately globalizes experience and promotes intercultural dialogue: thanks to technology—and in particular to the privileges afforded by the rising influence of *cyberspace*—people from different parts of the world can share the same performance reality, despite being physically removed from its actual site.

It might sound ironic that technology holds the mirror up to people's entrapment and loss of individuality within the media industry and the more general show-biz craze. Yet, for example, notwithstanding Sellars' reputation for (overly) relying on the extensive and expert use of technology in his controversial adaptations of classical texts, his primary ambition—also shared by McBurney when echoing in *The Elephant Vanishes* (2003) an "alienated, sped-up hyper-modernity" (Williams quoted in Mitter and Shevtsova 2005, 251)—is not merely to modernize the plays by setting their action in high-tech environments of amplified sound, microphone voices, and movie clips; rather, overexposure to technology is also the director's way of shocking audiences out of their complacency and of encouraging them to reflect on the actual necessity for such exposure. Sellars himself insists that technology is "just a part of our world":

> Everything we experience, most of the decisions you make about most of the things in your life, our profoundly mediated. That sense that our experience is so profoundly mediated must be shown, used and critiqued all at the same time. (Quoted in Delgado and Heritage 1997, 227)

Taking this point further, technology also serves the purpose of foregrounding the media's negative impact on people's lives by representing not just fictitious but ultimately false versions of the world. In their

elaborate technology-tied undertakings, auteurs such as LeCompte, Sellars, McBurney, and Lepage have entered new territories of scenic writing, striking a balance between the live and the represented, the real and its simulacrum. Others, however, recurrently fall short of the challenge not to let the "mechanics" take over as a sensational means and end in itself. Perhaps the challenge for directors in their encounters with the new media is how to stretch its limits to reflect the characters' inner selves and provide for spectators a more layered—and conceivably more involving—experience of time and place. The question thus becomes how to avoid the gratuitous use of technology as a glamorous alternative to action and to acting, since its most compelling function is not so much to describe or narrate but rather to *partner* with performance.

BODIES AS TEXTS

The pioneering celebration of "body" and of "presence" in the avant-garde experiments of the 1960s represents the performer's on-growing hold over the playwright's and, increasingly, the director's text. Counter to Craig's rather disconcerting vision of actors as "marionettes," later on emblematized by Beckett's dehumanized stage bodies, performers have advocated their own metatext (interpretation), defending their right for supremacy in performance. Despite some directors' notion of actors functioning merely as an additional, auxiliary pole in the pyramid of interpretation, whose duties are forever limited to servicing the mise-en-scène so that it can best render transparent the playwright's understanding of the world, respect for the performer's autonomous presence signals a changed attitude toward the principles of performance altogether. As theatre became more physical and less text-dependent, the ownership of interpretation by both director and playwright was by degrees defied by the "new actor," the self-proclaimed "performer." One can detect a natural entropy behind this series of power shifts: comparable to a number of playwrights, who at some point felt ready to succumb to the "in-charge" mission of the director, performers, being the audience's closest interlocutors, increasingly asserted their own rights as equally legitimate *authors* of the theatre event. In the process of actor emancipation, questions keep arising as to whether performers have the comprehensive potential to be even more privileged interpreters than directors. As Richard Schechner corroborates, soon a distinction began to be drawn between "actors" (embracing a role and engaging in a mimetic process) and "performers" (embodying the presence of the theatre event). Unlike the former, the latter chose not to hide their personalities, but deliberately let them show side-by-side with the roles they were playing. Interestingly, Schechner is also recalling Meyerhold's theory

of the "straight line," according to which the director absorbs the writer, while the performer absorbs the director, and, in the end, is left to face the spectator alone (Schechner 1981b, 11). While theatre reformers like Craig insisted that directors should be in charge of their material—even if that involved the substitution of living entities by marionettes—the mechanization of the actor, championed by Meyerhold, Oskar Schlemmer,[12] and Beckett, betrayed a similar longing for control. At the opposite end of the spectrum, Artaud's conception of the "holy" body as a vehicle and an engine for expressing equivocal moods and experiences endorsed the sovereignty of performers and the establishment of corporeality as a principal language of scenic writing.

The overruling critique that relates to several auteurs' attitude toward actors centers on the manner in which the former deprive the latter of their interpretative individuality, while [ab]using their bodies as mere compositional elements of performance; directors have often been blamed for treating performers more as pawns on a chessboard stage, or mere lines in a drawing, than crucial architects of expressive meaning. For example, for Foreman and Bogart, it is movement that shapes an action, not the reverse. Even more radically, in Wilson's exacting choreographies, performers are divested of any representational possibilities and responsibilities, while their presence "holds together and structures the work in a certain way" (Kirby 1987, 23). Surely, these observations leave plenty of room for speculation on actors' initiative and for examining notions of collaboration and trust in the "shared" creation of meaning in both rehearsal and performance.

Clearly, the reclaiming of the "body" against its "tyrannical" appropriation has disturbed the actor-director balance of power. As acting yields to performing, the player's control of performance tightens. The art of acting itself is revised, broadened, and expanded; it allows for those persistent elements of personality to creep into the interpretative form, for the essential physical self to mingle freely with the dramatic character. Besides, because performance art is closely connected to the concept of time and in particular to how real time touches upon theatrical time, the experience of the event is always channeled through the presence of performers holding onto their "corpor-reality." Disguised within the very body of the actor, reality intrudes into the artificiality of the stage, disturbing the forced compression of dramatic time. The element of the improbable and the unforeseeable brought about by the living presence of a performer who refuses to remain idle within the structured frame of a fixed mise-en-scène, carries the outside world and its contingencies inside the haven of the stage world, and furtively jeopardizes its cushioned yet tentative fiction. In describing her experience of continual transformation during dancing, Sondra Fraleigh foregrounds

the essential interweaving of body and time which is also pertinent in theatrical performance:

> My own identity merges with the movement I experience. And I can repeat it. To a great extent, my dance is repeatable; it has permanence, but my life moves always into the future. I cannot relive it, nor any part of it, as I can my dance. (Quoted in Carter 1998,142)

The performers' defense of their body involves risks, which add an extra degree of complexity to the already intricate mechanisms of theatre semiology. In essence, the "ostentatious" body cries out its right to exist independently of the text and not as a signifier, to no longer merely represent or illustrate. The body writes its own story, becomes its own text.[13] The actor's *interruption* and *interference* into the space of the action forever safeguards the affirmative role of the theatre as an ephemeral, breathing, and interactive art form. At the same time, through its sheer flesh-ness, the physical body eventually subjugates its electronic mediated "double." In Lehmann's understanding, in the abandonment of a "mental, intelligible structure" in favor of the "exposition of intense physicality," the actor's body is *"absolutized"* (2006, 96). "By pointing only to its own presence in an auto-deixis, it opens the pleasure and fear of a gaze into the paradoxical emptiness of possibility. Theatre of the body is *a theatre of potentiality* turning to the unplannable 'in-between-the-bodies'" (163).

The sanctification of the "suffering" body, altogether resistant to forced manipulation, dates back to Artaud's writings on the Theatre of Cruelty, receiving additional theoretical and empirical backing in the second half of the twentieth century. More than anyone else, Brook trusted the body as an "organic root" uniting all men, recognizing the actor as the fundamental source of creativity in the theatre, a vehicle for spiritual search, a "search for a renewed theatre language as penetrating, rich and alive...a grail-like quest for totality in theatrical expression" (Bradby and Williams 1988, 145). On that account, actor training ought to be a holistic process, "a physical approach to understanding," to borrow the words of Brook's long-term collaborator, actor and director Yoshi Oida (156). At the same time, Brook hails the opportunities for pure "play" that theatre forges: for example, in the celebrated rendering of *Midsummer Night's Dream* (1971), earnest physical examination of preverbal techniques and improvisation generated an overall atmosphere of primal ferocity and communal joy. In describing the release experienced by the ensemble during the staging of the scene between Titania and Bottom, Brook's actors speak of a "revelation":

> As the noise and the laughter died away, we looked around the room, and as though awakening from a dream ourselves, we realized that we had been

possessed by some wild anarchic force, that we had been in contact with ele-
ments of the play that no amount of discussion or carefully plotted produc-
tion could have revealed.[14]

The diverse methods that directors apply in training actors converge in their
setting off their performers' abilities to communicate emotions truthfully by
releasing the right amount of energy in the right moment. In fact, as Suzuki
maintains, "there can be no words spoken that are not intimately connected
to bodily sensations and rhythms" (5). In Suzuki's own reading of Artaud,
energy is built through a "coherent system of restraint (*tame*)" (Carruthers in
Mitter and Shevtsova 2005, 169) as well as through the conflict between the
opposing principles of freedom and restraint, the Dionysian and Apollonian
poles of our existence. Purely in terms of physiology, the tension between
the upper and the lower halves of the body balances the performer on a state
of endless alert. Suzuki has been repeatedly criticized of forcing his com-
pany to remain in a long uninterrupted state of discomfort; yet, beyond any
doubt, by physically accessing those regions of the body where the uncon-
scious rules, actors appear better equipped to sustain their energy and rigor
in performance. Quite familiar with Suzuki's fundamentals, Greek director
Theodoros Terzopoulos has also looked into ways of making the body an
instrument for ceremony and ritual violence. His biodynamic method of
actor training, with special emphasis on the performance of tragedy, is geared
toward the stimulation of the power conduits of the body and the unleash-
ing of repressed memory. In his production of *The Persians* (2003), instead
of the expected chorus of old Persians, their king and queen, the stage was
dominated by five "sacred" beings depicted as raging monsters, whose lips
were uttering all the words. Similar in function and form to ancient Sybils,
magicians, and Oriental shamans, those quivering bodies were possessed by
sacred ecstasies and hoarsely screamed out their dark prophecies, shudder-
ing in rhythmic convulsions from oracular inspiration and physical pain.
Terzopoulos' focus on the body's self-inflicted pain is a study in violence:
while the audience is shocked into recognizing elemental human conditions
stirred up by the performer, the frenetic rhythm of the agonizing figure,
joining ritual with instinct, is an expression of actors' abilities to explore and
articulate states of liminality through bodily discipline. One should never
ignore, however, that in Terzopoulos' work, this accomplishment is in most
cases painfully director-induced as well as controlled. In many respects, the
ways in which the actors' *carnality* is manipulated defines the degrees to
which the body is distorted and exposed.

Inevitably, at some point or other of the creative process, performers
will resist or at least question directors' command. Protected by the shield
of a "role" no longer, they can always transfix the audience in their raw

presence, flirting, as in Beckett's *Catastrophe*, with the voyeuristic tenden-
cies of spectators, who, in turn, will be thrilled to discard with the lim-
iting signifiers of the mise-en-scène in order to enjoy their unadulterated
bodi-ness. Fundamentally, in its public access, its *"auto-sufficient physicality"*
(Lehmann 2006, 95; emphasis original), the body is both glorified and vic-
timized. For all that, it may be wise to occasionally remind ourselves that
the "theatre of presence," by definition visual, can be susceptible to formalist
excess and arrogance. On several occasions, the impeccable yet also exhi-
bitionist mastery of the body masks the necessity for reflective absorption
and processing of actual "presence." Without question, technological plots
and images, designed and executed by the director-auteur, are fixed and
unchangeable. They abide by a given linearity—nothing can change their
course. Narrating its own story, the transparent body is subject to the laws of
gravity, not simply in dramatic terms; shedding off its cumbersome "psycho-
logical character" skin, it can suffer the contingencies of real life, even when
on stage, and subject itself to the relentless gaze of the spectator. In the end,
the idea of *presence,* which, as Lehmann reminds us, nevertheless embodies
representability,[15] unmediated, uncensored, and unique, night after night of
performance, cultivates and perpetuates theatre's communal and therapeu-
tic mission, actuating shared, unrepeatable, sensual, and vital adventures. It
is a sign of both courage and intelligence on the part of the auteur to allow
through the actor for *chance, crisis,* and, therefore, authenticity to enter the
event of the theatre.

SOUND AS LANGUAGE

The preoccupation with the aural possibilities of performance also refers
back to Artaud, and in particular to his fascination with the sonority of
language. In many auteur productions, the versatile technique of collage
also applies to sound as an additional means for narrative structuring. The
evocative and deliberately eclectic sound-scapes conceived, often in collabo-
ration with established composers,[16] attest to the fact that an artist's style
can sometimes consist of the appropriation of several styles or the absence of
one single unifying style.

In the late 1970s, Romanian director Andrei Serban, who had worked
as an assistant to Brook in the production of *Orghast* (1971), caused a sen-
sation with *Fragments* (1974–1976), his adaptation of a trilogy of ancient
Greek plays (*Medea, Electra,* and *The Trojan Women*). Besides being physi-
cally stunning, all three plays were performed in a devised idiom, which
was based on the rhythmic quality of archaic languages—most prominently
of ancient Greek—and was composed by renowned musician and direc-
tor Elizabeth Swados. In one of the most spectacular and moving scenes of

the *Trojan Women* (1974), the crowds of Trojans surrounding the cart that carried the naked and beaten Helen of Troy mixed with spectators, who were invited to follow the action together with the actors, virtually elbow-ing around Helen's cart, hoping to catch different glimpses of the unfolding story. All through the sequence, the haunting effect of the Chorus of Trojans chanting in made-up cadence felt fully in keeping with Artaud's ideal of achieving a transcendental connection between performers and spectators through nondiscursive means. Already, the paradigm for such innova-tive work with sound had been set up in Brook's *Orghast* , a version of the Prometheus story written in an invented language by British Poet Laureate Ted Hughes. The production, which travelled to Persepolis in Iran, was the culmination of Brook's Theatre of Cruelty season;[17] researching the com-municative potential embedded in physical modes of communication, it fur-ther developed the experiments previously conducted on tone and rhythm in *A Midsummer Night's Dream* (1970), giving up conventional language altogether. Integrating material from Greek, Latin, and Persian sources, *Orghast* was Brook's first official undertaking with a text of pure sound. The so-called words were designed to produce the immediacy of physical action and communicate, as the poet explained, "below the levels where dif-ferences appear, close to the inner life of what we've chosen as our material, but expressive to all people, powerfully, truly, precisely" (Hughes 1971).[18] In effect, Hughes' and Brook's ambition was to invent an Ursprache, a lan-guage archetype that people across cultures could relate to. To that pur-pose, as Innes reports, the actors improvised with various combinations of cries, chants, and guttural howls; meanings for different basic sounds were derived from common physiology (for example, "Gk" was the sound for "eat," "ULL" for "swallow", etc.). Hughes' "words," conceived physiologi-cally, were in fact intuitive vocalizations of music, honoring Artaud's ambi-tion of restoring sonority to the theatre. According to Hughes, the language in *Orghast* was intended to affect "magically" the mental state of a listener on an instinctive level, in the same way that "sound can affect the growth of plants or the patterning of iron fillings" (quoted in Innes 1993,137).[19]

In *The Poetics* (ca. 335 BCE) Aristotle connected the birth of poetry to human beings' innate sense of rhythm. Fundamentally associated with a language of sensory rather than of intellectual meaning, in fact, with a pri-mal kind of music, our experience and appreciation of myth relies on our intuitive responses to sound. For this reason, directing experiments with sound as *text* invest in the philosophy that conventional language—with all its rational makeup and built-in linearity—prevents these "prelogical facul-ties" from coming to the surface and consequently undermines the pos-sibilities of myth to enter our perception through the senses. Not foreign to these assumptions, Brook's pursuit of meaning-contained rhythms was

additionally moored on the conviction that rhythm supersedes discursive meaning. His line of work was justified by the understanding that there are profound aspects of human experience that actually manifest themselves in the sounds and movements that a human body produces, "in a way that strikes a chord in any observer, whatever his cultural and racial conditioning." This realization brought him much closer to accepting and celebrating the fact that any theatre artist can work without roots, because the body as such becomes a working source (quoted in Innes 1993, 142). In this spirit, because his endeavor had always been to discover and cultivate the conditions for a universal theatre, Brook duly turned to the exploration of vocal and gestural codes that were ingrained in human physiology. Looking into nonimitative, nonexclusively Western forms of expression, he has consistently viewed the value of words in today's theatre with suspicion and skepticism. This is not to say that he actually proposed a total abolition of language; rather, like Artaud, he advocated the need for a critical reevaluation of its function within performance.

True as it may be that few auteurs have been investing in the forging of a comprehensive stage idiom based purely on sound in the manner of Brook or Serban, we certainly ought to recognize that in some of the most accomplished dramaturgy today, a similar pursuit of linguistic immediacy and autonomy has delivered a new theatre of speech, where each word appears to reverberate with *meaningful* rhythms. Disconnected from clichéd symbolism, these words no longer signify but become forceful and compelling in themselves as poetry of sounds.

II. BEAUTY IN RELEVANCE: THE CHRONICLE OF LOSS

"True works of art," claimed the German transcendentalist philosopher Hegel in the early nineteenth century, are those of which "the content and form are seen to be rigorously identical . . . content is nothing but the transformation of content into form" (quoted in Pavis 1993, 27). Moving beyond the comforts of mimesis, contemporary performance processes have gradually swallowed up dramatic theatre and representational direction. Yet, the battle of content versus form constitutes a key dialectic in today's theatre, with the adversaries of auteurism pointing a finger to those directors-auteurs who, in their view, forego essence while scrambling to create impressive forms. It is a common experience among spectators that the much sought after form is often just a shell containing little or no substance; it is also a sad reality that more and more acclaimed artists give in to the pressure of "coming up with" a new aesthetic frame, which might accommodate a modicum of meaning.

At best, revisionist form produces startling imagery. Yet, ultimately, many of the images fail to sustain the weight of the play's dramaturgy, ending up

embarrassing a number of spectators, who seem unable to place or connect them to the dramatic situation at hand and who are probably—even if unconsciously—seeking to identify with something more satisfying or profound than technical wizardry. Directors' extreme emphasis on purely sensory effects can be damaging: visual signifiers, while attractive, are often out of context, stealing focus from the play's inner and outer movement. In some cases, auteurs' striking image-scapes are based on elements that are external or simply irrelevant to the overall concept of the production. It is in this perspective that Lehmann reminds us how, when the focus of a performance used to be to perceive the text in terms of a model of "suspenseful dramatic *action*," then the constitutive elements of the mise-en-scène, that is, the "*theatrical* conditions of perception," such as the physical, visual, and aural life of the event, became secondary (2006, 34). However, as he emphatically points out, in many contemporary productions these formal aspects are essential, in fact, they are "precisely the point" (34) and certainly do not function as "merely subservient means for the illustration of an action laden with suspense" (35).

Equally obsessive can be the artists' preoccupation with expensive accessories, with video monitors or computer paraphernalia, and, in general, with theatre as an image-machine, instead of an art-form based on challenge, conflict, and internal action. The problem is heightened when directors fall in love with their discoveries, which they consider too precious to review—a fact that clearly betrays some insecurity and a desire to maintain *constant* control over one's work. The complications are greater once the form is conquered and its principal motifs conveniently reproduced. The danger looming in the excessive application of formalist principles couples with directors' comfortable recourse to already tried out patterns of staging, a habit mostly representative of projects rejecting verbal texts in favor of exclusively physical expression. Whether by Foreman, Suzuki, or Wilson, specific combinations of movement and gestures generally arrived at in rehearsal exercises "become fixed images that appear as identifying 'trademarks'" (Innes 2000, 63), ringing a particularly familiar tone in the audience, production after production. In principle, predictable methods and styles, variously applied to different plays and different actors, deaden the text's potentiality, diffusing its possible revelations and deflating its dramaturgical particularities. If surprise is for the theatre the equivalent of what DNA is for life, then set patterns can be natural deadeners. It is in the very least naïve to ascribe directorial perspicacity to airtight staging formulas, the sole product of the latter ordinarily amounting to a handful of banal, painfully foreseeable structures. Rather, the question for directors to ask is whether the scenic language[s] they employ can facilitate the text's intended reception both by actors and spectators. Correspondingly, it

is always instrumental for auteurs to consider if their method of work will impart to their collaborators the necessary means to open up and enrich the form that they have so assiduously struggled to construct.

The proponents of formalist theatre, such as Anne Bogart, argue for the usefulness of form as a "container in which the actor can find endless variations and interpretive freedom" (2001, 46). Bogart observes that limitations invite the actor to meet them, disturb them, transcend them; she recognizes, however, that the shapes and forms that actors and directors seek in rehearsal should produce currents of "vital life-force, emotional vicissitudes and connection" (46). By the same token, faith in what Mnouchkine sees as "magical treasured words" (quoted in Delgado and Heritage 1997, 182) makes the issue of equal distribution of performance languages all the more relevant. Can we altogether discredit and discard language as a more or less obsolete ingredient of contemporary performance? No one can deny that under the pretext of "art for art's sake" formalist criteria for directorial accomplishment have been granted vampiric properties, devouring those elements on stage that threaten their solidity/rigidity. To a certain extent, the central issue in auteur practice needs to be redirected to how enterprising forms can generously accommodate the text's ardor as well as the actors' embodied emotion. Most directors' stance has been wavering and noncommittal: in his provocative manifesto on formalism, for example, Wilson encourages us to profusely (and perhaps, uncritically) abandon ourselves to his visual genius:

> Go [to my performances] like you would go to a museum, like you would look at a painting. Appreciate the color of the apple, the line of the dress, the glow of the light... You don't have to think about the story, because there isn't any. You don't have to listen to words, because the words don't mean anything. You just enjoy the scenery, the architectural arrangements in time and space, the music, the feeling they all evoke. Listen to the pictures. (Quoted in Brustein's introduction to Shyer 1990, xv)

Underneath Wilson's open invitation, one can detect glimpses of auteur-determined efforts to impose "spectacle" upon spectators. Without a central vision to drive it, however, the mise-en-scène rarely develops beyond a mechanical array of visual effects, which more often than not lack in depth, feeling, and resonance. In the end, instead of being taken on a journey, the audience is forced to accept the director's self-indulgent fantasies. Wilson's, Clarke's, and Bogart's work can indeed generate that lingering flavor of bittersweet vanitas: self-conscious tableaux, perfect in execution, yet shallow or unrepentantly frozen, abandon spectators to their own devices and leave them wondering whether they have been once again fooled by yet another

emperor's "new clothes." Thus, to never underestimate one's audience is a precious, if often equivocal piece of advice for directors; despite its surface simplicity, it seems to suggest that no audience will be deceived by extravagant visual metaphors if the inner core of the performance remains hollow. Even though we may be drawn into and entertained by a production's *impeccable* aesthetic, our interest will very soon wane, if style is all the performance has to offer. In fact:

> Striking ideas and visual imagination can only work if there is a deeper connection to the artist's viewing of the world that holds them together and breathes life into them. The inability of form to echo content underlies the fundamental criticism of *New Formalism*, an "increasingly self-absorbed focus upon form and structure in its own right." (Kaye 1994, 46)[20]

John Rockwell hits the nail on the head when describing another one of Wilson's ambitious theatre events in the *New York Times* review of *Danton's Death* in 1992. His conviction that Wilson's stronger performances "become conversations across time" is certainly shared by many critics and theatergoers. Yet, as he also befittingly illustrates, when his productions are "at their worst, they cannibalize the original," substituting "true dramatic insight" with directorial stratagems and shallow pose, so that in the end, all we are left with is the precious imagery and beautiful singing, rather than being in any way viscerally stimulated (Rockwell 1992).[21] Similarly disconcerting can be the divorce of the visual mise-en-scène from the verbal text, another distancing strategy, which can nevertheless, at least initially, occasion ephemeral thrill and keep the audiences on their toes, demanding their undivided attention. The downside is a systematic obscurity of meaning: directors' persistent and forceful resistance vis-à-vis facilitating their audience in making easier connections—a process viewed in terror as an irreversible seduction into empathy—reversely leads to an irritating, because unnecessary, sense of detachment; the separation between content and form, between images and words, gradually undermines the audience's ability to enjoy and engage with the stage. Apparently, what seem to be taken for granted in this broken equation of the visual and the linguistic text are the associative links that the audience must provide, but which are simply not always inscribed into the performance's genetic code.

Also central to some auteur work is a poignant lack of emotional resonance. The "de-psychologization" of the original text has generated a sense of internal indifference and deepened the chasm between so called "mainstream" theatre and avant-garde performance. Unwilling to portray the dramatic characters' emotional life on stage, in fact, weary even of the existence of fully developed psychological "characters" in the theatre, directors

fail to understand that fanciful imagery needs to contain at least *some* sparks of inner life and emotional depth in order to come to life. Often, once the image has been shaped, whatever emotion it might have awakened in the actor is clinically removed; this alone betrays several auteurs' obstinate protection of the form they painstakingly manufactured. Directors' unconscious fear of involving themselves and the audience in a passionate and emotionally committed "affair" with the piece "contagiously" flattens the actor's experience of the role. If anything, formalizing emotion is perhaps the safest way to tell an unsettling story. Quite a number of directors have been repeatedly critiqued of framing the irrational in such manner so that its core becomes neutered and eventually defused. Rather than accommodating the burning impulses of the actors, an overly formalist mise-en-scène will actually silence them to death. Frank Rich's biting observations on Wilson's bloodless, painless, finally lifeless directing of *Deafman Glance* in 1987 attack the director's lack of "emotional range" as well as the overly stylized and "denatured" rendering of violent and elemental states like crime. Rather than timeless, universal, and ritualistic—aspects to which Wilson aspires—the mise-en-scène pacifies even the most brutal scenes. Rich compares Wilson's set to a fashionable department-store window, where everything appears sleek and pristine, and wonders whether the director's more pressing concern is indeed to keep his spotless stage clean of all the blood. "As one watches the immaculate, seemingly painless carnage, it's hard to be certain where abstraction and asceticism end and anesthetization begins" (Rich 1987).

At the same time, in their relentless pursuit of formalist excellence, auteurs at times become oblivious to social and historical specificity and, as a result, produce work that frequently verges on cultural appropriation and ahistoricity. Should theatre claim absolution from memory and history? In rejecting verbal language and intellectually processed thought, avant-garde artists of the 1960s and 1970s were indeed attacked on the grounds of their noncommittal attitude toward history and culture. Following their steps, not a few imagist auteurs today, favoring visuals and form over verbal text and cognitive meaning, are also blamed for their asocial and apolitical agenda.[22] To bring up an eminent example: in Brook's version of *Hamlet* (2000), set in a different Denmark, which is under no military threat and where the kingdom of Claudius has been depoliticized, Fortinbras is altogether removed. When Brook stripped *Hamlet* of its politics in his quest for theatrical truth, British playwright David Hare spoke of "a universal hippie babbling which represents nothing but fright of commitment."[23] Even though Hare's criticism sounds especially harsh and unwarranted, albeit partly justified by his dedication to political theatre, the word "babble" interestingly resurfaces in another critique of intercultural theatre, this time by Pavis: "Never before,"

he points out, "has the western stage contemplated and manipulated the various cultures of the world to such degree, but never before has it been at such a loss as to what to make of their inexhaustible babble" (1992, 1). In reality, the lack of political validation has been instantly associated with acts of "cultural piracy," such as the ones both Brook and Mnouchkine are said to have perpetrated while exploring remote civilizations and integrating non-Western cultural forms in their art. The desire to illuminate—and perhaps, deep down, *appropriate*—cultural *otherness* has over the years led down dangerous one-way roads to ahistoricity. But there is certainly a case to make for these directors' poignant utopias: although most of these projects indeed betray a fear of commitment—perhaps also consonant with their desire to embrace uncharted cultural territories; perhaps unwilling to confront their own immediate social and political circumstances—ultimately, the revision of cultural myths and archetypes is valid. It stimulates artists to invent new stage codes and experiment with original styles so that the intermingling of images, cultural notions, and symbols can approximate in varying degrees of success the kind of universal theatre, a theatre of roots, that Artaud and Brook have looked upon. Without the inspired vision and talent of such daring artists, however, lack of historicity and perspective, dispersed imagery, and a scattered or fragmentary perception of the world can only lead to the fatuousness that first came upon the avant-garde work in the 1970s; that is, after the initial enthusiasm of the 1960s experiments in performance possibilities began to wane, collapsing under tired reproductions of empty formal structures. Against the spectacular formalism of postmodernism, *anaesthetization* is a recurrent charge, with the audience sitting back comfortably to extract maximum pleasure from an aestheticized, but, at the same time, often anaesthetized political spectacle.

Inevitably, in their overzealous avoidance of verbal language, physical theatre artists risk falling prey to the literalness of translating everything the dialogue would hold into readily accessed imagery. In discussing the work of the American avant-garde of the three decades following World War II, Innes explores how several groups actually ended up sacrificing the lyricism and richness of language to the often trite, ready-made reference of images, doing but little justice to Artaud's "precise and immediately readable symbols" (*TD*, 94). Recourse to cliché pattern continues to characterize physical theatre companies, whose image-locked work often presents itself as a mere sampling of preparatory or improvisational exercises, lacking in both subtlety and poetry. This is especially true with many devised theatre productions, where, sadly, the actor's body remains just a visual signifier, charged with pre-assigned meaning. Rather than being "hieroglyphs" communicating in nonverbal codes, these bodies merely substitute for missing speech. In such manner, the physical translation of dialogue happens by

forms of disposable visual transference of discursive meaning, and physical presentation remains in principle "structured by spoken language" (Innes quoted in Harding 2000, 64).

Finally, given how impossible it has become to separate the multimedia aesthetic from the work of auteurs, it might be a good thing to consider how, frequently, theatre's undigested overreliance on technology is prone to reducing performance to mere displays of "technicalism." It is tempting to fall into truisms, namely, the fact that emotions can never be successfully mediated or represented, as much as that their mimicry on stage generates nothing but exhaustible sentimentalism; still, the taste of imposed ideas is further embittered by the structure itself of several performances, where the uninspired mix-and-match of intertextualities is boosted by the arbitrary, as well as gratuitous integration of multimedia in what ultimately turns to be a superfluous assemblage of half-baked concepts. Strong controversy has, for example, arisen from Sellars' and LeCompte's productions, with both directors consistently criticized of alienating, rather than engulfing, their audiences by allowing or encouraging technology to absorb the words of the text together with the thought-provoking inner mechanisms of the audience. Whether induced by an exaggerated reliance on technology, or a calculated "mumble-jumble" of stage signs, the painful side-effect of over-conceptualization is a disenchanting sense of pomposity and pretentious-ness, which, nevertheless, goes hand-in-hand with the audience's growing awareness of the directors' lack of powerful primary responses toward their material. On those occasions, the production's design dresses up a weak interpretation of the text or feels completely at odds with the play's subject matter. For this reason, established set designers argue for an emotionally driven, even if ambiguous, set, which will engage the audience in more vis-ceral ways. Their conviction holds that once an overly abstract or cerebral design has been decoded, there are no more surprises for the audience. In like manner, exceedingly conceptual directing betrays a kind of "closure" ironically akin to the one it professes to have overcome. And even though representationalism is certainly no longer the most viable solution to this problem, obscure and over-theorized concepts are often merely indulgent, irritatingly solipsistic, and, in the end, unapologetically disenchanting exer-cises in form.

This sense of disillusionment at what pessimists consider theatre's "regres-sion" to and entrapment in empty formalism has provoked heated discussions over the future of art in general and of performance in particular. Today, more and more artists and theatre critics alike acknowledge that text in the theatre can take as many numbers of forms as there are combinations of artists working together. Even though the performance text has been estab-lished as the potential realization of all such combinations, in any kind of

dramaturgy, whether literary or visual, the theme, the situation, ultimately the story, is an indispensable component. Having said this, it may come as a natural conclusion that all auteur work should strive to strike the balance between the abstraction of the auteur's imagination and the solid structures of an inspired, as well as inspiring, narrative. At a time when all art-forms seem saturated, when experimentation with ever-multiplying performance genres appears exhausted, we should definitely take note of the directors' return to the primary—that is, the original text of the playwright—perhaps as a reaction against the self-gratifying and downright shallow equation of scenic writing with flamboyant exercises in staging. Whether this return constitutes a regression to conservative performative structures, compliance with "rational" thought, or simply an expression of the artists' exploration of ways to resuscitate the primal forces of theatre remains to be seen. All said, whether treating a preexistent text or a wholly new creation, and by exploiting all possible languages that the stage affords them, directors-auteurs "write" together with the actors, their designers, and the audience the viable text of the performance. Ultimately, it is the director's job to create the circumstances for this text to be meaningful.

CHAPTER 6

CONQUERING TEXTS

I. THE DIRECTOR AUTHOR[IZED]

The examples of auteur practice we have examined so far cover to some extent the scope of creativity that is invested in avant-garde work. Readers and audiences continue to ask themselves whether dramatic texts have a life of their own or whether their existence is dependent upon performance. Put in slightly different terms, which are those cases where a performance event that refuses to deal with the literary—or prescripted—dimension of a text can survive as anything more than a transient sensation? Are text and performance by definition interdependent or can they operate as separate entities?

One repercussion of the stage's liberation from what has been variously called the "tyranny" of the playwright's text has been the awareness that theatre is the meeting ground of several art forms and not a bastard offspring of dramatic literature. Today, increasingly complex concerns pertaining to the question of the text's authorship and the ethics of performance permeate auteur practice; the prevailing thrust in theatre research is the interrogation of the concept of "meaning" and, in particular, of whether it is predetermined by the playwright, served or reimagined by the director and the performer, or ultimately constructed anew by the individual spectator. This debate evidently brings into sharper focus the position of the dramatic text as *simply* one among the numerous ingredients of the performance event, along with set, costume, music, and choreography. Issues still to be settled are the subordination of the dramatic text to the "totality" of the mise-en-scène, the boundaries of directorial freedom, and the redefinition of directorial interpretation; add to that the notions of authority, trust, and the playwright's and director's mutual fear of giving in to each other, as well as to the fortuity of live performance. Attention is now paid to the equation with or conflict between interpretation of the playwright's vision and

illustration/translation of the playwright's words on stage, which could be paraphrased as the playwright's intention and the mise-en-scène's subjective rendering of it, or, to use a different metaphor, the coexistence and battle for supremacy on stage of the playwright's original verbal script and the director's "sensorial" (visual and aural) text. In recent theatre scholarship, discussion has turned to the very tentative definitions of "respect" and "loyalty" to the dramatic text and the idea of directorial intervention as an attempt to "improve" an inadequate play. The fragile concepts of mimesis, representation, devised or improvised performance, and presencing—as well as the essentialist equation of "literary" with "academic" and of the "dramatic" with the undramatic (i.e., *dull*)—have also entered the dialogue on auteurism, the consideration of the play's authorship lying at the bottom of the contention. A unique opportunity for a shared live[d] experience between artists and spectators, the performance event realized on stage through the synergetic involvement of many yet ultimately orchestrated by the agency of one (the director), questions earlier assumptions that theatre is merely a scenic illustration of the dramatist's intentions.

After Beckett, artists and audiences have been suspicious of verbal texts' ability to capture the abstractions and polysemies that define the fragmented, dislocated, and variously disquieting twenty-first-century experiences. Mistrust of the canon had already made its presence felt in the early surrealist experiments with the language of dreams, the unconscious, and the use of automatic writing, as André Breton conceived it, as "a key to open this box of multiple depths that make up a human being."[1] The loss of confidence in the capacity of traditional drama to express contemporary conflict led Arthur Miller in 1981 to characteristically lament the demolition of structure in dramatic form: "I don't know what's happened. It used to be a problem was put in Act I, complicated and brought to crisis in Act II, and resolved or answered in Act III" (quoted in Corrigan 1984, 154). Historically, Western theatre placed primary emphasis on the plot, which Aristotle referred to as the "first form of action." Aristotelian structure, both teleological and eschatological in nature and principally served by realistic plays, has for centuries continued to provide comfort to spectators by perpetuating the illusion of order in a no-longer-orderly world. It may be that the ability to imprison and contain order within a text entails some form of authorial control and guarantees that the playwright, who makes sure that the story is told, retains a firm grasp on the piece's overall design.

At the other end of Miller's rather predictable bewilderment, Foreman, in the program notes of his production *Pearls for Pigs* (1998), argues against the validity of linear storytelling. Describing the process of conceiving his play, he reflects that in it "there is no 'story' in the normal sense, but there is definitely a SITUATION..." (quoted in Schneider and Cody 2002, 172).

His is a statement that vindicates the free-floating structure of postmodern writing, which abandons the confining laws of plot unity and psychological characterization, regarding them both as dated mechanisms for conditioning spectators' behavior. Foreman explains that there is no story in his plays because "impulse is free to deflect normal linear development":

> Linear, narrative development in the theatre always ends with a denouement, which delivers a "meaning"—i.e., moral…This kind of narrative, this kind of logically arrived at "moral" conclusion, is in fact, a way of reinforcing the spectators' behavioural conditioning—conditioning provided by the world which exists "as we have been conditioned to perceive it" by physical reality, society, inherited psychological patterns, etc. (172)

In Lehmann's *Postdramatic Theatre*, the questioning of the structural supremacy of canonical literary texts is captured in what the author views as a dichotomy between *dramatic* and *postdramatic* theatre. In spite of the fact that Lehmann sees texts as "at least the imagination of a comprehensible narrative and/or mental totality" (2006, 21), he points out that dramatic theatre is the "formation of illusion," interested in constructing a "*fictive cosmos* and let all the stage represent—be—a world…abstracted but intended for the imagination and empathy of the spectator to follow and complete the *illusion*" (21). He similarly purports that wholeness, illusion, and world representation are inherent in what he calls the *model drama* and that dramatic theatre, through its very form, "proclaims wholeness as the *model* of the real" (22). By contrast, he rethinks the definition and expands the novelty of postdramatic theatre from it being "*simply a new kind of text of staging*" (emphasis original) to actually constituting a kind of "sign usage," which disrupts the commonly accepted "levels of theatrical staging" by reversing the orders of these levels thanks to "the structurally changed quality of the performance text." Correspondingly, an essential component of what Lehmann terms postdramatic theatre—which has also been the muscle in much of auteur work—is the awareness of the nature of performance as "more presence than representation, more shared than communicated experience, more process than product, more manifestation than signification, more energetic impulse than information" (85). One should always keep in mind, however, that when Lehmann refers to "dramatic" theatre, he tends to associate it with "model drama," his own understanding of dramatic realism. This misconception can lead to a dangerous slippery slope. For the purposes of this analysis, it is important to avoid falling into the trap of equating all dramatic theatre with realistically conceived plays, since there are numerous examples of playwrights whose dramatic and predominantly verbal texts display a fragmentary structure, a rejection of established forms

of characterization and an aversion to causal narrative. The theatrical avant-
garde of the 1960s had already brought in the physical environment and the
lived body experience and therefore challenged even the notion of repre-
sentation with the phenomenological notion of presencing. In the words of
Michael Vanden Heuvel:

> At a time when the pluralistic values of disinterment, deferral, and the dif-
> fraction of meaning into difference are being strongly foregrounded, there
> seems not to be much patience or desire for texts and theatre events that
> explicitly privilege acts of authority and power such as definition, judgment,
> interpretation, and the creation of presence. (1992, 48)

And yet, the ultimate test in all artistic creation being its reception by an
audience, one often wonders whether the emancipation of meaning from tra-
ditional realistic structure has not yielded some degree of confusion as well.
Besides the fact that exposition, ascending action, reversals, and catharsis are
markedly more "entertaining" to spectators—encompassing kernels of sus-
pense, if anything—Aristotelian structure, propounding as it does clarity,
order, and teleology can also satisfy our need to believe in something bigger
than ourselves, as it surreptitiously concedes to the existence of a divine
agency and in such manner appeases or momentarily silences our existential
terror. Therefore, Schechner's question to avant-garde composer John Cage
is a sound as well as intriguing one: "How do you take into account the fact
that people, as soon as they become an audience, demand structure and
impose it even if it's not there?" (quoted in Carlson 1990, 7). Paradoxically,
hierarchical structures, however limiting, can still be a powerful source
of comfort to audiences, for, to surrender to the primal "authority" of the
writer perversely bestows a sense of security. In fact, meaningful auteur the-
atre keeps resisting this, oftentimes, uncritical complacency, renouncing the
illusory nature of security in an age marked by fissure, perturbation, and
chance.

It must be said, in addition, that in the course of engaging an audience,
auteurs embrace their triple function as readers, scenic writers, and, by
proxy, spectators, which affords them a privileged position vis-à-vis the text.
Anne Ubersfeld defines the dramatic text as *troué*, as something containing
"holes" and "gaps," which will be subsequently filled by the mise-en-scène
(1999, 24). From a more radical perspective, Erika Fischer-Lichte views the
relationship between text and performance in terms of a "cultural paradigm
of sacrificial ritual" and argues that "each and every production that comes
into being by the process of staging a text, performs a ritual of sacrifice... It
is only the sacrifice of the text that allows the performance to come into
being" (2001, 283). Conclusively, in 1993, and at the height of the reign of

directors' theatre, Pavis identified three different levels of texts that coexist and intersect in every performance event: the *linguistic text*, the *text of the staging* (mise-en-scène, for short), and the *performance text*. The linguistic material and the texture of the staging interact with the theatrical situation understood comprehensively by the concept "performance text" (1993, 85). Pavis' typological analysis of the mise-en-scène helps clarify its function. The term does more than simply refer to the stage realization of a dramatic text; instead, "sometimes it designates an aesthetic practice of expressing and enunciating the text through the stage and in this way establishes itself as the meeting point of the *interpretation* of a text and its artistic realization" (133; emphasis original). Pavis argues that the role of the mise-en-scène as faithful and proper illustration of the playwright's text has been thoroughly misconceived and misinterpreted and that its practice in the work of avant-garde directors has fought for its autonomy from the dramatic text, rendering itself "a pragmatic activity involving the reception by a public called upon to perform a semiological undertaking as much as the production of a theatrical team" (135). Among the first to theorize on the typologies of contemporary mise-en-scène, Pavis formulates for it an intriguing definition as:

> The establishment of a dialectical opposition between T/P which takes the form of a *stage enunciation* (of a global discourse belonging to the *mise-en-scène*) according to a *metatext* "written" by the director and his team and more or less integrated, that is established in the enunciation, in the concrete work of the stage production and the spectator's reception. (146; emphasis original)

The viewing of the mise-en-scène as *text* is no doubt reinforced by the structuralists' approach to literature on the whole. As far back as in 1963, in *Literature and Signification,* Barthes lays the foundations for a more in-depth exploration of the relationship among writer, text, and reader. Barthes' theories on the "open text" were, in the course of several years, developed by theatre semioticians Keir Elam, Ubersfeld, Pavis, Marco De Marinis, and Marvin Carlson, who in strikingly different ways agree that the process of interpretation in the theatre culminates at the point where the processes of the text's conception by the author and the event's reception by the audience meet. Delivered through this convergence, the performance text—the unique, ephemeral, yet exclusive, property of actors, director, and writer—is shared with a particular group of spectators in a given place and moment in time. Especially in auteur performance, the audience's *authoring* prerogatives are highly pronounced. As Elam would contest in 1980, every spectator's interpretation of the text is in effect a

new *construction* of it according to the cultural and ideological disposition of the subject:

> It is the spectator who must make sense of the performance for himself, a fact that is disguised by the apparent passivity of the audience. However judicious or aberrant the spectator's decodification, the final responsibility for the meaning and coherence of what is constructed is his. (95)

Confronted with the issue of interpretation as a creative and democratic operation, one cannot help but wonder whether it is the sum of the individual "readings" that gives a work of art its totality. In other words, could authorial intentions and directorial point-of-view rely upon the spectator's assumed and potential perception of a performance for their full realization? Similarly, could the playwright's and director's pre-imagined reception of a performance ever inform their conception and staging of a dramatic text? Such an assumption would, by definition, appear absurd and pointless, no less because, no matter how significant the contribution of each spectator may be, the hierarchy of meaning is still firmly controlled by the author's— whether the playwright or the director-auteur—text. Still, a piece of theatre is effectively set in motion only when the spectators decide to embark on the journey of interpretation, decoding the several perspectives that the text affords them through the lens of their own aesthetic/social/ideological background and duly applying and organizing these perspectives in a product that contains its own rules. Interpretation assumes, if it does not presuppose, contextualization. The spectator's "reading" of a production is never a pure or innocent prima-vista affair, since "the genesis of the performance itself is necessarily intertextual," bearing the traces of and constantly "quoting" other works in terms of the writing, the set, the acting method, or the particular style of the mise-en-scène (93).[2]

Given that the frictive encounters among text, performance, and spectator on all levels and in all its intervening stages is a never-ending, dynamic, and highly idiosyncratic process, decoding a theatre event is surely an act of authorship. Directly related to the audience's reception of a performance is the director's manipulation of theatre semiosis. Due to the medium's polyphonic nature, theatre signification—de facto more intricate and challenging than literary signification—renders the audience's task of deciphering theatrical signs particularly elaborate. To exploit as much of the mise-en-scène's potential as possible, directors are at liberty to manipulate all five communication systems (linguistic, visual, aural, olfactory, and tactile) in inexhaustible ways and combinations. Within the increasing democratization of the stage and the new mise-en-scène's reviewed signification, they can prioritize them differently, according to the idiosyncrasy, aesthetics, and

intended response to each performance. In defining theatre as a "privileged" semiotic field, in 1979 Barthes analyzed how, at every point in a performance, spectators instantly receive several items of stage information, drawn from the set, costume and lighting design, and the architectural arrangement of the actors, as well as from movement and gesture, acting style, or delivery of speech:

> Some of these items *remain fixed* (this is true of the scenery) while others *change* (speech, gestures).... We have therefore, a genuinely polyphonic system of information, which is theatrical; a *density of signs* (this in contrast to literature as monodic).... The theatre constitutes a semiotically privileged object, since its system is apparently original (polyphonic) compared to that of language (which is linear). (29; emphasis original)

If we apply these principles on current auteur practice, we will have little trouble determining auteurs' sign-related predispositions: how, for example, Wilson glorifies painterly composition and Marthaler elevates time and sound codification, while LeCompte's focus is on highlighting the structural possibilities and ideological implications of technology. In another case, Brook's preoccupation with the actor's body reflects the understanding of its function as a physiological agent of spiritual expression. Clearly, it is virtually impossible to simultaneously experience the multitude of theatrical signs operating on stage concurrently. In this perspective, it would perhaps be more useful to view mise-en-scène as a vehicle, a system that brings us closer to the playwright's original grasp of the *mise-en-scène*-able world, but which does so through added layers of interpretative associations; in fact, to treat it as "a framing device, a modality, and a key to the reading of the fictional world" (Pavis 1993, 147). Pavis' typological analysis suggests that it is primarily the directors' metatext—a product of their reading of the text and subsequently the scenic writing of this metatext/"reading"—which informs the choices of the mise-en-scène. All said, and to address a previous point in our discussion, since the outcome of this collision between the mise-en-scène and its "reading" by the spectator is the writing/production of the performance event—yet another text—interpretation always has something fluid and "undecided" about it. Regardless of their role as the performance's final decoders, spectators, by definition, have no control over the production of either text or of its stage representation—a fact that relinquishes all "power of decision-making" to actors and, ultimately, to the director (135).

Going back to the notion of freedom, we need to remind ourselves that a director's control of semiology tends to be a fixed, deliberate, and often cerebral affair. Some formalist auteurs leave little, if any, breathing space to the actor, who suffocates inside the airtight frame of signification. On Beckett's

track, Wilson, Bogart, Foreman, and Suzuki are just a handful among those uncompromising lovers of emphatic stage semiosis. Yet, as is typical in most of this kind of work, in their productions, the disciplined mastery of signs clashes bitterly with the actors' constructions of fluid identities and unpredictable performances, as well as with the audience's "pre-expressive,"[3] nonintellectual interpretation and enjoyment; hence the conflict between the sign and the event, representation and presence. Still, it is always a challenge to detect which among these signs are actually intended by the director. Increasingly, "staged accidents" are integrated into the action to establish an illusion of immediacy and "presence." As audience members, we can never know if these "cracks" on the surface of performance are non-intentional intrusions of the outside world or common premeditated directorial quirks. In the same way, it takes practice and experience to be able to distinguish whether it is the performer's actual *live presence* that has consciously or unconsciously interrupted the production's flow, or, reversely, a directororiginated fiction of the "real." This undercurrent informs, for example, the productions of Belgian director, playwright, and visual and performance artist Jan Fabre: the house lights have been known to come up in the middle of the performance and exhausted actors may take a cigarette break and simply remain on stage to watch the audience after a particularly demanding scene. Lehmann's observation that "the interruption of the real becomes an object not just of reflection (as in Romanticism) but of the theatrical design itself" (2006, 100) is especially perspicacious. It was only in the 1990s, when the effect of viewing the mise-en-scène as a purely semiological activity had started to wear off, that increased emphasis on the phenomenological approach to performance, influenced by Maurice Merleau-Ponty's philosophy, started to investigate the kind of emotional as well as cognitive experience that is transferred from the actor to the spectator.

Today, the dominant view of performance is that of an open event, relying for its momentum on the dynamic presence of the human element (the performer), the carrier of contingency, play, and chance, who will forever perpetuate theatre's status of indeterminacy. It is this affirmative anarchy in all its Dionysian festivity that Artaud had first celebrated in the 1930s. By contrast, mise-en-scène as a conceptual, closed system of signification—Apollonian in its rational manipulation of signs and exclusively determined by one agency (the director)—struggles to prevent the intrusion of "external" elements, more particularly, of the performer's autonomous presence. Nevertheless, even in the most carefully designed mise-en-scène, the actual performance will persistently reassert itself, putting forth its own inevitable presencing, since the interpretation of the mise-en-scène is subject to what Derrida calls "distinerrance" ("deviation"), "la possibilité pour un geste de ne pas arriver à destination" ("the possibility that a gesture will not reach

its destination") (Pavis 2007, 53; my translation). One can understand why Pavis, in 2007, proposes a new model of theatre practice, condensed in his neologism of *performise* (mise-en-perf/ormance). In essence, *performise* can be viewed as a hybrid meeting place and viable interaction between a risk-averse, director-controlled, and semiotically defined mise-en-scène and a "naked," vulnerable, yet also redeeming, actor-controlled performance. This necessary convergence of the two basic components of the theatre event, namely, of the director and the actor, almost beckons to the return of the third ousted party, the playwright. It is certainly tempting to envision an ideal, if virtual, space in the theatre, which will base the dialogue between director and performer on a *meaningful* text, whether that of the playwright or the auteur, linguistic or sensorial, literary or imagistic.

II. Neo-Dramatic Writing

Running parallel to the development of auteur practice, the "reformation" of dramatic writing, an "écriture" enriched with the potentialities of the stage—foreshadowed by Beckett's minimalist drama—was developed in the late 1970s mostly by European playwrights, such as Heiner Müller, Caryl Churchill, and Peter Handke. A couple of decades later, in the 1990s, playwriting fully emerged from a realism-induced state of relative hiber-nation and lethargy, claiming its right to exist on stage not merely as an employee subservient to the performance text but also as a keen partner to the director's expression. Manifest internationally in the plays of Martin Crimp, Foreman, Valère Novarina, Mac Wellman, María Irene Fornés, Mee, and also of Jon Fosse, Sarah Kane, Howard Barker, Simon Stephens, Franz Xaver Kroetz, and others, fragmentation of character, discontinuity, distortion of narrative, and mistrust for conventional representation became essential features of the post-1980s dramaturgy, viewed as a manifestation of an inevitable growth toward ambiguity and abstraction. In both Europe and the United States there has been a marked interest in new plays, with the encouragement of fresh voices facilitating the establishment of playwrit-ing workshops and writers' residencies in theatres and academic institutions. Reversing the traditional roles of "author-supreme" text and "author-servile" performance has advanced not only new ways of devising stage narratives but also extraordinary forms of writing.

Violating the century-old norms of writing has meant rejecting a fixed and psychology-driven grasp of the world. Eventually, the author's text has placed itself at the disposal of the director's imagination, as a malleable and thus viable corpus of meaning in need of contextualization. Plays are no longer "obligated" to provide full service to the audiences' innate thirst for unity, instead allowing the director to take on several tasks: determining the

text's circumstances, assigning different lines to different personas, isolating actions and characters out of a thick body of words. Long and dense monologues, lack of descriptive stage directions and logical chronology, removal of all punctuation, and an uncanny disappearance of character[s], are additional elements of the new dramaturgy. This, of course, is fully in keeping with the collapse of traditional linear structure and the idea of conflict as the ultimate core of the narrative. Donia Mounsef and Josette Féral argue that many times these forms of writing combine characteristics of "the verbal, the vocal, and the pantomimic, calling upon the stage to give them their strongest expression," and coming alive within "the body of the actor and in the space of representation." Because of its polyphonic nature and its existence "at the intersection of presence and memory, duration and transience, individualism and collectivity, meaning and insignificance, poetry and the concrete," current writing incorporates both "enunciative" as well as "corporeal" influences:

> These texts demand a particular investment from the actor, calling for a style of acting different from the usual representation of a character's psychology.... The actor can no longer simply interpret a prescribed role but must make audible a text, vocalizing its musicality, rhythms, and tempos, like the early poet-dramatists. The playwright is likewise endowed with a new mission. Far beyond the conventional task of storytelling, he or she reinvents language, exploits its fault lines, in other words, infuses writing with performance. (Mounsef and Féral 2007, 2–3)

Clearly, the new dramaturgy pays tribute to the hierarchical shift in recent theatre practice. As spectacle-saturated audiences become all the wearier of the phantasmagoria of visuals in *yet another* avant-garde piece, it is only understandable that they would look for meaningfulness in the writing. Theatre's return to the text serves not only as a reminder of the limitations of empty formalism and of the need for stronger "narratives" as a point of departure for performance, but it also testifies to the emergence of a type of *neo-dramatic* writing—where textual primacy is distinctly restored, but only after having been percolated through performance considerations. Most neo-dramatists' emphasis is on how to unburden language of the ubiquitous accretions of trite, hackneyed, and cliché usages and to return its special and "root" immediacy back to it. Phenomenologically speaking, verbal language as a sign system—and as such, a system subject to the individual and subjective understanding or misunderstanding of symbols—is much more opaque than all the other sensory and corporeal theatre languages, a factor that naturally renders it more susceptible to abuse and fast decay. The decentering of Aristotelian elements and the undermining of plot open up textuality, testing its limits and potential, while refocusing both artists' and spectators'

attention to the marvels and perils of representation itself. The reconsidered function of language clearly highlights performance questions and in this respect "theatrical representation is not left to designers, actors and the director but is placed once again into the hands of the dramatic author" (Puchner 2002, 25). What Martin Puchner calls "descriptive language" now subsumes to some degree the stage idioms of set, lighting, props, movement, and, of course, acting (25). Thus, in its most powerful application, descriptive language, carrying within it virtual crystallizations of possible mise-en-scènes, can also assume directorial responsibilities and incorporate notes to actors, whose presence it does not hesitate to acknowledge or foreground. In Stanton Garner's words:

> Whether it has the scrupulously detailed stage directions of a late Samuel Beckett play or the minimal scenic specifications of Caryl Churchill's drama, the written text is both a blueprint for performance and a specific discipline of body, stage, and eye. In its directions for setting, speech and action, the dramatic text coordinates the elements of performance and puts them into play; reading "through" this text, one can seize these elements in specific and complex relationships. (1994, 3)

To illustrate the point: in Handke's *Offending the Audience* and *Self-Accusation* (1966) there is a clear acknowledgment by the author of the performer's (as well as of the audience's) presence. Handke refers to his plays as *Sprechstücke* (*spoken plays*), placing them on bare stages, where actors are allowed to be themselves, unencumbered by the burden of illusionistic setting and the pretext of character. In the gap of the three decades that separates Handke from the neo-dramatists of the 1990s, one can detect in the evolution of dramatic writing elements that are reminiscent of the gradual process leading to the coming into power of the auteur-director and which are clearly marked by a new emphasis on questions of representation and identity. Following in Handke's steps, the work of British playwright Martin Crimp is telling of the revitalized investment in theatrical representation: Crimp intelligently unearths and enhances what Ubersfeld calls "matrices of 'performativity,'" the "kernels of theatricality" (1997, 8) that exist inside the dramatic text. *Attempts on her Life*, subtitled *Seventeen Scenarios For Theatre*—first produced at the Royal Court in 1997—immediately lands readers-spectators on unstable yet intriguing ground: each "scenario" is an "attempt" to capture the elusive nature of the protagonist, Anne, who is variously described as a terrorist, porn star, refugee, singles-holiday hostess, and make of car, among other things. *Attempts* does not allocate specific lines to any particular speaker, a strategy also taken up in Mark Ravenhill's play *Pool, No Water* (2006), in which the characters also remain nameless

and alternate in the delivery of monologues. A similar dramaturgical frame is present in Simon Stephens' *Pornography* (2007), which deals with the July 7, 2005, London bombings, and where the dialogue is free-form, leaving the order of speeches to the director. Stephens', Crimp's, and Ravenhill's choices suggest that there is no sense in which any production of their play can ever be definitive. Their dramas give the director carte blanche to *realize* rather than *complete* their meaning, without necessarily tampering with any of the words. Crimp describes *Attempts'* conceptual basis in the foreword (1997):

> *This is a piece for a company of actors whose composition should reflect the composition of the world beyond the theatre.*
> *Let each scenario in words—the dialogue –unfold against a distinct world— a design—which best exposes its irony.*

In reality, the text's nonlinear narrative is constantly shifting between dialogue and monologue forms, interspersed with media imagery and excerpts from the discourse of theory. Once again, the playwright contests the possibility of fixed representation, playing meta-theatrically with both the nature of (theatrical) representation per se and the "death of character," as the protagonist, Anne, appears to be a ghost character, existing between presence (as imagined and described) and absence. In Pirandellian fashion, Crimp toys with the possibilities of the real and the fictional and never tires of impressing upon his readers that stable and coherent identity is a myth. In the end, *Attempts* brilliantly expresses people's need to fabricate reality, incorporating self-reflexive devices that draw attention to the world as a stage and to life as, ultimately, a performance:

> If on the other hand she's only play-acting, then the whole work becomes a mere cynical performance and is doubly disgusting
> —But why not? Why shouldn't it be/"a performance"?
> —Exactly—it becomes a kind /of theatre (50)

The manipulation of theatrical representation is a salient feature in British playwright Rebecca Prichard's nonlinear play *Yard Gal* (2000), which describes the dire circumstances of two London Eastender teenagers, Marie and Boo. The play is set to action in a self-conscious beginning, with the two girls urging each other to get it started. Gradually, the two characters establish a line of communication with the audience, whose function ranges from the openly confrontational to the purely confessional:

> *Marie:* Ain't you gonna start it?
> *Boo:* I ain't starting it start what?

Marie: Fuck you man, the play.
Boo: I ain't telling them shit.
Marie: What?
Boo: I ain't telling them shit. If you wanna make a fool of yaself it's up to you.
I ain't telling them shit.
Marie: You said you's gonna back me up! You said you's gonna back me up
telling the story.
Boo: Is backing you up starting it... Don't start calling me names Marie or I
ain't doing this play at all. (*Yard Gal,* 5)

In various scenes, Prichard has Marie and Boo engage in vigorous role-playing, impersonating other characters from their gang, as well as from their arsenal of lovers and enemies. Engaged in a peculiar type of oscillating storytelling, the two protagonists mix third person narration with self-dramatization, enactment and demonstration, Brechtian alienation, real conversation and direct audience address, pseudo-dialogue and the monologue form. Theatrical devices abound: for example, after Boo has been incarcerated, we learn the characters' thoughts through the content of letters. Furthermore, the agility of the text is built on an ingenious use of real story and the characters' "self-transformation"—which Lehmann sees as one of the most dynamic properties of performance art (2006, 137)—but traces of which can also be found in the theatre; that is, rather than bending external reality artistically to conform to whatever they intend to communicate, actors' true mission is to stand up for their own material presence as their "primary aesthetic material" and to refuse to "be doubles of a character" (137).

Unstable representation and a multi-perspectival outlook are also dominant in a variety of new plays that do not hesitate to juxtapose seemingly opposing narratives and conflicting time reference, echoing the collage methods of LeCompte and McBurney. Heiner Müller (1929–1995), both a poet and playwright, first treated his plays as "synthetic fragments,"[4] a kaleidoscope of images and memories derived from past events, mostly from Germany's history. "Fragments have a special value today," the writer claimed, "because all the coherent stories we used to tell ourselves to make sense of life have collapsed."[5] Müller viewed his plays as "production pieces" (*Produktionstücke*), a compact body of material through and out of which directors could model their own performance text. By mixing myth with contemporary history and refusing to revere classical texts, as his adaptations of Greek tragedies testify (see *Despoiled Shore Medea Material Landscape with Argonauts* [1982–83], *Philoctetes* [1968], *Prometheus* [1969], among others), Müller expanded on Brecht's theory of *Kopien,* a practice according to which an author regards texts by others as "inducements to work rather than as private property."[6] Müller's passion for literature interfaced with his trust in the protean quality of writing and the idea of text as fluid and malleable.

In effect, literature's task was to offer "resistance to theatre. Only when a text cannot be done the way the theatre is conditioned to do it, is the text productive for the theatre, or of any interest."[7] The adoption and adaptation of history as a context for the resurrection of language has been ingrained into postmodern forms. For American avant-garde writer Charles Mee, best known for his contemporary revisions of Greek tragedy, drama is an opportunity to expose historical and cultural fragmentation. In his afterword to *The Trojan Women: A Love Story* (2001), he uses the collage metaphor to describe the idea behind the writing of the play:

> This piece was developed—with Greg Gunter as dramaturg—the way Max Ernst made his Fatagaga pieces at the end of World War I: incorporating shards of our contemporary world, to lie, as in a bed of ruins, within the frame of the classical world. It incorporates, also, texts by the survivors of Hiroshima and of the Holocaust, by Slavenka Drakulic, Zlatko Dizdarevic, Georges Bataille, Sie Shonagon, Elaine Scarry, Hannah Arendt, the Kama Sutra, Amy Vanderbilt, and the Geraldo show.[8]

In fact, in a gesture of authorial gallantry, Mee invites readers and spectators to a form of postmodern [co]-authorship: he encourages us to use the material from his website freely, as a "resource" for our own work:

> ...pillage the plays as I have pillaged the structures and contents of the plays of Euripides and Brecht and stuff out of Soap-opera Digest and the evening news and the internet, and build your own, entirely new, piece—and then, please, put your own name to the work that results.[9]

Delighting in language's visual and aural qualities, neo-dramatic plays restore to writing a particularly theatrical status, wherein the density of words embraces a threatening, vital physicality, akin to the materiality present in many of Ionesco's absurd plays.[10] In line with Artaud's theories, this carnal discourse no longer functions as speech, but celebrates its original "vocation" as sound incantation. Indeed, one does occasionally experience through the very processing of the text's aurality the playwright's sheer pleasure in a form altogether divested of the classical values of verisimilitude, causality, and "beauty." As Pavis suggests, in the new conception of dramatic text, where writing (*écriture*) meets the performer's play (*jeu*) and the spectator's gaze (*régard*), meaning is not generated in the words but in the rhythmic associations that are revealed upon the words' enunciation. Playwright and spectator meet in the performer, who ultimately realizes the text's sonorous possibilities. To quote Pavis' exact words: "This is how writing becomes theatre, because it mixes material with spirit, and also because it chooses the performer's body as its ultimate destination.

The barrier between an act of writing and an act of performing is lifted" (2007, 27; my translation).

Albeit not a playwright in the traditional "job description" sense of the term, Wilson is in many instances involved in composing his texts for performance as an auteur. In scripting his production of *A Letter for Queen Victoria* in 1974, he used his director's insights to work with rhythm, systematically laboring to free up words from their signifying structures. His view was to replant the seeds of poetry back into a language that had gradually withered away through the sheer effort to serve the priorities of accepted meaning. Elaborating on the principles that informed his process, he came to observe how we become more conscious of the things we say and the feeling behind the words when we repeat them over and over. We also "become more aware of what somebody else is saying and feeling at the same time...People can do several things at once" (quoted in Marranca 2005, 49). Paradoxically, Wilson's contrapuntal theatrical language, his own type of "visual semantics," shaped a text that, notwithstanding the deliberate misspells and the comedic illegibility, remained quite resonant:

AND THEN ABOUT THE UM THE UMMM ABOUT THE MOST FLEETING ATTENTION AND ABOUT ABOUT THE ABOUT THE TREES IN IN THE WOODS IN IN IN IN WHERES WHERE WHERE IT IS TO DO THE EXERCISE OF OF THE ADDRESSING KN-KNOWING FULWELL AND THEN SOMETHING IT IS, OF THE PARADISE, PUZZLE OF THE PARADISE. GOOD.[11]

The longing to unbury words' dormant promise for unadulterated communication is also conspicuous in Swiss-born Valère Novarina, the French Michel Vinaver—whose work has often been compared to a musical score—and American poet/playwright Mac Wellman, all of whom display in their writing mechanisms not only for poeticizing the language but also for directing the actors in how to enunciate the text.[12] "What we cannot speak of, that is what must be spoken," Novarina urges (1989, 169), adding, "I have never been anything but an actor, not the author but the actor of my texts, the one who breathes them in silence, who speaks them without a word" (85). In *Le Babil des Classes Dangereuses* (*Babble of the Dangerous Classes* [1978])— one of his most extraordinary experiments in dramatic form, ostensibly indebted to Beckett—language also administers the subject matter of the play and becomes embodied: 297 characters are engaged in a "battle of languages" that culminates in the struggle of the two most fiercely articulate characters—Mouth and Ear—to silence the 295 others. The author's assertion of writing "books that have speech for a plot" holds particularly true (10). "The basic question is no longer 'what is the story?' The text exists

for its own sake, for its own qualities, for its literariness perhaps, or even of its 'theatricality,' while the story develops on the surface of the language only, in fits and starts, instead of being a deep and essential structure."[13]

The embodied-ness of speech is also saluted by African American Suzan-Lori Parks, who defines language as a "physical art" and understands words as "spells which an actor consumes and digests—and through digesting creates a performance on stage."[14] Like Parks, Adrienne Kennedy and Fornés use the violence and absurdity of linguistic expression to communicate the displacements of contemporary American society, building up with words, as Carlson points out, "landscapes of the psychic imagination, recalling the earlier experiments of symbolism and expressionism."[15] In exploring the tradition of playwriting in the United States, Carlson brings up the example of Gertrude Stein's landscape writing and investigates the ways in which her essentially modernist écriture reverberates in the powerful mix of "actual physical landscapes of psychic projection with verbal langscapes" that characterizes the writing of Foreman, Kennedy, and Wellman, among others (in Fuchs and Chaudhuri 2002, 148).[16] Despite our earlier brief reference to the ways in which Stein's landscape aesthetic influenced auteurs' directing style, an additional parenthetical note on Stein's idiosyncratic modus of writing is necessary here: in the modernist 1910s and 1920s, Stein experimented with various ways of rendering "alive" human consciousness by means of objectifying it through language. The importance of the theatrical event lay in detaching words from their trite or formal contexts (Stewart 1967, 63) and placing them against a static dramatic background in dynamic juxtaposition. For Stein, language *was* the play and words were the stage properties of each production; similarly, the characters were created and developed linguistically, their physical selves subordinated to their speech. "Plays are either read or heard or seen," she argued, "and after, there comes the question which comes first and which is first, reading, or hearing, or seeing the play" (Stein 1985, 94). In Stein's language theatre there is no concept of individuality: through an underlying direction, the agents of the "action" are usually words rather than human beings. Surely, Stein's methods of linguistic subversion and disengagement, of the total obliteration of syntax and the carefully selected randomness of "word heaps,"[17] have served many neo-dramatists' intentions to disentangle theatrical experience from the illusionistic identification with the outside world and attack the preconceived ideas of dramatic teleology promulgated in the Aristotelian poetics. A good example of such ambition is Kennedy's earlier work. Her plays reveal a yearning for a dramatic form that can encapsulate dystopia, bombarding readers with imaginary pictorial and poetic linguistic metaphors, such as the Jungle or the Victorian castle that haunt Sarah, the protagonist of *Funnyhouse of a Negro* (1962), or the Tower of London in *The Owl Answers* (1963).

On the forefront of all neo-dramatists, British Caryl Churchill has taken playwriting many steps forward, mixing in her plays different mediums and art-forms, evolving the tradition of performance inaugurated by Artaud's theoretical disseminations. Her drama clearly shies away from naturalistic representation: fragmentary and manifestly imagistic, it is also inhabited by symbolic and surrealist elements, intelligently composed into a totality adhering to its own logic. Inspired by Euripides' *Bacchae*, Churchill's *A Mouthful of Birds* (1986) is an exploration of madness and violence; its structural reasoning zooms in and out of seven separate vignettes, each focusing on a different character. While invisible Dionysus instigates every new action and transformation by a kiss, the actors play ensemble roles in all scenes other than their own while dance sequences are at the center of the episodes, involving those of a pig and his lover, a schizophrenic and her hallucinated tormentor, as well as a serial killer. By resorting to the associative logic of dreams, Churchill has always excelled in unsettling her audiences. In the jarring modern-day fairy-tale *The Skriker* (1994), one of her most bizarre linguistic experiments, an "ancient fairy" flees the underworld in an attempt to come into contact with human beings. In the same vein, in *Far Away* (2000), the playwright's unbridled imagination, served by a lyrical but alarming language, confronts the notions of global terrorism. Subversively, the play's idyllic opening, which reveals a colorful scene in the countryside, is "a muddled Manichaean total war in which 'the cats have come in on the side of the French,' 'the elephants went over to the Dutch,' and even the weather takes sides" (Solomon 2001, 3). As Nightingale observes: "More than any other writer, [Churchill] has transformed the theatre into what it needs to be: a gymnasium that exercises the imagination, shakes up the moral sense, stretches the spirit."[18]

From the 1990s onward, Churchill's work developed into a mixed-media theatre of text, dance, and music, reflecting her awakened interest in space and movement and significantly bringing the stage onto her pages. A small sampling of her works might be in order at this point: *The Lives of the Great Poisoners* (1998) is a narrative in song and dance about the murderous paths of four prisoners from different eras. In the arresting diptych *Blue Heart* (1997) there is choreographed repetition in almost every action of the play *Heart's Desire,* while in *Blue Kettle,* although the language crumbles into bits and pieces of gibberish, the visual element manages to hold together the essential narrative. Similarly, the play *Hotel* (1997) is a product of Churchill's investment in the dance form: performed by thirteen singers, three musicians and two dancers, the play is built out of fourteen movement-based visits to the same hotel room. The cyclical structure is effectively reinforced by the music and the dance.[19] Over the years, Churchill has collaborated extensively with several theatre companies, trusting that collective research helps her explore

the boundaries of writing from a more experiential standpoint.[20] Her experiments, which are starting to create a legacy in playwriting, should be positively attributed to her passion for a language that is kindled by a profound knowledge of the actor's instincts.

Quite a contrasting dynamic is set up in the more recent trend in dramatic writing to *display* the writer's text, valorizing its autonomy and treating it more as a sound or a graphic installation (Pavis 2007, 300). In such process there is no actual interpretation, for speech is divorced from its agent. Rather than explain (interpret), the writer's desire is now to cite (project/display), which makes narration the predominant discourse. Borrowing Mikhail Bakhtin's term, Jean-Pierre Ryngaert brings to attention that recently "the dramatic text has been infiltrated by forms that contribute to its 'novelization'" and that the general tendency is "for dramatic dialogue to be contaminated by narrative features" (in Mounsef and Féral 2007, 19). Consequently, the play's dramatis personae "come to include all manners of narrators, reciters, monologists, storytellers, and reporters—all manner of mediators between the fiction and the public" (19). This inclination is present in Irish writer Enda Walsh's *The New Electric Ballroom* (2008), a play about the lonely life of three sisters who ritualistically reproduce ad infinitum the memory of one single night of their lives. Not only do the characters' soliloquies make up the spine of the play's structure, but they also reveal a fascination with the non-semantic, purely incantatory aspects of language:

> Breda: (fast and frightened):
> By their nature people are talkers. You can't deny that. You could but you'd be affirming what you're trying to argue against and what would the point of that be? No point. Just adding to the sea of words that already exists out there in your effort to say that people are not talkers. But people talk and no one in their right mind would challenge that. Unless you're one of those poor souls starved of vocal cords or that Willy Prendergast boy who used to live in town and only managed three words. One was "yes," one was "no" and one was "fish." Yes yes yes. No no no. Fish fish fish. Fish yes yes. Fish no no. Yes no fish. Fish no fish. Fish yes fish. So even he talked. (*The New Electric Ballroom*, 5)

Similarly, Howard Barker's *The Dying of Today* (2008)—inspired by Thucydides' account of the Athenian military disaster in 413 BCE and the impact of war and devastation on people—builds on the self-conscious narrative of a barbershop patron who verbally tortures the barber who shaves him, which is matched by the latter's long monological effusions. Much as Barker's play is enterprisingly stylized, inducing a magnetic effect through repetition, it is true that the formal elements of the dialogue primarily

illustrate his flair for fiction. The somewhat purist conception of language as text—rather than as agent of communicative meaning—as a fully autonomous, self-defined material devoid of thematic reference, has also led to exaggerated experiments in stylization; in other words, the novelization of dramatic writing runs the same risks that are visible in the suffocating aestheticism of exceedingly formalist directors. Evidence of the tendency to over-stylize language is also traced in the plays of Wellman: a poet as well as playwright, in his dramatic work Wellman often vacillates between the structures of poetry and theatre. It is a wavering that on occasion triggers a portentous verbosity that not only levels the characters but also immobilizes and ultimately eviscerates, whether consciously or not, any sense of emotional content; this certainly applies to the following speech in *Description Beggared; or the Allegory of WHITENESS* (2000):

> FRASER
> Can you believe it? I am surrounded by
> maniacs and idiots. It is hard to say
> which is worse, the maniacs or the idiots.
> It is hard to say which is worse, the
> mania of the maniacs, or the idiocy of the
> idiots. For if there is one thing I
> cannot abide it is the mania of maniacs;
> for if there is something I hate even more
> than that it is the idiocy of idiots.[21]

Such examples abound in all dramatic traditions and may be said to account for some of the writers' challenges when trying to escape in their dramatic work the structural principles of fiction or of other literary genres. More than anything, recourse to wordiness and long-winding verbal equivocations shoulders the same kind of narcissism that is, in theory, comparable to the churning needs fuelling various auteurs' image-saturated yet essence-vacuous performances. This observation, together with readers' and spectators' ever-revamped "quest for meaning" does by no means vindicate a return to the structures of *well-made* plays. However, we can always try to keep in mind that what defines the identity of neo-dramatic texts is a "reformed" type of language: as sound, as body, as music; a language of multiple and fluid referentiality, celebrating repetition, hesitation, and ambiguity and gradually healing some of the wounds inflicted by discursive logic. There is indeed hopeful evidence that in its renewed significance it can only restore the balance between drama and theatre, by accepting and relying on the dual function of the word as a complex system of mental and symbolic association and a generator of sensory impact. Perhaps, as Pavis has often imparted, it is the language per se that decides on the text's destination. Following in his steps,

we might risk an assumption that would hold neo-dramatic texts to be the result of a fertile confrontation between writer and language.

III. TOWARD AN ETHICS OF THEATRE TEXTUALITY

Although the question pertaining to who the author of performance is remains open, the definition of the mise-en-scène as a result of the collision between different signifying systems helps clarify the multiple layers of interpretation leading to the construction of the performance text. Ironically, Edward Albee's contention in 1987 that "there is a kind of proof of existence that the print gives" (quoted in Luere 1994, vii) subtly hints at the fragile balance between the dramatic text, controlled exclusively by the playwright, and the performance event, ascribed to the director. Despite the fact that at the beginning of the third millennium the role of the all-mighty director has seemed to lose some of its earlier undisputed allure—a result of both the emergence of the new dramaturgy and the performer's increasing assertiveness—auteurs are still ready to claim authorial function whether they interpret someone else's script, formulate their own version of an existing text by ways of adaptation, or contrive a devised piece from different sources of material. It is interesting to note, however, that while in some directing projects one feels that if there is a play at all, it is "a broken text strewn about the stage amid other theatrical debris" (Cody in Schneider and Cody 2002, 125), the main criticism on auteur practice is principally centered on its transgressing the boundaries of legitimate interpretation. When it comes to the fierce debate on the ethics of directing, and in the light of reader-response theories—especially since Barthes' and Eco's views on the "openness of a work of literature" came to the fore—the conception of meaning as something fixed by the playwright (or in the case of auteurism, by the director) is severely contested. When discussing a piece of theatre, "meaning" is always a dynamic, ever-changing entity as well as process, a visceral, complex encounter between playwright, director, and spectator. What adds even more tension to this discussion is the paradoxical notion of directorial neutrality on stage: if we all agree on the impossibility of any artist *not* to interpret while giving birth to a work of art, the function of the mise-en-scène as faithful rendering of a play becomes absurd. Therefore, to aspire to a "pure" reading of any text is simply a dated naïve idea, if not altogether a dangerous one.[22] This holds especially true in the case of challenging *neo-dramatic* texts, the form and characterization of which remain unfixed.

Reversely, it could be argued that modern theories of the stage that regard dramatic texts as fundamentally "unstable," mere pretexts for performance, have unfortunately gone too far and that the staunch polemicists of dramatic theatre refuse to do justice to language's physical and incantatory

aspect. By dethroning speech from its formerly revered position, these crit-
ics occasionally reach opposite extremes and, in reality, refuse to give lit-
erature a chance to reveal the performative potential that is also inherent
in language. Vanden Heuvel's discussion of the "aggressive dichotomizing"
of the duality of text and performance and his condemnation of "limit-
ing" and "self-cancelling dualisms" is quite apt; especially when he argues
that the terms "text" and "performance" should be seen as "dialogic" rather
than "mutually exclusive," as well as "asymptomatically," "allowed to move
flexibly and interchangeably when they are in proximity to one another,
but reined back toward one another when they begin to drift too far apart"
(Vanden Heuvel 1992, 52).

This said, in attempting to come to a more conclusive understanding
of both the aesthetic and need that inform the practice of auteur theatre,
one can only suggest the obvious: writing is a fascinating process, offer-
ing us the possibility to become semi-gods, to receive the adulation even of
a handful of those who will read/watch/experience our own vision of the
world as contained in the solidity as well as validity of a frame, whether
that of the page or the stage. Directors' "sacrilegious"—often no more than
iconoclastic—impulses, their leaning on and toward writing, which some-
times indeed feels like a more solid and durable instance of creativity, the
undercurrent needing to fight against the ephemerality of performance,
all add up to the mere envy of and antagonism against writers. In reality,
this is what pushes directors further to claim a portion of the playwright's
text, "usurping" the right to interpret, by changing words into sounds and
speeches into sequences of images.

No doubt, this is why auteurs such as Brook, McBurney, and Wilson,
inspired by Artaud, insist on the potency and necessity of a purely theatrical
language of the body that can parallel the language of literature: conceiv-
ing and staging images constitutes the spine of "stage literature," a narrative
authored in a visual language that the audience can learn to appreciate by
being trained to a new scenic vocabulary and remaining open to "interior
impressions." On the other hand, Ariane Mnouchkine claims that you just
start higher when you have a text. "But the way of improvising, researching
and working collectively," she explains, "is the same...the only thing that
you don't have to look for is the words. They are there and they are magical
treasured words. So you immediately start higher and higher" (quoted in
Delgado and Heritage 1997, 182). No one can deny that in the new drama-
turgy of the 1990s, what Mnouchkine sees as "precious words," the same
kind of words that had been put aside in some of the most extreme physical
productions of the 1960s, 1970s, and 1980s, strike back.

"With a play that wants its text respected," urges Albee, "respect its text;
with a play that is a set of improvisations or that approaches theatre from

a totally different point of view, then do it that way, I've never thought anything was the wave of the future except possibly diversity" (quoted in Luere 1994, 22). Having one's words changed or cut, whether on page or stage, still strikes some playwrights as an irredeemable insult, and, to some extent, we cannot exactly dismiss their nervousness as one entirely without cause. Albee's view that the print gives playwrights "a kind of proof of existence" seems sound. Jean Luere, in her study of the playwright-director conflict, recognizes that authors such as Beckett and Miller, who refuse to have their texts re-examined or retouched, have become kinds of spokespeople for authors in general; in fact, Luere claims that there should be sympathy for those playwrights who toil to find the exact words for each dramatic moment, "a more ultimate or intense search, perhaps, than a designer's for a sleeve-line or an architect's for a stair." Luere plays devil's advocate when arguing that since playwrights struggle to "come up with their words and metaphors," they are somehow justified to perceive as "insensitive" those directors unwilling to use their "hard-won lines or phrases" in performance, afraid that they may not work. "What authors may fear," she insists, is that "if they free up what they formed out of blood and inspiration, they'll lose their text's essence" (Luere 1994, 12).

At length, no matter how hard theatre scholarship and the experience of avant-garde practice have tried to answer them, the vital questions remain: is theatre possible on a "text-less" stage ("text" here equated with a printed as well as "printable" play)? Can language simply be replaced by any compositional element of the mise-en-scène? In fact, would the omission of language cause a tremendous imbalance in the performance event? In the end, how disposable is dramatic language? What are the boundaries of directorial intervention? Where does interpretation cease and "rewriting" begin? How can a director deal with the writer's stage directions and character distribution? What "should" directors adhere to and playwrights allow? Finally, can we talk about the ethics of stage direction and who is to set the limits of directors' freedom to interpret?

The questions, it seems, cannot yield any easy answers. Without a shadow of a doubt, one of the most important things that experimental performance has taught us is that even though you can treat the text as texture and material, ultimately it is impossible to liquidate it. No matter what, language remains a "symbolic system, a textual hydra" (Pavis 2007, 299), complex and resilient. On the other hand, Frank Rich adamantly corroborates that "it's a sign of a thriving theatre that a director's actions can speak as loudly as, if not louder than, a writer's words" (1985). One can make endless assumptions about whether a written text is completed and perfected merely through directorial intervention; no less can we wonder as to whether it is still legitimate to talk about the *same* play or two different scripts in those cases

when the director consciously digs into the very foundations of the piece and works around its hydraulics, contextualizing the action, interpolating scenes, or restructuring the plot. On a good note, many auteurs increasingly "concede" to becoming "co-writers" of theatre works, in what could be just one among the potentially numerous viable paradigms of theatre-making; they thus seek alliances in their contemporaries and actually commission plays to writers they respect, together with whom they shape the texture of ideas, language, and forms after close and constant collaboration. On those occasions, playwrights are often an integral part of rehearsals from the start and frequently mould their texts according to the special requirements of casting. The secret motive of monitoring the process of writing in its various stages is balanced out by the directors' contribution of valuable insight to the work-in-progress, particularly vis-à-vis subtle performance considerations that can both layer and sharpen the play. This delicate and inspiring exchange renders the dialogue between playwright and director fluid and constructive, turning out stimulating texts that seem to vibrate with the interactive blending of the writer's disciplined technique and control of structure and the director's intuitive grasp of embodied character and staged situation. Once more, Wilson's observations may be worth noting: "An artist can create a new language; and once this language becomes discernible, he can destroy his codes. And in this deconstructive process he can then reconstruct another language" (quoted in Luere 1994, 58). This is definitely an optimistic statement about the future of the theatre. It underscores the responsibility of the director to remain open to change, aborting the old and the tried. It further suggests that many artists, having shaken off the censoring hand of the surprise-proof convention, have discovered in the theatre of the auteur the means to conceive and construct brand and brave new worlds, inviting the spectators to inhabit them each time they go to the theatre.

Afterword

THERE ARE TIMES WHEN THE THEATRE GROWS TIRED OF the struggle to keep up with the speed of fact and information, together with the cultural assumptions of its time. It often feels as if the medium is on the verge of collapsing under the weight of the effort. Forms may be getting frail, even dying. Yet, right at the moment of expiration, a legacy is passed on. Despite the numerous deaths and burials, a new avant-garde will always rise from the ashes; art's impulse and imperative for life and change out-winning its mortality.

APPENDIX:
SIX CASE STUDIES

I. COMPLICITÉ'S *MNEMONIC* (1999)

In the 1999 celebrated production of *Mnemonic,* Complicité embarked on a theatrical exploration of time and memory. Conceived and directed by Simon McBurney, the show was first produced at Riverside Studios in London and subsequently travelled all over Europe and New York, receiving critical acclaim. Since its founding in 1983, the company has been dedicated to staging original works, adaptations, and revivals of classic texts, but it is particularly devoted to the forms and methods of devised theatre. Consistent to its aesthetic, *Mnemonic* draws on a multiplicity of theatrical techniques: as a matter of course, it integrates new media into rigorous physical performance, generating hypnotic states of mind and inspired fusions of dreamscapes with reality, in which the choreographed yet intuitive dexterity of the actors becomes a most compelling language in the writing of the performance text.

The play tells the story of Virgil, whose lover, Alice, has left him, and also trails after her as she travels across Europe in search of her father. Underpinning this narrative is the account of the discovery of the Iceman, a fifty-five-hundred-year-old corpse discovered on a three-thousand-meter alpine peak in 1991. Through time shifts and jarring scenic superimpositions, the performance conjures up a convincing narrative that simultaneously attempts to reconstruct the history of the ice-preserved corpse of the neolithic man and follow Alice's adventures. These two paths converge in the consciousness of the protagonist, from whose perspective the story is told. McBurney, who also acts the main part, takes us through space and time, while the immensity and elusiveness of the past is made manifest in a series of intoxicating sequences that "transport" the audience from the depths of underground stations to the frozen vastness of the mountains. Purely in terms of structure, the stories of Virgil, Alice, and the Iceman run parallel to each other, allowing the piece to become

a comment about the origins of humankind and their resounding effect on our lives; the production is also a powerful vehicle for facilitating the connection that spectators inadvertently need to establish not only with their personal experiences and memories but also with global history and events that have defined the development of the human race across cultures and generations. Implicit in this perspective is McBurney's approach to the practice of devising as one of community and continuity. In fact, while confessing his life-long desire to make a "piece about memory," he described how, at the beginning of rehearsals, the company tried to discuss the function of some of their own recollections, looking into how much they actually could remember and how far back into childhood or their parents' childhoods their memories went. In doing so, they also addressed the question of how "if memory is not possible without consciousness, and our conscious selves are created by our backgrounds and where we come from," what we remember tells us who we are; and similarly, how if we forget where we come from, "what continuity we are part of," we actually forget who we are. The "root of the piece in this instance," explained McBurney, "was our own experience. It was about what we remembered, about where we came from. That was our text." However, the director was also intrigued by other sources and themes, as was the discovery of the neolithic man in the Alps, "Rebecca West's journey to Yugoslavia in the 1930s. And Hans Magnus Enzensberger's musings on civil war at the end of the 20th century." So that, in the end and "without knowing exactly how we would do it," McBurney relates, "we began to connect these and many other texts together... until the piece emerged."[1]

It is thanks to the structurally adept conception of *Mnemonic* that these seemingly unrelated events manage to come together. Techniques of collage and cinematic montage proliferate, as the past merges with the present and personal history intertwines with public reference. Performance styles are also mixed. For example, the stand-up comedy act at the beginning of the play, disguised as a biochemistry lecture with philosophical echoes, eases the way into Virgil's story, making the audience partake, if vicariously, in his troubled search for the roots of humankind. As the narrative fragments flow seamlessly into action, questions of existential implications and collective memory link the Iceman to each character and, ultimately, to the spectator. The production implicitly brings home to the audience its own sense of solitude and the constant reaching out to others. McBurney's impulse is to demystify our common loneliness through theatre's therapeutic power to transform, in those moments when "we touch the solitary imaginations of our neighbors and so for a brief moment we too are transformed, by the sense and realization that we are not alone" (quoted in Complicité's Website). Indeed, the performance constantly underscores the connection

of each individual spectator to a broader community, not just of theatergoers but also, more importantly, of human beings.

Perhaps the most salient feature of the production is the collision of reality and fantasy: when the protagonist, alone and unable to sleep in his apartment in London, drills his memory to the point of exhaustion, it becomes difficult to distinguish between fact and fiction. Endless leaps across dates and places also intensify the feeling of disorientation. However, the perplexity remains vastly alluring and the relentless shuffling of conceptual frames exhilarating, as we constantly re-examine our own perception of time and history. At the same time, Complicité's illusory iconic space resonates not only with existential significance but also with a hilarious and poignant sense of humor which is the culmination of the actors' unorthodox preparation. Normally, during rehearsals the ensemble is involved in rigorous physical activities, or as McBurney likes to describe it: actors might "play children's games, or paint all morning, or work with clay...work with buckets of water, or create instruments out of pots and pans" (quoted in Giannachi and Luckhurst 1999, 76), which stimulate their conceptual imagination to breed suitable stage metaphors:

> We played together...we'd kind of sit around banging tables and chairs for hours on end and then gradually somebody would come up with a character, just kind of out of desperation. And then somebody would play with somebody else and gradually these fragments would emerge. (McBurney quoted in Tushingham 1994, 17)

"Multi-formal" as well as multimedia in its aesthetic, the production's imagistic resourcefulness is truly engaging. McBurney's self-enclosed universe features its own rules: a chair becomes a body, sound-scapes of trains carry us across Europe, and a museum is automatically summoned with just a picture frame. The devising process is effectively iconoclastic: within the framework of the proscenium, the hybrid performance piece combines dramatic action with video installation, sculpture, photography, and dance. Surprising and consistent, the haunting imagery of *Mnemonic* prevails until the very end, which features the naked body of McBurney assuming the pose of the neolithic man's corpse, as a closing gesture of purging the audience's accumulated experience of existential loneliness and death. In fact, the visual reverberations of the images culminate in the final enthralling sequence of the play: the cast takes turns in impersonating the Iceman, by engaging in an accomplished folding-chair game suggesting "endless generations tumbling through time" (Spencer 2003) and underlining people's futile attempt to escape it. McBurney acknowledges the magnetic pull of transformative imagery—which has indeed become the hallmark of his

theatre making—as something "marvelous"; when a chair turns into a person, operated by five actors who can make it "walk" and "fall," people marvel at the achievement. Yet, as he contends, what matters more is what this attitude reveals:

> That theatre does not exist up there, up here on the stage. That is not the space of theatre. The space of theatre is in the minds of the audience. It is what separates this art form from all others. Not the fact that we imagine something to be there when it is not, nor the fact that we suspend our disbelief in this way, but the fact that we do it together... in the same moment. (Quoted in http://www.complicite.org/ productions/review.html?id=6)

If anything, *Mnemonic*'s reception has been triumphant all over Europe and the United States, with critics and spectators sharing *Guardian* critic Lyn Gardner's conviction: "Let me put it very simply: I think about the world differently now than when I entered the theatre, and I know that I shall remember *Mnemonic* all my life" (2003). This enthusiastic statement is no coincidence: beyond the company's success in embodying memory on stage, it may be that in the course of devising the piece, the ensemble was able to capture and embody abstractions such as time and remembrance in an economic, unpretentious, and consequential manner, by localizing universals. McBurney's production is permeated with a sense of thrill at the freedom that has been granted not only to artists but also to audiences to interpret and *enjoy* past the conventions that are normally rooted in more traditional ways of theatre making. Some reviews also brought to attention the unfailing emotional involvement that spectators had experienced, attributing it largely to the company's resistance to formalist rigidification, despite the privileging of nonverbal ciphers. It is important to note that as an auteur McBurney has excelled in this kind of work for several years and still holds on firmly to his directorial authority, retaining a strong grip of the production's orchestration. In this respect, he certainly manages to keep at bay the occasional chaos that can be the result of smaller-scale, more "egalitarian" devised work, while still experimenting with extraordinary ways of creating vital stage narratives.

II. MARMARINOS' *ETHNIKOS HYMNOS* (*NATIONAL ANTHEM*) (2004)

Michail Marmarinos, artistic director of the Athens, Greece–based Theseum Ensemble—founded originally under the name of "Diplous Eros" in 1983—based his mise-en-scène of *Ethnikos Hymnos* (*National Anthem*) on common devised theatre strategies. Accordingly, he set out on the text's composition by

handing out to friends, colleagues, and people from the general public a ques-
tionnaire relating to the significance and relevance of the Greek National
Anthem to twenty-first-century audiences and containing questions such as
whether people felt it could still move them or if they would still sing it on
occasion. The product of the extensive research was a dense and plurivocal
text that featured, among other things, newspaper and history-book extracts,
covering the period of time ranging from the 1922 Asia Minor tragedy to
Greece's occupation by the Germans, and from the Greek dictatorship's tank
invasion into the Polytechnic School in 1973 to today.

As the audience enters the bare theatre space, a handful of people are
invited to sit together with the actors along a big table. In fact, while the
play's characters rush into the scene from the very beginning, bearing a vari-
ety of different energies, the performers display a Chorus-like demeanor,
acting as spokespersons for the audience members: some of them sell "good
quality memories at a price you can afford," or alternatively, "the other side
of suicide" (quoted in Hadjiandoniou 2001). History and memory take on
almost at once: for example, the voice of an invisible actor-character enu-
merates dates associated with important events in Greece's history—such
as the destruction of Smyrna in the Asia Minor region and the end of the
Greco-Turkish War, or the long awaited rise of the Socialists into power in
1981—to which the "Chorus" replies. The strategy is repeated throughout
the performance, drawing material from an endless number of quotations
from newspapers, Greek and foreign literary texts, most of which attempt
to provide answers and stimulate dialogue in response to the spectators'
filled-in questionnaires.

Clearly, both the devised text and its stage realization could be viewed as
evidence of the changed cultural circumstances of the country, as an updated
social map of present-day multi-ethnic, multi-lingual capital Athens, where
the issue of national, racial, and religious identity is constantly challenged.
Arresting time and history, some of the production's speeches contained
the director's own phrases, while the actors had been supplied with pho-
tographs, newspaper clippings, drawings, and lines taken out of poetry
books and novels. Marmarinos calls these ready-mades "fragments of dra-
maturgy," emphasizing the tentative nature of the performance text: "In the
end, you just forgot whether this phrase was actually yours, or was a poem,
or a photograph, or some sort of document. In this process, directing itself
had created dramaturgy" (quoted in Keza 2003, 24; my translation). Laying
the questionnaires aside, the ensemble first rehearsed with no text, guided
solely by a kind of "amorphous emotion." This in turn yielded interesting
abstractions that functioned as characters, such as the director's conception
of a "history example," mirrored by an actor who stood still over a period of
time during performance.

In effect, Marmarinos' performance text was a synthesis of autonomous yet also interconnected fragments of plot, exploring the central tenet of the Greek National Anthem. Despite the fact that certain thematic and structural subsets inevitably failed to relate to the main core of the action, nevertheless, the breadth of the very concept of a National Anthem was able to provide the missing links for the audience to mentally connect the divergent *found* texts and to help build an emotionally charged depiction of the individual's position within a rapidly changing world. In addition, the self-referentiality of the performance invites us to undermine the essential artificiality of the stage. The event of the theatre establishes itself as a prefabricated spectacle, as is manifest in the act of actors giving each other directions when on stage, which duly draws attention to the fact that they are merely performing. Brechtian alienation is further reinforced by the interactive quality of the performance, which never leaves the spectator at peace: we are constantly bombarded by questions, invited to join in a dance, or offered soup by the actors-waiters. During intermission, the actors remain on the set serving the audience, a strategy of spectator involvement first introduced by Mnouchkine. In all these instances, performers cry out their "performing-ness," while engaging spectators in activities of a particularly palpable presence. By relying on the actors and the audience's joined coauthorship of the script night after night, the "end-text" of the performance is never finite; in effect, it is a moving, if occasionally heavy-handed prototype of devising principles and styles, which ultimately succeeds in capturing the moment, the instantaneous response, the sense of communal feeling and the totality of spectators' experience. This seems to be in keeping with the auteur's conception of literature as by definition "unfixed theatricality," allowing readers liberties and continually replenishing for them the illusion of functioning as by proxy directors. Reversely, Marmarinos introduces the notion of directing as "dramaturgy," aligning it with the "primal function of theatre as narrative":

> Some time ago we adapted texts. Today things are different. There is freedom in composition, the way an actor approaches literature is also different, much broader, richer and crucial to the final makeup of the text. In essence, dramaturgical work happens through the process of rehearsals. (Quoted in Grammeli 2007; my translation)

It is hardly surprising that the play-text is subtitled "a theorem for collectivity." *Ethnikos Hymnos* is a powerful appeal to audience participation. Collapsing the distinction between rehearsal and actual performance, the production feels complete only when the spectator comes to recognize and endorse the ensemble's constellation of stage codes. Luckily, the notions

with which Marmarinos grapples—nation, nationality, national anthem—are both ideologically and emotionally charged and therefore relevant and intriguing to the average Greek theatergoer. On that account alone, the piece feels like a little token, a gift of communal belonging and sharing even to the most cautious spectator. And even though admittedly, several parts of the text are in need of heavy editing, trying as they do to say it all and include everything within a very compact span of dramatic time; yet, in the end, most spectators are able to claim in the very least a small portion of the issues raised and improvised during the performance. Because of that, one can only admire Marmarinos'—overly—enthusiastic scope. There is an almost childlike quality in the nature of his work and as in most things childlike, also something moving about it. Ultimately, the director's choice of the National Anthem as a major point of reference and departure for the discussion of things both local and global is successful; in his own words, "[this] is a name to which everybody can refer. . . . As for me, I'm interested in theatre events that have to do with the meeting of people at a certain point, as well as with the collective. I'm looking for that small, yet significant common experience that will open us up" (quoted in Hadjiandoniou 2001; my translation).

III. IVO VAN HOVE'S *MISANTHROPE* (2007)

Ivo van Hove's *The Misanthrope,* performed at the New York Theatre Workshop in 2007, consistent with the director's anti-naturalistic reworkings of the classics, is auteur work *par excellence.* Van Hove manages to unearth and render relevant Molière's concerns about the nature of human beings, altogether recontextualizing the play and expertly involving his audience in a simultaneous distancing and empathetic relationship with the text. Based on a 1971 adaptation by British poet Tony Harrison, his revisiting of Molière's seventeenth-century romantic comedy indeed feels like a very contemporary biting social commentary. Plot-wise, the play takes on the adventures of protagonist Alceste, whose total rejection of his own culture's social conventions alienates him from his peer cycles. The director builds of him a truly sympathetic portrait of a dreamer still caught up in the "dated" principles of loyalty and truthful emotions, such as, markedly, his all-consuming love for Célimène, a superficial socialite; in reality, her actions—which oppose everything that he stands for—counter his determination to defy society and its hypocrisy.

Designer Jan Versweyveld's set is a pristine gray box walled with semi-transparent glass panels and vertical video screens. At some point in performance the stage is filled with garbage: all kinds of edibles like pizzas, whipped cream, chocolate syrup and a crushed watermelon, together with a

lot of paper and bottles are literally everywhere and food quickly becomes a metaphor for consumption. A hilarious scene of innocent chat and raillery is succeeded by one in which Alceste, rolling onto the table, covers himself up with an assortment of assembled snacks; characteristically, he uses chocolate sauce for the face and ketchup for his chest, while inserting a baguette down his pants and covering his exposed bread penis with whipped cream. Essentially, the modernization of the space and the novelty of the directorial point-of-view are not only present in the high-tech set, but seem to inform most of van Hove's blocking choices. For instance, at one point, the theatre doors are burst open to reveal a street-fight; Acaste plays video games while reciting Molière's poetry and invariably most characters find comfort in their cell phones, appearing and disappearing behind computer-screens to take calls. In addition, cameras follow the protagonists everywhere, making it impossible for them to escape from their image. In principle, the multi-functionality of technology allows van Hove to manipulate emotional distance and proximity to his advantage: a conversation between Alceste and Oronte off-stage is fully recorded by a cameraman and duly projected onto a screen at the center of the stage, where other characters eagerly watch. When Alceste and Oronte return, we glimpse at them whisper to one another, their backs turned to the audience. Thankfully, a technician holding a microphone makes sure that we know exactly what they are talking about, broadcasting their murmuring confessions all over the house. The experience of technologically aided communication is memorable:

> The effect is striking: the camera magnifies their intimate exchange, making us so privy that we can see Camp's [the actor playing Alceste] brow rise. Under bright lights, the close-ups might look superficially like a soap-opera, but it's just Van Hove's zoom lens on Molière's domestic interior. (Soloski 2007)

Notwithstanding the superb endorsement of cinematic techniques as a means for prying into his characters' essentia, van Hove's genius is made manifest primarily in his treatment of Molière's language. His method is almost clinical in precision: although he keeps every bit of the original dialogue, the words almost always seem fraught with new significance, as if their innermost kernels are finally popping out of an aged shell. Lines are stripped clean of familiar resonance and clichéd usage, allowing for raw feeling to flow uninhibited. In reality, in each of van Hove's auteur experiments one is gradually shocked to realize that the text spoken in performance is in fact the very Molière, Williams, or Ibsen original, without one single line cut, changed or added. Yet, rather than merely unveiling the play's subtext, van Hove also tries to physicalize it. In a recent interview with Tom Sellar for the *Village Voice,* in which he lays bare his method of "rewriting" the play

by means of recontextualization, he exposes the foundations of his theatre as based on psychology "but not only on psychology." He claims that in order to bring the subtext of the play out in the open, he "x-rays" the character and adds that this approach emboldens him to turn "the institutional set with fluorescent lighting" into a "laboratory of human behavior." Similarly, the dominant use of cameras, "functioning more as ancient Greek masks" and giving "huge expression to small things onstage," aims to foreground the play's "area of conflict." Fundamentally, for van Hove, "characters are created out of 184,000 different moments" (Sellar 2007). Altogether controversial and thought provoking, *The Misanthrope* reinstates the question of how many different readings a play can receive; and in the end, whether it really matters if the costumes are not all taffeta and velvet, if the metaphor is right.

iv. Terzopoulos' work on Greek tragedy

Theodoros Terzopoulos' Athens, Greece–based Attis Theatre (founded in 1985) has been committed to advancing forms of physical theatre that can encapsulate the grand dimensions of myths, and in particular of Greek tragedy. Not surprisingly, the company is named after God Dionysus, who stands for the absolute loss of self-control to which young actors are often led. Valorizing the body over speech, Attis' work focuses on the "violently physical, as well as violently ritualistic expression" (Varopoulou, intro to Terzopoulos 2000, 9; my translation). Over the years Terzopoulos has developed his own distinct way of reading classic texts. While in most directors' revisions of the classics it is the timelessness of the texts that matters the most, he is more concerned with those elements in ancient tragedy that speak across cultures, rather than through time. His theatre could thus be called "intercultural," in that it uses the actor's body as a "universal" that has the potential to make the text relevant to extremely varied international audiences. Intrinsic in this process is the conviction that the suffering body, the body as worshipped by the ancient tragic poets, displays common characteristics in different cultures and religions.

While working on the text, Terzopoulos focuses on what he calls a "nucleus" of meaning, elaborating on specific themes that are especially pronounced within the plays (i.e., heroism in *Prometheus Bound* or mourning in *The Bacchae*), instead of "psycho-analyzing" the characters to make the performances more familiar and accessible to a modern audience. In this respect, emotional involvement is not the result of an empathetic relationship between the audience and the stage, but rather, through that of the evocation of archetypal images, which the performers' trained physicality brings to the fore. Given the company's international projects—often

involving mixed casts—and the fact that the overarching goal is to make myth reverberate in different spectators across the globe, Terzopoulos is highly suspicious of the temptations that lurk behind adapting a classic work by means of re-contextualizing action or setting. In reality, he is totally adverse to restoring tragedy through straight-forward metaphors and paltry directorial quirks and is actually convinced that restorations give birth to "still-born babies."[2] More than anything else, he is concerned to highlight those elements or currents in the ancient tradition that would still be pertinent today; therefore, instead of small details and particular-case aesthetics, he creates the energy of collective integrity and of a balanced, yet fierce play of actors. No doubt the overriding characteristic of his performances is an orgiastic feeling of ritual and an intensity of tragic rhythm, as is certainly manifest in his productions of *The Bacchae* (1986), *The Persians* (1991, 2006), *Antigone* (1994), *Prometheus Bound* (1997), *Heracles Furens* (2000), and *Ajax* (2008). In those works Terzopoulos returns to the primal, uncontaminated source of myth and plunges directly into its foundations, refusing to resort to the readily available realism-based material of modern theatre. He passionately argues that "we can't turn ancient theatre into chamber drama," because "tragedy needs stature" (quoted in Karali 2008). In fact, he explicitly rejects the undercurrent trend in postmodern productions to approach ancient tragedy through the lens of psychological theatre, mixing it with naturalism or performance art. Adamant about his [op]position to "adaptation," he prefers to go "straight to the archetypes," such as "anthropomorphism" or "animal forms," especially because the exploration of the tragic form is presently more accessible, "beyond lament and guilt, beyond mourning even." For him tragedy is an "open form" with many dense layers and levels, all of which it would be impossible to interpret, since:

> the greater part remains unexplored, adjusting itself to new social, political and human conditions. We can adjust the timelessness of wars, modernize it, transfer it to human situation, to a the city, and other contemporary issues, such as the environment, to the issues of love and death, even to cloning; but we can never transcend certain principles that have to do with self-concentration, the grand stature, the grand energy...because we can never whisper those issues by adapting them to the new circumstances. (Quoted in Karali 2008; my translation).

The 1986 production of *The Bacchae*, in which Terzopoulos launched a major attack on conventional forms of representation, was perhaps his first in-depth attempt to arrest those moments of liminality that myth by its very nature encompasses. The very choice of the play was not accidental: its subject-matter relating to people's impulses, excesses and downfall through

divine intervention, allowed him to interrogate the extremes of human behavior: the body is summoned to foreground the existence of archetypes, manifest in shared intuitions, behavioral patterns and material conditions. As is true with most of Terzopoulos' work on tragedy, the irreparable rupture between intellect and emotion, between reason and the "irrational," is reflected in the half-naked actors' physical codes: trained to be able to locate and actuate even the hidden-most energy sources of the body, the performers paradoxically appear to operate on instinct alone, as if God Dionysus himself has been incarnated in each one of them. To further grasp the essence of ritual and ecstasy, the company has been researching age-deep traditions in several religious and folk festivals all over Greece, but also across Europe and Asia, in the hopes that these can disclose consistent patterns of physical life and gestural attitudes. At the same time, Terzopoulos' investigation of myth has been additionally fuelled by the revisionist aesthetic of Heiner Müller's tragedy-inspired texts (see *Medeamaterial* [1988] and *Heracles* [1997]).[3] Prompted by the formalism of Suzuki and Wilson, Terzopoulos recognizes in Müller's fragmentary *Produktion Stücke* the opportunity to delve into a sign-inscribed post-apocalyptic sphere, where he can look for those primal streams of energy that run through the human body across time and cultural reference.

As is characteristic in most of auteur work on mythological subjects and themes, Terzopoulos also by-passes other writers' existing versions to immerse into the very sources of the myth itself and work completely uninhibited from set forms. By means of an example: responding to this challenge in his treatment of the story of the classical hero Heracles, he departs from the play of Euripides, not to mention Heiner Müller's text, entering the pre-sources of the plot and the archaic layers of myth. In more than one ways and truthful to Artaud's vision, Terzopoulos strives to achieve contemporary relevance by freeing up the primitive force of violence, ritual and ecstasy. Beyond question, as Müller recognized in 1987:

> In Terzopoulos' theatre myth is not fairytale, it is condensed experience; the process of rehearsal is not the performance of a dramatic concept, it is an adventure on a journey to the landscape of memory, a search for the lost keys of unity between body and speech, the word as natural entity. (Quoted in Terzopoulos 2000, 35; my translation)

Thus in *Heracles*, where the hero triumphs as "Heracles-Hydra-Machine," the recurrent motifs of heroism and obsession are passionately scrutinized. Through the looking glass Heracles sees the reflection of Hydra whom he identifies with the "Machine" and subsequently kills his wife and children. In his 2000 production of *Heracles Furens* (part of the trilogy *Kathodos*

[*Descent*]), Terzopoulos has the hero acknowledge his deed yet realize that he is not in fact responsible for it, having been driven to this heinous crime through a divine-originating madness. Once again, the director applies the principle that our body carries inside it memories and images that have been pushed aside; these he sees as imprints of other times and other lives, a kind of consciousness of the world itself. Not surprisingly, he also transfers to his productions the certainty that tragedy holds one captive within its possibilities, providing entry-ways into the very core of humanity, in its blood and human cell, and releasing a metaphysical consciousness through its distinctive form and stature.

Having travelled all over the world, Terzopoulos studied keenly those constituent features that are common in every culture, aware that there exist in each person instinctual patterns of behavior that have been impressed long before he or she has been marked by a particular local or national culture. Carrying on this line, his method is to identify, classify, and afterwards rework them during rehearsal, always with a view to communicating a heightened sense of ritual in performance. His visual style is duly eclectic, drawing from the formalist geometry of Wilson and the disciplined physicality of Suzuki, and is further infused with re-activated sounds, which have been unlocked through extensive and exhausting training. In this perspective, the body becomes a sculpture as well as a transparency on which history and ritual are inscribed, universal, and timeless.

Terzopoulos' production of Sophocles' *Ajax* at the smaller theatre of Epidaurus (2008) was a stage composition resulting from the company's work on some of those "nuclei" of tragedy specific to the play and, in particular, the themes of betrayal, madness, revenge, suicide, and remorse. In the Sophoclean myth, heroic Ajax loses his sanity because of the injustice his co-warriors inflict on him during the Trojan War; as a result, he slaughters a flock of sheep, trusting that they are actually his enemies, and after realizing his self-ridiculing act, commits suicide. Terzopoulos brought onto the stage red stiletto shoes, butcher knives, seven bare-chested Ajaxes, and one mourning woman. Lasting a mere one hour and fifteen minutes, Attis Theatre's *Ajax* makes use of very few lines of Sophocles' tragedy and gives a new dimension to the myth of the ill-treated hero: that of a satyr play, where because of the chorus of satyrs, the stateliness of tragedy is no longer very prominent, even though the heroes remain tragic. Unlike his past productions of the play, which principally foregrounded the issue of madness, Terzopoulos now chose to research Ajax's guilt and lament. The effect of such emphasis is stunning, especially when Ajax fully realizes the crime of having killed a goat: the victimizer is turned into a victim, whose cry becomes an ode—the goat's cry—making allusions to the origins of tragedy itself. Narrating Ajax's transgressions, the actors themselves are, in the end,

transformed to victims-victimizers. Ultimately, remorse is choreographed, acquires flesh and blood, and thereafter turns into an object of mockery. Ajax's ode adds to the overall effect of modern ritual, while the performance closes with Pink Floyd's *Final Cut*, perhaps the sole overtly anti-war statement in the whole production.

Despite the physical and rhythmic rigor of his performances, in his most recent work on tragedy, Terzopoulos has been repeatedly critiqued of reproducing mere variations of the form he has arrived at in each of his experiments. If anything, his style frequently borders on mannerism, as though his creative resources have been exhausted, and so he is forced to resort to tried-out technique. Yet without question, his method as well as aesthetic is consistent and, to an extent, original. At a time when endless postmodern revisions of classical drama fail to register the volume and magnitude of the profound issues embedded in myth, Terzopoulos offers an alternative, which in the very least tries to communicate the sense of the (long-lost) primordial vitality surging out of the ancient form.

V. THE WOOSTER GROUP'S *VIEUX CARRÉ* (2011)

The Wooster Group's 2011 production of Tennessee Williams' 1977 *Vieux Carré* features the earnest title-prefix "a version of," which partly absolves the company of many of its habitual staging choices which ordinarily enrage a portion of critics and audience members. In fact, the production anything but emulates common renderings of Williams, remaining faithful to a multimedia aesthetic and committed to revisiting classic works from a contemporary "cutting-edge" sensibility. After all, re-writing established texts while simultaneously proposing to retain their established meaning is the underlying principle in any adaptation.

Vieux Carré is one of Williams' latest works and fully justifies its designation of a "memory play," tracing his own development as a playwright as well as his sexual awakening. The play is an autobiographical recounting of the time Williams spent as a young man in a run-down boarding house in the French Quarter of New Orleans, after he moved out of his native Saint Louis in 1938. Operated by Mrs. Wire, the establishment's semidemented landlady, the sordid dwelling, which is the play's central locus of action, is inhabited by several physically and mentally sick characters in various degrees of decay. There is Nightingale, the consumptive homosexual sketch-artist who keeps making advances on the main character, the Writer, by consciously and ferociously arousing his gay consciousness; also Jane, whose futile attempts to hold onto some sense of dignity while dying from an incurable disease, are invested with surprising sympathy. Yet, although the coming-of-age tale is retold with ample nostalgia by the playwright, in

LeCompte's staging—which actually keeps every word of the text intact—the play is heavily de-poeticized. Rather than over-coloring its already fraught lyricism, the auteur's adaptation is an attempt to turn the inside of the action out and give flesh to its subtext, partly through an expert use of technology. Notorious for modernizing classic works, LeCompte often leaves the text "uninjured" and "recasts" action, language, and context to such degree that the final product resembles nothing of the original. In many respects, the Wooster Group's "version of" Williams is unexpectedly honest and brave. The encounter between the playwright's late sensual poetics and the director's omnipresent brutal cynicism may initially strike an ominous chord. Yet, the obvious clash in aesthetics resonates powerfully. LeCompte gives the play's tortured subtext a face, leaving none of the gaps and hesitations that exist in the original text and which, to some degree, convey Williams' ever-wavering stance toward the treatment of his own homosexuality, as well as the preservation of memory and the past. Despite its occasional parodying sequences—the group vignette scenes being the weakest—the performance gives additional depth to the characters, revealing their inner agonies with unflinching candor.

As is typical in the Wooster Group productions, the theatre space becomes a show-room for digital equipment: all machinery, including numerous video screens and ample stretches of wires, is totally exposed, adding to the performance's overall post-industrial look. Essential to the action are two moveable platforms, which function as different rooms and are "infested" with the most unlikely combinations of objects, such as a chessboard, pills, dirty cups, and bottles, poignant reminders of a world falling apart. In effect, the "entrails" of the stage are visible throughout, while the intermittent video fictions provide constant exposition for the play's internal action. Quite predictably, the sound-scape is also evocatively urban. Having said this, the Wooster Group's alienated and chilling universe becomes an ideal home for Williams' heated despair, and LeCompte's poetry of disenchantment proves a roomy container for the frequently verbose and overly sentimental dialogue. LeCompte captures the subterranean quality of the play by investing in the characters' "subhuman" instincts, as well as appearance—for example, in Nursie's eerily absurd attire—and creating patterns of movement and costume that recurrently bring to mind Beckett's implacable bodies. The actors' frenzied delivery of lines, mirroring their turbulent emotional state, further enhances the aesthetic distance between the spectator and the performance.

Consistent to the play's treatment of the protagonist's literary growth as a parallel discovery of social and sexual identity, the visual conceit of writing is also pivotal; the Writer's keyboard initiates and also dictates the action. While he fully assumes the playwright's persona, constantly calling

attention to the autobiographical nature of the play, the typing up of the live dialogue and the overall meta-fictional element both seem to suggest that the play's characters *themselves* have materialized out of a fiction. At the same time, the raving rhythm of the dialogue perfectly frames its great bulk of words. Sometimes it appears as though the text actually needs the sharpness of the performance to harness some of its heavy-handedness and verbosity. Evidently, LeCompte's world has rules of its own, which once processed and understood can make the audience's journey truly engaging. However, the inventory of production tricks is almost never-ending: there is always room for even more objects, more variety sketches, more parody. Not seldom, the group reverts back to the comfort of cliché pattern, and sometimes the burlesque portrayal of mad despair flattens the acting and drains the performance both of sense and of meaning. The pastiche of styles is also disorienting: customarily, the video screens take center stage, stealing focus from the human drama, while there is also a pervading impression of gratuitousness in some of the imagery, as notably, in the abundance of phalluses. Indeed, the highly "sexed" mumble-jumble is too indulgent and on several occasions the phrase "a version of" feels understated. That being the case, rather than trusting in the stage world she has created, LeCompte displays an insecurity to supplement (overburden) it with even more heavy-handed symbolism—as is for example the Painter's angled plastic penis—which finally deprives the more intimate moments between the two men of depth and emotional texture. Some audience members felt that character delineation was bordering on caricature, while several have noted how, even in the most surprising and what are meant to be *dramatic* turns, you can never fully empathize with the protagonists' condition, trapped in the director's postmodern élan. In some respect, LeCompte is still held captive in the debilitating condition of constantly struggling to remain on top of the text.

Despite the fact that the constant stripping and the implied masturbation scenes may be an easy way to cheat into Williams' subconscious, some of these moments are actually illuminating, probing with courage in the play's disturbing malaise and piercingly depicting a world ruled by disease, insanity, squalor, and loneliness. The performance remains faithful to LeCompte's use of gnawing irony and humor, as in the scene where the tubercular Painter exclaims, "You have beautiful eyes!" while staring at the Writer's naked behind. When not interrupted by shrill screaming or relentless blood-spitting, the Writer's controlled silence is truly articulate, ringing a particularly William-esque tone, such as is his lyrical stagnation and monotone aloofness during the reminiscence of his grandmother. No doubt, one of the production's most engaging qualities has to do LeCompte's passion and talent for keeping her aesthetic rules tireless and stylistically consistent, which is perhaps why the term "a version of" ultimately becomes so apt. While the

stage transforms into a surreal landscape, more for characters out of *Alice in Wonderland* than those of Williams' plays, the all-pervasive decadence is engulfing, with the action gradually blending into an exploration of inner darkness. It is also worth referring to how the aesthetic frame invites identification with the perceptual techniques of film: the conjunction of video and live action provides simultaneity, which in itself layers the narrative with an even more pressing sense of urgency. In one particularly resounding scene, the painter draws the outline of the writer's body on screen while observing him in reality. The dialogue between the self and its mediated icon hence becomes a premier structural motif. In effect, the play's episodic frame is punctuated by technology, which in LeCompte's customary exuberance, fuels the tension between illusion and reality, Williams' perennial theme. At the end, the omnipresent video screens turn into windows and doors, giving closure to the theatre event. Notwithstanding the usual controversy which characterizes the Wooster Group's work, what remains indisputable is the director's daring choice to de-dramatize the action and emotional atmosphere of the play. The performance's cinematic staging, with the constant framing and the rapid succession of images, adds to that effect, making it challenging for spectators to pin down the elusive universe of Williams and of some of the characters themselves, as the actors move in and out of drama and parody.

VI. REZA SERVATI'S *MACBETH* (2010)

Reza Servati, who runs the predominantly physical theatre company Max Theatre Group in Tehran, is one of the most promising voices among the younger generations of Iranian directors. In 2010, his version of *Macbeth* was presented at the 28th Fadjr International Theatre Festival and won the Grand Jury prize; it subsequently toured Georgia and Germany. The production is a captivating adaptation of Shakespeare's text, a fine example of a thoughtful, probing, intelligent reconstruction of the archetypical tale of power, ambition, and human loneliness. Performed in Farsi, Servati's "take" is condensed into an hour-long narrative, composed from key dialogues and soliloquies taken out of the Shakespearean text. The storytelling is extremely compact, leaving out all reference to and details of the murders of Banquo or Macduff and the repercussions of these actions. Instead, the adaptation's structural axis revolves on the existential anguish that torments the two protagonists. The director avoided contextualizing and contemporizing the action, keen instead on reinforcing the poetic dimension of the text and universalizing the story.

Essentially, the allure of Servati's interpretation lies in the depiction of Macbeth and Lady M as two sides of the same character: they are ingeniously portrayed as identical twins, Calibanesque and androgynous in their

baldness, sometimes seemingly deprived of humanity, others brimming with sexuality and passion. Often it is difficult to distinguish the one from the other, as they are emphatically made to resemble a Siamese pair or a mirror reflecting one single face; more frequently, however, the character of Lady M functions as an embodiment of Macbeth's harrowing consciousness, the constant inner voice buzzing in his head. The irony of Lady M being performed by a male actor is all-pervasive and effective, adding touches of homoeroticism—which heightens the existent autoerotic element—and patriarchal resonances to the performance, as the two actors perpetually rub against each other in tight, tormented embraces. Fundamentally, the manner in which the scenes are organized suggests a zealous commitment to the metaphysical implications of the play and a keen understanding of structure. Primarily serving the psychological depth of Shakespeare's tragedy, this adaptation of *Macbeth* becomes a reflection on the anguished dissolution of the soul. In spite of the text's heavy editing, we feel as though we have travelled deep into the core of the play's conflict.

Within the eclectic yet consistent mise-en-scène, all stage idioms blend into a fluid and timeless representation of the main characters' inner struggle: the haunting musical score, originally composed by Bamdad Afshar and performed live on stage, is based on a mixture of Iranian and Western instruments. The broader sound-scape of the performance underpins the action relentlessly, allowing for startling gasps in moments of silence. Lighting is geometric and abstract, revealing the director's stylized proclivities and foregrounding the stark aesthetic of the company. Interestingly, the show starts in darkness, interrupted by a spotlight on the narrator, who functions more as a messenger as well as the Coryphaeus in a classical Greek tragedy, a harbinger of destruction and a commentator on the surrounding despair, who also wraps up the piece at the end. Overall, exact cultural and historic reference is omitted, since the director's purpose is primarily to universalize the action. In this perspective, the metaphors are minimal and symbolic yet genuinely consuming. At the same time, the visual imagery is stunning and so economically conceived that it never gets pretentious or imposed, illuminating rather than overshadowing the auteur's in-depth exploration of a psychic landscape bordering on madness. Servati's directorial inventiveness is thrilling: the paper crown on Macbeth's head unfolds into a letter bearing news of his victory, which Lady M reads and subsequently devours in a fit of frenzied ambition. The palette of the stage is mostly in the hues of black, white, red, and grey, all solids, while significant props such as the plexiglass dagger are eloquently minimalist. The director uses the stage sparingly, but his imagination angles it in surprising ways: for example, the bed on which Macbeth and Lady M lie, steeped in anxious delirium, is vertical to the stage floor and frames the inner action of the scene in painterly fashion. The

director's charisma is also present in the scene where the Porter unlocks the gate to the dead body of Duncan, clad in full red and in mask, with whom he dances mercilessly after removing the crown and placing it on his own head. As the royal couple enters the stage in circus mime and mirroring one another, dead Duncan's robe is handed to Lady M, and the coronation scene, fraught with lonesome stillness, blends masterfully with the dinner party during which Macbeth comes face to face with Banquo's ghost.

In similar ways, the physical patterning per se is telling, texturing the emotional content of the performance and building up with constant surprise and tension the anatomy of greed, lust, and obsession, which Servati's version of *Macbeth* ultimately becomes. The repetitive gestus of sleepwalking serves as a dominant conceit and, to a significant degree, appears inspired by Japanese Kabuki forms. Similarly, Lady M's frenetic rubbing of hands is always in synch with the performance's intoxicating rhythmic sounds. The all-embracing atmosphere is ritualistic and surreal, but the impending sense of insanity is carefully controlled. In a seeming state of constant unrest, the Macbeth-Lady M duo, in white ripped, timeless, and unisex costume, flounders barefoot through states of restless anxiety, danger, and remorse, punctuated by nightmarish sound reverberations. Slow motion alternates with frenzied pace and dance-like movement. Throughout the performance there is a dreamy monotony with glissando notes that periodically disrupt the suffocating solidity of Macbeth's world: more often than not, they reveal the tension between the two sides of the main character. In like manner, effigies of the dead bodies include two bloody plastic bags and a fetus in a glass box at the beginning of the play—foreshadowing Macbeth's crimes—together with a headless corpse and a bodiless head; they are paradoxically animate, resurrected objects, pulsating with echoes of Kantor's theatre.

Occasionally, Servati's purist aesthetics are interrupted by moments of parody, as in the "weird sisters" variety number, which involves three actors of significantly different sizes in abstracted military uniform, "sculpting" the space in unusual shapes and voicing their predictions against a surreal musical score that combines sound references to circus and march. These moments, rather than relieve us of the accumulated psychological horror, actually further enhance our feeling of wonderment and sense of the bizarre.

NOTES

INTRODUCTION

1. "Auteur" is the French word for "author."
2. Auteur caution vis-à-vis language's construction of meaning has been supported by Jacques Derrida's exposition of language's fragile subjectivity and invalidation of the sign-signified relationship that had been explored by Ferdinand de Saussure. Incredulous of people's ability to construct and sustain meaning, auteur productions attempt to transfer this attitude of wariness to stage narratives that both reveal and reinforce the fractured nature of the audience's cognitive process.
3. Roberta Mock argues in *Performing Processes* (2000) that the act of reading is an exchange between author, text, and reader that brings about the formation of a set of "new, possibly different, meanings." She claims that the perception and interpretation of theater is layered precisely because theater is a collaborative process. In her view, "the 'conversation' is a public debate between at least four elements—the written text, the performance text, the scenography and the spectator. The individual spectator is thus creating a meta-production influenced by what cultural experience or expectation s/he brings to this event" (104).
4. Additional discussions pertaining to the theoretical context of auteur work include some seminal studies on the new function of writing, such as Jacques Derrida's *Writing and Difference* (1978). Similarly, on reader-response theory (Wolfgang Iser's *The Implied Reader* [1974]); the semiotics of the stage (Anne Ubersfeld's *Lire Le Théâtre* [1977]; Marvin Carlson's *Theater Semiotics, Signs of Life* [1990]; and, of course, Keir Elam's *Semiotics of Theater and Drama* [1988]); the debate on interculturalism (*The Intercultural Performance Reader*, edited by Pavis [1996] and *Theater at the Crossroads of Culture* [1992], as well as *The Dramatic Touch of Difference: Theater Own and Foreign*, edited by Erika Fischer-Lichte [1990]); and theater phenomenology (Stanton Garner's *Bodied Spaces* [1994] and Bert O. States' *Great Reckonings in Little Rooms* [1985]). Finally, there have been treatises on the complicated subject of textual authorship, as is Gerald Rabkin's article "Is there a Text on this Stage? Theater/Authorship/Interpretation" (1987), as well as *Playwright Versus Director: Authorial Intentions and Performance Interpretations,* edited by Jean Luere (1994).

1 The Rise of the Modern Auteur

1. Craig defends the superiority of action to all other elements of the theatre art, since "the art of the theatre has sprung from action-movement-dance" (quoted in Walton 1991, 52).

2. Hugo further revolted against artifice by inviting audiences and practitioners to "take the hammer to theories and poetic systems" and "throw down the old plastering that conceals the façade of art." He was of the opinion that there were "neither rules nor models," or rather, in his words: "There are no other rules than the general rules of nature which soar above the whole field of art and the special rules which result from the conditions appropriate to the subject of each composition" (Roose-Evans 1991, 14).

3. August Strindberg's infamous introduction to *Miss Julie* (1888) was greatly indebted to Zola, and the play itself is thought to have been inspired by the latter's short story "The Sin of Father Mouret" (1875).

4. As Christopher Innes suggests, for Craig, "Theatre is the equal of literature, but a very different form of art that can reach its full potential only if it is no longer subordinated to the written word." Depending on how strong the "verbal imagery" of the play is and how vibrant the dialogue, the stage may be "forced into a simply illustrative function and the less it fulfils its true nature" (1983, 113).

5. Not only did Artaud propose a theatre that would put the audience in the centre, platforms in the four corners, and a gallery all around, so that the action could be pursued form one point to another, but he also went as far as to suggest abandoning the architecture of existing theatres and to insist that reform of theatre spaces was necessary.

6. The search for *alternative* or *environmental* performance spaces, also called *created* or *found space,* dates back to the 1960s protest movements in the United States. In their revolt against society and the cultural establishment at that time, artistic groups created theatrical performances that rejected conventional stages and seating arrangements. In most of the cases, the audience became a part of the playing space. Streets, basement garages, warehouses, art galleries, lofts, a side of a hill, apartment rooms, all became performance spaces.

7. Gerard Raymond, "Touched by an Angel," an Interview with Deborah Warner. *Theatre Mania*, New York, July 8, 2003.

8. According to Andy Field's analysis of the "site-specific theatre" phenomenon in *Guardian*'s Theatre Blog, "at best these productions—regardless of their merits—borrow the atmosphere and aesthetic of their new homes in a relatively superficial and inorganic manner, all take and no give." Actually, Field also comments on how they can also feed the criticism of those "who have suggested that site-specific theatre is merely a gimmicky staging of 'real' theatre for the cheap thrill of sensory titillation" (6 Feb. 2008).

9. See also the work of Russian theatrical innovator Alexander Tairov (1885–1950).

10. Meyerhold would argue that words are "a design on the fabric of movement" (quoted in Roose-Evans 1991, 23).

11. In his essay *The Paradox of Acting* (1773), Diderot regarded actors' *sensibilité* (*sympathetic feeling*) as the source of mediocre acting. In his view, great actors do not lose themselves in feeling, but "imitate so perfectly the exterior signs of feeling that you are thereby deceived. Their dolorous cries are noted in their memory, their despairing gestures are carefully rehearsed, they know the precise moment when their tears will begin to flow." Spontaneity is dangerous; rather, a systematic study of action, diction and gesture are the means to secure consistency and truth in acting. (In Cole and Chinoy 1970, 162–3; trans. Walter Herries Pollock)

12. Tadashi Suzuki's approach to acting and directing nevertheless originates in a different tradition and therefore his sense of formalism cannot be solely attributed to the same influences or ephemeral practices of the Western theatre.

13. "Pour l'oeuvre nouvelle qu'on nous laisse un tréteau nu" (Copeau quoted in Roose-Evans 1991, 55).

14. At the same time, Copeau trusted that for the theatre to regain its lost spirituality, actors should spend a lot of time in consuming self-exploration. That thought, in itself challenging, was extensively developed by Artaud.

15. Piscator believed that the theatre is part of the media and must disseminate information to the public.

16. Surely, Brecht's following statement in 1920 has adequately fed these new directions in critical thinking: "A man with one theory is lost. He must have several, four, many! He must stuff them in his pockets like newspapers, always the most recent, you can live well between them, you can dwell easily between the theories." (Brecht quoted in the book description of *Brecht on Art and Politics*, 2003).

17. A later side of Brecht, often neglected in theatre history.

18. Some of the most remarkable collaborations are Mee's work with Woodruff's former company at A.R.T. on *Full Circle* (2000) and Bogart's SITI on *Hotel Cassiopeia* (2007).

19. On a similar, yet less activist track, Jerome Savary of the Grand Magic Circus (known as Théâtre Panique in the 1960s), a passionate follower of Artaud, rejects the highbrow literary aspect that held theatre captive for many years and uses fireworks, pulleys, magic, live music, vaudeville, animals, etcetera, to celebrate its festive nature. He sees theatre as "a feast, a joyous occasion, a festival," separate from the structures of literature. In this respect, performances can happen anywhere, even in the most unlikely places such as a garage or even a stable. In effect, Savary identifies the problem with the avant-garde theatre of his times in it being "absolutely intellectual," forcing the audiences to be "cerebrally inclined to understand what is going on" and argues instead for an art that can "appeal to everyone: the illiterate, as well as the intelligentsia" (quoted in Roose-Evans 1991, 86).

2 ENTER ARTAUD

1. In the poem-like text "What I Lack Is Words That Correspond To Each Minute," Artaud ferociously addresses his opponents, "literary" people: "For

the mind is more reptilian than you yourselves, messieurs, it slips away snake-like, to the point where it damages our language, I mean it leaves it in suspense" (quoted in Auster 1982, 261).

2. During his lifetime, and despite his active involvement with the stage from the early 1920s until his death in 1948, Artaud actually wrote only three plays: *Le jet de sang* (*The Spurt of Blood* [1925]), *Ventre brûlé, ou la mère folle* (*The Burnt Belly* [1927]), and *The Cenci* (1935), of which two, *The Burnt Belly* and *The Cenci*, were produced while he was still alive, while *The Spurt of Blood* was produced by the Royal Shakespeare Company as part of its Theatre of Cruelty season. None of his pieces actually enjoyed notable acclaim either from the audiences or from the critics.

3. In his directing work, Schechner first sought to integrate stylistic elements of non-Western theatre traditions, particularly with regard to the relationship of the audience with the stage. Having travelled in India, China, Japan, and other parts of Asia, he developed an aesthetic largely based on the possibility of cultural exchange in the arts, pioneering the philosophy and practice of interculturalism. Similarly, in Eugenio Barba's theatre, artists from different cultures joined forces to discover common methods of devising a script around a theme, as, for example, in *Ego Faust* (performed in Germany in 2000), Barba's version of the *Faust* myth where actors and musicians from India, Bali, Japan, as well as the Odin worked together to develop the project.

4. A similar pattern of dramatic interpretation is suggested in Plato's dialogue *Ion*. The rhapsode (performer, actor) is not guided by rules of art but is an inspired person who derives a mysterious power from the poet (playwright); the poet, in like manner, is inspired by God. The poets and their interpreters may be compared to a chain of magnetic rings suspended from one another and from a magnet. The magnet is the muse, and the ring which immediately follows is the poet himself, from whom other poets are suspended. In addition, there is also a chain of rhapsodes and actors who hang from the muses but are let down at the side. Quite predictably, the last ring of all is the spectator. The poet is the inspired interpreter of God and in this respect, the rhapsode is the inspired interpreter of the poet.

5. Reversely, it can be argued that Aristotelian drama, based on logos and primarily identified with Western forms of theatre, derived its power from the literary elaboration of stories uniformly served to an audience and duly anticipating uniform responses.

6. Colin Russell in "A New Scène Seen Anew: Representation and Cruelty in Derrida's Artaud." For details on electronic articles, where no page numbers or specific publication details are provided and which are referenced by name of author and title of article, see bibliography section.

7. Derrida applies the term "theological" to a theatre that is structured and informed by speech. He denounces the "layout of a primary logos" as not belonging "to the theatrical site," but instead governing it "from a distance," and he identifies the rudiments of the theological stage to be: an

author-creator who, absent and from afar, is armed with a text and keeps watch over, assembles, regulates the time or the meaning of representation, letting this latter *represent* him as concerns what is called the content of his thoughts, his intentions, his ideas. He lets representation represent him through representatives, directors or actors, enslaved interpreters who represent characters who, primarily through what they say, more or less directly represent the thought of the "creator." Interpretive slaves who faithfully execute the providential designs of the "matter." (1978, 30)

8. By using the actual words of people interviewed by the playwright on a variety of different subjects, *verbatim theatre* imparts a sense of authenticity and a documentary-like quality to the script.

9. Thus removed from the sultry emptiness of bourgeois culture, the theatre ought to put forward its proposition for a magical yet also meaningful medium, able to reveal and enhance art's moral and aesthetic function.

10. Supporting Artaud's vision of a revised theatre, his actress and companion, Paule Thévenin, acknowledges that despite the existence of different mediums (such as the theatre, painting, or music) of making visible "what is buried and shadowed in our own depths," the theatre, which can combine all these different art-forms, has one additional, but essential attribute, namely, its perpetual dependency on an audience, "this multiplied body that the public is," having to act upon it by the intermediary of the actor's body" (Derrida and Thévenin 1998, 11).

11. The performing body holds an indispensable place in Artaud's relentless critique of verbal language; the body conveys ideas and emotions and, as is stressed in "An Affective Athleticism" (1935), feelings and thoughts that correspond to specific bodily movements, patterns of breathing, and universally comprehensible gestures. "Without a doubt," as Artaud illustrates, "an appropriate breath corresponds to every feeling, to every mental movement, to every leap of human emotion" (*OC*, IV, 155).

12. In Artaud's ideal stage, music (intonation and incantation), the visual and plastic arts (painting, sculpture, and dance), mime and circus, scenery and lighting, costume and props, all recover their rightful place, ousting the elitist word and "the exclusive dictatorship of speech" (*TD*, 40) to a secondary place. Characteristically, in his "Draft of a Letter to Rene Daumel" (1931), Artaud laments the fact that "all specifically theatrical means of expression have gradually been replaced by the text, which in turn has absorbed the action so completely that in the final analysis we have seen the entire theatrical spectacle reduced to a single person delivering a monologue in front of a backdrop" (*SW*, 206). This conception, however valid in itself, confirms in the minds of Westerners the supremacy of spoken language, which is more precise and yet more abstract than any other language. Artaud once again castigates Western culture at large, describing logo-centric theatre as a "theatre of idiots, madmen, inverts, grammarians, grocers, antipoets and positivists, i.e., Occidentals" (*TD*, 41).

13. In some ways, Artaud's emphasis on a language that provided space and time coordinates through its sheer physicality had been already anticipated by the *landscape* plays of Modernist writer Gertrude Stein.

14. Sontag describes literature as "the corrupt, fallen activity of words" (*SW,* 1).

15. Artaud's cautiousness vis-à-vis literature's role in the theatre is justifiable. For literature as product (and not process) remains fixed to the moment of its inception. To crack literature open is to cancel its original mission, which rejects the cataclysmic penetration of action and relies instead on the inevitability of contemplative interpretation, an auxiliary offspring of creation. Literature can become theatre when it lends itself as primary, gross material in the hands of the director, the author of the performance text.

16. In "The Reinvention of the Human Face." Accessed on Aug. 20, 1987. http://www.antoninartaud.org/reinvention.html.

17. Brook's and Marowitz's Theatre of Cruelty experiment culminated in a series of performances that included the first staging of Artaud's surrealist play *The Spurt of Blood.*

18. Elements of Artaud's ambition to extend the audience's imagination, by destroying conventional assumptions and presenting alternate visions of the world, together with "his methods of achieving this effect—hallucinatory distortions of scale and perspective, and overloading the brain with emotive images" (Innes 1993, 63), are present in the work of writers and artists as different as Jean Genet or Robert Wilson.

3 BECKETT'S TURBULENCE

1. Quoted in Mel Gussow's "Samuel Beckett Is Dead at 83; His 'Godot' Changed Theatre." *New York Times*, Dec. 27, 1989.

2. Beckett quoted in Gontarski 1998. All information on Beckett's correspondence with Barney Rosset and Charles Monteith is taken from "Revising Himself: Performance as Text in Samuel Beckett's Theatre" (Gontarski 1998).

3. Quoted in Gontarski 1998. As stated in Gontarski, in his analysis of Beckett's theatre, the correspondence of Beckett with his publishers as appears throughout his article is in the respective publishers' archives, Grove Press, Faber and Faber, and John Calder (Publishers) , and is used with permission of the publishers and Samuel Beckett.

4. Gontarski is questioning the sparing, if not altogether relentless ways in which the Beckett Estate handles performance rights based on the assumption that it is difficult to "determine authorial intent off the page."

5. Beckett's insistence on detailed *didascaliae* is at least in part inspired by George Bernard Shaw, whose plays thrive in extensive "guidelines" on how set, costumes, and characterization should be handled in rehearsal and performance. Not only does Shaw often insert substantial bodies of philosophical content intra-textually; he actually never lets go of his function

as a director, staging his plays on paper by mapping out numerous techni-
cal considerations. One certainly feels that underneath Shaw's, as well as
Beckett's, oscillation between text and performance lies the desire to control
or even forestall potentially divergent readings of their texts; therefore, it
can be said that the function of stage directions is to some degree, a preemp-
tive one.

6. See Rebecca Prichard's *Yard Gal* (1998), Ch. 6.

7. Ridge Theatre is an experimental theatre company based in downtown
New York. Founded by director Bob McGrath and visual artist Laurie
Olinder, the Ridge has staged theatre, opera, and new music perfor-
mances at venues such as the American Repertory Theatre, Brooklyn
Academy of Music, Carnegie Hall, and Lincoln Centre. In the com-
pany's words, "Ridge productions are epic visual and aural works that
typically position performers within film and video projections, rede-
fining traditional theatrical boundaries." http://www.ridgetheater.org
/about.html.

4 AUTEUR ON THE ROAD

1. Quoted in "'Hamlet' as Autobiography." *New York Times*, July 2, 1995:
2:4. Shot by Marion Kessel, the film is available through the Caddell and
Conwell Foundation for the Arts in Houston.

2. John Rockwell's observation that Wilson's work is very much a "creation"
is quite appropriate: "for any Wilson production of a text by someone other
than himself is still a Wilson work." Self-collaboration is not limited to his
directing, designing the set, and lighting of his productions; Wilson "also
reshapes the original text into something that counts as both his and the
author's" (in "Robert Wilson Tackles the French Revolution." *New York
Times*, Nov. 3, 1992).

3. Witkiewicz's belief was that art exists only as "Pure Form," with no further
entertainment or instructional value.

4. Jung identifies the characteristic effect of the archetype: "It seizes hold of
the psyche with a kind of primeval force and compels it to transgress the
boundaries of humanity" (*Two Essays on Analytical Psychology* 1999, 70–1).
"And the irrational is likewise a psychological function—in a word, it is the
collective unconscious" (71).

5. Ex Machina was founded in 1993.

6. Most of Complicité's production information and program quotes are taken
from Complicité's Website: http://www.complicite.org/productions/detail
.html?id=13.

7. For more on directors' control of the performer's significatory presence,
see also Ch. 6. Also, Martin Puchner's work *Stage Fright: Modernism, Anti-
Theatricality, and Drama* (2002) traces this duality by describing how the-
atre, being a performing art like music and ballet, "depends on the artistry
of human performers on stage." Being, however, also a mimetic art like

painting and cinema, "it must utilize these human performers as signifying material in the service of a mimetic project":

> Once the nature of mimesis is subject to scrutiny and attacks, as it is in modernism, this double affiliation of the theatre becomes a problem, because, unlike painting or cinema, the theatre remains tied to human performers, no matter how estranged their acting might be. The theatre thus comes to be fundamentally at odds with a more widespread critique, or complication, of mimesis because this critique requires that the material used in the artwork be capable of abstraction and estrangement. Directors may try to estrange or depersonalize these performing humans... an actor's impersonation remains nonetheless fundamentally stuck in an unmediated type of mimesis that keeps the work of art from achieving complex internal structures, distanced reflectivity, and formal constructedness. (5)

8. See Appendix, section ii.

9. Instrumental to this tendency is Umberto Eco's seminal book *The Open Work* (1962). For Eco, an open work is a text that is not limited to a single reading or range of readings; it admits complexity, encouraging or requiring a multiplicity of readings, depending on what the reader brings to the text.

10. In contrast, less mainstream, yet authentic and inspirational groups, such as London-based Right Size, Improbable Theatre, Shunt, and Filter, have been known mostly for their collective work, the figure of the director discreetly blending into a shared creative process.

11. McBurney quoted in Heather Neill's "Simon McBurney, Magic Man" (2004).

12. Sharing LeCompte's "sacrilegious" tendencies vis-à-vis canonical texts, Eimuntas Nekrošius with his company Meno fortas (established in 1998) in Lithuania has been involved in highly imaginative renderings of the great classics, as his productions of *Hamlet* (1997), *Othello* (1999), *Macbeth* (1999), and *Faust* (1999)—among others—testify. Nekrošius' take on adaptation is that everything, "even Shakespeare," can be totally dismantled and reconstructed in order to shock and genuinely move an audience. His attitude toward the classics would certainly enrage fans of straightforward, word-for-word revivals, given that it is imbued with the understanding that there is nothing holy or sacred in the world; rather, the pursuit of "safety" in interpretation and in form ultimately kills all artistic creation.

13. Account of the performance in Lancaster's "Theatrical Deconstructionists."

14. However, Brook has been repeatedly blamed for his apolitical stance.

15. In conversation with the author. New York, May 18, 2007.

16. Gussow views recontextualisation as a cubist process in which we are invited to view events from different angles, in newly chosen environments, both "eye-impelling" and "mind-provoking." (In "Cranking up a powerful 'Hamletmachine.'" *New York Times*, May 25, 1986.)

17. David Williams. "Remembering the Others that are US: Transculturalism and myth in the theater of Peter Brook" (in Pavis 1996, 68).

18. Similarly, Rustom Bharucha argues that context "is not an issue for Brook. What matters is the 'flavor of India' that is suggested through the mise-en-scène" (1990, 70).

5 THE MEANS AS AN END

1. Not too rarely, the results are detrimental if the objects are conceived and implemented in a literal fashion.

2. The term *ready-made* or *found art*—more commonly encountered as *found object* (French: *objet trouvé*)—describes the kind of art that is created from the use of objects not normally qualifying as "art," often because they already have an everyday, utilitarian function. Ordinarily, a ready-made object is made into art once it is placed into an unusual context.

3. In Tadeusz Kantor's production of Stanislaw Ignacy Witkiewicz's *The Cuttlefish* (1956), the environment, objects, and actors were engaged in a complex process of producing diverse spatial formations, shocks, and tensions, in order to unblock the imagination and to crush the impregnable shell of the drama (Michael Kobialka in Mitter and Shevtsova 2005, 71).

4. Account of the performance in Natalie Bennett's "Theater Review: *The Andersen Project* by Robert Lepage's Ex Machina." Accessed on Jan. 30, 2006. http://blogcritics.org/culture/article/theater-review-the-andersen-project-by/.

5. Quoted in a production review by Mark Fisher (2007).

6. In fact, Stein's plays exploit the "non-signifying notion of art as endless... display that demonstrates an endless, de-sublimated spectacle cut of from all narrative ends" (Berry 2001, 144). For more on Stein's aesthetic, see Ch. 6.

7. Run by John Collins, the company has been famous for its deconstructive versions of great American classics, such as F. Scott Fitzgerald's *The Great Gatsby* (*Gatz* [2005]) and, in 2008, William Faulkner's *The Sound and the Fury* [*The Sound and the Fury (April Seventh, 1928)*]. In 2010, the company's version of Ernest Hemingway's novel *The Sun Also Rises,* entitled *The Select,* premiered at Edinburgh International Festival.

8. Born in 1951, Marthaler studied music in Zurich and later trained at the Jacques Lecoq Institute in Paris, developing his own kind of *music-theatre,* wherein characters of a (usually) forlorn, nondescript community unite in notably quiet choral singing as a way to purge their existential anxiety.

9. According to the production's program notes, in the colony of *Riesenbutzbach,* encompassed in the minimalist environment created by set designer Anna Viebrock, twelve artists, actors, and musicians bring us face-to-face with a nightmare life in which each place and each person is continually subject to a variety of controls. The play examines the impact of a culture of consumption upon Central Europeans, foregrounding their anxieties, which relate to the loss of privileges and material riches.

10. See *Krapp's Last Tape* (1958).

11. A strategy foreshadowed by Beckett.

12. Bauhaus painter and choreographer Oskar Schlemmer (1888–1943) was fascinated by geometric body positions in his involvement with dance. Characteristically, his performances "Dance in space" and "Figure in space with Plane Geometry and Spatial Delineations," expressed his deep-rooted conception of the body as a mechanized object placed into a space formally defined by geometric coordinates.

13. In "Choreographing History," Susan Leigh Foster confirms the inherent function of the body as text: "A body, whether sitting writing or standing thinking or walking talking or running screaming, is a bodily writing. Its habits and stances, gestures and demonstrations, every action of its various regions, areas, and parts—all these emerge out of cultural practices, verbal or not, that construct corporeal meaning." (In Carter 1998, 180)

 Although Leigh Foster's observations are derived from the field of dance, one can certainly draw parallels with the autonomous presence of the body in theatre practice.

14. John Kane, the actor playing Puck in Brook's production of *Midsummer Night's Dream*, interviewed in *The Sunday Times*, June 13, 1971.

15. Lehmann makes a case that representability paradoxically remains in line with the awareness that "human reality can only be dealt with under the premise that it remains unrepresentable" (2006, 173). In this, he echoes Artaud's acknowledgment of the "nonrepresentation" of the original representation (life), see Ch. 2.

16. Some of Wilson's most celebrated collaborations have been with Philip Glass, Lou Reed, and Tom Waits.

17. Undertaken together with Charles Marowitz in 1964 at Royal Shakespeare Company to research the potential of practical application of Artaud's radical theories through a theatre of ritual.

18. See also Haydn White's *Tropics of Discourse* (1978), where it is argued that the deep structures defining human consciousness have a certain stability that allows for the creation of sound representations of human perceptions of reality.

19. Christopher Innes in "Text/Pre-Text/Pretext: The Language of Avant-Garde Experiment" (in Harding 2000, 66). The physical language that Brook displayed in *Conference of the Birds* was also largely anthropomorphic.

20. Lehmann regrets the lack in some contemporary work of a sense of navigation through the dramatic principles of the story, which he feels could correspond to painterly perspective, in making "totality possible precisely because the position of the viewer, the point of view, is excluded from the visible world of the picture, so that the constitutive act of representation is missing in the represented" (2006, 79).

21. See also Brantley's 1999 critique on Wilson's *Death, Destruction and Detroit III*, which traces a similar problematic. Brantley celebrates Wilson's spectacular imagery as something that could render spectators practically speechless, in fact reducing them "to the state of a spaced-out, slack-jawed teen-ager" whose reactions to Wilson's performances might be very similar

to the "attitude of religious awe" he or she has when watching Disney's *Fantasia.*

22. Much of the work of the 1970s, as Michael Vanden Heuvel argues, had essentially no temporal or thematic relation to history: Producing indeterminate structures of play—rather than the logical or temporal frameworks of a stable narrative—allowed performers and directors to create an immanence of a continuous present, during which the urge to repress experience and sensory input into patterns of determinate, fixed and (therefore) illusory meaning could be deferred. Instead, unrestricted flows of libidinous energy or of sensory images were experienced firsthand, unmediated by a preconditioned schema of meaning. One result, however, was that the liberation from the rational, ordering principles of the mind was tantamount to an abrogation of memory and history (1994, 51).

23. Kate Bassett. "Peter Brook: Of Masters and Masterpieces." *The Independent on Sunday,* Mar. 18, 2007.

6 CONQUERING TEXTS

1. From the "Second Manifesto of Surrealism" (1929), which appeared in *La Révolution surréaliste,* edited by André Breton. (12 [Dec. 15, 1929]: 1)

2. Julia Kristeva similarly purports that the text "is a permutation of texts, an intertextuality" and that within one single text "several *enonces* from other texts cross and neutralize each other" (quoted in Elam 2002, 93). Therefore, an "ideal" spectator would be someone endowed with a "sufficiently detailed, and judiciously employed, textual background, to enable him to identify all relevant relations and use them as a grid for a correspondingly rich decodification" (93).

3. In literary theory: "the pre-critical mode."

4. In his introduction to *Hamletmachine and Other Texts for the Stage,* Heiner Müller's translator, Carl Weber, defines synthetic fragment as: "seemingly disparate scenes, or parts of scenes, are combined without any particular effort at a coherent, linear plot. The result is a kind of assemblage, much like a not yet fully structured work-in-progress":... Müller's fragments are painstakingly crafted texts, "synthesized" from often widely diverse constituents, as CUNDLING'S LIFE FREDERICK OF PRUSSIA LESSING'S SLEEP DREAM SCREAM, HAMLETMACHINE, THE TASK, and DESPOILED SHORE MEDEAMATERIAL LANDSCAPE WITH ARGONAUTS attest. This is a dramatic structure, or rather antistructure he has developed and refined to arrive at a dramaturgy which could be defined as "post-structuralist" or "deconstructionist." (1990, 17; emphasis original)

5. Müller quoted in Arthur Holmberg's "In Germany, a Warning from Heiner Müller." *New York Times,* July 8, 1990.

6. The transparency of Müller's texts encompasses post-apocalyptic settings as abstract as a "time-space" in the opening stage directions of *Quartet* (1981–1982), with the action starting in a parlour before the French

Revolution and ending in an underground shelter after an envisioned Third World War.

7. "A Discourse with Horst Laube about the Tediousness of Well-made Plays, and about a new Dramaturgy which deliberately challenges the Spectator" (Müller 1990, 160).

8. The writer, in the preface to his Webpage "about the (re)making project." http://www.charlesmee.org/html/trojan.html.

9. All information on Charles Mee is taken from the writer's Website: http://www.charlesmee.org/html/trojan.html.

10. For example, in *The Lesson*, words become weapons in the hands of the Professor, who actually kills each of his students in his ferocious verbal attacks.

11. Wilson's *Letter to Queen Victoria* (in Marranca 2005, 52).

12. In an interview with Noëlle Renaude entitled "L'écriture, le livre et la scène" ("Writing, the Book and the Stage") (1991, 13), Novarina insists that: "Les acteurs les plus extraordinaires ne jouent pas autre chose que la vraie musique du poète qu'ils font toujours entendre pour la première fois" ("The most extraordinary actors never play anything else, but the music of the poet, which they always make us hear for the first time"; my translation).

13. Jean-Pierre Ryngaert. "Speech in Tatters: The Interplay of Voices in Recent Dramatic Writing" (in Mounsef and Féral 2007, 19).

14. "Elements of Style" in *The America Play and Other Works* (1995, 11).

15. "After Stein: Traveling the American Theatrical 'Lang-scape'" (in Fuchs and Chaudhuri 2002, 148).

16. In principle, as Carlson notes, Stein's plays are involved with spatial configurations of language itself that, like landscapes, frame and freeze visual moments and alter perception.

17. Roman Jakobson defines the "words heap" as a "vocabulary without syntax, which occurs with the suppression of the linguistic operation of combination" (in Stewart 1967, 56).

18. In "An Imagination That Pulls Everyone Else Along." *New York Times*, Nov. 10, 2002.

19. In the first part, fourteen different people, including tourists, businessmen, and couples spend a night in the hotel, while in the second part, which is a dance piece, two nights happen at the same time.

20. Churchill collaborated with Stafford-Clark's no-longer-operational Joint Stock Company (currently known as Out of Joint) on *Cloud Nine*, *Top Girls*, *Fen*, *Serious Money*, *A Mouthful of Birds*, and *Blue Heart*, among other productions. She also work-shopped plays such as *Vinegar Tom* (1978) with feminist theatre group Monstrous Regiment.

21. All information on Mac Wellman's texts taken from the author's Website: http://www.macwellman.com/plays.html.

22. In "Which Theories for Which Mise-en-scène?" Pavis contests the notion of directorial impartiality vis-à-vis the text, arguing that "even if the

mise-en-scène attempts to contrive a space of neutrality between the dramatic text and the scenic configuration, the practice of the mise-en-scène soon fills this space in an 'author-itarian' way." Assuming that the director wishes to remain relatively noncommittal toward the text, "the mise-en-scène will suggest a connection between text and scenic configuration." In this respect, the text will always and inevitably be deconstructed by the stage (in Harding 2000, 101).

APPENDIX: SIX CASE STUDIES

1. McBurney quoted in Complicité's Website. http://www.complicite.org/productions/review.html?id=6.
2. Quoted by Alexey Bartoshevich in Russian actress Alla Demidova's Website, http://www.demidova.ru/english/article02.php.
3. Terzopoulos first met Heiner Müller during the time he was a student at the Berliner Ensemble.

BIBLIOGRAPHY

PRIMARY SOURCES

BOOKS AND JOURNALS

Artaud, Antonin. *Oeuvres Complètes*. Tomes I à XXVI. Paris: Gallimard, 1956–94.

Artaud, Antonin. *The Theatre and its Double*. 1936. New York: Grove Press, 1958.

Artaud, Antonin. *Selected Writings*. Edited and with an introduction by Susan Sontag. Translated by Helen Weaver. New York: Farrar, Strauss and Giroux, 1976.

Auster, Paul, ed. *The Random House Book of 20th Century French Poetry*. 1982. London and New York: Vintage Books, 1984.

Barker, Howard. *Plays Four*. London: Oberon, 2008.

Beckett, Samuel. *Collected Shorter Plays of Samuel Beckett*. London and Boston: Faber and Faber, 1984.

———. *Happy Days*. New York: Grove Press, 1961.

Bonney, Jo, ed. *Extreme Exposure. An Anthology of Solo Performance Texts*. New York: Theatre Communications Group, 2000.

Breton, André, ed. *La Révolution surréaliste* 12 (Dec. 15, 1929).

Churchill, Caryl, and David Lan. *A Mouthful of Birds*. London: Methuen New Theatrescript, 1987.

Churchill, Caryl. *Blue Heart*. New York: Theatre Communications Group, 1998.

———. *Cloud Nine*. New York: Theatre Communications Group, 1995.

———. *Far Away*. New York: Theatre Communications Group, 2001.

———. *Hotel*. London: Nick Hern Books, 1997.

———. *Lives of the Great Poisoners*. London: Methuen Modern Plays, 1993.

———. *The Skriker*. New York: Theatre Communications Group, 1994.

Crimp, Martin. *Attempts on her Life*. London: Faber and Faber, 1997.

Handke, Peter. *Handke Plays: 1*. London: A&C Black, 2003.

Kennedy, Adrienne. *Funnyhouse of a Negro*. New York: Samuel French, 1990.

———. *In One Act*. Minneapolis: University of Minnesota Press, 1988.

Mee, Charles. *History Plays*. New York and Baltimore: Johns Hopkins University Press, 1998.

Müller, Heiner. *The Battle: Plays, Prose, Poems*. Translated by Carl Weber. New York: PAJ Publications, 1990.

Nietzsche, Friedrich. *The Birth of Tragedy and Other Writings*. Edited by Raymond Geuss. Translated by Ronald Speirs. Cambridge: Cambridge University Press, 1990.

Novarina, Valère. *Le théâtre des paroles*. Paris: P.O.L., 1989.

Parks, Suzan-Lori. *The America Play and Other Works*. New York: Theater Communications Group, 1995.

Prichard, Rebecca. *Yard Gal*. London: Faber and Faber, 1998.

Ravenhill, Mark. *Pool (no water) & Citizenship*. London: Methuen Modern Plays, 2007.

Stein, Gertrude. *Lectures in America*. Boston: Beacon Pr, 1985.

Theatre de Complicité. *Mnemonic*. London: Methuen, 1999.

———. *The Three Lives of Lucie Cabrol*. London: Methuen, 1995.

SECONDARY SOURCES

BOOKS

Appia, Adolphe. *Texts on Theatre*. Edited by R. C. Beacham. London: Routledge, 1993.

———. *Die Musik und die Inscenierung*. München: Bruckmann, 1899.

Aronson, Arnold. *American Avant-Garde Theatre*. London and New York: Routledge, 2000.

Astruc, Alexandre. *Film and Literature: An Introduction and Reader*. Edited by Timothy Corrigan. Saddle River, NJ: Prentice Hall, 1999.

Auslander, Philip. *From Acting to Performance. Essays in Modernism and Postmodernism*. London and New York: Routledge, 1997.

Baeten, Elizabeth M. *The Magic Mirror: Myth's Abiding Power*. Suny Series in the Philosophy of the Social Sciences. Albany: State University of New York Press, 1996.

Barker, Howard. *Arguments for a Theatre*. Manchester: Manchester University Press, 1997.

Barthes, Roland. *Barthes' Critical Essays*. Translated by Richard Howard. Evanston, IL: Northwestern UP, 1972.

Bazin, André. *What is Cinema?* Edited by Hugh Grey. Berkeley: University of California Press, 1968.

Beckerman, Bernard. *Theatrical Presentation*. London and New York: Routledge, 1990.

Bennett, Susan. *Theatre Audiences. A Theory of Production and Reception*. London: Routledge, 1990.

Bentley, Eric. *The Theory of the Modern Stage: An Introduction to Modern Theatre and Drama*. New York: Applause, 1997.

Berry, Cicely. *Text in Action*. New York: Virgin Publishing, 2001.

Berry, Ellen E. *Curved Thought and Textual Wandering. Gertrude Stein's Postmodernism*. Ann Arbor: University of Michigan Press, 1992.

Bharucha, Rustom. *Theatre and the World. Performance and the Politics of Culture*. London and New York: Routledge, 1990.

Birringer, J. H. *Performance on the Edge: Transformations of Culture*. New Brunswick: Athlone Press, 2000.

Blau, Herbert. *Sails of the Herring Fleet. Essays on Beckett*. Ann Arbor: University of Michigan Press, 2000.

———. *The Dubious Spectacle. Extremities of Theatre, 1976–2000*. Minneapolis: University of Minnesota Press, 2002.

Bloom, Michael. *Thinking Like a Director: A Practical Handbook*. New York: Faber and Faber, 2001.

Bogart, Anne. *A Director Prepares. Seven Essays on Art in Theatre*. London and New York: Routledge, 2001.

Bradby, David, and David Williams, eds. *Directors' Theatre*. London: Macmillan, 1988.

Bradby, David. *Le Théâtre en France de 1968 à 2000*. Paris: Editions Honoré Champion, 2007.

Brater, Enoch. *Beyond Minimalism. Beckett's Late Style in the Theatre*. New York and Oxford: Oxford University Press, 1990.

Braun, Edward. *The Director and the Stage: From Naturalism to Grotowski*. New York: Holmes and Meir, 1982.

———, ed. and trans. *Meyerhold on Theatre*. New York: Hill and Wang, 1969.

Braun, Kazimierz. *Theatre Directing. Art, Ethics, Creativity*. Lewiston, NY: Edwin Mellen Press, 2000.

Brecht, Bertolt. *Brecht on Art and Politics*. Edited by Tom Kuhn and Steve Giles. London: Methuen, 2003.

———. *Brecht on Theatre: The Development of an Aesthetic*. Edited and translated by John Willett. New York: Hill and Wang, 1964.

Brecht, Stefan. *The Theatre of Visions. Robert Wilson*. Frankfurt: Suhrkamp, 1978.

Breton, André, and Paul Eluard. *Dictionnaire abrégé du surréalisme*. Paris: Galerie des Beaux Arts, 1938.

Brook, Peter. *The Empty Space*. 1968. Harmondsworth: Penguin, 1990.

———. *The Open Door*. New York: Pantheon Books, 1995.

Carlson, Marvin. *Analyzing Performance: A Critical Reader*. Manchester: Manchester University Press, 1996.

———. *Haunted Stage: The Theatre as Memory Machine*. 2001. Ann Arbor: University of Michigan Press, 2003.

———. *Performance. A Critical Introduction*. 1996. London and New York: Routledge, 2003.

———. *Places of Performance*. Ithaca: Cornell University Press, 1989.

———. *The Semiotics of Theatre Architecture*. Ithaca: Cornell University Press, 1993.

———. *The Theories of the Theatre*. Ithaca: Cornell University Press, 1984.

———. *Theatre Semiotics, Signs of Life*. Bloomington and Indianapolis: Indiana University Press, 1990.

Carter, Alexandra, ed. *The Routledge Dance Studies Reader*. London and New York: Routledge, 1998.

Clurman, Harold. *On Directing*. New York: Macmillan, 1972.

Cole, Toby, and Helen K. Chinoy. *Actors on Acting*. New York: Crown Publishers, 1970.

Craig, Edward Gordon. *On The Art of the Theatre.* 1911. Edited by Franc Champerlain. London and New York: Routledge, 2009.

Delgado, Maria M., and Caridad Svich, eds. *Theatre in Crisis: Performance Manifestos for a New Century.* Manchester and New York: Manchester University Press, 2002.

Delgado, Maria M., and Paul Heritage, eds. *In Contact with the Gods? Directors Talk Theatre.* 1996. Manchester and New York: Manchester University Press, 1997.

Derrida, Jacques, and Paule Thévenin. *The Secret Art of Antonin Artaud.* 1986. Translated by Mary Ann Caws. Cambridge: The MIT Press, 1998.

Derrida, Jacques. *Writing and Difference.* Translated by Alan Bass. Chicago: University of Chicago Press, 1978.

Elam, Keir. *Semiotics of Theatre and Drama.* 1980. New York and London: Routledge, 2002.

Fischer-Lichte, Erika, et al., eds. *The Dramatic Touch of Difference: Theatre Own and Foreign.* Tübingen, DE: Narr, 1990.

Foreman, Richard. *Unbalancing Acts: Foundations for a Theatre.* New York: Pantheon Books, 1992.

Foucault, Michel. *Archaeology of Knowledge.* 1969. London: Routledge, 1997.

Fuchs, Elinor, and Una Chaudhuri, eds. *Land/Scape/Theatre.* Ann Arbor: University of Michigan Press, 2002.

Garner, Stanton B. Jr., *Bodied Spaces—Phenomenology and Performance in Contemporary Drama.* Ithaca and London: Cornell University Press, 1994.

Giannachi, Gabriella, and Luckhurst, Mary, eds. *On Directing: Interviews with Directors.* London: Faber and Faber, 1999.

Giannachi, Gabriella. *Virtual Theatres. An Introduction.* 2004. London and New York: Routledge, 2005.

Goldberg, Rosalee. *Performance Art: From Futurism to the Present.* London: Thames and Hudson, 2001.

———. *Performance: Live Art, 1909 to the Present.* London: Thames and Hudson, 1979.

Greene, Naomi. *Antonin Artaud: Poet Without Words.* New York: Simon and Schuster, 1970.

Gussow, Mel. *Conversations with (And About) Beckett.* London: Nick Hern Books, 1996.

Harding, James M., ed. *Contours of the Theatrical Avant-Garde. Performance and Textuality.* Ann Arbor: University of Michigan Press, 2000.

Heddon, Deirdre, and Jane Milling. *Devising Performance. A Critical History.* New York: Palgrave, (2005).

Hilton, Julian. *New Directions in Theatre.* London: Macmillan, 1993.

Holmberg, Arthur. *The Theatre of Robert Wilson.* Cambridge: Cambridge University Press, 1996.

Huxley, Michael, and Noel Witts, eds. *The Twentieth Century Performance Reader.* 1996. London and New York: Routledge, 2002.

Innes, Christopher. *A Sourcebook on Naturalist Theatre.* London and New York: Routledge, 2000.

————. *Avant-Garde Theatre 1892–1992*. London and New York: Routledge, 1993.

————. *Edward Gordon Craig*. London and New York: Cambridge University Press, 1983.

Iser, Wolfgang. *The Implied Reader*. Baltimore and London: Johns Hopkins University Press, 1974.

Jones, Amelia, and Andrew Stephenson, eds. *Performing the Body/ Performing the Text*. London; New York: Routledge, 1999.

Jung, Carl Gustav. *Two Essays on Analytical Psychology*. 1953. London: Routledge, 1999.

Kalb, Johathan. *Beckett in Performance*. New York: Cambridge University Press, 1989.

Kantor, Tadeusz. *A Journey Through Other Spaces: Essays and Manifestos: 1944–1990*. Edited and translated by Michal Kobialka. Berkeley: University of California Press, 1993.

Kaye, Nick. *Postmodernism and Performance*. London: Macmillan, 1994.

King, Bruce. *Contemporary American Theatre*. London: Macmillan, 1991.

Kirby, Michael. *A Formalist Theatre*. Philadelphia: University of Pennsylvania Press, 1987.

Kostelanetz, Richard: *On Innovative Performance (s): Three Decades of Recollections on Alternative Theatre*. Jefferson, NC: McFarland, 1994.

Lehmann, Hans-Thies. *Postdramatic Theatre*. 1999. Translated by Karen Jurs-Munby. London: Routledge, 2006.

Lepage, Robert. *Connecting Flights*. Translated by Wanda Romer Taylor. London: Methuen, 1995.

Lévi-Strauss, Claude. *The Structural Anthropology*. Translated by Claire Jacobson and Brooke Grundfest Schoepf. New York: Basic Books, 1963.

Luere, Jean, ed. *Playwright Versus Director. Authorial Intentions and Performance Interpretations*. Westport, CT: Greenwood Press, 1994.

Lyotard, Jean-François. *The Postmodern Explained*. Translated by Don Barry et al., Minneapolis: University of Minnesota Press, 1992.

Manfull, Helen, ed. *In Other Words: Women Directors Speak*. Lyme: A Smith and Kraus Book, 1997.

Marranca, Bonnie. *The Theatre of Images*. 1977. Baltimore: PAJ Publications, 2005.

McDonald, Marianne. *Ancient Sun, Modern Light: Greek Drama on the Modern Stage*. New York: Columbia University Press, 1992.

McMillan Dougald, and Martha Fehsenfeld. *Beckett in the Theatre. The Author as Practical Playwright and Director*. London: John Calder, 1988.

McMullan, Anna. *Theatre on Trial. Samuel Beckett's Later Drama*. New York and London: Routledge, 1993.

Merleau-Ponty, Maurice. *Phenomenology of Perception*. London: Routledge and Kegan Paul, 1976.

Mermikides, Alex, and Jackie Smarts, eds. *Devising in Process*. New York: Palgrave Macmillan, 2010.

Milling, Jane. *Modern Theories of Performance*. Basingstoke and New York: Palgrave, 2001.

Mitter, Shomit, and Maria Shevtsova, eds. *Fifty Key Theatre Directors*. London and New York: Routledge, 2005.

Mock, Roberta, ed. *Performing Processes*. Bristol and Portland: Intellect, 2000.

Mounsef, Donia, and Josette Féral, eds. *The Transparency of the Text: Contemporary Writing for the Stage*. Yale French Studies, Number 112. New Haven: Yale University, 2007.

Mudford, Peter. *Making Theatre. From Text to Performance*. London: The Athlone Press, 2000.

Nagler, A. M. *A Source Book in Theatrical History*. New York: Dover Publications, 1959.

Oppenheim, Lois, ed. *Directing Beckett*. Ann Arbor: University of Michigan Press, 1994.

Patsalidis, Savas. *Apo tin Anaparastasi stin Parastasi. (From Representation to Presentation)*. Athens: Ellinika Grammata, 2004.

Pavis, Patrice, ed. *The Intercultural Performance Reader*. London and New York: Routledge, 1996.

Pavis, Patrice. *Analyzing Performance. Theatre, Dance, and Film*. Translated by David Williams. Ann Arbor: University of Michigan Press, 2003.

———. *Dictionnaire du théâtre*. Paris: Dunod, 1996.

———. *La Mise-en-scène Contemporaine: Origines, tendances, perspectives*. Paris: Armand Colin, Coll. "U", 2007.

———. *Languages of the Stage*. New York: Performing Arts Journal Publications, 1993.

———. *Theatre at the Crossroads of Culture*. Translated by Loren Kruger. London and New York: Routledge, 1992.

Pefanis, Giorgos. *Skines tis Theorias [Scenes of Theory]*. Athens: Papazisis, 2007.

Phelan, Peggy, and Lane, Jill, eds. *The Ends of Performance*. New York: New York University Press, 1998.

Puchner, Martin. *Stage Fright: Modernism, Anti-Theatricality, and Drama*. Baltimore and London: John Hopkins University Press, 2002.

Rice, Philip, and Patricia Waugh, eds. *Modern Literary Theory*. New York: Arnold, 1996.

Ricks, Christopher. *Beckett's Dying Words. The Clarendon Lectures*, 1990. Oxford and New York: Oxford University Press, 1995.

Robinson, Marc. *The Other American Drama*. Baltimore: Johns Hopkins University Press, 1997.

Rogoff, Gordon. *Vanishing Acts. Theatre since the Sixties*. New Haven: Yale University Press, 2000.

Roose-Evans, James. *Experimental Theatre from Stanislavski to Peter Brook*. London: Routledge, 1991.

Savran, David. *The Wooster Group, 1975-1985*. Ann Arbor: UMI Research Press, 1986.

Sayre, H. M. *The Object of Performance: The American Avant-Garde since 1970*. Chicago: University of Chicago Press, 1989.

Schneider, Rebecca and Gabrielle Cody, eds. *Re: Direction: A Theoretical and Practical Guide*. London and New York: Routledge, 2002.

Schumacher, Claude. *Artaud on Theatre*. London: Methuen , 2001.

Shyer, Laurence. *Robert Wilson and his Collaborators*. New York: Theatre Communications Group, 1990.

States, Bert O. *Great Reckonings in Little Rooms. On the Phenomenology of Theatre*. Berkeley: University of California Press, 1985.

Stewart, Allegra. *Gertrude Stein and the Present*. Cambridge: Harvard University Press, 1967.

Tairov, Alexander. *Notes of a Director*. Translated by William Kuhlke. Coral Gables, FL: University of Miami Press, 1969.

Terzopoulos, Theodoros. *Theodoros Terzopoulos kai Theatro Attis (Theodoros Terzopoulos and Attis Theatre)*. Athens: Agra, 2000.

Tharu, Suzie J. *The Sense of Performance. Post Artaud Theatre*. New Delhi: Arnold-Heineman, 1984.

Thévenin, Paule, and Jacques Derrida. *Artaud, Dessins et Portraits*. Paris: Gallimard, 1986.

Tushingham, David. *Live 1: Food for the Soul. A New Generation of British Theatre Makers*. London: Methuen, 1994.

Ubersfeld, Anne. *Reading Theatre*. 1977. Translated by Frank Collins. Edited by Paul Perron and Patrick Debbeche. Toronto: University of Toronto Press, 1999.

Vanden Heuvel, Michael. *Performing Drama/ Dramatising Performance. Alternative Theatre and the Dramatic Text*. Ann Arbor: University of Michigan Press, 1994.

Walton, Michael J, ed. *Craig on Theatre*. London: Methuen, 1991.

Wellwarth, George E. *The Theatre of Protest and Paradox*. New York: New York University Press, 1964.

Williams, David, ed. *Collaborative Theatre: The Theatre du Soleil Sourcebook*. London: Routledge, 1999.

Wright, Elizabeth. *Postmodern Brecht. A Representation*. London and New York: Routledge, 1988.

Zarrilli, Phillip. *Acting (Re)Considered*. London and New York: Routledge, 2002.

JOURNALS, PERIODICALS, WEBSITES AND ELECTRONIC ARTICLES

Abbe, Jessica. "Anne Bogart's Journeys." *TDR* 24.2 (1980): 85–100.

Andrews, Benedict. "Christoph Marthaler: In the Meantime." *Realtime* 76 (2006): 8. Accessed on June 10, 2009. http://www.realtimearts.net/article?id=8246.

Arnold, Paul. "The Artaud Experiment." *Tulane Drama Review* 8.2 (1963): 15–29.

Aronson, Arnold. "Technology and Dramaturgical Development: Five Observations." *Theatre Research International* 24.2 (1999): 188–97.

Auslander, Philip. "Toward a Concept of the Political in Postmodern Theatre." *Theatre Journal* 39.1 (1987): 20–34.

Barthes, Roland. "Barthes on Theatre." Translated and with an introduction by Peter W. Mathers. *TQ* IX.331979): 25–30.

Ben-Zvi, Linda. "Beckett and Television: In a Different Context." *Modern Drama* 49.4 (Winter 2006): 469–90.

Birrell, Ross. "The Radical Negativity and Paradoxical Performativity of Postmodern Iconoclasm: Marcel Duchamp and Antonin Artaud." *Theatre Research International* 25.3 (2000): 276–83.

Bonnie Marranca. "The Forest as Archive: Wilson and Interculturalism." *Performing Arts Journal* 11.3 (1989): 36–44.

Bryant-Bertail, Sarah. "*The Trojan Women: a Love Story:* A Postmodern Semiotics of the Tragic." *Theatre Research International* 25.1 (2000): 40–52.

Carlson, Marvin. "Theatre and Performance at a Time of Shifting Disciplines." *Theatre Research International* 26.2 (2001): 137–44.

———. "Theatrical Performance: Illustration, Translation, Fulfilment, or Supplement?" *TJ* 37.1 (1985) : 5–11.

Chin, Daryl. "The Avant-Garde Industry." *Performing Arts Journal* 26/27.2/3 (1985): 59–75.

Corrigan, Robert. "The Search for New Endings: The Theatre in Search of a Fix, Part III." *Theatre Journal.* 36.2 (1984): 153–63.

Demidova, Alla. Accessed on Nov. 27, 2010. http://www.demidova.ru/english /article02.php.

Erickson, Jon. "The Ghost of the Literary in Recent Theories of Text and Performance." *Theatre Survey* 47.2 (2006): 245–52.

Fischer-Lichte, Erika. "Reversing the Hierarchy between text and performance." *European Review* 9.3 (2001): 277–91.

Foreman, Richard. "How I Write My (Self: Plays)." *Drama Review* XXI.4 (1977): 5–24.

Fuchs, Elinor. "Performance as Reading." *Performing Arts Journal* 23.2 (1984): 51–4.

———. "Presence and the Revenge of Writing. Rethinking Theatre After Derrida." *Performing Arts Journal* 26/27.2/3 (1985): 163–73.

Gardner, Donald. "The Reinvention of the Human Face." Accessed on May 20, 2009. http://www.antoninartaud.org/reinvention.html.

Gontarski, S. E. "Reinventing Beckett." *Modern Drama* 49.4 (2006): 428–51.

———. "Revising Himself: Performance as Text in Samuel Beckett's Theatre". *Journal of Modern Literature* 22.1 (1998): 131–55. Accessed on December 7, 2007. http://www.iupjournals.org/jml/mod22-1.html.

Hunka, George. "Ghosts in the Text: Thirty Years and More of The Wooster Group." *Superfluities Redux. On Culture and Theatre* (October 2007). Accessed on May 15, 2009. http://www. georgehunka.com/blog/wooster_group.html.

Ionesco, Eugene. "The Avant-Garde Theatre." *The Tulane Drama Review* 5.2 (1960): 44–53.

Kramer, Jane. "Experimental Journey." *The New Yorker* (October 8, 2007): 48–57.

Lallias, Jean-Claude, ed. *Théâtre Aujourd'hui No 10. L'Ère de la mise en scène.* Ministère de la Culture et de la Communication. Paris: Éditions SCÉREN-CNDP, 2005.

Lancaster, Kurt. "Theatrical Deconstructionists. The Social 'Gests' of Peter Sellars' *Ajax* and Robert Wilson's *Einstein on the Beach*." *Modern Drama* 43.3 (2000): 461–68.

Lyons, Charles R. "Perceiving Rockaby- As a Text, as a Text by Samuel Beckett, As a Text for Performance." *Comparative Drama* 16.4 (1982–3): 297–311.

Marranca, Bonnie. "The Forest as Archive: Wilson and Interculturalism." *Performing Arts Journal* 11.3 (1989): 36–44.

Mehta, Xerxes. "Notes from the Avant-Garde." *TJ* 31.1 (1979): 6–24.

Mnouchkine, Ariane. "'L'Age d'Or'. The Long Journey from 1793 to 1975." *Theatre Quarterly* V.18 (1975): 4–13.

Pavis, Patrice. "The Interplay between Avant-Garde Theatre and Semiology." Translated by Jill Daugherty. *Performing Arts Journal* 5.3 (1981): 75–86.

Poulet, Elisabeth. "Artaud et les avant-gardes theatrales." *Acta Fabula* 6.3 (2005). Accessed on October 11, 2007. http://www.fabula.org/revue/document995.php.

Rabkin, Gerald. "Is there a Text on this Stage? Theatre/ Authorship/ Interpretation." *Performing Arts Journal* 26/27.2/3 (1985): 142–59.

Rosik, Eli. "The Corporeality of the Actor's Body: The Boundaries of Theatre and the Limitations of Semiotic Methodology." *Theatre Research International* 24.2 (1999): 198–211.

Russell, Colin. *A New Scène Seen Anew: Representation and Cruelty in Derrida's Artaud.* Accessed on December 20, 2007. http://www.drama21c.net/class /artaud/derrida_artaud.htm.

Sarris, Andrew. "Notes on the Auteur Theory in 1962." *Film Culture* (1962/3): 561–4.

Schechner, Richard. "The Decline and Fall of the (American) Avant-Garde: Why It Happened and What We Can Do about It." *Performing Arts Journal* 5.2 (1981a): 48–63.

———. "The Decline and Fall of the (American) Avant-Garde: Why It Happened and What We Can Do about It. Part 2." *Performing Arts Journal* 5.3 (1981b): 9–19.

Shevtsova, Maria. "Interculturalism, Aestheticism, Orientalism: Starting from Peter Brook's *Mahabharata*." *Theatre Research International* 22.2 (1997): 98–104.

Shewey, Don. "Not Either/ Or But and: Fragmentation and Consolidation in the Postmodern Theatre of Peter Sellars." Accessed on March 10, 2008. http://www .donshewey.com/theater_articles/peter_sellars.htm.

Solomon, Alisa. "Irony and Deeper Significance. Where Are the Plays?" *Theatre* 31.3 (2001): 2–11.

Theatre Record III–XXVII (1983–2008). Accessed on July 7, 2007. http://www. theatrerecord.com.

Truffaut, Francois. "Une certaine tendance du cinéma français." *Cahiers du Cinéma* 31 (1954).

Vanden Heuvel, Michael. "Complementary Spaces: Realism, Performance and a New Dialogics of Theatre." *Theatre Journal* 44.1 (1992): 47–58.

Wetzeston, Ross. "The Theater's New Stars: The Directors." *New York Magazine* (February 23, 1981): 24–30.

Wilcox, Dean. "Defamiliarisation of a Significant Phenomenon." *Theatre Research International* 25.1 (2000): 74–85.

———. "Ambient Space in Twentieth century Theatre: The Space of Silence." *Modern Drama* 46.4 (2003): 542–57.

Wilson, Robert and Umberto Eco. "A Conversation." *Performing Arts Journal*, 15.1 (January 1993): 87–96.

REVIEWS AND INTERVIEWS, LECTURES AND SEMINARS

Bassett, Kate. "Anny, are you okay? Attempts On Her Life." *Independent on Sunday*. March 18, 2007.

———. "Peter Brook: Of Masters and Masterpieces." *Independent on Sunday*. March 18, 2007.

Bel, Andréine and Bernard Bel. "Artaud and the 'deconstruction' of contemporary theatre-dance." Seminar: In Homage to Antonin Artaud. Delhi University & National School of Drama. New Delhi, January 1997.

Bennett, Natalie. "Theatre Review: *The Andersen Project* by Robert Lepage's Ex Machina." Accessed on January 30, 2006. http://blogcritics.org/culture /article/theatre-review-the-andersen-project-by/.

Billington, Michael. "The Andersen Project." *Guardian*, January 30, 2006.

Brantley, Ben. "Journey in a Labyrinth of Dreams." *New York Times*, July 9, 1999: E1.

Brustein, Robert. "I Can't Go On, Alan. I'll Go On." *New York Times*, January 31, 1999: 7:13.

Clapp, Susannah. "A great one-hander. 'The Andersen Project.'" *Observer*, February 5, 2006: Features 20.

Field, Andy. "'Site-specific theater'? Please be more specific." Theater Blog. Accessed on February 6, 2008. http://www.guardian.co.uk/stage/theatreblog/2008/feb/06 /sitespecifictheatrepleasebe.

Fisher, Mark. "An extraordinary piece of theatre in anybody's language." *Scotsman*, February 18, 2007.

Gardner, Lyn. "Mnemonic." *Guardian*, January 8, 2003.

Grammeli, Aphroditi. "Exi Prosopa Anazitoun ton Kafka" ("Six Characters are Looking for Kafka"). *To Vima*, October 21, 2007.

Gussow, Mel. "Cranking up a powerful 'Hamletmachine.'" *New York Times*, May 25, 1986.

———. "Martha Clarke speaks the language of Illusion." *New York Times*, June 22, 1986.

Hadjiandoniou, Natalie. "Me Symmetoho to Theati" ("The Spectator as Participant"). *Eleftherotypia*, November 26, 2001.

Holden, Stephen. "Tortured Repression in Wonderland." *New York Times*, October 9, 1995: C11.

Holmberg, Arthur. "In Germany, a Warning From Heiner Müller." *New York Times*, July 8, 1990: 2:5.

Kane, John. "Interview with John Kane." *Sunday Times*, June 13, 1971.

Karali, Antigone. "Thelei Parastima I Tragodia" ("Tragedy Needs Stature"). *Ethnos*, June 29, 2008.

Keza, Lori. "Michail Marmarinos. I Skinothesia os Dramatourgia" ("Directing as Dramaturgy"). *To Vima*, March 3, 2003.

Logan, Brian. "Is 'devised' theatre always a case of too many cooks?" *Guardian Unlimited: Arts blog-theatre*, March 12, 2007.

Millar, Gordon. "MNEMONIC. Theatre de Complicité at Oxford." Accessed October 7, 2008. http://www.dailyinfo.co.uk/reviews/theatre/mnemonic.html.

Neill, Heather. "Simon McBurney, Magic Man." *Independent*, May 23, 2004.

Nightingale, Benedict. "An Imagination That Pulls Everyone Else Along." *New York Times*, November 10, 2002: 2: 7.

Novarina, Valère. "L'écriture, le livre et la scène" (entretien avec Noëlle Renaude) in *Théâtre Public*, nos. 101–2, September –December 1991: 9–17.

Raymond, Gerard. "Touched by an Angel." An Interview with Deborah Warner. *TheaterMania*, July 8, 2003.

Rich, Frank. "From Brook, 'The Mahabharata.'" *New York Times*, October 19, 1987: C15.

———. "Stage: Robert Wilson's 'Deafman.'" *New York Times*, July 20, 1987: C16.

———. "Auteur Directors Bring New Life to Theatre." *New York Times*, November 24, 1985.

Richards, David. "Sellars's *Merchant of Venice Beach.*" *New York Times*, October 18, 1994: C15.

Rockwell, John. "If Length were all, or, why a 10 1/3 Hour play?" *New York Times*, June 5, 1986.

———. "Robert Wilson Tackles the French Revolution." *New York Times*, November 3, 1992: C13.

———. "Critic's Notebook; Ritual and Faith in Epic Theater of Two Visionaries." *New York Times*, July 20, 2005.

Sellar, Tom. "The Dark Secrets of the Belgian Avant-Garde." *Village Voice*, September 11, 2007.

Soloski, Alexis. "French Tickler: Ivo van Hove's *Misanthrope* really cuts the mustard." *Village Voice*, September 25, 2007.

Spencer, Charles. "Unforgettable exploration of the mysteries of memory." *The Telegraph*, January 8, 2003.

Van Hove, Ivo. "The Dark Secrets of the Belgian Avant-Garde or, How Director Ivo van Hove Rehearses Molière's *The Misanthrope.*" Interviewed by Tom Sellar. *Village Voice*, September 11, 2007.

Wilson, Robert. "'Hamlet' as Autobiography, Spoken in Reflective Voice." *New York Times*, July 2, 1995: 2:4.

INDEX

adaptation, 29, 77, 80, 81, 91, 93, 94–9,
 102, 111, 119, 124, 147, 148, 154,
 167, 169–70, 173–4, 176–7, 186
 recontextualization, 95, 98–9, 167,
 169–70, 186
 compare with historical reconstruction
Afshar, Bamdad, 177
Akalaitis, JoAnne (formerly of Mabu
 Mines), 58, 85
 Endgame (Beckett), production of,
 58, 59
Albee, Edward, 154, 155–6
alienation
 effect and techniques, 13, 25, 88, 96,
 147, 166
 see also Brecht, Bertolt
alternative space, 180
American Cinema, 2
American Repertory Theatre (A.R.T.),
 58, 181, 185
Andersen, Hans Christian, 108
 "The Dryad," 108
 "The Shadow," 108
Anderson, Laurie, 116–17
 Songs and Stories from Moby Dick,
 production of, 117
 United States, production of, 117
Andrews, Raymond, 83
Andreyev, Leonid: *Life of Man, The*, 15
Antoine, André (Théâtre Libre), 15, 17, 20
 "fourth wall," notion of, 14–15
Apollinaire, Guillaume, 181
Appia, Adolphe, 16, 17, 18–19, 37, 108
 Die Musik und die Inscenierung
 (*Music and Stage Setting*), 17

archetypes, 3, 37, 82, 131, 170, 171
 see also Jung, Carl
Aristotle (*The Poetics*), 66, 144
 rhythm, 125
 spectacle, rejection of, 18, 41
 teleology, 3, 25, 39, 53, 136, 138, 150
Artaud, Antonin, 4–5, 9, 13–14, 16,
 19, 22, 23, 29, 31, 32, 33–50, 73,
 75, 81, 85, 87, 90, 100, 102, 107,
 115, 121–6, 131, 142, 148, 151,
 171, 180, 181–4, 188
 Cenci, The, production of, 182
 Le Jet de Sang (*Spurt of Blood*),
 production of, 182, 184
 "Manifesto for a Theatre that Failed," 35
 Theatre and its Double, The, 32, 34,
 48; *see also individual references*
 Ventre Brûlé, ou la mère folle (*Burnt
 Belly*), production of, 182
Asian theatre forms, 44, 48, 81, 101,
 117, 178
Astruc, Alexandre: "Naissance d'une
 nouvelle avant-garde: la camera-
 stylo" ("Birth of a new Avant-
 Garde: the camera-pen"), 1
Auslander, Philip, 5, 6, 118
Auteurism, 1–2, 78, 82, 84, 95, 126,
 136, 154, 155
 auteur directors, *see under individual
 directors; see also* "director author;"
 director-*creator*; "scenic writer"
 authorship, 2, 9, 10, 54–9, 78, 91,
 98, 135–6, 140, 148
 ethics of, 6, 135, 154, 156;
 see also interpretation

Auteurism—*Continued*
 film auteur theory, 1–2; "politique
 des auteurs" (policy of auteurs), 2
 key elements of, 3–4
 scholarship on, 5–6, 179
avant-garde dramaturgy, 51
Avignon Festival, 114

Baeten, Elizabeth M.: *Magic Mirror:
 Myth's Abiding Power, The*, 100
Bakhtin, Mikhail: "novelization,"
 notion of, 152
Balinese theatre, *see under* Artaud,
 Antonin
Barba, Eugenio (Odin Teatret), 5, 14,
 24, 36, 50, 182
 Ego Faust, production of, 182
 see also interculturalism
Barker, Howard (*Wrestling School, The*),
 76, 143
 Dying of Today, The, 152–3
Barthes, Roland
 "death of the author," 5, 91, 118
 Literature and Signification, 139
 Mythologies, 101
 on the density of [theatre] signs, 141
Baudrillard, Jean: "recycling," notion
 of, 79, 80
 see also collage; *pastiche*
Bauhaus, 188
Bazin, André: *What is Cinema?*, 1, 194
Beck, Julian (Living Theatre), 27, 31, 50
Beckett, Samuel, 9, 23, 31, 39, 42, 44,
 51–73, 76, 84, 107, 108, 118, 120,
 124, 145, 149, 156, 184
 Act Without Words I, 68, 71
 Beckett Estate, 57, 184
 Breath, 52–3
 ... but the clouds, 61
 Cascando, 70
 Catastrophe, 57, 65
 Come and Go, 59, 65, 69
 Endgame, 55, 58, 59
 Film, 69
 Footfalls, 62, 66, 67, 70–1

 Ghost Trio, 61
 Happy Days, 51, 60, 64
 Krapp's Last Tape, 71, 72, 187
 Nacht und Träume, 53, 61
 Not I, 51, 57, 59, 60, 63, 65, 68,
 69–70, 72
 Ohio Impromptu, 68, 72
 Piece of Monologue, A, 65, 68, 70, 72
 Play, 56, 61, 62, 63, 66, 70
 plays for the stage, 52; mimes; 52;
 radio plays, 52, 61; for television,
 52, 61
 Quad, 61, 63–4, 65, 68
 Rockaby, 59, 61, 64–5, 67, 69, 71, 72
 That Time, 63, 72
 Waiting for Godot, 55
Belasco, David, 15
Bennett, Susan, 6
Ben-Zvi, Linda, 72–3
Berliner Ensemble, 26, 27, 191
Bharucha, Rustom, 187
Billington, Michael, 93, 109
Bishop, Tom: "Whatever Happened to
 the Avant-Garde?," 7
black minstrelsy, 81, 117
 see also cross-racial casting
Blau, Herbert, 60
Boal, Augusto: *Theatre of the Oppressed,
 The*, 27
 spectactor, notion of, 27
 see also Forum Theatre
body in performance, 21, 23, 34,
 38, 45–6, 47–8, 62, 67, 72, 85,
 117–18, 120–4, 131, 138, 144,
 148, 155, 169, 171–2, 183, 188
 auto-deixis, 122
 corporeality, 121
 embodied-ness, 67
 see also Craig; Edward: "The Actor
 and the Über-marionette"
Bogart, Anne (SITI Company), 26, 27,
 80, 95, 99, 121, 128
 American Silents, production of, 80
 Bob, production of, 80
 Culture of Desire, production of, 80

Gertrude and Alice: A Likeness to Loving, production of, 80
Hotel Cassiopeia, production of, 181
Lilith, production of, 80
Room, production of, 80
Seven Deadly Sins, production of, 80
War of the Worlds, production of, 80
Brantley, Ben, 109, 188
Brater, Enoch, 66–7
Brecht, Bertolt, 3, 15, 24–5, 26, 27, 116
 Alienation effect (Verfremdung) and distancing, 13, 25, 76, 80, 88, 89, 96, 116, 129, 147, 166, 175; *contrast with* emotional involvement and empathy
 Baal, 25
 epic theatre, 24; *see also* Piscator, Erwin
 Jungle of the Cities, 25
 Kopien, theory of, 147
 and postmodernism, 15, 181
 Threepenny Opera, The, 110
Breton, André: "Second Manifesto of Surrealism," 189
 automatic writing, 136
Brook, Peter (Thιβtre des Bouffes du Nord), 5, 19, 85, 100, 102–5, 122–3, 125–6, 130, 131, 141, 186, 187
 Conference of the Birds, production of, 188
 Empty Space, The, 18, 24, 28
 Hamlet (Shakespeare) production of, 88, 130
 Ik, production of, 36
 Mahabharata, The (Carrière), production of, 36, 102–5
 Midsummer Night's Dream, A (Shakespeare), production of, 96, 122–3, 125
 Open Door, The, 103
 Orghast, production of, 36, 125–6
 Theatre of Cruelty Workshop, 49, 125, 184
 see also interculturalism; theatre: "holy"

Brooklyn Academy of Music (B.A.M.), 104
Burton, Richard, 80, 119
Butler, Paul, 88

Cage, John, 138
Cahiers du cinema, 1
Carlson, Marvin, 6, 139, 150, 179, 190
Carrière, Jean-Claude: *Mahabharata, The*, 102, 103
 see also Brook, Peter
Carroll, Lewis: *Alice in Wonderland*, 110
Chaikin, Joseph (Open Theatre), 26, 31
chance, notion of, 27, 92, 124, 142
 see also "staged accidents"
characterization, reconsideration of, 22, 65–7, 69, 137–8, 144, 146, 150, 165, 176–7
Churchill, Caryl, 143, 190
 Blue Heart (Heart's Desire and *Blue Kettle)*, 151, 190
 Cloud Nine, 190
 Far Away, 151
 Fen, 190
 Hotel, 61, 151, 190
 Lives of the Great Poisoners, The, 151
 Mouthful of Birds, A, 151, 190
 Serious Money, 190
 Skriker, The, 151
 Top Girls, 190
Cixous, Hιlθne: *Terrible but Incomplete Story of Norodom Sihanouk, King of Cambodia, The*, 101
Clarke, Martha (formerly of Pilobolus Dance Theatre), 27, 111, 128
 Garden of Earthly Delights, The, production of, 111
 Vienna: Lusthaus, production of, 111
 see also Crowsnest
coauthorship of performance script, 92, 133, 135, 148, 166
Cob, John, 109
collage, 79, 80–1, 83, 124, 148, 162
Collins, John (Elevator Repair Service), 113, 187

Collins, John—*Continued*
 Gatz, production of, 187
 Select, The, production of, 187
 Sound and the Fury (April Seventh, 1928), The, production of, 187
Colonial Exhibition of Paris, 44
Comédie Française, 21
Complicité, *see under* McBurney, Simon
Copeau, Jacques (Théâtre du Vieux Colombier), 12, 21, 23–4, 26, 30, 181
Craig, Edward Gordon: *On the Art of the Theatre*, 3, 4, 11–12, 14, 15–17, 18, 20–1, 22, 37, 120, 121, 180
 "The Actor and the Über-marionette," 21, 120
created space, 180
Crimp, Martin, 143
 Attempts on her Life, 145–6
cross-racial casting, 88
Crowsnest, 111
"cruelty," theatre and notion of, *see under* Artaud, Antonin; *see also under* Derrida, Jacques

Dadaism, 83
Dafoe, Willem, 97
"dance theatre," 20, 151
Da Ponte, Lorenzo, 95
deceleration, 115
deconstruction, notion and practice of, 3, 33, 40, 98, 157, 187, 189
De Marinis, Marco, 139
Derrida, Jacques, 5, 38–9, 41–2, 45–6, 179
 différance, notion of, 5
 distinerrance ("deviation"), notion of, 142–3
 "La parole soufflée" (the "Stolen Word"), 45
 "parricide," notion of, 41
 "The Theatre of Cruelty and the Closure of Representation," 38, 43
 "theological stage," critique of, 41–2, 182

De Saussure, Ferdinand, 179
didascaliae, 184–5
 see also stage directions
Diderot, Denis: "Paradoxe sur le comédien" (on *The Paradox of Acting*), 23, 181
director, 8
 see also "metteur en scène; " *under individual directors*
"director author," 4, 29, 35
director-*creator*, 14
directors' theatre, 3, 6, 139
Duke Georg of Saxe Meiningen, 12, 17
 Julius Ceasar (Shakespeare), production of, 12
Duncan, Isadora, 20

Eco, Umberto, 5, 100, 186
 Open Work, The, 5, 139, 154, 186
 see also poststructuralism
Edinburgh International Festival, 187
Elam, Keir, 139
elongation, 115
emotional involvement and empathy, 45, 88, 90, 129, 130, 137, 142, 164
empathy, 88, 90, 129, 137
ensemble acting, 26, 34, 163, 165
"environmental," 19
environmental space, 180
Epidaurus, 172
Evreinov, Nikolai (Vera Komisarjevskaya Theatre), 26
expressionism, 4, 81, 83, 150

Fabre, Jan, 142
Fadjr International Theatre Festival, 176
Faulkner, William: *Sound and the Fury, The*, 187
Féral, Josette, 6, 144
Field, Andy, 180
Filter, 186
Fischer-Lichte, Erika, 104, 105, 179

Fitzgerald, F. Scott: *Great Gatsby,*
 The, 187
Foreman, Richard
 (Ontological-Hysterical Theatre),
 39, 76, 77, 78–9, 80, 89, 121, 150
 Paradise (*Hotel Fuck*), 77
 Pearls for Pigs, 77, 116, 136–7
 Permanent Brain Damage, 77
Formalism
 content versus form dialectic, 7,
 16, 18, 20, 21–2, 31, 49, 50, 107,
 111–12, 128, 131–2, 144, 153,
 171, 173, 181
 see also mannerism; *New Formalism*
Fornés, Maria Irene, 143, 150
Forum Theatre, 27
Fosse, Jon, 51, 143
Foster, Susan Leigh: "Choreographing
 History," 188
found object (*objet trouvé*), 187
 see also Kantor, Tadeusz
found space, 19, 180
 see also *alternative space*; *created
 space*; *environmental space*
"fragments of dramaturgy," 165
Fraleigh, Sondra, 121
Freud, Sigmund: *parricide*, notion of,
 9, 41
 see also Derrida, Jacques
Fuchs, Elinor, 6
 "death of character," 146

Gardner, Donald, 49
Gardner, Lyn, 164
Garner, Stanton, 67, 145
gender
 construction of, 88, 117–18
 cross-gender casting, 88
Genet, Jean, 184
Gesamtkunstwerk (a total work of art),
 7, 10, 12, 84
 see also Wagner, Richard
Glass, Philip, 81, 188
Gontarski, S.E., 56, 57, 184
 "Reinventing Beckett," 56–7

"Revising Himself: Performance
 as Text in Samuel Beckett's
 Theatre," 55–6
Grand Magic Circus, 181
Grotowski, Jerzy (Polish Laboratory
 Theatre), 5, 14, 49, 50, 91
 Doctor Faustus (Marlow), production
 of, 90
Grove Press, 55, 184
Guardian, The, 93, 109, 164, 180
Gunter, John, 99
Gussow, Mel, 56, 57, 99, 111, 186

Hamsun, Knut, *Drama of Life, The*, 15
Handke, Peter: *Sprechstücke* (*spoken
 plays*), 145
 Offending the Audience, 145
 Self-Accusation, 145
Hare, David, 130
Harrison, Tony, 167
Heddon, Deirdre, 91
Hegel, Georg Wilhelm Friedrich, 126
Hemingway, Ernest: *Sun Also Rises,
 The*, 187
hieroglyphs, 39, 44–5, 47 , 131
historical reconstruction, 12
history, Greek, 165
Hughes, Ted, 125
Hugo, Victor, 14, 180
 preface to *Cromwell*, 14
Hunka, George, 117

Ibsen, Henrik
 A Doll's House, 204
 Hedda Gabler, 40
Iceman, *see under* McBurney, Simon:
 Mnemonic
identity, construction of, 117–18,
 120, 142, 145–7, 150, 165,
 174, 176
 see also mediation; representation
Improbable Theatre, 186
Industrial Revolution, 14
inner truth in acting, 22
Innes, Christopher, 105, 125, 131, 180

interculturalism, 36, 81, 103–5, 119,
130, 169, 179, 182
critique of, 186, 187; *anaesthetization,*
131; ahistoricity, 104, 130–1;
cultural stereotyping, 104
interpretation, notion of, 2, 5, 6, 9,
27, 39, 40, 47, 57, 70, 84, 91,
92–3, 94, 97–9, 120, 132, 135–6,
139–43, 154, 155, 184, 186
see also Auteurism: authorship;
mediation; text: *metatext*
Ionesco, Eugene: "The Avant-Garde
Theatre," 1, 5
Lesson, The, 148, 190

Jakobson, Roman: "word heaps," 190
Jarry, Alfred: *Ubu Roi,* 4, 13, 14, 31,
81, 107
John Calder Publishers, 184
Joint Stock Company (currently Out of
Joint), 190
Jouvet, Louis, 40
Jung, Carl Gustav: theory of the
unconscious, 28, 82
on archetypes, 185

Kalb, Jonathan, 58
Kane, John, 188
see also under Brook, Peter:
Midsummer Night's Dream, A
Kane, Sarah, 143
Kantor, Tadeusz, (Cricot 2), 31, 78,
79–80, 108, 178
Cuttlefish, The (Witkiewicz),
production of, 187
"inn of memory," notion of, 114
I Shall Never Return, production
of, 114
Today is my Birthday, production
of, 80
Kennedy, Adrienne
Funnyhouse of a Negro, 150
Owl Answers, The, 150
Kessel, Marion, 185
Kharms, Daniil, 86

Kramer, Jane, 87
Kristeva, Julia, 189
Kroetz, Franz Xaver, 143

language as speech and incantation,
45, 49, 124–6, 144, 148–50,
152, 153
see also physical language; poetry of
sounds
LeCompte, Elizabeth (Wooster Group),
67, 80, 81–2, 83, 87, 88, 94, 116,
117–18, 120, 132, 141, 147, 173–6
Emperor Jones, The (O'Neill),
production of, 81, 88, 97, 117
Hairy Ape, The (O'Neill), production
of, 81, 97, 117
Hamlet (Shakespeare), production of,
80–1, 119
House/Lights (Stein), production
of, 118
L.S.D. (*…Just the High Points…*),
production of, 97, 117
Route 1&9, production of, 117
To You The Birdie, production of,
98, 118
Vieux Carré (Williams), 173–6
Lecoq, Jacques, 86, 187
Lehmann, Hans-Thies, 4, 6, 7, 32, 102,
107, 112, 116, 122, 124, 127, 137,
142, 147, 188
see also theatre: *postdramatic*
Lepage, Robert (Ex Machina), 32,
85–6, 120
Andersen Project, production of,
108–9
Seven Streams of the River Ota, The,
production of, 86
Tectonic Plates, production of, 109
Lester, Adrian, 88
Lévi-Strauss, Claude: *Structural
Anthropology,* 100
Lincoln Centre, 185
Lind, Jenny, 109
Lindau, Tina, 27
literary, 4, 14, 28, 100

Logan, Brian: "Is 'devised' theatre always
 a case of too many cooks?," 93
logocentric, 3, 100, 183
Luere, Jean, 156
Lyotard, Jean-François, 47–8

Malina, Judith (Living Theatre), 31
mannerism, 173
Marmarinos, Michail (Theseum
 Ensemble)
 Ethnikos Hymnos (National Anthem),
 production of, 164–7
Marowitz, Charles, 49, 184, 188
Marranca, Bonnie, 101
Marthaler, Christoph, 113, 141, 187
 Papperlapapp, production of, 114
 Riesenbutzbach. A Permanent Colony,
 production of, 113–14, 187
Maxwell, Richard (The New York City
 Players), 76
McBurney, Simon (Complicité), 26, 31,
 84–5, 86, 93, 112, 119–20
 Elephant Vanishes, The (Murakami),
 production of, 119
 Mnemonic, production of, 15–16,
 161–4
 Out of a House Walked a Man,
 production of, 86
 Street of Crocodiles, production of, 93
 Three Lives of Lucie Cabrol, The,
 production of, 93
 Visit, The (Dürrenmatt), production
 of, 93
McGrath, Bob (Ridge Theatre), 185
McMullan, Anna, 62
mediation, 10, 31, 39, 47, 118, 119
Mee, Charles, 27, 80, 111, 143, 183
 Full Circle, 181; see also Woodruff,
 Robert
 Hotel Cassiopeia, 181; see also Bogart,
 Anne
 Trojan Women: A Love Story, The, 148
 Vienna Lusthaus, 111; see also Clarke,
 Martha
melodrama, 14

Mendel, Deryk, 56
Merleau-Ponty, Maurice, 142
"metteur en scène," 11
Meyerhold, Vsevolod, 20, 21–3, 26, 30,
 85, 91, 120–1, 180
 Biomechanics, 22–3, 85
 "Fairground Booth," 22
 "jeu de théâtre" ("game of theatre"),
 notion of, 22
Miller, Arthur, 136, 156
 Crucible, The, 97; see also LeCompte
 Elizabeth: L.S.D. (. . . Just the
 High Points . . .)
Milling, Jane, 91
mime, 22, 28, 48, 52, 68, 178, 192
mimesis, 9, 25, 38, 39, 78, 116, 126,
 136, 186
 see also Aristotle
minimalism, 51, 52, 73, 143, 177, 187
Mitter, Shomit, 6
Mnouchkine, Ariane (Théâtre du
 Soleil), 27, 31, 34, 50, 85, 87, 90,
 128, 155
 1789, production of, 19, 27, 87, 90
 1793, production of, 87
 L'Age d'Or, production of, 87
 Le Dernier Caravansérail (Odysés),
 production of, 94, 114
 Les Atrides, production of, 36
 Les Clowns, production of, 87
 Terrible but Unfinished Story of
 Norodom, King of Cambodia, The
 (Cixous), production of, 36, 101
 Creation Collective (Collective
 Creation), practice of, 87, 94
 see also Asian theatre forms;
 interculturalism
Mock, Roberta: Performing Processes, 179
model drama, 137
 see also Lehmann, Hans-Thies
modernism, 50, 56
Molière: Misanthrope, The
 (dir. Van Hove), 98, 167–9
Monks, Aoife, 117
Montheith, Charles, 56

Mounsef, Donia, 144
Müller, Heiner, 143, 171
 Despoiled Shore Medea Material
 Lanscape with Argonauts, 147
 Heracles, 171
 Philoctetes, 147
 Produktionstücke ("production
 pieces"), 147
 Prometheus, 147
 Quartet, 189
 "synthetic fragments," 147, 189;
 see also "fragments of dramaturgy"
Murakami, Haruki, 94
Myth, 27, 35–6, 44, 91, 100, 115,
 125, 147
 and archetypes, 28, 131
 Barthes' understanding of, 101
 in the Mahabharata, 102–5
 mythical figures and references, 102,
 103, 104
 "neomythical" theatre, 102
 in Terzopoulos, 169–73

naturalism, 14, 16, 170
 see also New Naturalists movement
Nekrošius, Eimuntas (Meno fortas), 186
 see also individual productions
New Formalism, 129
New Naturalists movement, 14
New Realism, 15
New Wave, French, 1
Nietzsche, Friedrich Wilhelm:
 Dionysian and Apollonian spirit,
 28, 41, 123
nontextuality, 4
Novarina, Valère
 Le Babil des Classes Dangereuses (Babble
 of the Dangerous Classes), 149
 "L'ιcriture, le livre et la scθne"
 ("Writing, the Book and the
 Stage"), 190

Oida, Yoshi, 122
Okhlopkov, Nikolay, 19, 21
Olinder, Laurie, 185

O'Neill, Eugene
 Emperor Jones, The, 81, 88, 97, 117
 Hairy Ape, The, 81, 97, 117
 More Stately Mansions, 98
Oresteia trilogy, The (Aeschylus), 81
Ortiz, John, 89
O'States, Bert: binocular vision, 88
Ostermeir, Thomas (Berlin
 Schaubühne), 40, 204
 see also individual productions

Parks, Suzan-Lori, 150
pastiche, 79, 175
Pavis, Patrice, 6, 7, 29, 31, 47–8,
 130–1, 139, 141, 143, 148, 153
 "Which Theories for Which
 Mise-en-scθne?," 190
performance art, 84, 108, 116, 121,
 142, 147, 170
performer, autonomy of, 120–2,
 123–4, 145, 147, 148–9, 154, 166
performise, 143
phenomenology, 8, 88, 179
physical language, 46–7
Pink Floyd, Final Cut, 173
Piscator, Erwin (Volksbühne), 24,
 116, 181
 see also Brecht, Bertolt: epic theatre
Planchon, Roger, 30
Plato: Ion, 182
playwright, relationship with director,
 2, 4, 14, 21, 29–31, 36, 39–41, 47,
 57–8, 92–3, 135–8, 140, 154–7
 see also Auteurism: authorship;
 interpretation; mediation
Poetics, The, see under Aristotle
poetry of sounds, 126
postmodernism, 3, 5, 6, 79, 81, 97, 107,
 115, 118, 131, 137, 148, 170, 173,
 175, 181
 and Beckett, 51, 60
 and Brecht, 25, 181
 and Kantor, 108
 see also deconstruction, notion and
 practice of; Formalism

poststructuralism, 118, 189
 see also deconstruction, notion and
 practice of
"pre-critical mode," 189
presence, notion of, 45, 63, 67, 78,
 88, 115, 120, 122, 124, 137,
 138, 142, 144, 145, 146, 147,
 185, 188
Prichard, Rebecca: Yard Gal, 146–7
Puchner, Martin: Stage Fright:
 Modernism, Anti-Theatricality, and
 Drama, 185
"Pure Form" ("Czysta Forma") theory
 of, 78, 108, 185
 see also Witkiewicz, Stanislaw Ignacy

Rabkin, Gerald, 179
Ravenhill, Mark: Pool, No Water, 145
reader-response theory, 154, 179, 186
realism, 6, 13, 14–16, 20, 21–2, 25, 90,
 112, 115, 137, 180
 see also empathy; New Realism;
 compare with alienation
Reavey, Jean, 63
recycling, notion of, 79, 80, 83
Reed, Lou, 188
Reinhardt, Max (Deutsches Theatre),
 18, 19, 21, 26, 42
 Everyman (Hofmannsthal),
 production of, 19
 Faust (Goethe), production of, 19
 relationship with the stage, 19–20,
 25, 26, 27, 32, 35, 42–3, 87,
 90, 91, 112, 125, 138, 164,
 166–7, 180
representation, 9, 13, 14, 19, 20, 21,
 24, 31, 38, 49, 52, 63, 67, 79,
 81, 112, 117–18, 136–8,
 142–7, 170, 188
 and Derrida's reading of Artaud,
 38–41, 183
representability, 7, 38, 124, 188
representationalism, 108, 132
representational theatre, 16, 50, 115,
 121, 126

Rich, Frank, 30, 76, 130, 156
 "Auteur Directors Bring New Life to
 Theatre," 76
Ridge Theatre, The, 73, 185
Right Size, 186
Riverside Studios, 161
Rockwell, John, 114, 129, 185
romanticism, 12, 14
 see also melodrama
Ronconi, Luca: Orlando Furioso
 (Ariosto), production of, 19
Roose-Evans, 28
Rosset, Barney, 55
Royal Court, 145
Royal National Theatre, 93
Royal Shakespeare Company (R.S.C),
 182, 188
Ryngaert, Jean-Pierre, 152

Sarris, Andrew: "Notes on the Auteur
 Theory," 2
 see also American Cinema
Savary, Jerome, 181
 see also Grand Magic Circus;
 Théâtre Panique
"scenic writer," 32
Schechner, Richard (formerly of
 Performance Group), 19,
 26, 36, 50, 100, 120–1,
 138, 182
 Dionysus in 69,
 production of, 100,
Schlemmer, Oskar: "Dance in
 space;" "Figure in space with
 Plane Geometry and Spatial
 Delineations," 188
 see also Bauhaus
Schmidt, Paul, 110
Schneider, Rebecca, 6
Schubert, Franz, Lied, Nacht und
 Träume, 53
Schulz, Bruno
 Sanatorium under the Sign of the
 Hourglass, 94
 Street of Crocodiles, 93, 94

Schumann, Robert (Bread and Puppet Theatre), 31
Seago, Howie, 96
self-collaboration, 10, 29, 56, 76–9, 149, 185
 see also solipsism
self-transformation, 147
 see also Lehmann, Hans-Thies
Sellar, Tom, 168
Sellars, Peter, 24, 90, 119
 Ajax (Sophocles), production of, 96
 Così fan tutte (comp. Mozart), production of, 95
 Don Giovanni (comp. Mozart), production of, 95–6
 Marriage of Figaro, The (comp. Mozart), production of, 95
 Merchant of Venice (Shakespeare), production of, 88–9, 96
 Persians, The (Aeschylus), production of, 96
semiology of mise-en-scène, 8, 82, 88, 122, 139–43
 see also theatre signification
Serban, Andrei: Fragments (Medea, Electra, and The Trojan Women), production of, 124, 126
Servati, Reza (Max Theatre Group): Macbeth (Shakespeare), production of, 176–8
Shakespeare, William, 12, 28, 29, 88–9, 95, 96, 99, 104, 176–8
 see also individual productions of his plays
Shaw, George Bernard, 184
 see also didascaliae
Shevtsova, Maria, 6
Shunt, 186
Silva, Geno, 89
Simov, Viktor, 16
solipsism, 76
Sontag, Suzan: Selected Writings, 42, 48, 184
sound, function in the theatre, 51–2, 54, 64, 69–71, 80, 89, 110, 124–6, 148, 172, 178, 188

"spectacle," 18, 25, 33, 38, 41, 42, 43, 54, 62, 76, 88, 90, 101, 102, 116, 118, 128
spectator
 and reception of theatre event, 6, 31–2, 54, 68, 69–70, 82–3, 88–9, 98, 104–5, 107, 112, 114, 118, 127, 129, 138–41, 162–3, 179, 186, 188–9
 see also coauthorship of performance script; relationship with the stage
"staged accidents," 142
stage directions, 52, 56, 57, 58–9, 61, 65, 66, 144, 145, 156
 see also didascaliae
staging, elements of, 3, 11, 12, 15–16, 28, 34, 44, 54, 59, 60, 61–6, 78, 81, 108, 124–6, 177–8, 183
Stanislavski, Constantin (Moscow Art Theatre), 15, 16, 20, 22, 30
 method acting, 22; see also inner truth in acting
stasis, 114
Stein, Gertrude, 80, 110, 150, 184, 187
 landscape writing, 110, 150, 184, 190
Stephens, Simon: Pornography, 143, 146
"straight line," theory of, 121
Strindberg, August: introduction to Miss Julie, 180
 see also Wilson, Robert: Dream Play
structure, elements of, 17, 18, 22, 29, 32, 64, 66, 67, 68, 70, 75, 102, 108, 115, 136–8, 144, 149, 157, 166, 171, 174, 189
surrealism, 81, 83, 97, 189
suspension, 115
Suzuki, Tadashi, 34, 80, 85, 96–7, 123, 142, 171, 181
 Bacchae, The (Euripides), production of, 97
 King Lear (Shakespeare), production of, 97
 tame, system of, 123
 Trojan Women, The (Euripides), production of, 97
Swados, Elizabeth, 124

symbolism, 15, 16, 22, 44, 81, 103, 126, 150, 175
Szondi, Péter: "crisis of drama," 75

Tairov, Alexander, 21, 180
techniques, film, 3, 24, 80, 110, 116, 118–19, 162, 168, 176, 185
"technologization," 7
technology in the theatre, 24, 31, 71–3, 83, 107, 113, 114, 115–20, 132, 141, 168–9, 174
 cyberspace, 118, 119
 media, 7, 52, 115–16, 119–20, 146, 181; mixed-media, 61, 73, 75, 79, 98, 151; multimedia, 24, 94, 115, 116–18, 132, 163, 173
 see also "technologization"
Terzopoulos, Theodoros (Attis Theatre), 169
 Ajax (Sophocles), production of, 170, 172–3
 Antigone (Sophocles), production of, 170
 Bacchae, The (Euripides), production of, 36, 169, 170
 Heracles (Euripides, Müller), production of, 171
 Heracles Furens (Euripides), production of, 170, 171
 Kathodos (Descent), production of, 172
 Medeamaterial (Müller), production of, 171
 Persians, The (Aeschylus), production of, 170
 Prometheus Bound (Aeschylus), production of, 169
text
 anti-textuality, 3; see also nontextuality
 found text, 97, 166
 intertextuality, 189
 metatext, 139, 141; see also interpretation
 mistrust of, 28–9, 30–1, 34, 36, 43, 45, 47, 49, 91

para-textuality, 60
performance text, 5, 32, 33, 35, 42, 47, 60, 78, 87, 92, 112, 118, 132, 137, 139, 143, 147, 154, 165, 166, 179, 184
 subtext, 66, 98, 99, 168–9, 174
 technology as textuality, 107
 textuality, 46, 144
 theatre textuality, 154
 über-text, 47
Tharu, Suzie J., 45
theatre
 avant-garde, see under Auteurism; directors' theatre
 devised, 26, 46, 91–4, 131, 161–5, 182
 documentary, 24
 dramatic, 6, 54, 86, 100, 116, 126, 136, 137, 154; see also literary; logocentric; contrast with theatre: postdramatic
 epic, 24, 94; see also Brecht, Bertolt; Piscator, Erwin
 "holy," 14, 49–50; see also Artaud, Antonin; Brook, Peter
 "of Images," 4, 31; see also Wilson, Robert
 interactive, 42
 intercultural, see under interculturalism
 mimetic, 25, 75, 80, 88, 116, 120, 181, 185, 186; see also well-made plays; compare with representational theatre
 music-theatre, 187; see also Marthaler, Christoph
 pantomime, 22, 44; see also mime
 physical, 23, 24, 45, 49, 131, 161, 169, 176; see also "dance theatre"
 postdramatic, 4, 6, 116, 137
 "site-specific," 19–20, 180; see also "environmental"
 "of the absurd," 5
 universal, 126, 131; see also Artaud, Antonin; Brook, Peter
 verbatim, 42, 183
Théâtre de l'Oeuvre, 13
Théâtre Panique, 181

theatre signification, 140, 142, 185
Theatre Workshop, 93
Thevenin, Paule, 183
Thucydides, 152
time, function and manipulation of in
 the theatre
 acceleration, 115
 contrast with deceleration
 "crisis of time," notion of, 112
 dramatic time, 67, 112–13,
 121, 167
 duration, 53, 61, 67, 113, 115, 144
 prolongation, 83, 114; *see also*
 elongation
 real-time, 100, 113
 repetition, 52, 60, 67, 68, 72, 113,
 114, 151, 152, 153
 shared time, 113, 164
 simultaneity, 114, 119, 176
 stillness, 63, 115, 178; *see also* stasis;
 suspension
tragedy, Greek, *see under* adaptation
 also under Terzopoulos; *individual*
 productions
Truffaut, François Roland: "Une
 certaine tendance du cinema
 francais" ("A certain tendency in
 French cinema"), 1
Tse, Elaine, 88

über-marionette, *see under* Craig,
 Edward Gordon
Ubersfeld, Anne, 138, 139
Ursprache, 125

Vakhtangov, Yevgeny, 21
Valk, Kate, 88, 97, 117
Vanden Heuvel, Michael, 138,
 155, 189
Van Hove, Ivo (Toneelgroep
 Amsterdam), 98, 167–9
 Hedda Gabler (Ibsen), production
 of, 98
 Little Foxes, The (Hellman),
 production of, 98

Misanthrope, The (Molière),
 production of, 167–9
More Stately Mansions (O'Neill),
 production of, 98
Streetcar Named Desire, A
 (Williams), production of, 98
Versweyveld, Jan, 167
Viebrock, Anna, 107
Village Voice, The, 168
Vinaver, Michel, 149

Wagner, Richard, 12, 17, 84, 85
 see also *Gesamtkunstwerk*
Waits, Tom, 188
Walsh, Enda: *New Electric Ballroom,*
 The, 152
Warhol, Andy, 80
Warlikowski, Krzystof, 8, 67
Warner, Deborah, 19–20
 Angel Project, The, production
 of, 19
 St. Pancras Project, production
 of, 19
 Wasteland, The (T. S. Eliot),
 production of, 19
Weber, Carl: introduction to
 Hamletmachine and Other Texts for
 the Stage, 189
Weins, Wolfgang: "Making of a
 Monologue, The," 77
Welles, Orson, 80
well-made plays, 153
Wellman, Mac, 143, 149
 Description Beggared; or the Allegory
 of WHITENESS, 153
Whitelaw, Billy, 57
Wilcox, Dean, 63
Williams, Tennessee: *Vieux Carré*,
 173–6
 Streetcar Named Desire, A, 98
Wilson, Robert, 2, 46, 50, 80, 157,
 172, 185, 188
 Alice (comp. T. Waits), production
 of, 110–11
 CIVIL warS, production of, 84

Danton's Death (Büchner),
 production of, 129
*Days Before: Death, Destruction and
 Detroit III, The,* 109, 188
Deafman Glance, production of,
 83–4, 110, 130
Dream Play, A (Strindberg),
 production of, 110
Einstein on the Beach (comp. P. Glass),
 production of, 81, 110
and form, 107, 108, 110, 121, 128,
 129, 130, 141
Hamlet (Shakespeare), production
 of, 77–8
Happy Days (Beckett), production
 of, 110
Krapp's Last Tape (Beckett),
 production of, 110
and the landscape aesthetic,
 109–10
Letter for Queen Victoria, A, text and
 production of, 149
Life and Times of Joseph Stalin, The,
 production of, 110
*Making of a Monologue: Robert
 Wilson's Hamlet, The,* 77
and myth, 100, 101–2
and perception, 82, 83

and rhythm, 149
and "self-collaboration," 77–8
and the Theatre of Images, 4
Threepenny Opera, The (Brecht),
 production of, 110
and time, 115
Time Rocker (comp. L. Reed),
 production of, 110
Witkiewicz, Stanislaw Ignacy
 (Witkacy): "Pure Form," theory
 of, 78, 108, 185
 Cuttlefish, The (dir. Kantor), 187
Woodruff, Robert, 27, 97
 Full Circle (Mee), production
 of, 181
Woolf, Virginia, 80
Wooster Group, The, *see under*
 LeCompte, Elizabeth
Wright, Elizabeth, 25
writing, 155
 automatic, 136; *see also* Breton, André
 "neo-dramatic," 31, 61, 143–54;
 see also avant-garde dramaturgy
 scenic, 30, 31, 120, 121, 133, 141

Zarrilli, Philip, 5
Zola, Emile, 14, 15
 "The Sin of Father Mouret," 180